CHINA

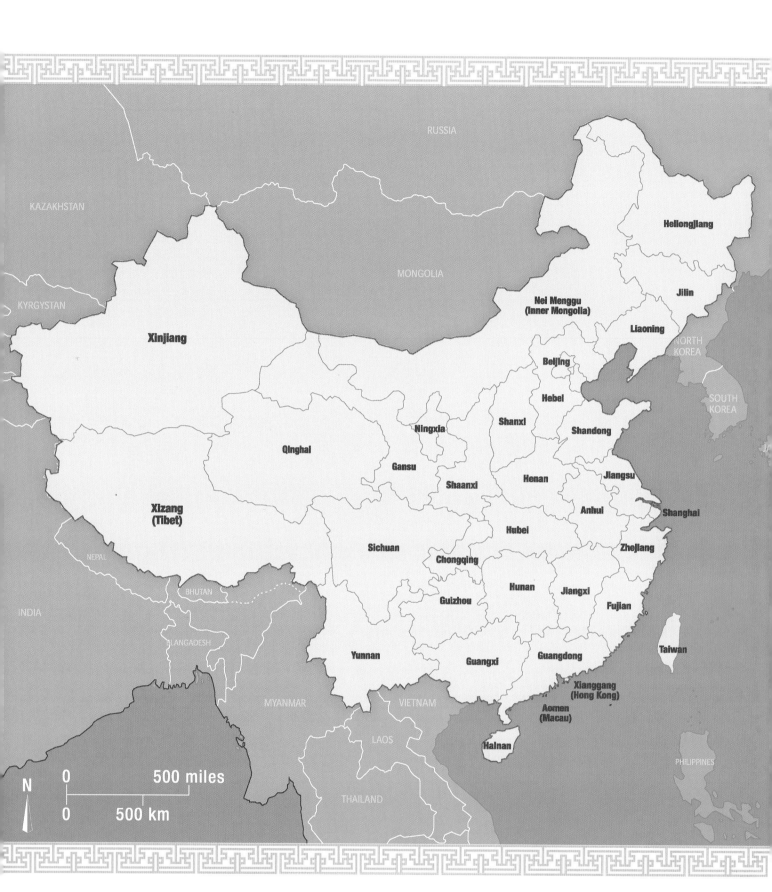

KAZAKHSTAN

RUSSIA

MONGOLIA

KYRGYSTAN

Xinjiang

Nei Menggu
(Inner Mongolia)

Heilongjiang

Jilin

Liaoning

NORTH
KOREA

SOUTH
KOREA

Beijing

Hebei

Qinghai

Ningxia

Shanxi

Shandong

Gansu

Henan

Jiangsu

Shaanxi

Xizang
(Tibet)

Anhui

Shanghai

Hubei

Zhejiang

NEPAL

Sichuan

Chongqing

BHUTAN

Hunan

Jiangxi

Guizhou

Fujian

INDIA

BLANGADESH

Yunnan

Guangxi

Guangdong

Taiwan

Xianggang
(Hong Kong)

MYANMAR

VIETNAM

Aomen
(Macau)

Hainan

LAOS

PHILIPPINES

N

0 500 miles

0 500 km

THAILAND

FRONTISPIECE: Administrative Divisions of China. © The Field Museum. Illustrator Lori Walsh.

CHINA

VISIONS THROUGH THE AGES

Edited by Lisa C. Niziolek, Deborah A. Bekken,
and Gary M. Feinman
Assisted by Thomas A. Skwerski

The University of Chicago Press : Chicago and London

The University of Chicago Press, Chicago 60637

The University of Chicago Press, Ltd., London

© 2018 by The Field Museum. All rights reserved. No part of this book may be used or reproduced in any manner whatsoever without written permission, except in the case of brief quotations in critical articles and reviews. For more information, contact the University of Chicago Press, 1427 E. 60th St., Chicago, IL 60637.

Published 2017

Printed in Hong Kong

27 26 25 24 23 22 21 20 19 18 1 2 3 4 5

ISBN-13: 978-0-226-38537-2 (cloth)

ISBN-13: 978-0-226-45617-1 (e-book)

DOI: 10.7208/chicago/9780226456171.001.0001

Library of Congress Cataloging-in-Publication Data

Names: Niziolek, Lisa C., editor. | Bekken, Deborah A., editor. | Feinman, Gary M., editor.
Title: China : visions through the ages / edited by Lisa C. Niziolek, Deborah A. Bekken,
 and Gary M. Feinman ; assisted by Thomas A. Skwerski.
Description: Chicago ; London : The University of Chicago Press, 2018. | Includes bibli-
 ographical references and index.
Identifiers: LCCN 2016045897 | ISBN 9780226385372 (cloth : alk. paper) | ISBN
 9780226456171 (e-book)
Subjects: LCSH: China—Antiquities. | Field Museum of Natural History—Art collec-
 tions.
Classification: LCC DS714 .C45 2017 | DDC 931.0074/77311—dc23
 LC record available at https://lccn.loc.gov/2016045897

♾ This paper meets the requirements of ANSI/NISO Z39.48-1992 (Permanence of Paper).

CONTENTS

INTRODUCTION

Lisa C. Niziolek, Deborah A. Bekken, and Gary M. Feinman

Timeline for the Exhibition

One of the questions we have frequently been asked since the opening of the *Cyrus Tang Hall of China* in late June 2015 is "How long did it take to create and install this exhibition?" The answer is not a simple one. In theory, and the answer most often given, is that it took three years: one year to plan, one year to write and develop, and one year to build. In reality, however, a permanent exhibition like this one takes much longer, and the process is much more complex—for the *Cyrus Tang Hall of China*, a decade might be more accurate, for it was early in the first decade of this century that former Field Museum curators of Asian anthropology and archaeology Bennet Bronson and Anne Underhill began developing ideas for a new permanent exhibition on the history and culture of China that would highlight the Museum's extensive collections. If we wanted to deepen our time frame even more, we could say that the exhibition was more than one hundred years in the making. This, however, might be a bit of an exaggeration, although it could be said that the practice of displaying and interpreting artifacts and traditions from China did indeed start when the Museum first opened in 1893 as the Columbian Museum of Chicago.

As Deborah Bekken points out in her chapter in this volume on the history of the Chinese collections at the Museum, China was not well represented at the World's Columbian Exposition. Because The Field Museum was founded in part so that exhibitions from the 1893 World's Fair could continue to be displayed and

curated for public education and enjoyment, China's presence in early collections and exhibitions was small. The first mention of a Chinese display in the Museum's annual reports is from 1897–98, and it is one describing the deinstallation of the Chinese Joss-House materials, which were "no longer being regarded as worthy of exhibition" (Skiff 1898, 281). (The basis for this assessment is not clear.) Ten years later, though, in 1907, three halls in the Museum's old building in Jackson Park were dedicated to the anthropology of Asia (Skiff 1908, 135). Notably, this was the year that Berthold Laufer joined the Museum, becoming the Museum's first curator of Asian anthropology and embarking immediately on the first of two major expeditions to China, during which he would collect an estimated nineteen thousand objects.

The momentum for displaying cultural objects from China started to build in 1911 after Laufer returned from the Mrs. T. B. Blackstone Expedition to China and continued through 1915. Reading through the Museum's annual reports for this period calls to mind the puzzle game Tetris, in which a player is constantly shifting and matching colored blocks to make room for new ones—exhibition halls and cases, as well as storage areas, were in a state of constant flux in order to accommodate the display of new acquisitions. In 1913, for example, sixty-nine new cases were installed in the Chinese Section plus three special exhibitions (Skiff 1914, 300). Of one of these displays, the director wrote, "The important event of the year in matters of installation proved to be the placing on exhibition of the Chinese and Tibetan masks, and in view of the complexity of the technical problem involved, due credit should be given to the Department's efficient preparators who with untiring zeal and resourcefulness have made this exhibit a success. In principle this group of exhibits essentially differs from the other Chinese exhibits. The latter are analytic depicting certain periods and facts; the former are synthetic, presenting in their totality an essential and vital organ of Eastern life, and spontaneously convey a feeling of reality" (Skiff 1914, 301). Also in 1913, two scroll paintings, gifts of the Tuesday Art and Travel Club of Chicago, were installed— one of these was *Along the River during the Qingming Festival*, which is on display in the new exhibition. It was reported that "the numerous scenes displayed thereon have been interpreted in detail in a series of descriptive labels freely suspended from the lower rim of the wall-case, so that the interested visitor may hold them up to his eye to suit his convenience in reading" (Skiff 1914, 302). Today, visitors can learn about the 27-foot-long Ming Dynasty painting and Chinese traditions through a display that includes a small portion of the scroll itself (which will be rolled forward periodically so that visitors can see other sections of it and to reduce its overall exposure to light to better preserve it), a larger-scale version that shows multiple scenes at once, printed labels, and an interactive touch table that enables visitors to see the scroll in detail and select from a variety of stories related to scenes depicted on the piece.

Based on the annual reports, from 1915 through 1920 there appears to be a lull in installations of Chinese materials. In 1920, the Museum moved to its new

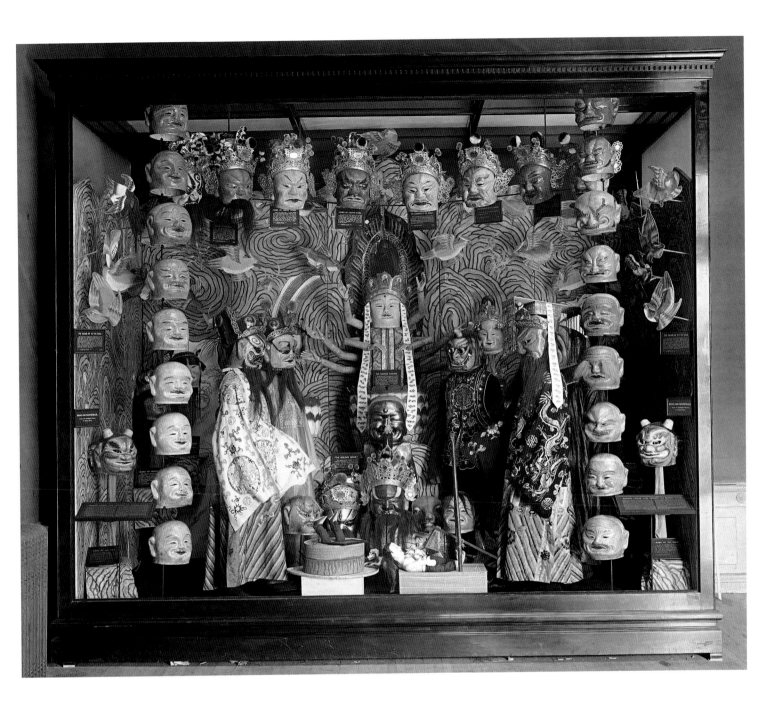

location in Grant Park, and, in 1921, materials from the Blackstone Expedition and other acquisitions were again on public display (fig. 1). The Museum's "desire to render accessible to the public the results of recent expeditions" is clear (Davies 1925, 303) and new acquisitions and research being done by the Museum's curators continued to be highlighted in permanent and temporary exhibitions. For example, in 1924, Qing Dynasty robes and other court paraphernalia from the Captain Marshall Field Expedition to China led by Laufer were displayed in Stanley Field Hall, and Chinese pewters from the Mr. Edward E. Ayer collection were exhibited

FIGURE 1

Early installation of religious drama masks and theater materials, 1929. © The Field Museum. Photo ID No. CSA63188. Photographer Charles Carpenter.

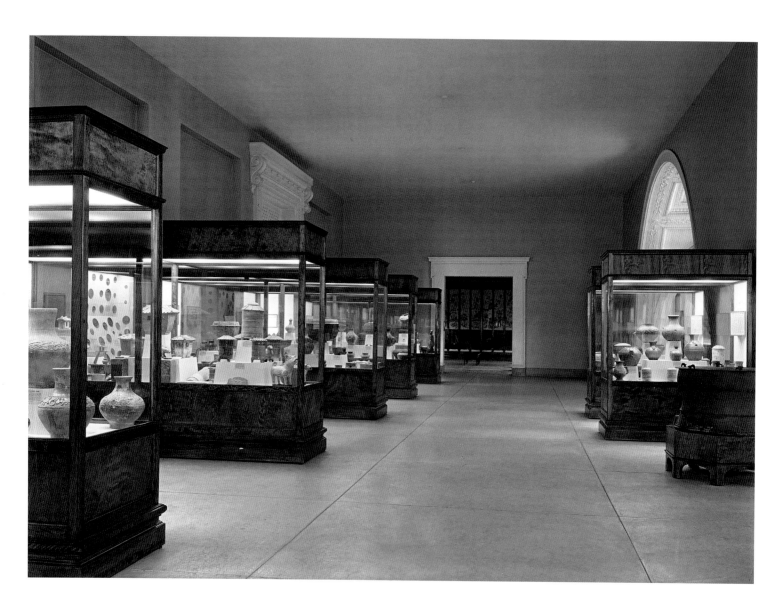

FIGURE 2
Installation of cases featuring artifacts
from ancient China, 1930. © The Field
Museum. Photo ID No. CSGN76949.

in Hall 23. In 1925, rhinoceros-horn cups presented by Mr. John J. Mitchell were installed in Hall 24 and, in 1926, some of the Museum's artifacts related to the history of Christianity in China, including the Ming Dynasty painting of the Chinese Madonna and Child, were displayed in conjunction with the Eucharistic Congress, which was held in Chicago that year. The following year, in 1927, more than 220 ancient Chinese jades were exhibited in Stanley Field Hall, and theater pieces related to the "great Chinese religious drama showing the ten purgatories" were installed at the south end of Hall 32 (Davies 1928, 260).

Laufer provided the basis both in terms of the objects and the content for most of the Museum's exhibitions on China from 1907 until the 1930s. In 1931, the Jade Room, which featured about 1,200 jade items mainly from the Blackstone Expedition, opened. According to the annual report for that year, Laufer "was the first to collect the archaic jades of China to study and interpret them" (Simms 1932, 147).

FIGURE 3
Exhibition cases of artifacts from ancient China, 1987. © The Field Museum. Photo ID No. GN84962_11. Photographer Ron Testa.

During the following couple of years, Laufer dedicated himself to developing the Museum's main displays on ancient China in Hall 24 (Simms 1933, 321) and Hall 32 on the west balcony (Simms 1935, 183), where much of his work remained on view until it was deinstalled for the new exhibition in 2013–14 (figs. 2 and 3). Hall 32 was the last exhibition on which Laufer worked before his death in September 1934. His contributions to the field of Chinese studies and to The Field Museum cannot be underestimated: "While his scholarship achieved its summit in his researches in the realm of Oriental subjects, his brilliant mind encompassed vast knowledge of all branches of anthropology, and his keen, helpful suggestions were always appreciated by the younger men working with him. His staff held him in highest esteem and respect for the genius he displayed in his science, and beyond that, there was a strong bond of affection between him and his assistants" (Simms 1935, 183). In the decades that followed, a number of new curators built on Laufer's foundation, adding to the collection, undertaking their own fieldwork and research, and continuing to develop and assist with important exhibitions on China and its peoples.

The *Cyrus Tang Hall of China*

During the Museum's early decades, exhibitions were closely tied to research, particularly research stemming from expeditions and fieldwork, and they were developed by the curators and their associates. By today's standards, many of the cases would have seemed crowded and the labels dense (fig. 4), however, at the time, The Field Museum was at the forefront of presenting materials from China (and elsewhere) and telling stories about them that helped visitors better understand and appreciate the societies from which they came. And, although the Museum's early annual reports position exhibitions as part of the various research "sections" (e.g.,

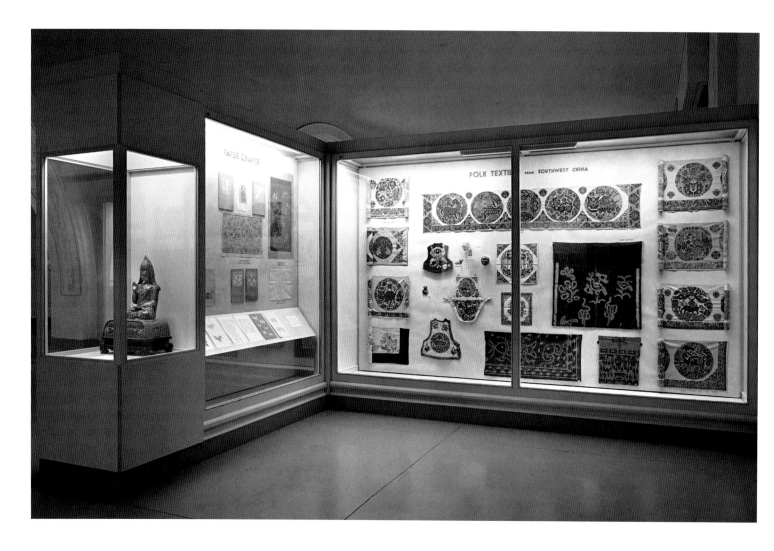

Anthropology), it is apparent that there was close collaboration with preparators, and innovations, such as new label formats, different lighting and backgrounds, and even magnifiers for visitors to use to study specimens, are frequently mentioned. This spirit of innovation is carried on through the *Cyrus Tang Hall of China*.

One of the main goals in developing the new hall was to find new ways of introducing objects in our collections—and, more importantly, the stories they can help us tell about China—to our visitors and providing them with more personalized experiences. To do this, we needed to develop ways of presenting information that appealed to multiple audiences who have different learning styles and ways of engaging with the world around them. Although the foundation of each experience in the exhibition is a real object, technologies such as interactive digital rails, immersive landscape projections, and other media elements enable visitors to choose the stories they want to read and become immersed in various aspects of China, its diverse environments, and its traditions.

Early displays of the Museum's material from China were largely meant to highlight new acquisitions and research, and, in many ways, the *Cyrus Tang Hall*

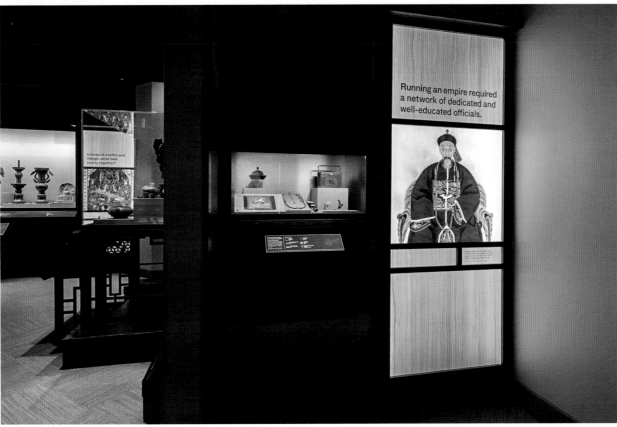

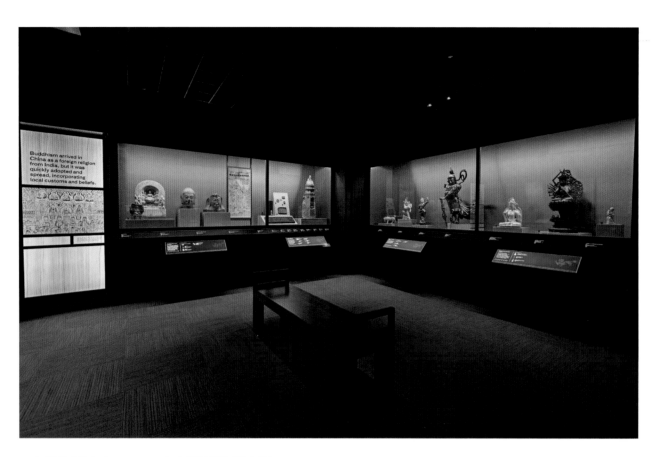

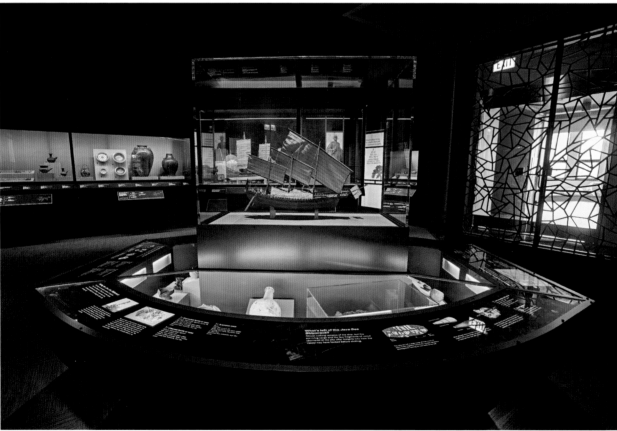

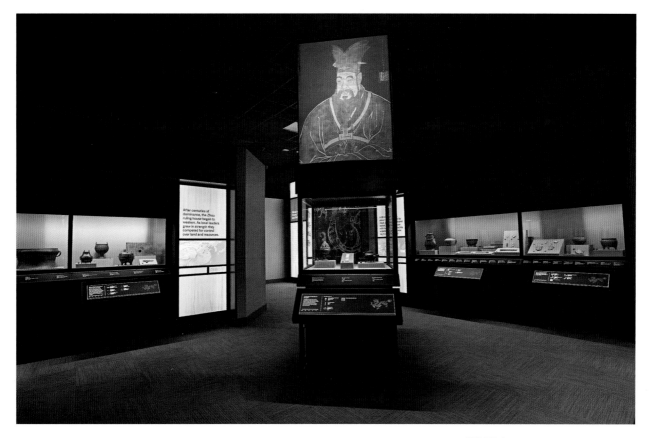

FIGURE 9
View of the second gallery of the *Cyrus Tang Hall of China*, 2015. © The Field Museum. Photo ID No. GN92154_054d. Photographer Karen Bean.

FIGURE 7
View of the fourth gallery of the *Cyrus Tang Hall of China*, 2015. © The Field Museum. Photo ID No. GN92154_126d. Photographer Karen Bean.

FIGURE 8
View of the fifth gallery of the *Cyrus Tang Hall of China*, 2015. © The Field Museum. Photo ID No. GN92154_161d. Photographer Karen Bean.

of China continues this tradition (figs. 5, 6, and 7). Although much of the exhibition includes "old friends," or artifacts that have been on display for decades, it also presents new acquisitions, such as the Java Sea Shipwreck collection, which was acquired in 1998–99 (fig. 8), and research, including that being undertaken by curator Gary Feinman and colleagues on China's unification during the Qin Dynasty (fig. 9). Whereas a century ago the curator himself would have developed and written the exhibition, today exhibitions at the Museum are created by a team of content specialists and exhibition professionals who work together to identify key stories and the best methods for sharing these with the public. For the *Cyrus Tang Hall of China*, nearly one hundred staff members contributed their time and talent, and more than seventy-five outside scholars and community members were consulted. We believe the end result is a rich and rewarding experience for our visitors in which content, design, and technology are seamless.

A Companion Book

The purpose of creating a companion book for the *Cyrus Tang Hall of China* is to give readers the opportunity to learn more about particular objects and themes presented in the exhibition, and, holistically, the contributions provide greater context and historical background for the Museum's extensive East Asian collections. The book is not intended to be either a traditional exhibition catalog or a comprehensive survey of Chinese history and culture; rather, it provides readers with a foundation to expand their understanding of a variety of topics that are introduced in the exhibition. In doing that, the volume contributors aim to enhance the readers' familiarity with key themes in the history of China, while offering suggestions for other bodies of literature that may also be pursued.

The overall plan of the book mirrors that of the *Cyrus Tang Hall of China*. Like the exhibition, it is split into five sections, with two chapters each, plus a two-chapter introductory section and a conclusion. The first section, corresponding to Gallery 1 ("Diverse Landscapes, Diverse Ways of Life"), focuses on the Paleolithic and Neolithic periods; the second, corresponding to Gallery 2 ("Ritual and Power, War and Unification"), covers the Bronze Age, the first dynasties, and early writing; the third, corresponding to Gallery 3 ("Shifting Power, Enduring Traditions"), highlights the imperial system and how power was maintained over the vast territory that made up China; the fourth, corresponding to Gallery 4 ("Beliefs and Practices, Symbols and Stories"), centers on religion and performance; and the fifth, corresponding to Gallery 5 ("Crossing Boundaries, Building Networks"), discusses interregional trade (especially the overland and maritime "Silk Routes"). Each section also includes at least one "highlight" section which features a brief narrative about one of the exhibition's objects or themes.

In chapter 1, "Building the China Collections at The Field Museum," Deborah A. Bekken provides readers with background on the Museum's extensive holdings from China. An estimated nineteen thousand of the approximately thirty thousand pieces in the Chinese collections were collected by Berthold Laufer, the Museum's first curator of Asian anthropology, during his expeditions to China in 1908 and 1923. Much of the chapter is devoted to his contributions to the Museum's collections and to the study of Chinese history and culture, but the author also presents contributions made by other curators over the past century.

In chapter 2, "Domestication and the Origins of Agriculture in China," Gary W. Crawford introduces audiences to early processes of domestication and agriculture in Neolithic China. How did different environments and exchange networks influence the plants and animals that communities in different regions relied upon, a process that eventually produced a range of domesticates? What was the role of agriculture in shaping early societies and vice versa?

The first highlight section, "Zhoukoudian: Peking Man and Evidence for Human Evolution in East Asia," was written by Chen Shen. Some of the earliest artifacts in The Field Museum's collections are stone tools from the famous site

of Zhoukoudian in China and date to about 700,000–300,000 years ago. In this section, Shen discusses the importance of these finds and what they can tell us about our early ancestors.

Chapter 3, "China during the Neolithic Period," by Gary M. Feinman, Hui Fang, and Linda M. Nicholas, highlights the diversity of societies that existed in China during the Neolithic period (c. 8000–1900 BC). Special attention is paid to the research being conducted by the authors in Shandong Province. This international team of scholars is using archaeological survey methods to trace changes in settlement patterns and social relationships in the Shandong region during the Longshan period (c. 2600–1900 BC).

During the Shang and Zhou periods in China (c. 1600–256 BC), ancient bronzes were important for rituals involving ancestor worship, feasting, and offerings to the gods. They also represent an important step in the history of metallurgy. In chapter 4, "The Bronze Age in China: What and When," by Yung-ti Li, readers learn about the roles that bronzes played in mediating social (including supernatural) relationships and the technologies that made their production possible.

In the second highlight section, "Sanyangzhuang: Life and Death in the Yellow River Floodplain," Tristram R. Kidder and Haiwang Liu discuss Sanyangzhuang and rural life during the Han period. *Mingqi*, or spirit goods made for use in the afterlife, are often found in Han Dynasty (206 BC–AD 220) tombs. Many of these are ceramic models of utilitarian structures and equipment, such as farm implements, and they provide insight into domestic practices. Sometimes referred to as "China's Pompeii," the site of Sanyangzhuang in Henan Province was buried under meters of sediment, which preserved a Han-period homestead that included real-life elements after which *mingqi* are modeled. The site provides an amazing record of rural life along the early Silk Road.

Early writing in China is covered by Edward L. Shaughnessy in chapter 5, "Written on Bamboo and Silk, Inscribed in Metal and Stone: Varieties of Early Chinese Writing." Beginning with oracle-bone inscriptions of the Bronze Age, dated to about 1200 BC, the author introduces audiences to the various media on which early writing was produced, such as bronze vessels, and demonstrates some of what inscriptions can reveal about ancient Chinese society. In addition to writing on oracle bones and bronzes, inscriptions found on stone and less durable materials, including bamboo and silk, are discussed.

This chapter is followed by a highlight section by Shaughnessy, "Consort Hao's Inauspicious Delivery," in which the author describes an oracle-bone inscription regarding the birth of a daughter to an imperial consort. In this section, Shaughnessy also outlines the components of an oracle-bone inscription.

Chapter 6, "*Along the River during the Qingming Festival*: A Living Painting with a Long History," by Lu Zhang, provides different perspectives on The Field Museum's Ming Dynasty painting, *Along the River during the Qingming Festival*. The original version of this work was painted during the eleventh or twelfth century by Zhang Zeduan. Since then, the famous painting has been copied and reinterpreted

over the centuries. The Museum's copy, dated to the late sixteenth or seventeenth century and possibly depicting the city of Suzhou in southern China, provides a lens through which to view a prosperous society during the Ming Dynasty. Among other themes, the painting depicts life in the rural countryside, leisurely activities of the well-to-do, important social events, and everyday economic transactions.

The fourth highlight section, "Conserving a Treasure: Preparing *Along the River during the Qingming Festival* for Display," is authored by Rachel Freeman and Shelley R. Paine. It discusses the labor-intensive but fascinating steps that must be taken to conserve a fragile handscroll and develop a mount and case for its eventual display within the exhibition.

In chapter 7, "Men of Culture: Scholar-Officials and Scholar-Emperors in Late Imperial China," Fan Jeremy Zhang discusses imperial power and the scholar-official. This chapter examines the importance of the imperial examination system and the officials and literati who were the products of it. Readers learn about the relationships between scholar-officials and the imperial court and the important role art and art appreciation played in the bureaucratic ranks.

The fifth highlight section, "Commemorating a Gathering of Friends: The *Lanting Xu* Rubbing," was authored by Yuan Zhou. The rubbing of *Preface to the Poems Composed at the Orchid Pavilion (Lanting Xu)* preserves a work by the great poet and calligrapher Wang Xizhi. It describes a gathering of forty-two scholars near Shaoxing in southeastern China during the Spring Purification Festival in AD 353 and is one of China's most important calligraphic works. The Museum's copy dates to the Song Dynasty, twelfth or thirteenth century, and is one of the highlights of the collection.

Chapter 8, "Daoism and Buddhism in Traditional China," is by Paul Copp. Throughout China's history, people have followed many different belief systems. Two of the most influential and popular are Buddhism and Daoism. In chapter 8, Copp investigates the impact that Buddhism, originally a foreign religion, and Daoism, considered a "home-grown" religion, had on Chinese culture. Although distinctive, the two belief systems borrowed elements from one another and were often practiced side by side.

In another highlight section, entitled "Sealed in Time: A Manuscript from Dunhuang," Yuan Zhou discusses an object we were unable to display in the exhibition, a Buddhist manuscript from Dunhuang. More than two thousand years ago, individuals of multiple faiths and from many places along the Silk Road expressed their beliefs at the Mogao Caves just outside the oasis town of Dunhuang in Gansu Province. The caves are primarily known for remarkable Buddhist wall paintings, but the library cave also contained a cache of religious texts and secular documents. Among the more than forty thousand manuscripts recovered from the cave was a copy of a one-thousand-year-old Buddhist sutra, now in The Field Museum's collection. This section introduces this important artifact to readers and provides background on the discovery and importance of the Dunhuang cave library and the manuscripts found there.

In chapter 9, "Shadows between Worlds: Chinese Shadow Theater," Mia Yin-xing Liu introduces audiences to some of the theater pieces acquired by Laufer and others. Since early times, performance has been an important aspect of Chinese history and culture. In addition to being a form of entertainment, theater has been a way by which different communities are introduced to stories and ideas that are essential for maintaining, perpetuating, and changing practices and beliefs. Shadow puppetry, or *piying*, is a traditional art form that may date back to the Han Dynasty and is shared by audiences of all ages across China.

Chapter 10, "The Silk Road: Intercontinental Trade and the Tang Empire," by Lin Meicun and Ran Zhang, explores the Silk Road during the Tang Dynasty, which linked China with Japan to the east and the Mediterranean to the west. The Tang Dynasty (AD 618–907) often is considered to be one of the most open and cosmopolitan periods of Chinese history. It was a time of great economic prosperity and artistic florescence, especially at the capital of Chang'an (modern Xi'an). Many Tang tombs include ceramic models of foreigners, such as Central Asian grooms and Bactrian camels, and show foreign influences that flowed along the Silk Road.

Many readers may be familiar with the overland "Silk Road," however, few may know about the "Maritime Silk Routes," which connected China with the Indian Ocean World. Whereas chapter 10 focuses mainly on overland Silk Routes, chapter 11, "The Java Sea Shipwreck and China's Maritime Trade," by Lisa C. Niziolek, introduces readers to early interregional maritime trade involving China, with special attention being paid to the Museum's twelfth- to thirteenth-century Java Sea Shipwreck collection.

In the final highlight section, "Herbs and Artifacts: Trade in Traditional Chinese Medicine," Amanda Respess examines Chinese medicine and trade. Perishable items represent many of the commodities traded into and out of China during the medieval period, and many of these materials were related to medical practices. This section highlights some of the pieces in the Museum's collections related to Chinese medicine and knowledge, including rhinoceros horn and ivory and the containers used in medicinal preparation, storage, and transport.

China has one of the world's longest enduring traditions of civilization, originating in large part during the Qin Dynasty (221–206 BC). In the concluding chapter, "Legacies of Qin Unification: A Hinge Point of Chinese History," Gary M. Feinman reviews some of the important events, beliefs, and practices that led to the unification of China. How was an area as large and as environmentally, culturally, and linguistically diverse as China unified? How has the unification endured, albeit with significant disruptions, until modern times?

With Gratitude

A project of this magnitude would not be possible without the support of many, many people and organizations, including the outside scholars and community members who so generously gave their time and expertise. We are deeply grateful

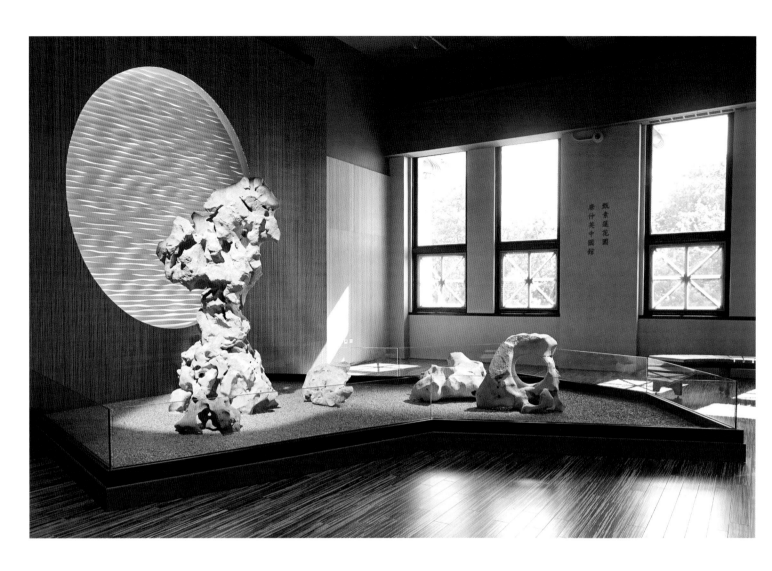

FIGURE 10

View of the Sue Ling Gin Garden, 2015. © The Field Museum. Photo ID No. GN92154_189d. Catalog Nos. 358195, 358197, 358200, 358201, 358202. Photographer Karen Bean.

to the Cyrus Chung Ying Tang Foundation, without the support of which this project would not have been possible; the Elizabeth F. Cheney Foundation and the Henry Luce Foundation for their generous support of this publication; the Efroymson Family Fund and Bank of America for assisting with educational programs related to the exhibition; the William G. McGowan Charitable Fund for helping make the final area of the exhibition, the Sue Ling Gin Garden, one of contemplation and respect; the Suzhou Municipal Government for its generous donation of the spirit stones from Lake Tai that enabled us to create a space that is inspired by traditional Chinese gardens (fig. 10) and United Airlines for flying these treasured pieces from Shanghai to Chicago; and Captain Dave Truitt for enabling us to commission the two ship models in the exhibition that are now part of our collections. We also owe thanks to the E. Rhodes and Leona B. Carpenter Foundation, the Chicago Community Trust, Sue Ling Gin, Holly and John Madigan, and Carol H. Schneider for supporting the development and production of the *Cyrus Tang Hall of China*. We extend our gratitude, too, to the Chinese Consulate General in Chicago for its

support throughout this process. Numerous scholars shared their knowledge with us regarding the Museum's collection and other matters concerning China, and we are thankful for their incredible help and generosity. Finally, we are indebted to Karen Bean, Paola Bucciol, Sarah Crawford, Jillian Mayotte, Susan Neill, Libby Pokel-Hung, Sarah Sargent, Tom Skwerski, Yanxi Wang, and Lu Zhang for their invaluable assistance in the preparation of this volume.

TIMELINE

Note: Exact dates may shift and vary depending on geographic region, current research, and scholars' interpretations.

Paleolithic	1.8 mya–10,000 ya
Neolithic period	c. 8000–1900 BC
Bronze Age	c. 2000–500 BC
Shang Dynasty	c. 1600–1046 BC
Zhou Dynasty:	c. 1046–256 BC
Western Zhou Dynasty	c. 1046–770 BC
Eastern Zhou Dynasty	770–256 BC
Spring and Autumn period	770–475 BC
Warring States period	475–221 BC
Qin Dynasty	221–206 BC
Han Dynasty:	206 BC–AD 220
Western Han Dynasty	206 BC–AD 9
Xin Dynasty (Han interregnum)	AD 9–23
Eastern Han Dynasty	AD 25–220
Six Dynasties:	AD 220–589
Three Kingdoms	AD 220–265
Jin Dynasty	AD 265–420
Northern and Southern Dynasties	AD 386–589

Sixteen Kingdoms	AD 304–438
Sui Dynasty	AD 589–618
Tang Dynasty	AD 618–907
Five Dynasties and Ten Kingdoms	AD 907–979
Liao Dynasty	AD 907–1125
Song Dynasty:	AD 960–1279
Northern Song Dynasty	AD 960–1127
Southern Song Dynasty	AD 1127–1279
Jin Dynasty	AD 1115–1234
Yuan Dynasty	AD 1279–1368
Ming Dynasty	AD 1368–1644
Qing Dynasty	AD 1644–1911
Republican Period	AD 1912–1949
People's Republic of China	AD 1949–present

1

Building the China Collections at The Field Museum

Deborah A. Bekken

The Field Museum is in the fortunate position of being the steward of a remarkable collection of materials from East Asia generally, and China more specifically. Numbering more than twenty-nine thousand objects and specimens, the Chinese collection is diverse in material type, time period, and geographic origin. In addition, the collection documents diverse facets of human activity, ranging from religious artifacts, to humble objects of daily life, to imperial court objects, to finished products such as books, and the tools used to manufacture them, such as printing blocks and carving tools. The collection has been well studied, but there is a great deal more to do, and the questions that researchers will ask in the future have yet to be imagined. As a tool for public education and enjoyment, the collection has provided the material basis for exhibitions continuously since its original acquisition, and there have always been display cases devoted to the archaeology and cultures of East Asia in the halls of The Field Museum. Lending objects for exhibition at other museums further broadens the degree to which the public has access to the collections. But how does a museum build a collection in the first place? And, more specifically, how did The Field Museum build a collection of materials from China?

The World's Columbian Exposition of 1893 and the Early Years of the Museum

Many of the Museum's collections began with the closing of the World's Columbian Exposition in 1893. The Field Museum was in fact incorporated in September of 1893 as the Chicago Columbian Museum in order to be a repository for the materials that had been collected for the fair, and the first fifty thousand artifacts in the collection stem from that time. The Museum was renamed in 1905 as the Field Museum of Natural History in order to honor the $1 million endowment gift of Marshall Field, a retail magnate. As the level of ambition in developing and staging the World's Columbian Exposition had been grand and far reaching, so too was the ambition for a new museum to house the natural wonders from the fair also expansive. Soon after the incorporation of the Museum, additional collections and expeditions were organized in order to study and collect the natural and cultural history of the world, whether botanical, zoological, geological, or anthropological.

Collecting from China, however, began later. Although there is a small selection of Chinese items that date from the fair, it is important to remember that Qing Dynasty China had boycotted the fair due to the renewal of Chinese immigrant exclusion policies through the 1892 enactment of the Geary Act. A previous piece of legislation, the Chinese Exclusion Act, was originally signed into law in 1882, and

FIGURE 11
Chinese pavilion along the Midway Plaisance, Chicago, 1893. © The Field Museum. Photo ID No. GN91733_095d. Photographer C.D. Arnold.

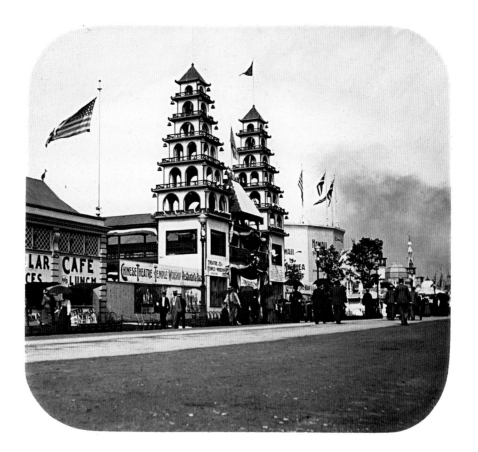

the Geary Act of 1892 provided another ten years of policy support for the exclusion of immigrant laborers based upon their ethnicity. The policy was made permanent in 1902 and was not repealed until 1943. Due to the unfavorable treatment of Chinese immigrants, the Qing Dynasty government boycotted all participation in the fair (Ooi 2009, 57–58). However, cultural exchanges between Chinese and Americans were not completely absent, and the Chinese community already in Chicago was interested in having a presence at the fair. Through the Wah Mee Corporation, organized for this purpose, a pavilion was established on the Midway Plaisance outside the fairgrounds, consisting of a "joss house," or Chinese temple, a theater, and a restaurant (fig. 11). Many visitors to the fair had their first taste of Chinese foods along the Midway that summer.

Despite the position of the United States regarding immigration, diplomatic initiatives between China and the United States did occur. Chinese government officials visited on various occasions to assess the level of industrialization in the West and how it might be brought to China for the benefit of the country. One such visitor was Duan Fang (fig. 12) (see Fan Jeremy Zhang, this volume). Duan Fang (1861–1911) was a scholar-official of the Qing government as well as a connoisseur and collector of Chinese art and antiquities. He came to the United States in 1906 with a delegation studying the political, business, educational, and social institutions present in America and Europe (Pearlstein 2014, 8–9). He was so impressed

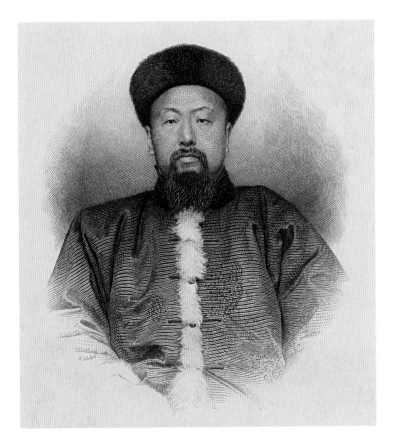

FIGURE 12
Portrait of Duan Fang by William Adolph. Courtesy of the Pennsylvania Academy of the Fine Arts, Philadelphia. Gift of the artist.

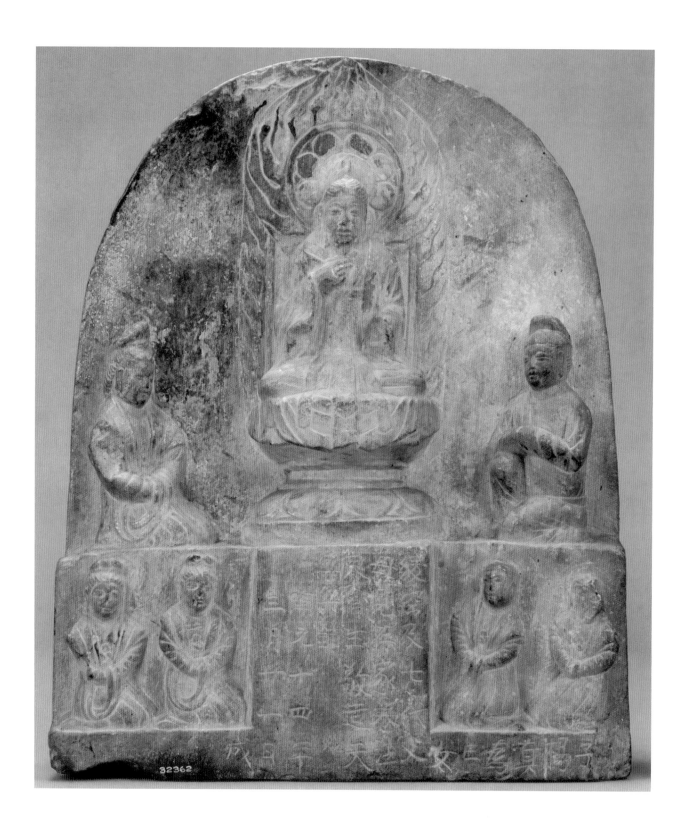

FIGURE 13

FIGURE 13
Daoist stone stele. © The Field Museum.
Catalog No. 32362. Photographer Gedi
Jakovickas.

with the Museum, then barely more than ten years old, that he sent a stone stele from his personal collection as a gift and token of his appreciation (fig. 13). The object, on view in the third gallery, "Shifting Power, Enduring Traditions," is a Daoist stele that dates to AD 726 (catalog no. 32362). It is a memorial made to honor

a deceased daughter, whose father includes in the inscription a wish for blessings for "seven generations of his fathers and mothers, his living family, and all the beings of the world."

Duan Fang was an avid and learned collector in the long tradition of the scholar-official who was not only a working administrator but also a connoisseur of the arts. He assembled a well-known collection of art, artifacts, rubbings, and books during the course of his lifetime. During his stay in Chicago he held a position as viceroy in the Qing administration. After his return to China, he held several other posts during the final, chaotic years of the Qing Dynasty. The Xinhai Revolution, which toppled the Qing government, progressed throughout the fall of 1911, and in November Duan Fang was beheaded in a massacre of ethnic Manchus in Sichuan Province. Neither he nor The Field Museum could have known in 1906 that the Museum would again be a beneficiary of his great connoisseurship; that would not happen until 1960.

Building the Collection through Expeditions

Building a great collection requires attention to detail, a very broad set of research interests, a long view, and a talent for predicting the future value of, and insights to be gained from, the material accoutrements with which we decorate and document the opportunities and challenges of daily life. The Field Museum is enormously fortunate to have had as its first curator for Asian ethnology Dr. Berthold Laufer (1874–1934), an individual definitely equal to the task of assembling a collection that continues to provide both insights and wonders to the researchers who study it and the visitors who learn from and enjoy it.

With a figure such as Berthold Laufer, it is difficult to know where to start (fig. 14). An academic of herculean achievements, Laufer was both brilliant and seemingly inexhaustible. He was born in Cologne in 1874 and studied at both the University of Berlin and the University of Leipzig, receiving his doctorate in 1897 from Leipzig (Bronson 2003, 117). At the university Laufer had concentrated on Asian languages, studying a dizzying list that included Persian, Sanskrit, Malay, Chinese, Japanese, Manchu, Mongolian, and Tibetan, among others (Hummel 1936, 101). Bronson (2003, 117) argues that, although some of these may have involved familiarity rather than fluency, it is also evident that by 1897 he had attained fluency in Chinese, Manchu, and Tibetan, languages representative of areas in which he would concentrate his research activities. Laufer was also proficient in European languages including Russian, French, English, and, of course, German.

Laufer first came to the United States as part of the Jesup North Pacific Expedition (1898–1900) sponsored by the American Museum of Natural History (AMNH) in New York. Later, he also led the Jacob H. Schiff Expedition to China for the AMNH from 1901 through 1904. Laufer joined the staff of the AMNH upon his return from China in 1904, but by 1907 he was ready for another opportunity (Bronson 2003, 119; Hummel 1936, 101). Laufer proposed to George Dorsey, the head

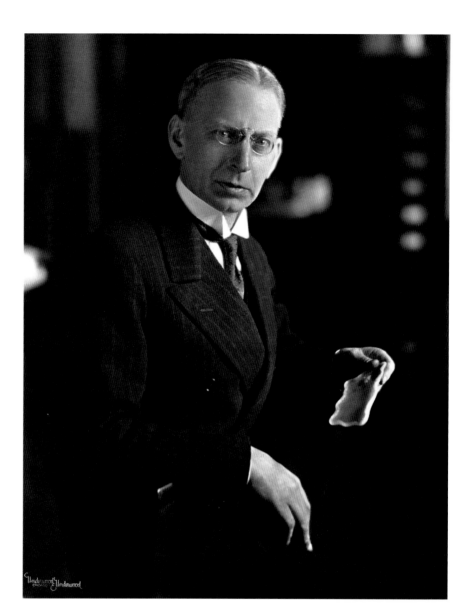

curator of anthropology of The Field Museum, an expedition focused on developing a collection of Tibetan materials. He joined The Field Museum as an assistant curator and immediately set out upon the Blackstone Expedition, funded with a $40,000 donation from Mrs. Timothy B. (Isabella F.) Blackstone, the widow of a Chicago railway executive (Bronson 2003, 119; Pearlstein 2014, 9). Although the expedition was focused on gathering materials from Tibet, Laufer was prevented from reaching the plateau, and Lhasa, first from the Indian side, and later from the Chinese side of the border. He persevered in collecting Tibetan objects from Tibetan areas of northern India and western Sichuan and Gansu Provinces, and he also branched out, assembling a collection of Chinese materials drawn from Beijing, Taiyuan, Xi'an, Chengdu, and points along the way. Laufer was interested in developing a collection that included not only ethnographic materials but also

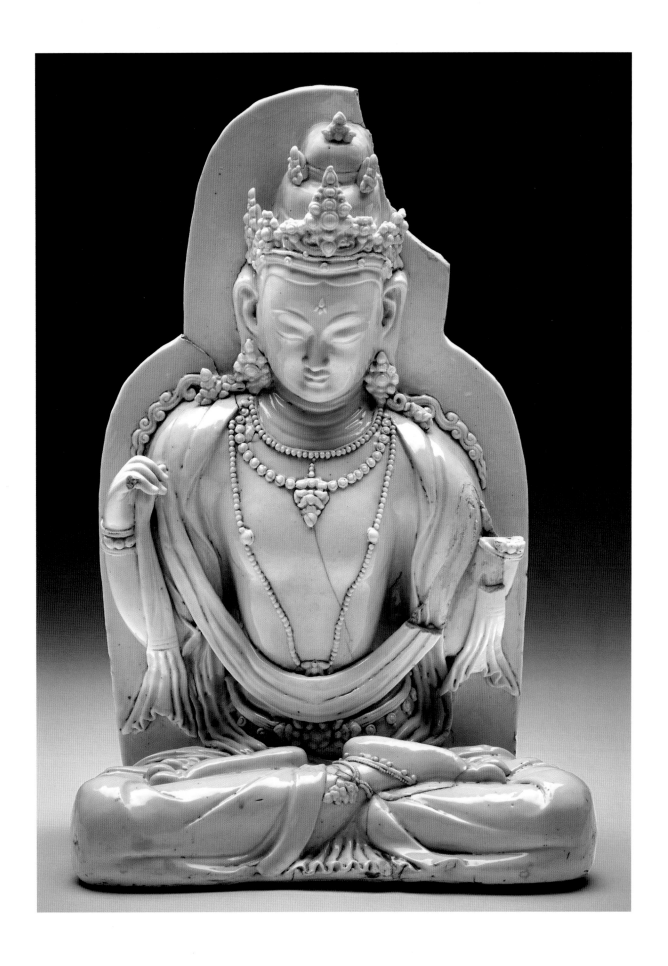

archaeological objects, and his surviving shipping logs document a collection that included theater items, shadow puppets, ceramics, jades, bronzes, stone statuary, textiles, paintings, and books, among other items. Among the materials from the Blackstone Expedition that are on display, a rare and beautiful Yuan Dynasty (c. fourteenth century) porcelain figure of a bodhisattva (fig. 15) in the fourth gallery, "Beliefs and Practices, Symbols and Stories," illustrates the observation that Laufer's judgment was at its best with regard to ceramics (Pearlstein 2014, 10).

Laufer traveled on one other collecting expedition to China, the Captain Marshall Field Expedition of 1923. During that expedition, Laufer concentrated his efforts in larger cities, specifically Beijing and Shanghai, with short trips to adjacent locales such as Hangzhou and Suzhou (Bronson 2003, 122). Although the expedition lasted less than a year, Laufer was still able to assemble an impressive set of materials to send back to Chicago. Although the collection contained many ancient materials, the Captain Marshall Field Expedition focused on more recent items from the Ming (AD 1368–1644) and Qing (AD 1644–1911) Dynasties. Objects on display that were collected in 1923 include rhinoceros horn cups (fig. 16) and Yixing clay tea wares (fig. 17) from the fifth gallery, "Crossing Boundaries, Building Networks," as well as the court hat worn by a scholar-official in the third gallery, "Shifting Power, Enduring Traditions" (fig. 18).

FIGURE 16
Rhinoceros horn cup, Qing Dynasty (AD 1644–1911). © The Field Museum. Photo ID No. A114613_010d. Catalog No. 110655. Photographer John Weinstein.

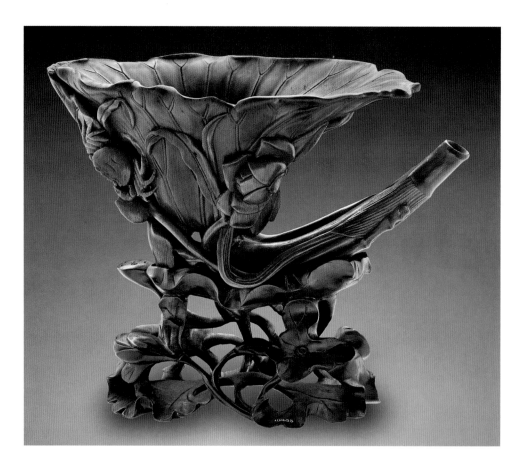

CHAPTER ONE

Many scholars have noted that Laufer's perspective regarding Chinese history and culture was very positive. This stood in contrast to the prevailing attitudes of the general population at that time (Bronson 2003, 118, 123; Latourette 1936, 46; Pearlstein 2014, 10). Laufer professed a deep admiration for China, the Chinese people, and the long traditions of culture and scholarship among the educated elites. Laufer also stressed the importance of mutual understanding and promoted the study of East Asia. The Field Museum archive contains many examples of letters written by Laufer that include admiring statements illustrating his thoughts. As just one example, in response to a letter from President Benjamin Wheeler of the University of California at Berkeley requesting advice on candidates for the Agassiz Chair of Chinese Language and Literature, Laufer responds by providing the names of several candidates. In addition he states that

> if I am allowed to give expression to my personal opinion, I should venture to say that my ideal of the incumbent of such a chair would be a man who, broad-minded and large-hearted, imbued with a sincere sympathy for the people of the Orient and a deep insight into their cultural achievements, could prove a fresh and living inspiration to the student and a stimulus to advance him not only in mere knowledge but also in culture of mind. It seems to me that our relations with the East are increasing from year to year on a moral and intellectual basis, and that it becomes our foremost duty to bring to the hearts of our fellow men the ideals and aspirations of the East in thought, religion and art as a living organism. We are living in an era of Pacific developments

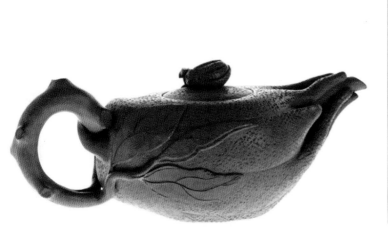

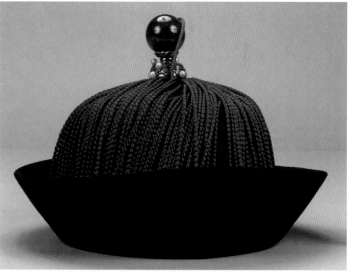

FIGURE 17
Yixing clay teapot in the shape of a buddha's hand citron (nineteenth–twentieth century). © The Field Museum. Catalog No. 127120. Photographer Gedi Jakovickas.

FIGURE 18
Court hat worn by a scholar-official, Qing Dynasty (AD 1644–1911). © The Field Museum. Catalog No. 125911. Photographer Gedi Jakovickas.

and therefore require a profounder understanding for the spirit of the East and the mutual ties binding us with the Orient. (Letter dated May 17, 1912)

Laufer remained at The Field Museum throughout his subsequent career. During this time, he produced a remarkable body of research numbering more than 450 publications. In addition, he was responsible for exhibition halls devoted to East and Southeast Asia, the reinstallation of all the anthropology exhibition space during the move from the old Jackson Park location to the Museum's current building during the 1920s, and the administration of the entire Anthropology Department in his later years. Laufer's death by suicide, precipitated by a diagnosis of cancer, shocked the community of East Asian scholars. Tributes by colleagues illustrate the impact of Laufer's research productivity and the general esteem in which he was held (Hummel 1936; Latourette 1936). Bronson (2003, 124) makes the important point that Laufer did more in his exhibition layout and label writing than any other museum curator at that time in attempting to reflect the views and perspectives of the people who had originally made the artifacts, an extraordinarily foresighted perspective that set the tone for future Field Museum efforts regarding China and East Asia.

Building upon Laufer's Achievements

Dr. C. Martin Wilbur (fig. 19) was appointed curator for Sinology (Chinese archaeology and ethnology) in 1936, two years after the death of Berthold Laufer (Nash and Feinman 2003b, 260, app. 1). His tenure at the Museum coincided with World War II, and he spent much of his time not at The Field Museum but rather in China working for the U.S. State Department. Although Wilbur (1908–97) did not undertake extensive collection-building activities, he did preside over several significant acquisitions, including the very first artifacts seen in the exhibition. The two stone guardian lions at the entrance to the *Cyrus Tang Hall of China* were acquired during Wilbur's tenure as a donation from Grace Studebaker Fish (fig. 20). Mrs. Fish was the daughter of John M. Studebaker, of Studebaker automobile fame. Around 1940, Mrs. Fish offered to donate the lions to the Museum in honor of her late father, stating that

> I have them in front of my son's house in South Bend [Indiana] where they of course do not belong. My father was an old friend of Mr. Marshall Field and I should like very much to present them to the Field Museum. I have been living in New York for the past twenty years and this December I am spending in South Bend. This house is closed most of the time and I feel these dogs [editorial note: she refers to the figures earlier in her letter as "Ming Chinese stone dogs" rather than as guardian lions] should be placed in a museum. I will motor to Chicago and tell you more about them if you can please place them there. (Accession record no. 2248)

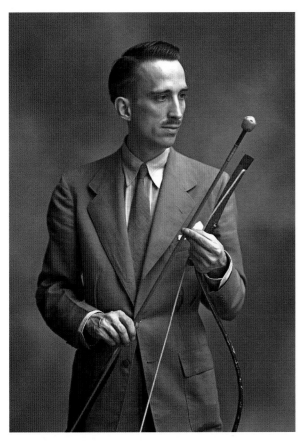

FIGURE 19
Curator C. Martin Wilbur (1908–97), July 16, 1940. © The Field Museum.
Photo ID No. A88751.

FIGURE 20
Stone guardian lions at the entrance to the *Cyrus Tang Hall of China*. © The
Field Museum. Photo ID No. GN92154_002d. Catalog Nos. 127916, 127917.
Photographer Karen Bean.

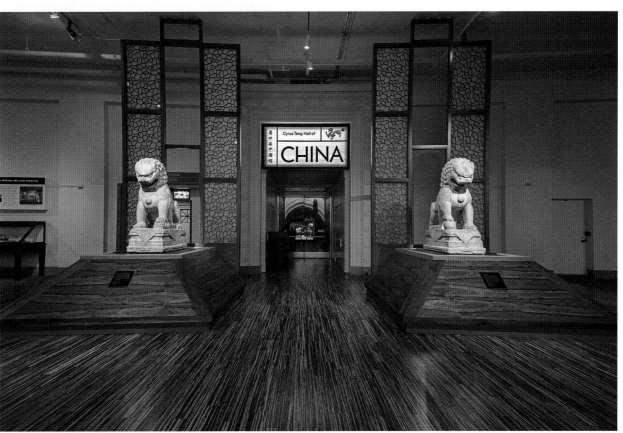

It becomes clear from the correspondence that there was a dispute over the monetary value of the lions, and Wilbur found this aspect of the negotiations to be unpleasant and even painful, a perspective that he shares with the Museum's director, Clifford C. Gregg, in part of a letter dated May 15, 1942 (accession record number 2248):

> There is no question about the Field Museum's valuing the two Chinese stone lions, for we have exhibited them prominently and given them wide publicity.
>
> As to the valuation of them carried in our Departmental records, Mrs. Fish perhaps does not understand the principle underlying our book evaluations, and this might be explained. Since we are a scientific institution rather than an art museum, we acquire most of our collections in all departments by means of expeditions and field collection. Valuations are determined by actual cost, even though some of the specimens may be very rare, and might bring more if we were to sell them. (Incidentally, for $10,000 we could have an expedition to China and purchase many items of far greater scientific and exhibition value than the two lions: I believe the Marshall Field Expedition to China was only four times as much as Mrs. Fish Evaluation of her two lions!) [Editorial note: This was in fact the budget for the Blackstone Expedition of 1908–10.]
>
> When we receive a gift and must evaluate it for our own records we follow the same principle so we may have a single standard for all parts of the collections. Thus, with our Chinese jade, we record that the various items actually cost the Museum or the donor when and if we know. Many of the specimens are "worth" much more than they cost, and some are worth less. I'm evaluating cost to Mrs. Fish, or an estimate of what the pair could have cost the Museum had we secured them in China. It is not a reflection on the lions that we do not enter the sort of fictitious valuation that dealers in America place on Chinese works of art.

The depth of Wilbur's frustration over assigning a valuation, a common dilemma for any museum receiving an artifact donation, is listed in a short postscript, in which he confides that he would be ready to return the lions if necessary. Luckily, the lions remained at the Museum, where they were on view for many years (fig. 21). They were taken off display sometime after 1985, after which time they were held in oversized storage. During the planning for the *Cyrus Tang Hall of China*, the paired lions were among the first artifacts to be selected for display in the new exhibition. Extensive conservation and cleaning was required before the lions were ready to be installed as the iconic "attractor" for the exhibition.

In addition, the Dunhuang manuscript (see Zhou, this volume, highlight 6) was acquired during Wilbur's tenure. A Buddhist sutra (catalog no. 233000), it was acquired in 1941 from Mr. Samuel E. Wilson, a dealer based in Chicago, but it is thought that the manuscript was purchased in Beijing in 1926 (accession record no. 2271). The manuscript is one of several examples that exist written by the scribe

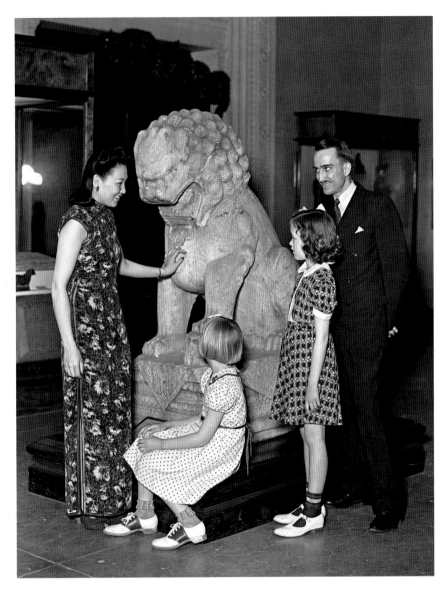

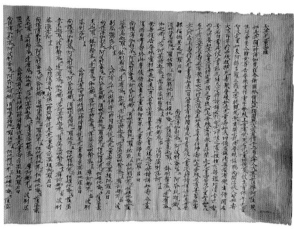

Zhang Luemozang 張略沒藏 in the late eighth or ninth century. Originally authenticated by both Wang Chungmin and A. W. Hummel of the Library of Congress, it was also examined more recently by Li Wenjie of the National Library of China and Yuan Zhou of the University of Chicago. Although the team that developed the exhibition was very interested in displaying this artifact, it was eventually decided that it was too fragile to be exposed to light for such a long period of time. The manuscript fits into a core exhibition theme of the importance of writing, and the use of writing as a form of devotional practice, as well as the remarkable story of the manuscript's preservation (fig. 22).

Wilbur was clearly pleased to have been appointed as a curator at the Museum, but he writes that the curatorial life did not suit him well. He seems to have enjoyed academic research, and he writes warmly of his efforts to develop a new

exhibition of jades willed to the Museum by Mrs. George T. Smith in 1936. He also describes efforts to develop a small exhibition, or exhibition element, directed specifically for children. This featured two figures of a Chinese boy and girl, about twelve years old, dressed in characteristic clothing of the time and carrying representative schoolbooks, all sent over from Tongzhou by a colleague (Wilbur 1996, 43). Wilbur felt himself unsuitable, however, for the more social aspects of curatorial life, such as participation in friends' groups through which the Museum seeks to build relationships with interested individuals and groups, not only for the benefit of additional learning, but also to promote the Museum as a worthy recipient of donor funding. Wilbur had inherited leadership of the "Friends of China" group that had been organized by Laufer, but he felt that he was "not much good at cultivating wealthy Chicagoans. Mr. Kelley at the Chicago Art Institute was far better connected and more skillful than I at that sort of thing" (Wilbur 1996, 43). Wilbur left the Museum for war work through the State Department in 1943 (Wilbur 1996, 54), and, although he remained nominally on the curatorial staff of the Museum during the war years, he did not return to Chicago after 1943, eventually taking a position at Columbia University in 1947.

Postwar Developments

After the disruptions caused by the war effort, it seems to have taken the Museum some time to mount a search for a new curator for East Asian anthropology. In 1953, the Museum hired Dr. M. Kenneth Starr (1922–2011) (fig. 23) as curator for Asiatic archaeology and ethnology (Nash and Feinman 2003b, 260, app. 1). Throughout his tenure he was most closely associated with his interest in the Museum's collection of rubbings.

The Field Museum maintains one of the largest collections of Chinese rubbings outside China. Also known as ink squeezes, rubbings are ink-on-paper impressions of everything from stone inscriptions, their primary use, to stone-inscribed artworks and even three-dimensional objects, such as bronze vessels. The collection was assembled primarily through the activities of Berthold Laufer, and it even includes rubbings collected by Laufer for the American Museum of Natural History prior to 1904. These were sent to join him at The Field Museum after he had left New York for Chicago. The rubbings collection was subsequently augmented through additions made by Kenneth Starr, who had an intense interest in rubbings and all aspects of their production, collection, and appreciation (Starr 2008). During his tenure, the David C. Graham collection of Han-period rubbings from Sichuan was added to the Museum's holdings (fig. 24). In 1960, Starr also acquired a remarkable set of eleven rubbings, all mounted in albums, from the collector Professor Li Zongtong of National Taiwan University. Principle among this collection is one of the Museum's most valuable artifacts, a Song Dynasty volume, *You Si's Fifty-Second Rubbing of the Lanting Xu*, on display in the third gallery, "Shifting Power, Enduring Traditions" (fig. 25) (Bekken et al. 2015).

FIGURE 23
Curator M. Kenneth Starr (1922–2011), October 15, 1964. © The Field Museum. Photo ID No. A99894.

FIGURE 24
Exhibition of Chinese rubbings presented to the Museum by Dr. David C. Graham. *From left to right:* M. Kenneth Starr, Professor Edward A. Kracke, Mrs. John Kracke, and Miss Lucy Driscoll at exhibition viewing, December 10, 1957. © The Field Museum. Photo ID No. A96248.

FIGURE 25
You Si's Fifty-Second Rubbing of the Lanting Xu, Song Dynasty (c. 1140–1278). © The Field Museum. Photo ID No. A114800d_05A. Catalog No. 233914. Photographer John Weinstein.

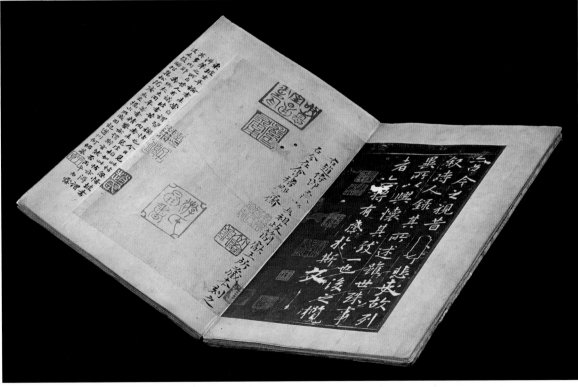

The particulars of the connection between Li Zongtong (1895–1974) and Starr are mysterious though. Li Zongtong, a grandson of the high-ranking Qing Dynasty official Li Hongzao, was an eminent historian, having taught both at Peking University and, after 1949, at National Taiwan University. He also was an avid collector of both books and rubbings. It is unclear exactly how Starr became aware of Li Zongtong's willingness or desire to sell items from his collection. Despite an extensive set of archives, not only in the Museum's library but also in its anthropology collections, we do not have written correspondence between the two. Starr left The Field Museum in 1970 to become the director of the Milwaukee Public Museum, but the archival collections there do not record any correspondence with Li Zongtong either (Claudia Jacobson, personal communication). We can speculate that Starr may have met Li Zongtong through his close friendship with Professor Tsuen-Hsuin Tsien (1910–2015), curator of the Far Eastern Library (now East Asian collection) of the University of Chicago (Bennet Bronson, personal communication). Starr also traveled in Taiwan in 1960, and perhaps he met Li Zongtong during his travels (Nash and Feinman, 2003b, 296, app. 4). In addition, Dr. Hoshien Tchen, consultant on East Asian collections at the Museum from the 1950s through the 1970s, indicates in his preface to the *Catalogue of Chinese Rubbings from Field Museum* (Tchen 1981, xvii) that he recommended the purchase of the *Lanting Xu*, and he goes on to describe its rarity and value. Museum records indicate that the purchase of the rubbings was made through funds that were dedicated at that time for anthropology acquisitions (accession no. 2720) (Bekken et al. 2015).

The *Lanting Xu* and other rubbings in the Li Zongtong collection have been exhibited periodically over the years they have been at The Field Museum. Most recently, the *Lanting Xu* was part of the exhibition *Lasting Impressions: Chinese Rubbings from The Field Museum* (February 12, 2010, through January 3, 2011). In addition, the *Lanting Xu* was exhibited for a short period of time as part of the *Cyrus Tang Hall of China* exhibition and was replaced by a facsimile in order to prevent deterioration.

Among the other volumes in this remarkable collection are several that were once in the collection of Duan Fang. Although we do not know how Li Zongtong built his collection, it is known that after Duan Fang's death, his descendants sold parts of his collection, most famously a set of early Western Zhou–era (c. 1046–770 BC) bronzes to the Metropolitan Museum of Art in New York. An example of a work collected by Duan Fang is a rubbing of an inscription from Langya Mountain, written in small seal script by Qin Chancellor and calligrapher Li Si (c. 280–208 BC) in commemoration of the deeds and proclamations of the First Emperor, Qin Shihuangdi. By the same calligrapher, it is a companion piece to the Mount Yi rubbing on display in the second gallery, "Ritual and Power, War and Unification," in the case devoted to the short-lived, but influential, Qin Dynasty (221–206 BC) (Walravens 1981, 15–16) (see Feinman et al., this volume).

The rubbings collection continues to excite the interest of historians and connoisseurs. The National Library of China has entered into a collaborative

agreement with the Museum to publish a complete facsimile of the *Lanting Xu*, making the work available to an audience of connoisseurs and scholars who will understand and appreciate its value, rarity, and beauty.

Modern Developments

In 1971, Dr. Bennet Bronson was appointed curator for Asian archaeology and ethnology (fig. 26). During his tenure, Bronson would oversee several major acquisitions. He would also contribute a leading voice to changing understandings of how museums acquire, steward, document, and develop the collections under their care.

A large selection of artifacts in the fifth gallery, "Crossing Boundaries, Building Networks," comes from the Museum's collection of materials recovered from the Java Sea Shipwreck, primarily consisting of twelfth- to thirteenth-century trade porcelains and iron (see Niziolek, this volume). Discovered by fishermen in the Java Sea in Indonesia, the site was looted for some period of time prior to the involvement of the Indonesian government regarding access to the site. Government involvement, however, did not immediately lead to the site's protection. The site was assigned to a salvage company that retrieved materials off the bottom of the seafloor, but it seems there was no attempt to map the site or conduct controlled underwater excavations. Subsequently, the Indonesian authorities assigned the site to another salvage company, Pacific Sea Resources, which had on board archaeologist Dr. Michael Flecker, who oversaw the archaeological recovery. During the subsequent excavation of the site, it was mapped for the first time, and the artifacts were treated as collective archaeological materials with provenience or site context information, rather than as random individual items (Mathers and

Flecker 1997). The arrangement with Pacific Sea Resources was a modern form of partage agreement, with one-half of the finds being delivered to the Indonesian government, and one-half of the finds to be donated to a museum. Pacific Sea Resources contacted Bronson to see if The Field Museum might be interested, and the materials from the excavation were donated to the Museum in 1998–99.

The ship and its cargo fit well into Bronson's long-standing interests in ancient trade and technology, including long-distance maritime trade (Bronson and Wisseman 1976; Rostoker and Bronson 1990). It is estimated that the Museum collection contains 5 percent of the original cargo, but even at 5 percent, this amounts to more than seven thousand individual ceramic artifacts (fig. 27), and other items

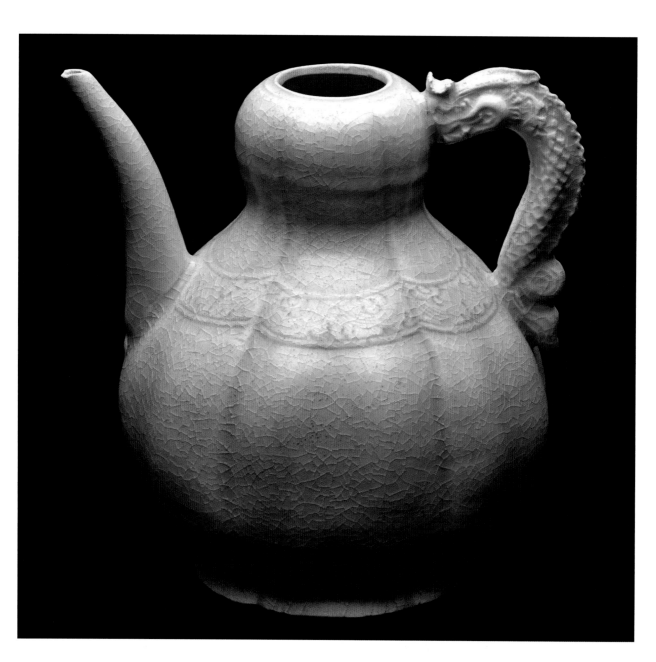

including iron, resin, ivory, and objects that might have been the personal possessions of the crew. Because the site was eventually mapped and excavated in an organized fashion, it is possible to determine the overall shape and size of the ship's hull, the diversity of the cargo and where it was stored on the ship, and, by extension, the potential ports of call and markets for the goods being transported (Mathers and Flecker 1997). It is a remarkable collection, filling out a picture of maritime trade that is illustrated by only a few other examples, such as the Breaker Shoal Wreck and the Investigator Shoal Wreck.

Among the many changes in the practice of museum anthropology over the course of the twentieth century, none has perhaps had as much impact as the vastly changed attitudes on the part of museums and curators to the ethics of collecting (Haas 2003; Nash and Feinman 2003a). Museums have moved from a position of valuing the primacy of the object, almost regardless of its archaeological context and provenance, to a position of far greater scrutiny regarding both the provenience and provenance history of new acquisitions, especially if they are acquisitions of antiquities. Bronson was deeply involved in the effort to advocate for the protection of antiquities and to make changes to policy at The Field Museum.

In 1970, the United Nations Educational, Scientific, and Cultural Organization (UNESCO) published a set of guidelines on the protection of antiquities. Known as the 1970 Convention, or the Convention on the Means of Prohibiting and Preventing the Illicit Import, Export, and Transfer of Ownership of Cultural Property, the agreement recognized the damage done not only to archaeological sites but also to nations and their cultures by the removal of cultural property such as antiquities. Although the United States did not implement the convention until 1982, The Field Museum enacted new policies regarding the acquisition of antiquities by 1972, followed soon after by more inclusive policy statements also covering accessions and deaccessions (1975) and loans of the collection (1976). Nash and Feinman (2003a, 252) point to the change in the perception on the part of museums and curatorial faculties of care for collections as a question of ownership versus stewardship. Certainly The Field Museum, like many other museums, today sees its role as a steward of collections for their care and safety, safeguarding tangible examples of global heritage for current and future research, discovery, and education.

On a practical level, a desire to focus on stewardship rather than simply on ownership also requires a museum to be thorough and detailed in documenting the collection in its care. In this regard, the record is mixed. Not surprisingly, the level of documentation is variable in any large collection, including that of The Field Museum. The painting *Along the River during the Qingming Festival* is a case in point (fig. 28). The painting was purchased in Beijing by George Dorsey in 1911, and a subsequent donation was made by the Tuesday Art and Travel Club to support its acquisition. In the Museum's annual report for 1912, the director writes that this painting was "one of the most significant acquisitions of the year" (Skiff 1913, 198). Presented along with it was another painting, *100 Children at Play*, covering a popular subject—children engaged in fun and games. Both were put on display

upon their acquisition; however, there is a letter from the Museum's director to the club from years later, in 1932, which indicates that at least some members of the club were unhappy that the paintings were no longer exhibited at that time. Today, *Along the River during the Qingming Festival* is on view in the third gallery, "Shifting Power, Enduring Traditions." Beyond brief notes in reports and letters, and an evaluation of the painting itself, we have few clues to its history (see Freeman and Paine, this volume; Lu Zhang, this volume). Clearly the painting was on

FIGURE 28
Museum staff examining the handscroll painting *Along the River during the Qingming Festival* (late sixteenth–early seventeenth century). © The Field Museum. Catalog No. 33723.

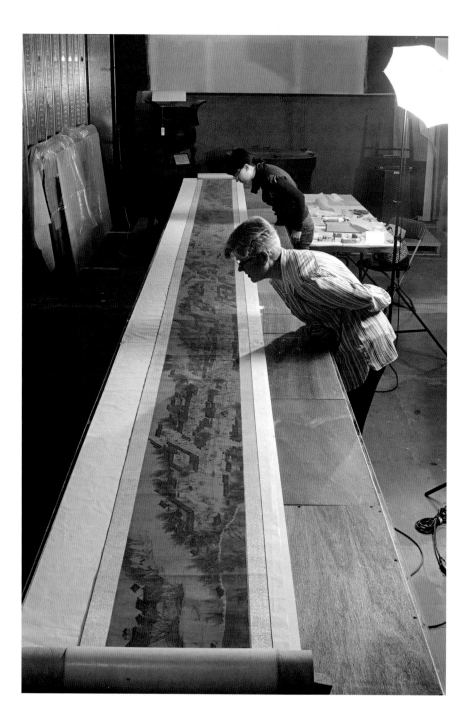

view previously at the Museum, and there is a neat row of pin marks along the top and bottom edge that show where the painting was pinned flat to a backdrop for display. Unfortunately, despite extensive record keeping throughout the years, there is no additional record of the history of this handscroll providing detailed information regarding its acquisition and study, a situation that would be considered poor collection management in the museum environment today.

In contrast to *Along the River during the Qingming Festival*, there is abundant and detailed documentation for the embroideries and textiles that constitute the Schuster collection (fig. 29). Anthropologist Carl Schuster (1904–69) was interested

FIGURE 29
Embroidery depicting wedding procession (nineteenth–twentieth century).
© The Field Museum. Catalog No. 234227.
Photographer Gedi Jakovickas.

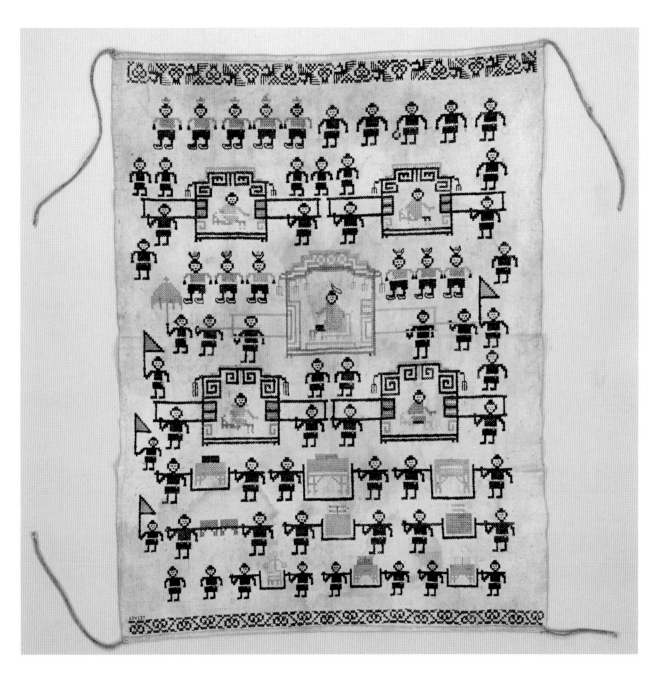

in the symbolism of the motifs being embroidered onto textiles, and he was acutely aware of the changing fashions of the day, such that he declared in 1936 that the traditional folk embroideries of western and southwestern China were a dying art (Schuster 1936, 21–24). Schuster devoted his academic career to the study of folk motifs and their symbolism, amassing a large collection in the course of sustained fieldwork throughout the 1930s. In 1960, Schuster agreed to let The Field Museum acquire his collection of 1,175 items (accession no. 2724). All items were originally collected between 1932 and 1938. Schuster had carefully labeled each embroidery or garment with the acquisition location, in Chinese characters, and he also kept field notebooks in which he recorded the date of collection for each piece. When the collection came to the Museum, Schuster also sent along all of his field notebooks to ensure that the data for each piece followed it to the Museum. Once it was here in Chicago, departmental staff constructed a list of geographic locations that included, in addition to the Chinese characters recorded by Schuster, Wade-Giles Romanization for all place-names. Fully cataloged, the collection is an important record of the folk traditions, design motifs, and textile arts of south and west China during the late nineteenth and early twentieth centuries. Its size offers researchers the ability to compare many examples, a rare opportunity within museum collections.

FIGURE 30
Curator Gary M. Feinman, February 8, 2002. © The Field Museum. Photo ID No. GN90395_27d. Photographer John Weinstein.

The collection from China continues to grow, and modern efforts to augment the collection have been led in the 2000s by curators Dr. Anne P. Underhill (fig. 26) and Dr. Gary M. Feinman (fig. 30). Researchers continue to make study visits to the collections, and requests for loans for exhibitions at other museums are ongoing. As the Museum enters the twenty-first century, it is as evident as ever that objects have many stories to tell. It is still the ambition of The Field Museum to steward, develop, and investigate the collections from China for the benefit of scholarship, appreciation, and public learning.

Note

I gratefully acknowledge the many colleagues who have contributed to the *Cyrus Tang Hall of China* project, whether here at The Field Museum or from around the globe. Specifically, I wish to acknowledge Elinor Pearlstein, Bennet Bronson, Theodore Foss, Fan Jeremy Zhang, and Yuan Zhou; Claudia Jacobson provided invaluable research from the archives of the Milwaukee Public Museum. My sincere thanks also to Gary Feinman, Lisa Niziolek, Lu Zhang, and Tom Skwerski.

Diverse Landscapes, Diverse Ways of Life

Domestication and the Origins of Agriculture in China

Gary W. Crawford

Introduction

Agriculture is usually depicted as crop production and raising animals on farms. Certainly, the modern Chinese economy is supported by the production of hundreds of crops, including annual herbaceous plants (upland and wetland) and arboreal crops (peach, apricot, persimmon, and others) as well as by raising water buffalo, cattle, sheep, goats, chickens, geese, and fish, among other animals. Production styles today range from agrobusinesses to family-level subsistence farming. How the systems developed is a complex story beginning more than ten thousand years ago. In reality, agriculture is a form of human behavior in which people create highly productive ecosystems by involving themselves in every phase of the life span of certain plants or animals (Rindos 1984). In most cases, these plants and animals are transformed so that their evolutionary success is determined by the nature of their dependence on people and vice versa. Investigating early agriculture thus involves interdisciplinary archaeological research that includes settlement studies (how are archaeological sites organized on the landscape?),

materials analysis (what types of tools did people use and for what purposes?), ancient ecology (to what extent were habitats created and managed by people?), interaction of people with plants and animals (were plant or animal populations evolving codependences with people and, if so, how?), and the contexts in which these factors were set (what were the influences of climate, resource availability, demography, regional interaction, and so on?). China provides a wealth of data due to its rich archaeological record found in zones ranging from tropical to temperate and wet through dry, as well as its diverse agricultural traditions (such as wet rice, rain-fed millet, and pastoralism). The following discussion emphasizes the early human ecology, plant management, and, to some extent, animal management that led to the traditions that we know today and expands upon some of the stories presented in the first gallery of the *Cyrus Tang Hall of China*, "Diverse Landscapes, Diverse Ways of Life."

FIGURE 31

Map of key Upper Paleolithic and Neolithic sites mentioned in the text. © The Field Museum. Illustrator Lori Walsh.

Farming 5000–2000 BC

Research on early agriculture in North China and the Yangtze basin of south central China is better known than the more tropical South China region, where

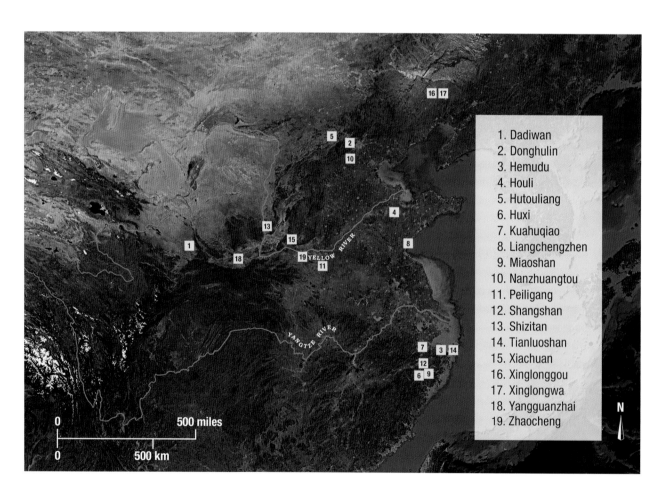

1. Dadiwan
2. Donghulin
3. Hemudu
4. Houli
5. Hutouliang
6. Huxi
7. Kuahuqiao
8. Liangchengzhen
9. Miaoshan
10. Nanzhuangtou
11. Peiligang
12. Shangshan
13. Shizitan
14. Tianluoshan
15. Xiachuan
16. Xinglonggou
17. Xinglongwa
18. Yangguanzhai
19. Zhaocheng

500 miles

500 km

research is still in its infancy (Zhao 2011). The archaeological record of relatively mature ancient agriculture in China informs our understanding of developments in these regions. We have detailed archaeological information for the Middle Neolithic Yangshao (c. 5000–3000 BC) and Late Neolithic Longshan (c. 2600–1900 BC) periods in the Yellow River basin, for example. The Yangshao was a mainly egalitarian society (Peterson and Shelach 2012) or set of societies with a material culture shared over much of the Yellow River basin. Yangshao subsistence was mixed hunting, gathering, and substantial farming. At the Yangguanzhai site (c. 3500–2700 BC) (fig. 31), for example, detailed analysis of plant remains indicates that the main crops were foxtail millet (*Setaria italica* subsp. *italica*) and broomcorn millet (*Panicum miliaceum*) (fig. 32), with foxtail millet grain accounting for about double the number of grains of broomcorn millet (Zhong 2016). A short distance to the east in the Yiluo River valley, an Early Neolithic through Bronze Age sequence of plant remains also indicates that foxtail millet was more common than broomcorn millet in the central Yellow River region; rice was present in some late Yangshao sites such as Zhaocheng (Lee et al. 2007). Late in the sequence evidence suggests that agriculture may have developed some specialization related to community size and sociopolitical function (Lee et al. 2007). That is, some crops may have been grown

FIGURE 32
Broomcorn millet (*Panicum miliaceum*).
© Jinfeng Zhang | Dreamstime.com.

at some communities and not at others due to local sociopolitical or ecological constraints.

Longshan communities were increasingly variable in size, characterized by a hierarchy of many small farming villages, intermediate-size, multipurpose towns, and a smaller number of large, walled economic and political centers (see Feinman et al., this volume) (fig. 33). They were supported by an agricultural economy and enmeshed in a broadly based political sphere. The Liangchengzhen site (2400–1800 BC) is an example of one of these mature agricultural systems that was based primarily on rain-fed millet agriculture that included rice (*Oryza sativa*) production to some extent (Crawford et al. 2005). By sampling sediments recovered from a range of contexts at the site (e.g., pits, ditches, refuse layers, and house floors) the remains of resources and ecological indicators can be recovered. Millets (mainly foxtail, but a little broomcorn or common millet) and rice were the main grains grown here. A few other plants of modern economic significance also appear in the record. These include soybean (*Glycine max* subsp. *max*), adzuki bean (*Vigna angularis*), and perilla (*Perilla frutescens*). The diverse assemblage of wild plants includes an array of grasses, other herbaceous plants that grow today in open sunlit (disturbed) habitats, and a few nuts and berries from woody plants, for example, acorn and grape, that are productive both along

FIGURE 33

Diorama of a Late Neolithic-period settlement in Gallery 1 of the *Cyrus Tang Hall of China*. © The Field Museum. Photo ID No. GN92128_008d. Photographer Karen Bean.

woodland edges and in open areas. Two of the grasses at Liangchengzhen belong to the same genera as foxtail and broomcorn millet, so the crops and their wild relatives probably continued to thrive together even thousands of years after their original domestication.

Other plants such as goosefoot (*Chenopodium* sp.) and *Senna nomame* (syn. *Cassia nomame*), an arboreal legume, were of significant economic importance and potentially managed or grown along with the aforementioned grains due to their relative abundance and in clusters in particular contexts. The seeds of a few wetland plants are evidence of nearby habitats in which rice could have thrived. The economy seems relatively local, given that we do not see much evidence of resources that would have been obtained from far away and sold, or bartered, at markets. A few grains of wheat (*Triticum aestivum*) (fig. 34) are found at archaeological sites dating to this period, and Liangchengzhen is no exception. The wheat is a small form of bread wheat, possibly related to an early compact variety identified in the early archeological record in Pakistan (Costantini 1979). The local residents probably considered wheat to be a relatively special plant whose source was unknown to them. Wheat, being a native of Southwest Asia, probably trickled into China by informal, down-the-line exchange from regions to the west by some yet-unknown route.

The relationship between people and domesticated animals in China, particularly dogs, cattle, sheep/goats, pigs, and chickens, is complex and still coming into focus. Probably the first domesticated animal is the dog, most likely raised as

FIGURE 34
Wheat (*Triticum aestivum*). © The Field Museum. Photo ID No. GN92035_040d. Photographer Karen Bean.

hunting dogs and possibly for food too. The oldest dog finds date to about 10,000 BC at Nanzhuangtou. So far, though, there is no evidence that dogs were initially domesticated in China, because older remains are from Siberia and Europe (Larson et al. 2012). Sheep (and goats?) have a long history in Central Asia but do not appear in any abundance until between 2500 and 2000 BC in central and eastern China (Jing 2008). Domesticated cattle in China have strong genetic ties to Southwest Asian cattle, the earliest being taurine cattle (*Bos taurus*) (Cai et al. 2014). Research on ancient DNA (aDNA) from cattle bones dating from 2500–300 BC indicates that domesticated cattle were introduced to the Central Plains of China during this period and that zebu cattle (*Bos indicus*) arrived c. 1500 BC (Cai et al. 2014). The wild auroch (*Bos primigenius*), ancestral to domesticated cattle, lived in North China, where its earliest record dates to c. 7500 BC (Cai et al. 2014). The origin of East Asian domesticated cattle is complex, with local populations contributing to the gene pool introduced from Southwest Asia. Ancient DNA analysis points to the pig (*Sus scrofa*) having been domesticated at least once (in North China) and possibly twice (the second being in the Yangtze River valley) in China (Larson et al. 2010) (fig. 35). Modern Chinese pigs are descendants of the first domesticated pigs in China (Larson et al. 2010). The earliest pigs date to the Early Neolithic at sites such as Xinglongwa and Kuahuqiao. The domesticated pig, identified based on phenotypic divergence, is dated to 6600 BC at Jiahu (Cucchi et al. 2011). Finally, chicken bones recovered from the Nanzhuangtou site suggest that this bird was in North China and being exploited by about 8000 BC; however, chicken bone identifications reported from North China (Xiang et al. 2014) are being called into question (Eda et al. 2016). Apparently some animal species such as the dog had been introduced to China by the end of the Pleistocene, and the pig and possibly the chicken were domesticated relatively early in China, while cattle have a complex history involving interbreeding with cattle introduced to the region.

An agricultural system distinct from that found in North China is found about 1,000 kilometers from the Yellow River basin in the Ningshao Plain immediately to the south of Hangzhou Bay. It was centered on wetland resources, particularly rice. Other wetland resources that are common in the Chinese economy today such as foxnut (*Euryale ferox*) and water chestnut (*Trapa natans*) were also important (Fuller et al. 2011; Pan 2011). Bottle gourd (*Lagenaria siceraria*) appears to have been grown too. The Hemudu culture was supported by just such a system. A thick layer of rice remains was found at the Hemudu site in the 1970s (Zhejiang Provincial Museum 1978). Excavations here documented for the first time that early communities in the region had relatively sophisticated architecture, technology, and a varied subsistence base that included rice production. Since the completion of the Hemudu excavation, another site belonging to the same culture, the Tianluoshan site, has been and is still being investigated (Sun et al. 2007) (fig. 36). The new research supports the conclusion of the existence of a diverse resource base that included rice production (fig. 37) and possibly the management of peaches, foxnuts, and water

FIGURE 35
Wild boar skull (*Sus scrofa cristatus*).
© The Field Museum. Catalog No. 25705.
Photographer Gedi Jakovickas.

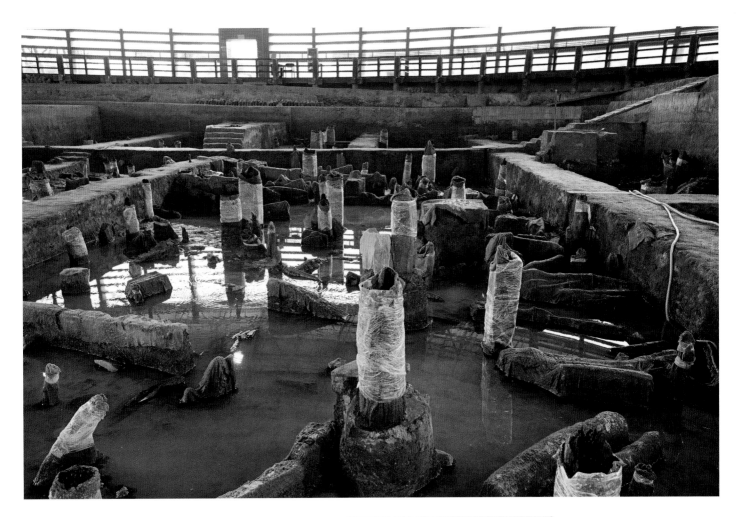

FIGURE 36
The Tianluoshan excavation.
The site lies below the water table,
thus preserving the lower portions
of the wooden posts and walls.
Image courtesy of Gary Crawford.

FIGURE 37
Rice from Tianluoshan. Thousands
of rice grains have been preserved
by charring. Pictured is a small
sample of what has been recovered.
Image courtesy of Gary Crawford.

chestnuts. People also collected hog plums, plums, apricots, persimmons, and the fruit of a number of vines including hops and grapes.

A number of pits filled to the brim with acorns have also been uncovered at Tianluoshan. Our dilemma is to determine how to interpret these acorns. Acorns may simply have been an important part of the diet, but hard evidence for their actual consumption by people is difficult to obtain. Acorns could also have been fed to pigs that were raised there. Wild Eurasian pigs prefer evergreen oak woodlands, although they can live in almost any habitat; they also subsist primarily on a plant-based diet, including seeds and fruit (Oliver and Leus 2008). Another possibility is that they were stored for unpredictable food shortages. In other words, they were not for immediate consumption. They may simply have been a form of insurance against times when food was lean. In fact, encouraging and managing plants was a common tactic among hunters and gatherers (or people who did not grow domesticated plants), so archaeologists think that agriculture arose from these strategies. In other parts of the world, such as California, indigenous peoples managed oak trees in order to ensure high acorn productivity (Lewis and Bean 1973). Conceivably, the landscape of the Hemudu culture was a highly managed one that included farming along with management of other resources in addition to hunting and collecting other edibles. This diverse economic system, which relied on both aquatic and terrestrial resources that lay along a gradient from wild through domesticated, was quite distinct from that of the farming cultures of the Yellow River basin.

Evidence before 5000 BC

Two closely related cultures, one being ancestral to the other, dating from 9400 to 5000 BC preceded the Hemudu culture (Jiang 2008, 2013). The early culture is known as Shangshan (c. 9400–6500 BC) and is followed by the Kuahuqiao culture (c. 6000–5000 BC). These cultures probably represent two ends of a spectrum of developing village life and experience with resource management that culminated in the first steps in the domestication of rice and other plants. Shangshan sites are restricted to an upland region (40–100 meters above sea level) measuring roughly 170 by 70 kilometers, centered along the Puyang River about 80 kilometers south of the Ningshao Plain (fig. 38).

Shangshan sites have the earliest evidence of rice exploitation, in the form of pottery tempered with rice chaff (Liu et al. 2007). Jiang suggests that tempering with rice chaff, leaves, and stems is evidence of rice processing and agriculture (Jiang 2008). Pigs were raised by the Kuahuqiao people (Jiang 2013; Zong et al. 2007), and we expect that the beginning of their management lies in the Shangshan culture, although evidence has not yet been found. We know precious little about the ancestors of the Shangshan culture, because older occupations have not been found in the region. What we do know is that some Shangshan settlements were quite large, with shallow basins that appear to have been house foundations

FIGURE 38
Interior lowland. The Miaoshan site, a
Shangshan site, is situated on a terrace
(*left*) well above the water table overlook-
ing a floodplain (*right*). Image courtesy of
Gary Crawford.

and pits that were probably used for storage. Shangshan pottery was well developed, and the sites are not far from where pottery was invented thousands of years earlier (Boaretto et al. 2009). The earliest Shangshan pottery was fiber tempered, most of the plant fiber being rice chaff. Thus, rice was an important technological resource (Jiang and Liu 2006). Rice spikelet bases have been recovered from the Huxi site, and they have nonshattering characteristics, meaning that the rice has already undergone selection by people (domestication under way). (Wild rice grains naturally fall away from the plant after the grains ripen, whereas domesticated rice retains the grains, so that people can bring the stalks back to the village for threshing and recover most of the grains.) The sample of rice embedded in Shangshan pottery has been examined, and the results have led to a heated debate about when and under what circumstances rice was domesticated (Crawford 2011; Fuller et al. 2007; Liu et al. 2007). For now, the extent to which rice was used as food at this time is not known. However, charred rice fragments (grains and spikelet bases) have been recovered from the Huxi site (fig. 39). The fact that these plant remains had come into contact with heat and were subsequently preserved is further indication that the rice had some relevance to these people and was purposefully brought to the site to be used. Significant levels of rice management are evident by 6000–5000 BC at Kuahuqiao.

Rice is a wetland grass that grows either as a perennial or an annual plant (for a more detailed discussion of rice see Crawford 2011) (fig. 40). In its perennial form, it does not produce much seed unless water levels vary and flower growth is stimulated. Rice is an annual plant where water levels rise and fall seasonally (Sato 2002), as it does in the Yangtze region, the high-water season occurring during the late spring–early summer monsoon. Even then, rice does not produce many seeds compared to domesticated rice, because of the few branches that make up

FIGURE 39

The Huxi site. The excavation exposed more than 1.5 meters of archaeological deposits that contain worked stone and pottery. Rice remains have been found in small pits underlying the dark-colored sediment. Image courtesy of Gary Crawford.

the flowering head of the rice plant. The seeds are not produced simultaneously, either, so harvesting the grains presents a timing issue. Once mature, the fruits are quickly severed from the plant (a tendency known as the shattering trait) in order to facilitate dispersal. Immature rice may have been harvested in order to collect the rice before shattering (Fuller et al. 2009). The problem with this is that the rice grains have low nutritional value before maturity. In Africa and Southeast Asia where wild grasses, including *Oryza*, are harvested, people preferred to collect mature grains by using such methods as tying stalks together to prevent the seeds from dropping on their own (Vaughan et al. 2008). Rice grains and the spikelets in which they develop are the best-preserved record for ancient rice, so we pay particular attention to their characteristics.

Rice grains do not change much over time, being quite variable in size and shape (Crawford 2011). Spikelet bases from nonshattering rice are recognized by the presence of tearing at the region of attachment or by a vestige of the stock or rachilla still attached to the spikelet base. In contrast, the shattering type has a clean break as a result of an abscission layer that grew across the base of the stalk, severing the spikelet from the plant.

The Shangshan-period spikelet bases range from shattering through intermediate forms to nonshattering types. Human selection of rice plants had begun

by at least 6500 BC, and, conversely, rice attracted the attention of people, so that not long after 6500 BC both humans and rice were benefiting. By 6000–5000 BC about 40 percent of the Kuahuqiao rice spikelet bases are the nonshattering type, evidence that people were not only selecting but also maintaining a population of rice that was significantly differentiated from the wild type (Zheng 2007). Furthermore, the spread of new resources outside their original range is complementary evidence of their significance and probably their domestication. Rice had spread as far north as the Yellow River basin in Shandong Province by 6000 BC (Crawford et al. 2013; Crawford et al. 2006; Jin et al. 2014). We do not know if these northerners planted rice, but they certainly incorporated it into their economy. The earliest paddy fields in the region date to much later and are documented at Tianluoshan (Zheng et al. 2009). Rice paddies are manufactured wetlands that allow water levels to be carefully controlled, facilitate nutrient enrichment, and help isolate rice populations. Water buffalo bones (fig. 41) have been recovered from sites such as Tianluoshan, but they may not have been domesticated, given that water buffalo aDNA from the Yellow River Valley shows that these individuals have no relationship to modern domesticated water buffalo (Yang et al. 2008). Whether the lower Yangtze valley water buffalo were domesticated, hunted, or used as traction animals to prepare rice paddies is not at all clear. No aDNA studies have been done on the Yangtze valley water buffalo remains.

Evidence for selection of other resources beyond rice and pigs in the region includes the peach. Native tree or arboreal crops besides the peach are important throughout China today and include the apricot (*Prunus armeniaca*), chestnut (*Castanea* spp.), Chinese bayberry (*Myrica rubra*), hawthorn (*Crataegus* spp.), hazelnut (*Corylus* spp.), hog plum (*Choerospondias axillaris*), litchi (*Litchi chinensis*), mandarin orange (*Citrus reticulata*), paper mulberry (*Broussonetia papyrifera*), and

tea (*Camellia sinensis*) (Crawford 2006). The apricot, hog plum, paper mulberry, peach, and *Camellia* sp. are well represented in the Zhejiang archaeological record. Peaches mature within two to three years, and they respond to grafting and root stock production (Zheng et al. 2014). The oldest peach stones so far discovered are from Kuahuqiao. Differences in stone shape and size correlate with flesh quantity, so we can clearly identify instances of peaches being managed. By four or five thousand years ago peach stones are quite similar to modern ones, but how early they were being managed is a matter of interpretation. For example, the Kuahuqiao peach stones hint at being bimodal in size and shape; this bimodality indicates to researchers that there were two types of stones and, thus, two types of peaches emerging at the site. Considering it takes several thousand years for modern-like forms of domesticated plants to evolve, the Kuahuqiao people were probably managing peach trees (Zheng et al. 2014). If they were managing peaches and rice, we can hypothesize that they were managing other plants too.

North China includes the North China Plain, the Yellow River basin, and the northeastern region composed of Liaoning, Heilongjiang, and Jilin Provinces as well as Inner Mongolia. The Loess Plateau forms much of central North China. Rainfall and tree cover decrease with distance from the coast, and, due to the permeability of the deep loess sediment, tree cover tends to be limited to river courses (Crawford 1992). These drier areas and loess deposits are covered in grasses (Poaceae) and herbaceous vegetation, particularly *Artemisia* and *Chenopodium*. Research on early crops in North China has focused on two millets (foxtail, *Setaria italica* ssp. *italica*, and broomcorn, proso, or common millet, *Panicum miliaceum*) (fig. 42) and soybean (*Glycine max*). Not surprisingly, the two Chinese millets have low water

requirements and thrive in areas with short growing seasons (sixty to eighty days) and at higher elevations (Crawford 2014).

Developments from the Late Glacial Maximum (LGM) (20,000–17,000 BC) into the Early Holocene are being clarified by research at sites such as Dadiwan, Donghulin, Hutouliang, Nanzhuangtou, Shizitan, and Xiachuan (Liu and Chen 2012) (fig. 43). Microliths and pottery (c. 11,000 BC) (Bettinger et al. 2010; Hao et al. 2001; Liu et al. 2010) are new aspects of technology indicating that people were making technological adjustments after the LGM for reasons that are not clear at the moment. Technology hinting at long-term utilization of smaller areas, lowered mobility, and small-scale landscape modification, such as grinding stones, adzes, and axes (for digging and for cutting and working wood), appear twenty-three thousand to sixteen thousand years ago. The earliest adze-shaped tools appear near the end of the Upper Paleolithic and are particularly numerous at one site, Hutouliang (Zhang et al. 2010). The emergence of this tool signals that people were more effectively cutting trees and shaping wood, implying that efforts being made to alter local habitats were growing. A wide range of animals were being exploited, including ostriches, frogs, ground squirrels, hamsters, voles, wolves, wild horses, wild donkeys, wild boars, deer, oxen, and gazelles (Guo and Li 2002). Pits are also reported at Hutouliang (c. 11,000 BC) (Guo and Li 2002) indicating that people were planning to stay in the area (storage of resources for future use). Dogs, pigs, birds, fish, and shellfish are found at sites by c. 8500 BC, indicating a broadly based subsistence as well as management of particular animals (e.g., dog) (Liu and Chen 2012). Possibly by the Younger Dryas cold period (11,000–10,000 BC), people were pushed southward, where they developed food production (Bettinger et al. 2010).

Broomcorn millet was widely used by about 8,000–7,500 years ago from the Yellow River basin to Inner Mongolia (e.g., at Dadiwan, the Peiligang culture, the Houli culture, and the Xinglonggou culture) (Crawford 2014). The first steps to their domestication must date to an earlier period, considering that it takes considerable time to fix domestication-related traits in a population of plants. How long ago is currently an active area of research. People began to exploit wild grass seed during the LGM. Paniceae (the grass tribe to which the Chinese millets

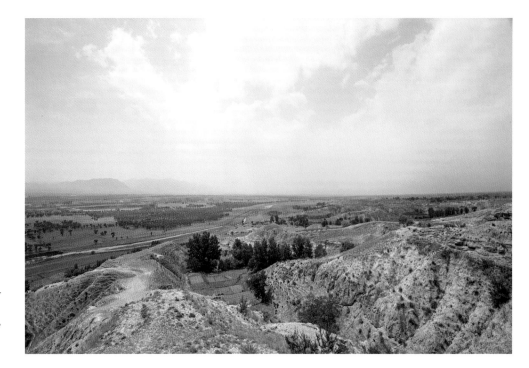

FIGURE 43
Vicinity of the Hutouliang locality. The site is approximately 20 kilometers southwest of Nihewan town. Hutouliang is in the foreground on a dissected terrace overlooking a wide lowland, part of the Nihewan Basin, through which the Sanggan River slowly flows. Image courtesy of Gary Crawford.

belong) starch grains extracted from grinding stone surfaces at Shizitan Locality 14 date between 23,000 and 19,500 years ago (Liu et al. 2013). Some starch grains are similar to those of green foxtail grass (*Setaria viridis* subsp. *viridis*), the ancestor of foxtail millet. A number of the starch grains are argued to be large enough to be from a domesticated form of millet, but some scholars are skeptical (Liu et al. 2013). Research at Shizitan Locality 9 (c. 9000 BC) did not recover evidence of domesticated Paniceae starch (Liu et al. 2011), but research on Nanzhuantou and Donghulin (c. 9000 BC) starch grains suggests that some are from domesticated millets (Yang et al. 2012). The ratio of domesticated to wild-type starch grains increases between 13 and 16 percent by 9500 BC (Yang et al. 2012). Researchers are debating the meaning of the large starch grains, suggesting other influences such as grinding may be responsible for the larger size. On the other hand, the contrasting data could indicate regional differences in domestication as well as sampling differences. Isotopic studies suggest that nearly 25 percent of the diet in the Yellow River basin c. 6000–5500 BC was from millet. Within a thousand years, millet had become so relied upon that it contributed up to three-quarters of the diet (Hu et al. 2008).

Two other plants, members of the bean family (Fabaceae), add insight to the development of agricultural systems. These are the adzuki, or red bean (*Vigna angularis* var. *angularis*), and the soybean (*Glycine max* subsp. *max*). The ancestor of the domesticated soybean is *G. max* subsp. *soja* (syn. *Glycine soja*), which is indigenous to China, Japan, the Russian Far East, Taiwan, and the Korean Peninsula (Hymowitz 2004) (fig. 44). *G. max* subsp. *soja* is adapted to disturbed, sunlit habitats and can be found growing in dense stands where people have cleared vegetation. This

FIGURE 44
Wild soybean (South Korea). Black seeds
have been spread over the ground by
the pods when they dehisced in a spiral
fashion. Wild soybean is a vine common
in such open, disturbed habitats where
competition with other plants is low.
Image courtesy of Gary Crawford.

is part of the reason charred soybean seeds are found at most northern Chinese Neolithic sites; people and soybeans had a well-established symbiotic relationship probably as early as 6000–5000 BC (Lee et al. 2011). The soybean is attracted to human habitats, while humans are attracted to it as a resource. Legumes also fix nitrogen in the soil so they help replenish nutrients used by other crops. Domesticated soybean plants are mainly erect nonvines, with determinate growth (the plant stops growing when it produces the beans) and reduced pod dehiscence (in the wild, the process by which the two halves of a bean pod break apart to release the seeds), among other traits (Lee et al. 2011). The wild soybean is a vine that continues to grow after fruit production begins, thus splitting nutrients between fruit production and vegetative growth. Soon after the pod ripens it dehisces and disperses its seeds, making it difficult for people to harvest. None of these traits are visible in the archaeological record, so we need to rely on other traits, such as seed size, to establish a minimum date of human selection that resulted in phenotypic change to soybean. I say "minimum" because seed size probably increased after traits such as dehiscence changed. Larger seed size among the Neolithic Chinese soybean populations is not apparent until c. 3000–1000 BC (Crawford 2011).

Adzuki bean reports are rare and relatively late, one of the first being from the Longshan-period Liangchengzhen site in Shandong Province (Crawford et al. 2005). The adzuki bean's wild ancestor is *Vigna angularis* var. *nipponensis*, another vine in the bean family that is widely distributed in East Asia and that may grow together with wild soybean. As in the soybean, large seed size is the only trait with archaeological visibility, at least for now. The many other domestication related traits (DRTs), such as pod dehiscence, are not discernible, because seeds (not pods)

are the only remains found at sites so far. The only relatively continuous chronological sequence of adzuki seeds in the archaeological record is from South Korea (Lee 2011). Large adzuki beans are also reported from the Middle Jomon period (c. 3300–2800 BC) in Japan (Sasaki et al. 2007). Until we recover more adzuki beans from China, the adzuki's history there will remain poorly known.

How Did Agriculture Begin in China?

We need to be cautious applying modern knowledge of agriculture and what it has done for human societies to understanding how it arose. Hindsight is not the best approach. We also need to be careful about defining agriculture through modern, industrial, or Eurocentric eyes (Deur and Turner 2005). In other words, this is not a question of progress, but of evolution. Evolution is not a matter of improvement, but of fitness related to context; Darwin described the process as "descent with modification" (Darwin 1859), that is, biological changes from generation to generation are adaptations to changed circumstances. We now know that these adaptations are coded in DNA. Anthropologists also consider the codes of human behavior—learned behavior that can be transmitted from generation to generation—a similar form of descent with modification. Behavior may be modified by decisions that people make in order to survive and maintain their culture in changed circumstances. In all likelihood, agriculture was an unintended consequence of actions taken by people to solve immediate resource procurement problems rather than to create a new cultural practice about which they would have known little. Most people without agriculture still managed resources and were well aware of the biological world around them. Agriculture probably involved a shift in emphasis to greater resource management. Certain management techniques led to unexpected genetic changes in organisms that we now know form the domestication syndrome. Archaeologists are trying to sort out what these techniques were. In the case of goats, we think that females were kept for breeding and males used for food (Zeder and Hesse 2000). Thus, the development of agriculture as we know it today was slow with many twists, turns, and failures, as well as successes.

In China, domestication of rice, millet, soybeans, peaches, pigs, and other plants and animals took place over thousands of years, so the genetic changes in these organisms would not have been obvious at first. Archaeologists know that agriculture was developing, but we cannot assume that the people developing agriculture knew what was to come. Thus, it is crucial to learn when the first steps were being taken so that we can understand conditions at that time. In China, we only know the general period of time (c. 9500–5500 BC) for the first steps, but we cannot be more specific at the moment. Only a handful of analyses have been carried out on data from this period—the Pleistocene and beginning of the Holocene, when the climate significantly warmed, sea levels rose, and the plant and animal

communities that we are familiar with today became established. But these communities were not precisely what exists today in China; they were in flux, responding to periods that were warmer, wetter, drier, or cooler than today. A sudden cold snap known as the Younger Dryas, which lasted about one thousand years, from c. 12,900–11,700 years ago (Maher et al. 2011), is sometimes hypothesized to have triggered behaviors that led to agriculture, but for now this period is well before significant agricultural developments in China occurred. Other possibly relevant climate periods are the Pre-Boreal (c. 11,400–10,200 BC), when the environment bounced back from the colder Younger Dryas, marking the beginning of the Holocene, and the 8.2 cold and dry event that lasted a little less than two centuries (Kobashi et al. 2007; Maher et al. 2011). The Holocene Thermal Maximum (HTM) in East Asia began earlier, c. 7000–6000 BC in eastern China, and lasted four thousand years, although regional variation of the timing and maximum warmth depends on factors such as latitude; furthermore, the monsoon was more intense before the HTM (Renssen et al. 2012). Landscapes were evolving too. This involved the formation of modern river courses and their subsequent down-cutting. As landscapes changed, plant communities adjusted accordingly.

Even if we are able to find correlations of changes in the archaeological record with one of these periods, correlation is not an explanation. For example, it would be tempting to link early rice exploitation to the more intense monsoon before the HTM. However, how these events may have or could have been encoded in traditional ecological knowledge is an important issue to consider. Kent Flannery and his team proposed a model based on archaeological and ethnographic research conducted in the 1960s. They hypothesize that fluctuations in rainfall over short periods (no more than a few years) in highland Mexico were enough for people to adjust their plant procurement strategies (Flannery 1986); by this Flannery means that short-term fluctuations have a significant impact on how people perceive the environment and make adjustments. We simply do not have the kind of high-resolution data from China that we need yet.

In the context of traditional ecological knowledge, resource management strategies have long been a part of human subsistence ecology, and they are not specifically associated with agriculture. The knowledge related to these strategies is culturally and physically imprinted in people and the landscape through a process called "ecological inheritance" (Laland et al. 2001). People everywhere influence their environment at different scales, and archaeologists are able to recognize some large-scale impacts. These anthropic or anthropogenic influences may result in the formation of specific plant or animal communities (e.g., disturbance-loving plants or deforestation, landscape burning). In a broader context, this process falls in the realm of niche construction, a theoretical perspective that acknowledges that organisms make changes to their local circumstances and in turn make adjustments to those circumstances (Laland et al. 2001). Human-plant or human-animal mutual adjustments are best exemplified by domestication. Grasses,

for example, may respond to harvesting techniques such as cutting the inflorescence to bring home for later processing by shifting the balance of the population to nonshattering types (Hillman and Davies 1990).

Clues to the beginnings of agriculture and domestication should, therefore, be found in the ecological contexts of human occupations. Populations of dryland, rain-fed annual through perennial arboreal crops would have increased through anthropogenic influences, such as fire, increased sedentism, and tilling. In the late Upper Paleolithic and Early Holocene of North China, we see the emergence of increased sedentism, evidenced by less-than-portable technology (grinding stones), the appearance of storage pits, and longer-term habitations, culminating in the development of cultures such as Dadiwan, Peiligang, Houli, and Xinglonggou. Although these activities do not, in themselves, explain agriculture or domestication, they are important components of domestication and agricultural origins hypotheses.

The issues in the Yangtze basin are far less clear than in North China. The ancestors of the Shangshan culture are, as yet, unknown. Rice is not obviously an anthropogenic plant gravitating to human-influenced habitats, but rice may be a clue to human-modified wetlands existing during Shangshan times. Annual rice may have been an important solution to resourcing annually flooded habitats where other resources were less accessible during the wet season. Because the monsoons were more intense before 6000 BC in China, annual water level and flooding fluctuations would have been more severe than either earlier or later. Houses, pits, and technology are consistent with habitual use of local areas hinting at anthropogenesis, at least in the upland areas. The lowland Kuahuqiao culture (c. 6000–5000 BC) has evidence of a dense local population who managed wetland and dryland resources. They also relied on architecture appropriate for these wet lowlands. Selection for preferred types of plants and animals shifted their phenotypes (in the case of plants).

Closing Thoughts

Understanding early agriculture in China, both its origins and subsequent developments, is an ongoing process, with each year bringing new data and ideas as well as modifications to earlier hypotheses. Nevertheless, archaeologists are coming to a general understanding. Agriculture developed independently in two or possibly three regions in China. As in other areas of the world where agriculture evolved, simple single causes are not evident. Climate change, demographic pressure, and the like are not of much explanatory power. The process probably began as a result of incremental changes brought about by decisions of people to resolve short-term perceived resource problems (they may not have been real problems). Although these decisions were designed to maintain their ways of life, the results led them to an unanticipated result: agriculture. The archaeological record, therefore, is one

of incremental changes best documented in North China. Here, Upper Paleolithic people at the end of the Pleistocene developed strategies in the face of climate warming, reorganized ecosystems, and landscape evolution that resulted in habitual use of more local areas than in earlier times. Early to Middle Holocene climate changes resulted in fluctuations of temperature and precipitation that lasted for varying periods of time, each period having its own seasonal swings that were difficult to predict. People probably developed strategies such as storage and resource management to deal with unpredictable local rainfall and temperature patterns that would have affected some resources and not others. In this way, domestication and resource management may have resulted from risk reduction strategies. Human interaction with the biosphere was, therefore, changing, ultimately resulting in the evolution of new plants, animals, ecosystems, and societies by the Middle Holocene. The archaeological record for the period before eleven thousand years ago is almost unknown in the lower Yangtze valley. However, between eleven thousand and eight thousand years ago people were settling into small villages, fewer than twenty of which have been discovered by archaeologists. These people must have been taking the first steps to agriculture just as their northern counterparts did, because, between eight thousand and seven thousand years ago, life was fundamentally transformed compared to the Upper Paleolithic. A few large communities in wetland areas near the coast were producing rice and probably other resources while still maintaining hunting, gathering, and fishing. By about 4,500–3,500 years ago many domesticated plants and animals familiar to contemporary society had evolved in China, and agricultural life was well established. These economies would ultimately support the development of large cities and a unified China. Whether these strategies are ultimately successful or sustainable remains to be seen.

FIGURE 45

Zhoukoudian Locality 1 cave, the Peking
Man site, viewed from the *Gezhitang*
Pigeon Hall subcave on the top layers.
The cave roof was damaged through the
original excavation in the 1920s and
1930s. Photo taken by the author in 2008.
Image courtesy of Chen Shen.

Zhoukoudian:
Peking Man and Evidence for
Human Evolution in East Asia

Chen Shen

On a dark, cold evening in December 1929, a discovery in paleoanthropology that later became a worldwide sensation was made in a cave near Zhoukoudian (or Chou-Kou-Tien), located about 55 kilometers southwest of downtown Beijing (fig. 45). The first skull of a new hominid was unearthed by Mr. Pei Wenzhong (W. C. Pei), working under Canadian anthropologist Davidson Black. Dr. Black first named this fossil *Sinanthropus pekingensis* after the country and city of its origin. The fossil was later redesignated *Homo erectus pekingensis* and is now more commonly known as "Peking Man" (Boaz and Ciochon 2004) (fig. 46).

This was significant evidence for the missing link (*Homo* genus) between extinct apelike species and living anatomically modern humans, a link that scientists had been seeking since the publication of Darwin's theory of evolution in *On the Origin of Species* seventy years before. Scientists from the Field Museum of Natural History were so excited about the discovery that anthropologist Henry Field acquired two casts of Peking Man skulls and 115 artifacts through excavator W. C. Pei in 1939. Some of these stone tools are now showcased at the very beginning of the *Cyrus Tang Hall of China.*

FIGURE 46

The author examined the only remaining piece of Peking Man's cranial fragment, discovered in 1966 at the Institute of Vertebrate Palaeontology and Palaeoanthropology in Beijing. The five original Peking Man skulls were lost during World War II, but multiple casts of the original skulls were made before their disappearance and remain in several institutions and museums including The Field Museum. Image courtesy of Chen Shen, Zhang Xiaoling.

Archaeologists can confidently assess that these stone tools were made and used by Peking Man through examining patterns of breakage and polish on tool edges. The tools (fig. 47), which appear rather rough and simple, were detached from quartzite nodules by intentional knapping techniques. The hominid toolmaker further modified his or her tool by fine retouch on the margins and tip to create straight or slightly curved edges, or points. This created a variety of tools for practical use, such as cutting or butchering knives, scrapers, drills or borers, and the like. Peking Man's use of these tools for hunting can be further confirmed by examining worn edges through microscopic analysis to reveal telltale marks of use wear.

These hominids were much smarter than their primitive appearance might indicate. In a time when icy climates predominated worldwide, more than half a million years ago, Peking Man was able not only to make fire but also to control and use it for many different needs, such as defense from cold and predators. There has been much debate on whether Peking Man actually had the ability to use fire purposefully, but recent field investigations at the Zhoukoudian site provide positive evidence. Examinations of burned and unburned sediments in newly excavated areas include detailed measurements of magnetic susceptibility, color, and diffuse

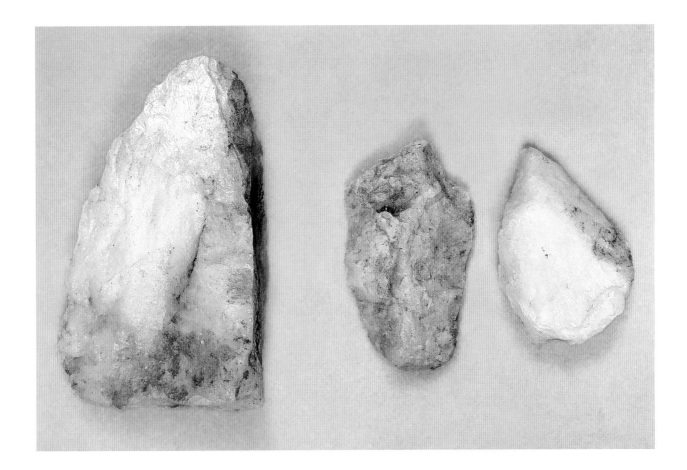

reflectance spectrum, which indicate the difference between fires in human-controlled and natural settings (Zhong et al. 2014).

The cave where Peking Man fossils and tools were recovered was labeled the "Locality 1" site, one of twenty-seven localities at Zhoukoudian containing hominid remains or hominid-related cultural materials without *Homo* fossils. The cave at Locality 1 was filled with tens of thousands of stone tools, enormous quantities of fossils from now-extinct Pleistocene megafauna such as the woolly rhinoceros and Irish deer, and hominid remains belonging to forty-one individuals. These rich deposits were embedded in thirteen layers of sediments that represent different temporal divisions of varying textures and richness, all dating to the Pleistocene epoch. Based on these findings, East Asian *Homo erectus* was shown to have been present in northern China between 780,000 and 300,000 years ago, subsequently confirmed by sophisticated dating methods derived from the field of geophysics (the more familiar carbon-14 [C-14] dating technique cannot be used because its dating range is too short). The Peking Man stone tools do not represent the earliest evidence of hominids in China: the earliest hominid occupations date to 1.6 million years ago and are located at the Nihewan Basin less than 200 kilometers from the Peking Man site.

FIGURE 47

Stone tools made and used by Peking Man for scraping (Field Museum catalog no. 232773), drilling (Field Museum catalog no. 215716), and cutting (Field Museum catalog no. 232788), all made using quartz materials. Although these are difficult raw materials to work, Asian hominids seemed to have been able to master their manufacture and use. Stone tools similar to these are commonly found at most Paleolithic sites in China. Image courtesy of Chen Shen, Amyn Adatia.

Hominids continued to live near Zhoukoudian for many thousands of years. The most recent and important discovery in 2003 revealed human fossils at Locality 27, or Tianyuandong Cave. A cluster of fossil remains represents a nearly complete individual—an anatomically modern human. Using the accelerated mass spectrometry (AMS) C-14 dating method directly on a limb bone, scientists deduced that the individual lived around forty thousand years ago. This is the earliest confirmed date for early modern humans known so far in East Asia (Shang and Trinkaus 2010).

These findings raise a central question: did Peking Man *Homo erectus* evolve into modern humans that we call the Chinese (or East Asian) people, or were they driven to extinction or otherwise replaced by modern humans arriving from Africa? If the "out-of-Africa" theory is correct, then we should be able to find evidence of cultural materials that were brought in by the newcomers. However, to date, Chinese archaeologists have not found any evidence for a sudden change or interruption in material culture at any sites in China during that time span. Tools from Chinese Paleolithic sites appear to be similar to those found at Zhoukoudian, indicating cultural continuity. Chinese Paleolithic archaeologists have yet to find any toolmaking kits similar to those known to have once prevailed in Old World localities further to the west. What is also fascinating is that modern East Asians have certain anatomical features that physically resemble those of Peking Man.

One likely hypothesis is that Asian *Homo erectus*, represented by Peking Man, and archaic African *Homo sapiens* might have interbred during their encounters in the landscape that is now China. Genetic and fossil evidence of long-term interbreeding between *Homo neanderthalensis* and modern *Homo sapiens* throughout Europe lend feasibility to this model. However, in order to prove this we need more genetic studies that include hominid fossils. At present, Chinese Paleolithic evidence supports a modern human evolution model in China; namely, the "continuity with hybridization" theory proposed by Wu (Gao et al. 2010). Continuity in lithic technologies from northern China is indicated by persistent ways of producing and using stone tools. This strengthens an argument for the indigenous capacity of Peking Man's descendants to survive in the face of immigrating newcomers and contribute to the evolutionary story of modern humans in China.

3

China during the Neolithic Period

Gary M. Feinman, Hui Fang, and Linda M. Nicholas

Continuity and change are two key dimensions of China's past. Despite dramatic transitions in technology, statecraft, and population, familiar symbols that were first introduced millennia ago retain importance today, while philosophies and ideas concerning social contracts and appropriate societal roles outlined by Confucius more than 2,500 years ago remain part of current dialogues and ongoing debates. The roots of Chinese civilizational traditions extend back to the Neolithic period (c. 8000–1900 BC). As an example, rice was domesticated in southern China during this era, while millet, another important staple grain, was domesticated in the north (see Crawford, this volume).

Yet the Neolithic period also was a time of dynamic demographic, settlement, political, economic, and material cultural shifts across much of China; it was an epoch of significant regional diversity. Here, we draw heavily on recent archaeological findings to discuss this dynamic period that extends back before the advent of written texts. We focus principally on three regions, the central floodplain of the Yellow River, the lower basin of the Yangtze River, and Shandong Province (fig. 48).

Topographic map of China illustrating three focal regions. © The Field Museum. Illustrator David Quednau.

Our empirical vantage on this distant time has greatly expanded over the last decades as Chinese archaeologists and their foreign colleagues have widened their spatial perspective beyond the Central Plain (the Yellow River Valley)—where Neolithic communities first were uncovered—to a much larger area of China (Li Liu 2004). These geographically wider and empirically richer archaeological findings have forced the reconsideration of traditional archaeological models that proclaimed China's Central Plain as the heartland of Chinese civilization, from whence the traditions radiated out to the rest of China. No longer can this perspective be sustained in the face of new data, and it is clear that early Neolithic traditions in China were diverse, with key differences in subsistence regimes, community plans, political relations, and other basic cultural practices (Falkenhausen 1993).

In China, the Neolithic period encompasses a sequence of transitions from mobile hunter-forager lifeways to the advent of urban landscapes that populated this region by the early Bronze Age. Some of the shifts, including a greater reliance on domesticated resources, more sedentary and larger settlements, and more widely spanning socioeconomic networks, characterize most of China during this

CHAPTER THREE

TABLE 1 Select Regional Chronologies for Neolithic China

Beginning of Era (years BC)	Upper Yellow River	Middle Yellow River	Shandong	Lower Yangtze River	Liao River
1000		Shang	Shang	Regional cultures	Upper Xiajiadian
1500	Regional cultures	Erlitou	Yueshi	Maqiao	Lower Xiajiadian
2000	Qijia	Late Longshan			
2500	Majiayao	Early Longshan	Longshan	Liangzhu	Xiaoheyan
3000			Dawenkou		
3500					
4000	Yangshao	Yangshao		Songze	Hongshan
4500				Majiabang	
5000			Beixin	Hemudu	
5500					Zhaobaogou
6000	Dadiwan	Peiligang	Houli	Kuahuqiao	Xinglongwa
6500					

period. Yet other temporal changes were more regionally specific, as pathways of transition were not uniform. In the remainder of this essay, we review China's Neolithic era chronologically, beginning with early developments and then dividing our coverage into three broad time horizons (c. 7000–5000 BC, 5000–3000 BC, and 3000–1900 BC; table 1). This era was marked by both the spread of farming and sedentary life to ever-larger areas across what is today China and increasing connectivity between the different Chinese Neolithic traditions that were dispersed across the expansive floodplains of the Yellow and Yangtze Rivers and adjacent areas.

Neolithic Beginnings

The term "Neolithic" is generally associated with a "package" of cultural behaviors that developed in various parts of China and roughly a half-dozen other global regions during the early and middle Holocene (c. 12,000–5000 BC). Recent research has pushed the Chinese Neolithic back in time, about as early as in Southwest Asia

(the Middle East), where the first steps toward Neolithic lifeways traditionally have been thought to have initially occurred. The "Neolithic package" (Price 2000) commonly refers to the domestication of plants and animals, the increasing proportion of these foods in the diet, the transition from mobile (seasonal) lifeways to more sedentary communities, the increasing importance of both ceramic containers and grinding technologies, growing settlement sizes, demographic growth, and the shifting patterns of social interaction, networks, cooperation, and leadership that accompanied them. Nevertheless, for China as well as globally, these behavioral changes associated with the Neolithic did not always occur simultaneously or in the same temporal sequence, and in certain cases elements of the "package" were not adopted for centuries, even millennia.

In China, as in neighboring regions such as Siberia, pottery was first made and used during the Pleistocene, in contexts that precede the domestication of plants (Cohen 2013). Sites with early pottery extend back before 20,000 BC in South China—possibly the world's earliest ceramic containers (Cohen 2013; Wu et al. 2012)—and just prior to 8000 BC in North China (Wang et al. 2015). By 8000–7000 BC in several areas of North and South China, indications of a transition toward more sedentary occupations have been found (Cohen 2011), yet the advent of farming and a heavy reliance on domesticated plants is less clear. Nevertheless, important shifts in diet and settlement occurred in both the north and south (Crawford, this volume). Early Neolithic populations maintained a reliance on hunting, gathering, and fishing but with an intensified exploitation of a suite of plants that later were cultivated agriculturally (Juzhong Zhang et al. 2014). Dogs were domesticated at an early date, probably before 8000 BC (Olsen et al. 1980; Savolainen et al. 2002), while pig domestication occurred by 7000 BC, and they were widely utilized thereafter (Larson et al. 2010; Luo and Zhang 2008; Yuan and Flad 2002). These subsistence shifts were accompanied by behavioral changes that include living in larger, more permanent communities often characterized by round houses, domestic storage facilities, and discrete funerary sectors. Changes in diet and mobility were amplified by the diversification of ceramic forms, cooking vessels, serving wares, and storage containers.

Early Neolithic (c. 7000–5000 BC)

Across China, the processes of "Neolithization" were diverse in subsistence practices, associated artifact assemblages, domestic construction, community layouts, and sociopolitical relations. Regional differences include a reliance on strains of millet (foxtail and broomcorn) in the north, rice in the south, and more site-to-site diversity and mixed subsistence regimes in the areas between (Cohen 2011). Pockets of regional diversity were linked through cross-regional networks that followed interconnected river systems that facilitated communication and the spread of innovations across eastern China. At the outset, pottery, more sedentary settlements, and the associated social and ideological adjustments were generally sustained by

mixed subsistence economies with increasing focus on wild cereal resources, but by the end of this period (c. 5000 BC), morphologically domesticated grains were well represented in most Neolithic communities across China.

Although they belonged to different archaeological traditions (each defined by somewhat distinctive classes of artifacts) (fig. 49), most Early Neolithic communities in North China were composed of clusters of small, semisubterranean houses interspersed with large numbers of underground storage and trash pits (fig. 50). Many of these settlements had discrete cemetery precincts, and in a few cases they were ringed or partially ringed by walls or ditches. Houses and other features were sometimes found outside these enclosures. By the end of the Early Neolithic, houses in certain communities varied in size and elaboration (Peterson and Shelach 2010; Shelach 2015, 70–79).

Most communities were no larger than several hectares, although in each region, a few settlements were as large as 8–20 hectares. The nature of the relationships between larger and smaller sites is not well understood, although at some of the larger settlements burial assemblages of grave goods indicate degrees of status differentiation that do not conform solely to age and sex distinctions. Artifacts recovered at these sites comprise a diversity of pottery vessels, including an array of bowls, jars, plates, cooking cauldrons, and lids, large grinding querns, bone implements, especially spears, points, and needles, and stone adzes and sickles. The

FIGURE 49
Chinese Early Neolithic cultural traditions (c. 7000–5000 BC). © The Field Museum. Illustrator Erica Rodriguez. Redrawn by Linda Nicholas.

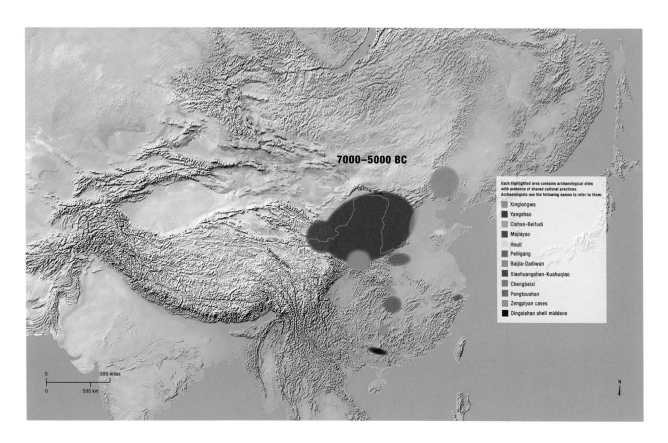

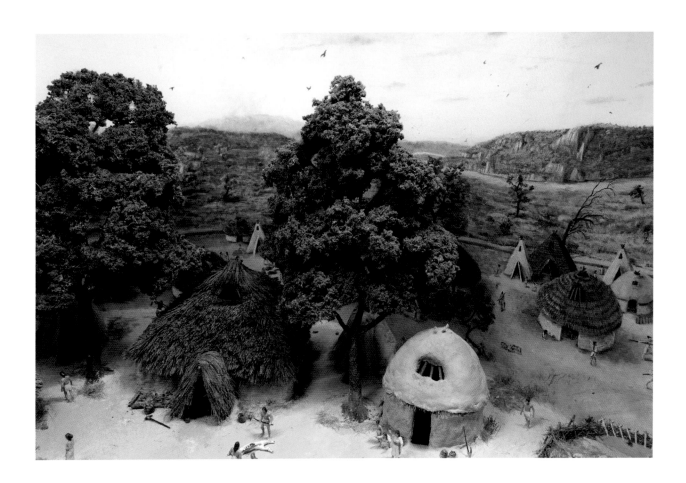

FIGURE 50

Yangshao village diorama. © The Field
Museum. Photo ID No. GN92102_012d.
Photographer Karen Bean.

specific artifact forms and styles of decoration varied regionally, thereby defining
the different archaeological traditions (e.g., Yangshao, Majiayao, Cishan-Beifudi,
Baijia-Dadiwan, and Houli).

In the far northeast (Xinglongwa) (see fig. 49), the shifts toward "Neolithiza-
tion" occurred centuries later than in the basin of the Yellow River. Even follow-
ing the transition to more permanent villages, hunting, rather than a reliance on
morphologically domesticated pigs, retained greater importance for meat pro-
curement than to the south (Inner Mongolian Team [CASS] 1997, 1–26; Yuan et al.
2008). Even at this early time, carved jades have been found on Xinglongwa house
floors and in burials (Shelach 2000), products of a craft activity that attained far
greater significance in this region during the Middle Neolithic.

In South China, Early Neolithic communities integrated the cultivation of
morphologically wild rice into a mixed economy of hunting, gathering, and fish-
ing. In general, at this time villages were rarely larger than 5 hectares in size, small-
er than the largest contemporaneous communities in the north. At Pengtoushan
sites along the Middle Yangtze River, Early Neolithic houses were small and round,
but rarely semisubterranean like those to the north. Burials were rarely clustered
in a separate settlement sector, as in the north; rather, they were positioned near
individual houses, as were subterranean storage features. In addition, burials gen-

erally were simpler than at sites to the north, with few grave goods. Walls encircled some sites (Hunan Provincial Institute 2006).

Xiaohuangshan settlements along the Lower Yangtze River were associated with large, rectangular longhouse structures. Burials were not clustered in discrete funerary areas. Pottery forms generally were less diversified and mostly had rounded bottoms in both Yangtze regions, so cooking practices may have differed from those of the north at this time. Although variable, most Early Neolithic communities across China appear to have been planned, with relatively even spacing between houses, separation between public and ritual spaces, and the placement of walls or ditches beyond the earliest and densest cluster of dwellings (Heng Zhang et al. 2005).

Middle Neolithic (c. 5000–3000 BC)

By the end of the Early Neolithic period in China, emergent social differentiation and inequalities are evidenced by marked disparity in settlement sizes, burial treatments that varied for factors other than age or sex, and house sizes and degrees of elaboration that varied within settlements. Each of these axes of variation was present in certain regions but not necessarily all others, at a time when people settled in more permanent settlements that fostered demographic growth and adjusted means of cooperation (e.g., Feinman 2013; Price and Feinman 2010). During the subsequent Middle Neolithic, population dramatically increased across China. Reliance on staple, generally morphologically domesticated, grains grew as Neolithic ways of life had an expanded footprint over a wider area of China, across a broader suite of environmental zones (fig. 51). At the same time, both in the north and the south, degrees of social stratification and political complexity increased in many regions. Yet the pathways and manifestations through which these inequalities of power and access were materialized varied regionally. By the Late Neolithic, economic stratification and distinct differences in political power and authority were in place across a broad swath of China, but the specific manifestations of these inequities were not uniform, with somewhat distinct patterns of interpersonal differentiation emerging in eastern and western China (Shelach 2015, 158–59).

During the Middle Neolithic, larger communities, especially in North China, often had architectural features indicative of special functions rarely seen at small contemporaneous villages. At Yangshao communities, small domestic units often encircled a central plaza or a number of larger structures, which may have had communal functions (see fig. 50). For example, at the Xipo site, which grew to 40 hectares in size during this period, there were several large central buildings (each roughly 80 square meters in extent), one of which has been excavated. These structures sat atop foundations of pounded earth. The entrance to the excavated structure was long and narrow, with an interior hearth placed in front of the entryway. There were traces of red pigment associated with the floor and walls of the

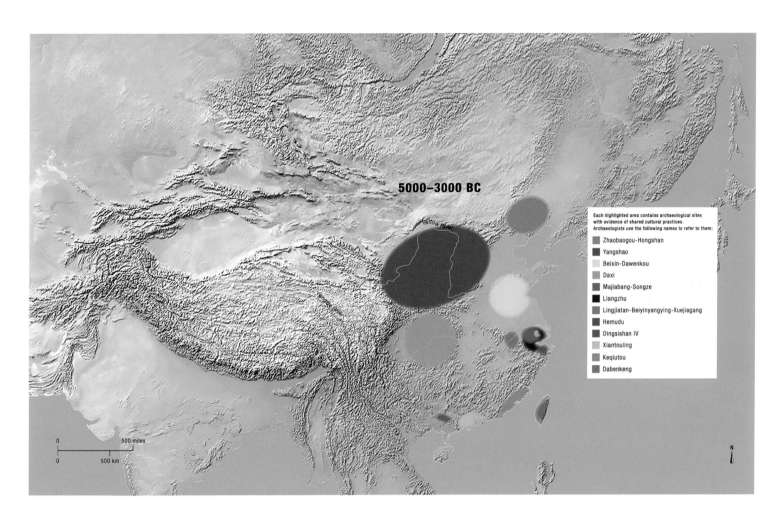

5000–3000 BC

Yellow River

Each highlighted area contains archaeological sites
with evidence of shared cultural practices.
Archaeologists use the following names to refer to them:

- Zhaobaogou-Hongshan
- Yangshao
- Beixin-Dawenkou
- Daxi
- Majiabang-Songze
- Liangzhu
- Lingjiatan-Beiyinyangying-Xuejiagang
- Hemudu
- Dingsishan IV
- Xiantouling
- Keqiutou
- Dabenkeng

0 500 miles
0 500 km

N

FIGURE 51

Chinese Middle Neolithic cultural tra-
ditions (c. 5000–3000 BC). © The Field
Museum. Illustrator Erica Rodriguez.
Redrawn by Linda Nicholas.

building, indicative of a setting for ritual activities that were not open to all but
also were not restricted to a single household or family (Ma 2005, 29–36; Shelach
2015, 77). This part of the settlement was associated with communal feasting at
which large quantities of pork were served (Li 2013, 224).

Although large Yangshao villages during the Middle Neolithic often had pub-
lic or ritual buildings, central plazas, and encircling walls—all indicative of de-
grees of suprahousehold forms of cooperation—there is little evidence for marked
degrees of economic stratification or wealth concentration from burials or oth-
er contexts. Fine painted pottery was abundant at these sites (fig. 52), but it was
broadly distributed across houses. A highly unusual Yangshao burial of an adult
male from the site of Xishuipo, in northeastern Henan Province, seems more char-
acteristic of a ritual specialist than an aggrandizing individual or accumulator.
The central male was surrounded by three adolescents (two males and one female),
thought to be sacrificial victims. On each side of the principal's corpse were piles
of clamshells that were arranged to form representations of a tiger and a dragon.
Another pile of shells was positioned near the feet of the main internment next to
two human tibiae in a form that represents an axe (Shelach 2015, 83–85).

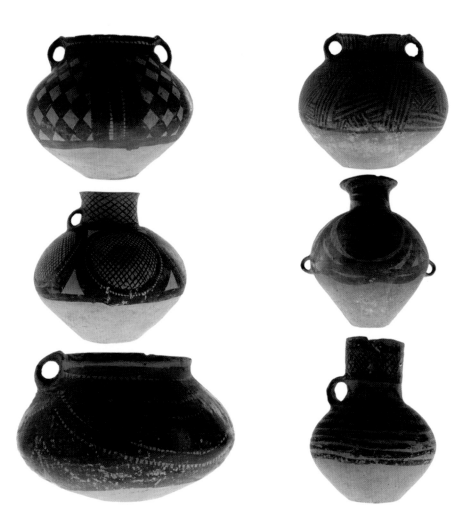

In Shandong Province, by 3500 BC, greater differentiation in access to funerary goods at death is evident in late Middle Dawenkou burials (see fig. 51). Graves from this period vary in size, quantity of interred goods (from zero to more than one hundred items), and in the elaboration of those grave accompaniments. Finely made tall cups, jade objects, and pig mandibles are some of the items that are more typically found in larger burial cists with greater numbers of grave goods (Li Liu 2004, 138–42). Yet even starker evidence for stratification has been found for the Late Dawenkou period.

Interpersonal and interhousehold differences in access and status were manifested in distinctive ways in Northeast China; for example, at Xinglongwa sites (see fig. 49) houses were laid out in rows, so that the doors of the dwellings did not face each other, as they did in contemporaneous Yangshao communities. Activities that took place inside or in front of dwellings were thus hidden from other houses. In contrast to the exterior pits found at Yangshao villages, Xinglongwa storage facilities were generally inside domestic structures (Shelach 2006, 2015), hidden from other coresident community members. In Northeast China, during the Middle Neolithic, a number of carved stone anthropogenic statues

and figurines have been found, some of which may represent specific individuals (Shelach 2015, 99–102). At the same time, archaeological correlates for community-based integrative mechanisms are less evident; thus, sociopolitical organization seems to have been less collective and more individualizing than for Yangshao (e.g., Feinman 2013; Li 2013; Price and Feinman 2010; Renfrew 1974). At this time in Northeast China, the importance of individualized socioeconomic networks was seemingly linked to the significant role of long-distance exchange. By the Middle Neolithic, domesticated rice from South China reached the northeast, probably through indirect, down-the-line exchanges.

In South China, a broad-spectrum subsistence regime dependent on a wide range of plant and animal species but centered on domesticated rice was in place by the Middle Neolithic. Along the Lower Yangtze River, Hemudu- and Liangzhu-phase sites (see fig. 51) generally are found in wetland catchments, and by the middle of this era, rice was cultivated in paddy-field systems (Chi Zhang and Hung 2008). Because of the waterlogged nature of the deposits at the site of Hemudu and some of its satellite communities—for example, Tianluoshan—the preservation of organic materials is exceptional, including large quantities of rice, as well as basketry and wooden artifacts (Center for the Study of Chinese Archaeology and Zhejiang Provincial Institute 2011).

FIGURE 53
Hemudu village diorama. © The Field Museum. Photo ID No. GN92118_058d. Photographer Karen Bean.

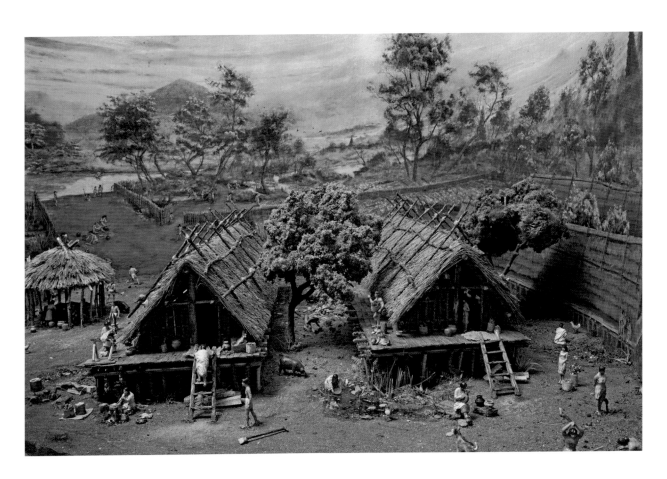

At Hemudu, houses were built of wood, raised off the ground by wooden poles (fig. 53). These "pole houses" were elongated in form and much larger than most residential structures in other regions of China during this period (Chang 1986, 208–11). Although we lack evidence to make a firm determination regarding power differentials or inequalities during the Middle Neolithic in the Lower Yangtze region, we do see marked differentiation in grave assemblages during the fourth millennium BC at the site of Lingjiatan. There, a large earthen platform was built at the center of the site, and more than fifty tombs were constructed. Whereas some graves had few goods, others contained hundreds of items, including crafted jade artifacts (Shelach 2015, 112–13). The crafting of jade pieces, especially prominent at Lingjiatan, was one of several highly skilled and labor-intensive artisan activities documented at Lower Yangtze sites of this period. At Hemudu, in excavations of waterlogged contexts, archaeologists recovered early lacquer artifacts (Jun Liu 2006), products of a highly skilled and time-consuming process by which a core material, such as wood or cloth, was coated with many thin layers of tree resin. The production of lacquer objects has continued for millennia in China. As in Northeast China, nascent inequalities during the Middle Neolithic along the Lower Yangtze were based on exchange and links to longer-distance networks, although the underlying subsistence regimes and village layouts were dramatically different in these regions.

Late Neolithic (c. 3000–1900 BC)

Across most of China, the Late Neolithic was a time of accelerated population growth and the continued expansion of sedentary agricultural villages (fig. 54). For the Late Neolithic, rapid growth is evidenced in two regions studied through systematic regional settlement pattern survey projects that have documented the size and location of sites across two extensive regions of North China, coastal Shandong Province (Fang et al. 2015; Feinman et al. 2010; Underhill et al. 2008) and the Yiluo area at the center of the Yellow River basin (Li Liu et al. 2004). The systematically collected findings from these regions parallel more general indications of increasing numbers of sites and sizes of the largest settlements across China, although there are exceptions, as in the Chifeng region in Northeast China, where the population declined from the fourth to the third millennium BC (Chifeng International Collaborative Archaeological Project 2011).

The increases in the number of Late Neolithic settlements across most of North China often were accompanied by greater population nucleation, marked by significant expansions in the size of the larger settlements in each region. These larger communities often were at the center of clusters of smaller communities, with the former encircled by walls or moats. Occupation often has been found beyond the extent of the walls at a number of these large settlements, while at others the encircling diameters of the exterior walls were expanded during the history of the site (Li Liu 2004, 109–10).

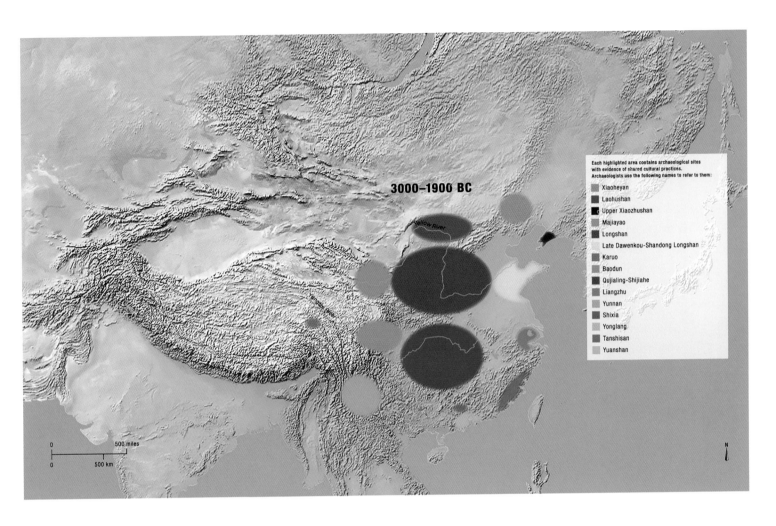

3000–1900 BC

Each highlighted area contains archaeological sites
with evidence of shared cultural practices.
Archaeologists use the following names to refer to them:

- Xiaoheyan
- Laohushan
- Upper Xiaozhushan
- Majiayao
- Longshan
- Late Dawenkou-Shandong Longshan
- Karuo
- Baodun
- Qujialing-Shijiahe
- Liangzhu
- Yunnan
- Shixia
- Yonglang
- Tanshisan
- Yuanshan

Yellow River

0 500 miles
0 500 km

N

FIGURE 54

Chinese Late Neolithic cultural traditions
(c. 3000–1900 BC). © The Field Museum.
Illustrator Erica Rodriguez. Redrawn by
Linda Nicholas.

One of the largest Late Neolithic settlements in China, Taosi, a Longshan-period site in Shanxi Province, was more than 3 square kilometers in size. The settlement was circled by a sequence of rammed earth walls during its occupation; some of the preserved wall segments are up to 10 meters wide. The site includes an area of roughly 1,000 square meters where large subterranean storage pits, possibly for centralized or community storage of grain, were concentrated. On a raised area that sat above the rest of the community, the foundations of more than one large structure were recorded (He 2013; Li Liu 2004, 109–11; Shelach 2015, 131–32, 137–38). Because of their raised and somewhat segregated location, these large foundations are thought to have an elite or public function. Another large earthen platform, linked to ritual and thought to be an astronomical observatory, also was found outside the site's central precinct (He 2013).

Many graves have been excavated at Taosi in discrete cemetery areas, and a wide disparity has been noted in the sizes and accompaniments of these funerary features (He 2013). Most were small with few grave inclusions. One burial, however, was especially elaborate, with large numbers of highly crafted jade, lacquer, wood,

bone, and ceramic goods, some of which probably were exotic. The individual in this grave was interpreted to have been a paramount leader. Yet most of the mortuary accessories in association with the burial, including masks and hunting tools, are related to specific ritual and functional activities and were mostly not items of elaborate adornment. Overall at Taosi, despite the presence of a small percentage of high-status burial contexts (just above 1 percent of known graves), there appears to have been more consistent investment in platforms, structures, and walls at the site than in the production of fine, portable objects of value and their internment (He 2013; Shelach 2015, 141).

Although Late Neolithic social relations across most of China were generally more hierarchical and stratified than they had been earlier, region-to-region variation remained a key feature of the Chinese Late Neolithic (Shelach 2015, 150). For example, no settlements, even larger ones, in the south were walled. Most Liangzhu sites in the Lower Yangtze region (see fig. 54) were small, and while ritual mounds were built at some of these sites, they mostly were associated with elaborate burials that were positioned in the mounds. There are no discrete cemetery areas. The interred graves were parts of monuments, often including elaborate jade ornaments and ritual items that are more plentiful and intricate than those found at Henan-Shanxi Longshan sites. The production and exchange of these jades may have been tied to status and power (Li Liu 2003).

Shandong Longshan settlements generally have more in common with Longshan sites to the west than with Liangzhu communities in South China (see fig. 54). The largest Longshan centers in Shandong Province range between 2 and 4 square kilometers and, in some cases, have surrounding walls (Fang et al. 2015; Feinman et al. 2010; Underhill et al. 2008). As at Taosi, centrally situated earthen platforms have been noted at some of the large Longshan settlements in Shandong, although the function of these platforms remains unclear. Jade ritual items are more prevalent on the Shandong coast than farther to the west; however, they are not as intricate, finely fashioned, symbolically complex, or diverse in form as they are to the south.

Elaborate jade forms such as *cong* (tubes with a circular inner section and a squared outer section) and *bi* (flat discs with round central hole)—most frequently made of stone materials local to the Liangzhu area—are naturally most common in this region (figs. 55 and 56). Yet these labor-intensive stone objects also have been found (mainly in graves) in coastal Shandong, in Northeast China, and in small quantities at Taosi and sites even farther west (Shelach 2015, 152–54). These objects probably were transported via indirect or down-the-line exchanges that could extend over more than 1,500 kilometers. The widespread distribution of Liangzhu jades does not indicate that these objects necessarily held equivalent meanings for all who possessed them. Nor do they indicate a shared culture across China. Rather, these objects almost certainly had a deeper symbolic significance for people in the Liangzhu region, but they were still recognized as precious and prestigious across wider socioeconomic networks. These networks were particularly

active in eastern China, where communications along the coast have an extended history. The importance of these extraregional networks in eastern China during the Neolithic, especially for those of higher status, would seem to underpin the more individualizing forms of inequality and stratification present in that part of

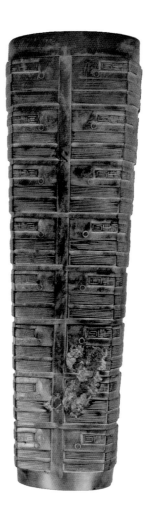

FIGURE 55
South China Neolithic-style and Neolithic jade *cong* tubes. © The Field Museum. Catalog Nos. 182677, 183456. Photographer Gedi Jakovickas.

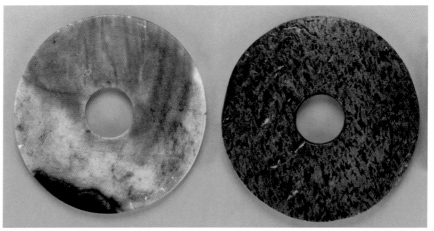

FIGURE 56
South China Neolithic jade *bi* disks. © The Field Museum. Catalog Nos. 116577, 116578. Photographer Gedi Jakovickas.

CHAPTER THREE

China as compared to the more collective or communal forms of organization evident in the west (e.g., Blanton and Fargher 2008; Blanton et al. 1996; Shelach 2015, 154–60). These interaction networks were an essential element of Neolithic China, as much more than jades were shared through these links. Yet we now can recognize that whereas Chang's (1986, 238) early recognition regarding the importance of cross-regional networks was spot on, we presently know that the directionality and timing of the flows were far more diversified and variable than the steady outward pulsations from the two major river valleys to the rest of China that he and others envisioned decades ago.

Concluding Thoughts

We began with the observation that China's history is a mosaic of dramatic change and remarkable continuity. These seemingly contrasting elements are starkly evident in the consideration of the Neolithic era. On one hand, the millennia of the Neolithic span the time when people in China transitioned from life in small villages and a reliance on mixed economies that included regionally different wild grains and other plants, hunting, and fishing to large communities of thousands of people (possibly more than ten thousand) with economies dependent on cereal agriculture of different kinds, extensive management of domesticated animals, but also the production and exchange of wheel-made pottery, highly crafted jade, lacquer pieces, and woven textiles. By the end of the Neolithic, regional populations across China were orders of magnitude higher than they had been at the outset of this era, and new forms of social, political, and economic cooperation were forged.

At the same time, key elements of China's Neolithic era endure to the present and have served to shape the subsequent four thousand years of the region's history. These continuities extend beyond cereal staples and other key domesticated foods that continue to underpin China's subsistence regimes (Zhao 2011) and extend to copper and bronze metallurgy, a Late Neolithic technological innovation from China's northwest that also was found in Late Neolithic contexts at Taosi, and in north coastal Shandong Province (Shelach 2015, 146; Underhill 1996, 145). Like bronze, the Chinese written script was another key element fundamental to China's subsequent Bronze Age (c. 1900–221 BC) that also may have had its earliest foundations in the Neolithic era (Li Liu 2004, 203; Shaughnessy, this volume), even though Neolithic signs and symbols found on pottery and other materials may not be directly ancestral to any later Chinese scripts.

Likewise, Neolithic Liangzhu ritual forms, such as the *cong* and *bi*, persisted into the Bronze Age and even more recent times (Chang 1989). Yet it is too early and our knowledge is too fragmentary to presume that the meanings attached to these enduring symbolic forms remained constant over time and space, or that the temporal transmission of them was direct and continuous, rather than complex and punctuated.

The evident deep historical continuities that we have noted here (and in the *Cyrus Tang Hall of China*) should not be interpreted in support of the perception that China or Chinese cultural traditions are somehow primordial, natural, or uniform. In fact, from the earliest Neolithic roots (and even before) Chinese people and their traditions have always been highly diverse, and they remain so today. At the same time, institutions, mechanisms of cooperation, and shared traditions were constructed over time to bridge that cultural and landscape diversity, and some of these human constructions, including political and philosophical constructs and social contracts, have had great and repeated endurance over time, although generally not unbroken continuity. Some of these long-lived elements extend back to the Neolithic era, thereby affording us the chance to highlight future-shaping continuities during a time of dramatic change.

Note

We thank Deborah Bekken, Xuexiang Chen, Lisa Niziolek, and Hua Wang for offering comments on an earlier version of the paper and providing essential bibliographic assistance.

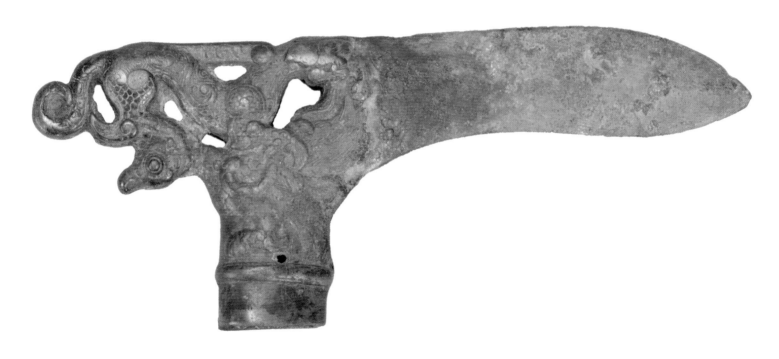

Ritual and Power, War and Unification

The Bronze Age in China:
What and When

Yung-ti Li

The term "Bronze Age" comes from the tripartite scheme of Stone-Bronze-Iron Ages first proposed by Christian Jürgensen Thomsen (1788–1865), a Danish antiquarian and museum curator, who attempted to order human prehistory and history into periods based on the predominant materials used for tools at the time. Although this periodization has become more problematic with new archaeological discoveries and research in recent times, the tripartite scheme is still widely used, with modification, to refer to specific time periods in different parts of the world.

"Bronze Age" in China conventionally refers to the time period from c. 2000 to c. 500 BC, during which bronze, an alloy of copper and other metals such as tin and lead, was the predominant medium used by society or, to be more precise, the elite classes of society. Bronze objects, mainly in the forms of vessels, weapons, and, later, musical instruments, were reserved for the upper ruling class and were used mostly as paraphernalia during rituals and feasting. Although the appearance of bronze objects marks the onset of the Bronze Age in China, the conventional end date is more arbitrary. It falls conveniently in the Middle Eastern Zhou period (770–256 BC), when iron technology became more widespread. Bronze objects, however,

were not replaced but were still being made and used until much later. "Bronze Age" in China also indicates the emergence and eventual maturation of states with their bureaucratic systems, the presence of urban centers, a sophisticated writing system, and advanced craft-producing industries, especially metal production.

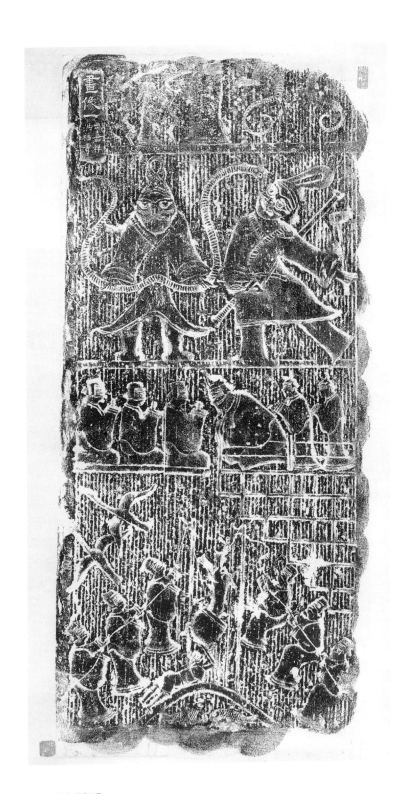

Discovery of Bronzes and the Metal-Stone Antiquarian Tradition

The discovery of artifacts from the ancient past is not a monopoly of modern archaeologists. As early as the Han Dynasty, pictorial representations depicted scenes of a bronze vessel being discovered and hauled from a river. As in figure 57, the scene shows a group of figures in formal attire hauling a *ding* vessel from a river with a rope. A common pictorial theme of the time, it tells the story of how the First Emperor, Qin Shihuang 秦始皇 (259–210 BC), tried but failed to retrieve a *ding* 鼎 vessel from the Si River 泗水. As *ding* symbolized the heavenly mandate to rule, the story no doubt served a propagandist function to the Han Dynasty, which succeeded Qin Shihuang's. While not a record of the finding of an actual bronze, it shows how people in the past came into contact with the antiquity of earlier periods.

FIGURE 58

Full-form composite rubbing 全形拓 of an inscribed *you* vessel similar to the *you* in The Field Museum. Rubbing from the collection of Liu Tizhi 劉體智 (1879–1962), courtesy of the Institute of History and Philology, Academia Sinica, Taipei, Taiwan. Early Western Zhou vessel: © The Field Museum. Catalog No. 117377. Photographer Gedi Jakovickas.

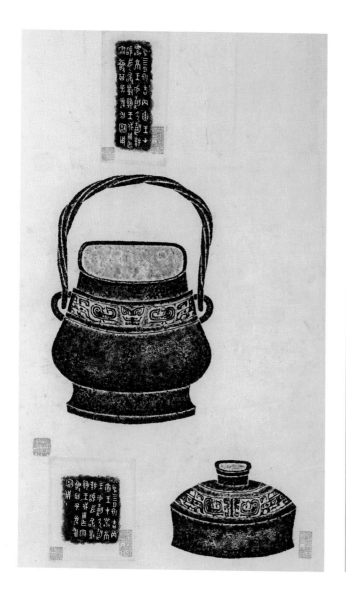

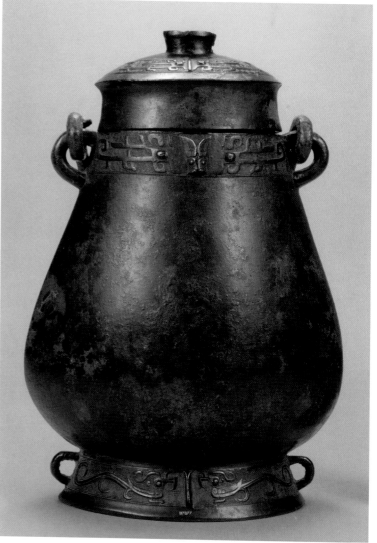

By the Northern Song Dynasty (AD 960–1127), the study of ancient metal and stones, *jinshixue* 金石學, had become an established academic tradition. *Jinshixue*, or antiquarianism, refers to the study of unearthed, mostly accidentally found, bronzes (*jin*) and steles (*shi*), especially the inscriptions found on bronzes and stones. Members of the literati, or the educated elites, formed collections of bronzes and collected and circulated rubbings of inscriptions (fig. 58). The earliest known bronze catalog is *Kaogu tu* 考古圖, *Investigations of Antiquity Illustrated*, compiled by Lü Dalin 呂大臨 (1040–92), whose tomb and associated family cemetery in Shaanxi were found and excavated between 2006 and 2009. Literati in later times continued the tradition, and before the introduction of modern archaeology in the twentieth century, *jinshixue* was the main academic tradition that studied objects and inscriptions from antiquities. Up to the present day, epigraphy and the study of Bronze Age China have been deeply influenced and shaped by the antiquarian tradition (Chang 1980, 1986; Falkenhausen 2015; Feng Li 2013).

Modern Archaeology and the Rediscovery of the Bronze Age

In the early twentieth century, archaeology was introduced to China as a new means to study ancient history. The new Institute of History and Philology (IHP) 歷史語言研究所, Academia Sinica 中央研究院, appointed scholars trained in the West to lead archaeological investigations at the site of Anyang, where inscribed oracle bones were said to have been unearthed. The fifteen seasons of excavations by IHP uncovered the rich material culture of the Shang Dynasty, a dynasty known previously only from transmitted texts (fig. 59). Although the Anyang campaign between 1928 and 1937 was not the first archaeological expedition in China, it established and cemented the importance of the discipline of archaeology in modern China. In the following years and through field archaeology, scholars have rediscovered the Chinese Bronze Age in its most tangible manifestations (Chang 1980; Chi Li 1977).

Traditional Historiography and the Three Dynasties

China has a long tradition of historiography, one of the earliest and most well-known examples being *Records of the Grand Scribe* 史記 by Sima Qian 司馬遷 (c. 145–86 BC), written in the Han Dynasty (206 BC–AD 220). In his accounts, which were based on other earlier and contemporary historical texts, Sima Qian wrote of a period known as the "Three Dynasties" 三代, which includes the Xia 夏, supposedly the earliest dynasty in China; its successor, the Shang 商; and the Zhou 周, which overturned the Shang and became the hegemonic power in ancient China. The term "Three Dynasties" implies a linear and evolutionary trajectory that emphasizes single and successive hegemonic political powers. The emphasis of this linear scheme is on obtaining the mandate to rule, or the Mandate of Heaven 天命, a concept invented by the Zhou that became seminal in later times. The scheme of

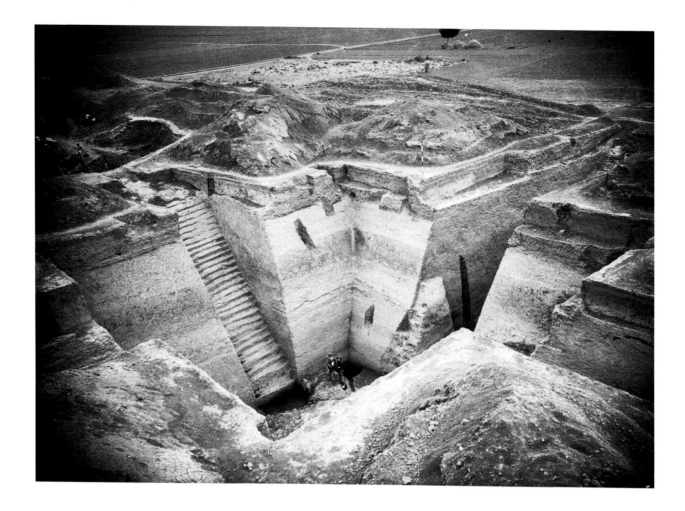

FIGURE 59

Excavation of Royal Tomb No. 1002, Xibeigang, Anyang, by the Institute of History and Philology, Academia Sinica, spring 1935. Courtesy of the Institute of History and Philology, Academia Sinica.

the Three Dynasties had since been firmly established in traditional historiography and was not challenged until the "Doubting Antiquity" 疑古 movement led by Gu Jiegang 顧頡剛 in the early twentieth century. Gu and his followers questioned the trustworthiness of transmitted texts, among them those mentioning the Xia Dynasty. They argued that the Xia was fabricated by later generations, noting that the later the text, the more detailed the history of Xia becomes. Although the arguments of the Doubting Antiquity movement had force, the movement did not keep its momentum for long. Excavations at Anyang in the 1930s, and especially more recent archaeological finds in China, seemingly validated the accounts recorded in transmitted texts, leading some scholars to claim that it was time to leave the Doubting Antiquity movement behind. (For a review of the movement and its influences see Chang 1980, 1986; Falkenhausen 2015; and Feng Li 2013.)

Although many modern scholars endorse the scheme of the Three Dynasties, labeling sites of Bronze Age as well as Late Neolithic periods with place-names and dynasties recorded in transmitted texts, some question the validity of the unilinear model and the practice of quoting from transmitted and noncontemporary texts to study Bronze Age China (e.g., Allan 2007; Bagley 1999; Chang 1983;

Falkenhausen 1993; Yung-ti Li 2014; Liu 2009; see also Chang 1980 and 1981 on the productive use of transmitted texts). They argue that transmitted texts misrepresent the multifaceted nature of Bronze Age China, the vast area of which was probably not ruled over by a single hegemonic dynasty. The notion of linear, successive, and hegemonic dynasties in Bronze Age China is basically a projection of the later imperial dynastic model, and its accompanying presumptions, into the past. Modern archaeology did not just provide evidence for the existence of the Shang and the Zhou Dynasties. It has also shown convincingly that traditional historiography and transmitted texts can be biased and do not represent the full picture of the past.

This chapter applies names and terms found in traditional historiography only cautiously. The term "dynasty" is only used to refer to the Shang, in particular Anyang, and the Zhou, from both of which we have contemporary texts, such as oracle-bone and bronze inscriptions, that name kings and mention in passing details of political history. To describe Bronze Age China before the time of Anyang, names of "archaeological cultures" are used. "Erlitou" 二里頭, instead of Xia, and "Erligang" 二里崗, instead of Early Shang, are used to refer to the main Bronze Age archaeological cultures preceding Anyang.

Bronze Age China Outlined by the Development of Metal Technology

Archaeological discoveries suggest that metalworking came to China via the Qijia 齊家 culture (c. 2200–1600 BC), a bronze-using culture in the Gansu Corridor in northwestern China (Chen 2013). The dates and the westerly geographic location of the Qijia culture indicate that bronze technology most likely was introduced to China from the surrounding regions such as Siberia, although several scattered finds have been made in China, among them the cast bronze bell from the Late Neolithic site in Taosi 陶寺, Shanxi, which might indicate a different scenario for the beginning of bronze technology in China (see Mei et al. 2015 for an up-to-date discussion on recent metallurgical studies). Bronzes produced and used by the Qijia culture consist mainly of tools and small objects such as mirrors, and the metal production is characterized as "small-scale metallurgy" by Bagley (1999, 140–41), which refers to the small scale of operation and relatively simple technology.

Soon after its appearance in the Gansu Corridor, metal technology developed quickly in the Central Plains region in manufacturing techniques and production scale. The first full-blown bronze civilization in China, the Erlitou culture, located in the Middle Yellow River Valley (c. 1900 BC), began to cast bronze vessels of complex shapes using section-mold technology. Although simpler in forms and decorations and smaller in sizes and numbers than those from later periods, bronzes from the Erlitou culture indicate that artisans at the time already had begun to make pieces that were drastically different from the bronzes of the preceding Qijia culture in terms of function and manufacturing techniques. Erlitou bronzes include vessels such as *jue*, *ding*, *he*, and openwork plaques with turquoise inlays. The

making of vessels with complex shapes for cooking and serving required the more sophisticated section-mold technology, rather than the simple bivalve-mold casting of the Qijia culture. Scholars argue that the Erlitou bronze industry is therefore qualitatively different and should be termed "large-scale production" (Bagley 1999, 141–42). The Erlitou culture is also known for its large palatial complexes at the type site (Erlitou), and for large jade blades of several types. With these features, together with the ability to procure metal from other regions for its bronze industry, the Erlitou culture is recognized as the first state-level society that passed the threshold of civilization in China (Xu 2013). However, no evidence of writing has been found, leading some scholars to reject correlating the archaeological culture with the Xia Dynasty (Bagley 1999; Liu 2009; Liu and Xu 2007). A second group of scholars argues that while we lack evidence to prove that the so-called Xia Dynasty existed, we also must recognize that some archaeological discoveries coincide with the temporal and spatial framework of it (e.g., Feng Li 2013). At the moment, the opposing schools of thought are not reconcilable, as the argument of each side is based on the acceptance or rejection of the accounts recorded in transmitted texts.

By the subsequent Erligang culture, artisans in the Central Plains region were casting bronze vessels of impressive sizes and in large quantities (fig. 60). The type site, Erligang, known for its massive rammed-earth wall enclosure, was

FIGURE 60
Erligang bronzes from a hoard found in Nanshunchengjie 南順城街, Zhengzhou, Henan Province. The assemblage includes four *fangding* 方鼎, two *jue* 爵, two *jia* 斝, two *ge* 戈, one *yue* 鉞, and one *gui* 簋. © Henan Provincial Institute of Cultural Relics and Archaeology.

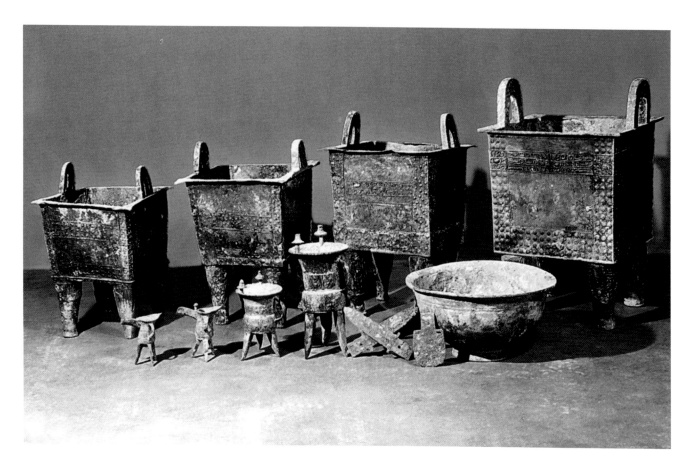

one of the largest urban centers in the world at the time. Although now buried underneath the modern city of Zhengzhou, periodic finds of caches of bronzes, bronze workshops, underground water pipes, and human sacrifices testify to the advanced nature of the urban center (Yuan 2013). There is, however, little trace of writing except for some individual characters written on pottery. Erligang, situated in Henan Province in the middle Yellow River Valley, is also known for its expansion, as pottery and bronzes of uniform styles have been found widely across China (Bagley 1980, 1999; Liu and Chen 2003; see also Steinke 2014). For example, a walled settlement with identical elite material culture was found 500 kilometers south of Zhengzhou at Panlongcheng 盤龍城, Hubei Province (see Bagley 1977). Panlongcheng is generally thought to be an outpost established by Erligang in the copper-rich middle Yangtze River valley to secure the raw materials needed for its bronze industry. Or it could be one of the many garrisons of Erligang outside the Central Plains (see Steinke 2014). Future research and excavations at Panlongcheng may show that the southern walled settlement was a regional center of its own, not just a mere offshoot of Erligang.

It is also right before the Anyang period that we begin to see regional variation in styles and forms of bronzes in contrast to the more uniform styles seen among the Erlitou and Erligang bronzes (Bagley 1999). Scholars suggest that this was the result of the receding influence of the Central Plains region and the increasing social complexity outside the Central Plains after the Erligang period. It is argued that the Erligang expansion introduced metal technology and perhaps some elements of the sociopolitical system of the Central Plains to the surrounding and outlying regions, spreading the seeds of civilization (Bagley 1980). By the Anyang period, more distinctive regional bronze cultures had formed, although, except in certain areas such as the upper Yangtze River valley, bronzes made outside of Anyang seem to be of lesser quality.

By the Anyang period, when a fully developed writing system is known to us in the form of oracle-bone inscriptions (see fig. 79 in Shaughnessy, this volume), bronze production was unprecedented in scale. Bronze workshops were found in several locations across the settlement at Anyang, which produced bronzes for the lower and upper elite, and especially for royal use. The bronze workshops were usually situated in production precincts, and other craft industries, such as bone and pottery working, were located in the same vicinity (Yung-ti Li 2007). Workshop debris, such as mold and furnace fragments, was found in the tens of thousands of pieces at these various locales. Anyang was not only the capital of the Shang Dynasty; it was also a center of craft production and consumption of resources (for recent studies on the capital, see Jing et al. 2013).

Current archaeological data suggest that the Western Zhou (c. 1046–770 BC) adopted Shang bronze technology and perhaps also the managerial bureaucracy over craft production. Soon after the conquest, bronze workshops with technology identical to that at Anyang started producing bronze vessels on an equally large scale in Zhouyuan 周原, Shaanxi, and Beiyao 北窯, Henan, the homeland

and heartland of the Western Zhou. Thanks to the large corpus of bronze inscriptions, we now know Western Zhou consisted of multiple regional states that had sovereignty over domestic matters but were bound by the kinship system of royal lineage and not totally independent from the Zhou king (Feng Li 2008, 2013; Shaughnessy 1999). By the late Western Zhou, bronze assemblages used in burial contexts had become more homogenized, perhaps as the result of the now firmly established codes and rituals of the elite culture (Falkenhausen 1999; Rawson 1999).

By the late Spring and Autumn period (770–475 BC), the regional states had become more autonomous, and we see many more full-fledged regional bronze production centers throughout Zhou territory (Falkenhausen 1999; Feng Li 2013). This is also the time when regional styles can be clearly associated with individual states. For instance, scholars have identified bronzes from various states, including Jin 晋, Zheng 鄭, Chu 楚, Zeng 曾, and Qin 秦 (fig. 61). By the time of the Warring States period (475–221 BC), the sovereignty of the Zhou king was no longer recognized by the regional states, which were competing among themselves for supremacy over what had been the Zhou realm. The political landscape shifted constantly as one hegemonic power overturned another. Warfare intensified with the help of newly formed military specialists, and colossal walls were built around settlements for defensive purposes. Other social and economic changes included advancement in metal technology, the use of regional currencies, an active merchant class, and large-scale civil engineering, all paving the road to the eventual unification of China by the peripheral state of Qin situated in the west of the Central Plains region (Lewis 1999; Feng Li 2013; Xueqin Li 1985).

FIGURE 61
A *guanpan* 盥盤 basin (Eastern Zhou period), presumably for ablutions. Similar examples are found in the Huai River Valley and may be vessels from the state of Xu 徐. © The Field Museum. Catalog No. 117361. Photographer Gedi Jakovickas.

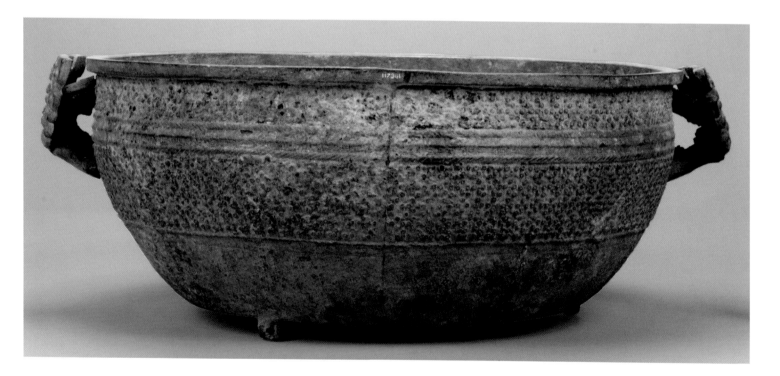

Bronze Vessels: Forms and Decorations

The current terminology for bronze vessels comes mainly from the antiquarian tradition. Terms such as *ding*, *gui* 簋, and *you* 卣 were already in use in the Northern Song bronze catalogs. Some terms, such as *ding* and *gui*, correlate well with terms used in the inscriptions. Others, however, may not necessarily reflect the names of the objects used in the Bronze Age. In the occasional instances when bronze vessels are mentioned in the inscriptions, the terms used may be generic or different from the current terminology. Since the traditional nomenclature has been used for centuries and is well established in the literature, it is still followed in this chapter. Figure 62 shows examples of the diverse shapes and forms of bronze vessels from the Shang, the Western Zhou, and the Eastern Zhou periods, and their names in Chinese.

Bronze vessels also can be classified by function. Although not all of the functions can be verified, scholars usually divide bronze vessels into categories of cooking, serving, decanting, drinking, performing ablutions, and other functions. Early texts mention the use of certain vessels for specific purposes, such as *ding* for offering sacrificial meat, *yan* 甗 for steaming food, or *gui* for offering grains. Archaeologists have found animal bones inside *ding* vessels, and liquid, possibly alcoholic beverages, inside lidded vessels such as *you*. Soot is often found on the outside of *ding* vessels, suggesting that they were used for cooking. During the Eastern Zhou period (770–256 BC), pictorial representations of rituals and feasting depict how vessels similar to known bronzes were used at the time. For instance, figure 63 shows a large *ding* vessel being used during ceremonies, possibly for cooking food to be shared.

The earliest bronze vessels from the Erlitou culture are either plain or have simple linear or geometric decorations. By the time of Erligang, bands of creatures with eyes began to appear on bronzes, but most of the vessel body remained undecorated. In the following transitional period, multibanded decorations began to cover more areas of the vessel body, and the creatures developed into more complex shapes. By the Anyang period, these motifs were given more concrete rendering, and real animals such as tigers, elephants, buffalo, long-tailed birds, and snakes were added to the older imaginary animals of Erligang bronzes. Decorations of a typical Anyang-style *ding* vessel, for instance, have three separate panels evenly situated between the legs—a design related to the mold division pattern—with an animal motif that is split, unfolded, and placed in the center of each panel. The centrally placed animal often has another vertical animal, usually a dragon, flanking either side. The background is filled in with spirals (fig. 64). The center motif takes up most of the space in each panel and becomes the focal point. It was given the name "*taotie*" 饕餮, a gluttonous mythical animal, by the Song-period (AD 960–1279) antiquarian scholars and has been in use since. It is also referred to as the "animal-face motif" 獸面紋 in the more recent literature.

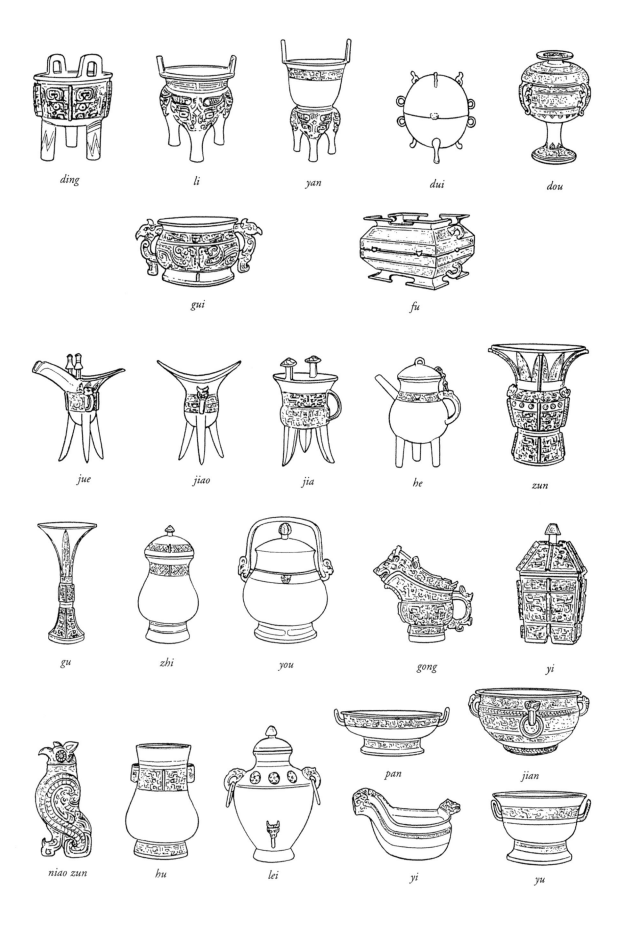

ding li yan dui dou

gui fu

jue jiao jia he zun

gu zhi you gong yi

pan jian

niao zun hu lei yi yu

FIGURE 63
Incised decoration on a *yi* 匜 bowl from the
Warring States period, in the Shanghai
Museum, that depicts scenes of rituals
and feasting. A large *ding* vessel can be
seen on the right side of the elevated and
roofed platform. © Li Xiating.

FIGURE 64
A large *fangding* with a prominent and
elaborate animal mask motif, or *taotie*,
with buffalo horns. Flanking the *taotie* are
two crested parrots. Late Shang period.
From Royal Tomb No. 1004, Anyang,
excavated by the Institute of History and
Philology, Academia Sinica. Courtesy
of the Institute of History and Philology,
Academia Sinica.

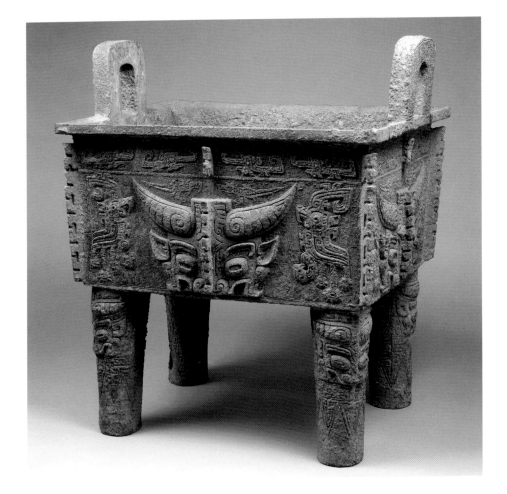

The classic Anyang style was adopted in the early Western Zhou, and it was not until the middle Western Zhou that a new and distinctively Zhou style of bronzes began to appear (Rawson 1990, 1999). By the late Western Zhou, decorations had become more geometric, with simple and repeated patterns forming continuous waves and bands (for an example of late Western Zhou bronzes, see fig. 81, Shaughnessy, this volume). New vessel forms were also introduced, suggesting different functions and different ritual contexts (Rawson 1990, 1999; cf. Feng Li 2013). Along with the technological changes in the Eastern Zhou (see below) came new decorative styles, including lively representations of realistic and mythical animals, and the use of incision and copper, gold, and silver inlay on the vessel surface, and, for the first time, a few pictorial representations of realistic and imaginary scenes and landscapes (fig. 62) (So 1995; Wu 1999). Some of these new styles continued into the Han Dynasty.

Making Bronzes from Clay: Section-Mold Technology

The intricacy of the designs and shapes of vessels led early Western scholars to argue that Chinese bronzes were cast using the same lost-wax method known for Greek and Roman bronze sculptures. Even though Chinese archaeologists had already found fragments of clay section molds and models and recognized that they were used for casting bronzes as early as the Anyang excavations in the 1930s, the fact that ancient Chinese metalworkers used section-mold technology was only firmly established in the 1960s in the West (cf. Karlbeck 1935). Through technical studies of bronzes, clay model and mold fragments, and especially replication experiments, we now know much more about the technical details of section-mold technology.

The act of casting involves making the model, which is in the shape of the finished product, transferring the shape and decoration of the model to the mold, and then reproducing the model by pouring molten bronze into the mold (fig. 65). Although in the Greco-Roman tradition the model was often made of wax, in ancient China the model was formed in clay and then fired. Section-mold technology refers to the making of a mold in sections in order to remove the mold from the clay model. Lost-wax casting and section-mold casting are not necessarily opposing technologies, as section molds were also used during complex lost-wax casting in the Greco-Roman tradition. In China, lost-wax casting appeared in the Spring and Autumn period in the sixth century BC, more than a thousand years after the beginning of section-mold casting in the Erlitou period.

Bronze casters of ancient China used a wide range of techniques in making bronzes with the section-mold method. During the Erlitou period, decorations were carved directly on the mold, as indicated by the raised lines on the bronzes. The cursive contours of the decoration on Erligang bronzes suggest that brushes were used (Bagley 1987, 2009). In the Anyang period, artisans applied decorations

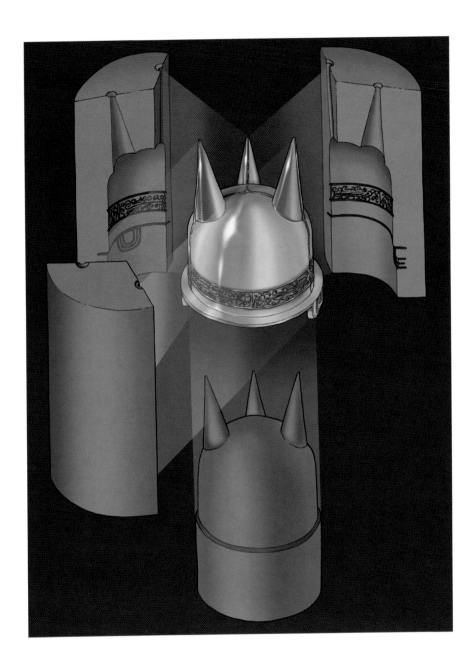

on both the model and the mold. It is likely that the model was made in sections
and decorated with the main motifs only, while the fill-in spirals were applied di-
rectly on the mold (cf. Bagley 2009; Nickel 2006). The discovery of stamp-like dec-
orated pieces in Anyang indicates that artisans also stamped individual patterns
directly onto the mold.

By the Eastern Zhou period, the scale of bronze production increased mani-
fold, and the political landscape had become more segmented and diffuse. These
two factors—increase in production and a segmented political landscape—per-
haps led to changes in workshop organization for more efficient production, at
least in the bronze industry, of which the Houma 侯馬 foundry serves as a good
example.

The Houma foundry of the state of Jin was located archaeologically in the 1960s and the excavations yielded large amounts of foundry debris, including model and mold fragments with intricate and finely executed designs (fig. 66) (Bagley 1996; Shanxi sheng kaogu yanjiusuo 1996). Studies on fabrication techniques of the Houma bronzes have shown that by the late Spring and Autumn period, the vessel bodies and appendages of bronzes were made separately and joined later in the production process (Gettens 1967, 1969). Studies of the making

FIGURE 66
Mold fragments from the Houma foundry of the state of Jin for a *ge*-halberd almost identical to a *ge* in The Field Museum. Late Spring and Autumn period. Mold: Image courtesy of Feng Zhong; *Ge*: © The Field Museum. Catalog No. 232992. Photographer Gedi Jakovickas.

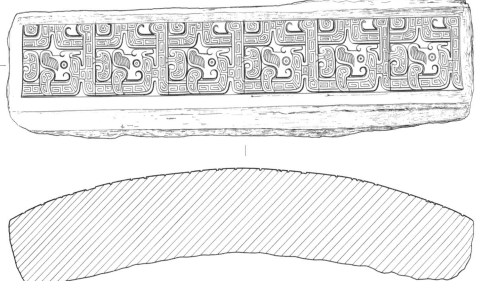

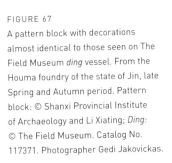

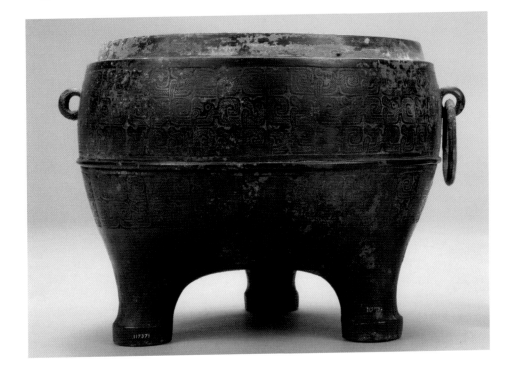

of bronze decor, on the other hand, indicate that replication techniques were developed to produce versions of the same decorations to be applied to vessels of different sizes and shapes (Bagley 1993, 1995; Keyser 1979). The method involves making a fired clay model of only the decoration, called a pattern block (fig. 67), and then applying wet clay slabs to take impressions of the decoration. The decorated clay slabs could then be trimmed, molded, or joined to form larger and longer bands of fine decoration in the mold sections. This method, called the "pattern block technique" by Bagley (1993, 1995), enables a division of labor between the model and the mold makers, meaning that the work of the model makers, whose carving and artistic skills could be attained only through years of training, could be maximized by replicating and transferring decor from the model onto the mold. These changes in the fabrication techniques and division of labor undoubtedly indicate changes in the operational sequence and the organization and management of the workshop.

Casting the Foundation of Civilization: Metal Production in Bronze Age China and Its Significance

The most important characteristics of metal technology in Bronze Age China are the section-mold method, the scale of production, and the emphasis on ritual vessels and paraphernalia for elite use, all of which are clearly demonstrated by archaeological discoveries such as the tomb of Marquis Yi of the Zeng state 曾侯乙 (buried in 433 BC) and the Houma foundry of the Jin state (sixth to fifth century BC). The massive number of bronzes from the tomb of Marquis Yi (fig. 68) and the tens of thousands of foundry debris fragments found in Houma show that bronzes were produced on a scale unparalleled in other ancient civilizations. Both finds also show that section-mold technology was highly developed to meet the elite demand for large quantities of bronzes in various forms and styles. Last, all the bronzes in the tomb of Marquis Yi and most Houma products were intended for the exclusive use of the elites.

The massive scale of production and the technological choice of section-mold casting has led scholars to characterize the bronze industry of ancient China as one based on the abundance of metal (e.g., Bagley 1999) and one with complicated production organization (e.g., Franklin 1983a, 1983b; Yung-ti Li 2007). For instance, while hammering was the preferred way of making simple metal shapes in ancient Egypt and Mesopotamia, casting was the predominant method the Chinese used to make bronzes. It has been pointed out that hammering makes use of the malleability of metal to economize the raw material, whereas casting is a more costly way of making metal objects, as the process does not conserve metal (Bagley 1987, 1990).

Replication experiments have shown that artisans of section-mold casting paid particular attention to the preparation of clay (e.g., Tan 1999; see also Stoltman et al. 2009). In order for the mold to reproduce precise impressions of decoration from the model, clay used for the mold, especially the inner surface of the

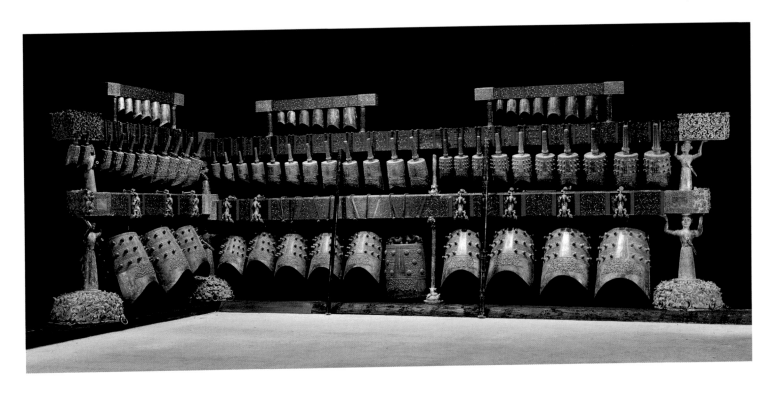

mold, had to be very fine and without inclusions. Through experiments, we know that clay for making models and molds had to be levigated and kneaded, while decorated mold sections needed to be slowly dried and fired to prevent warping. The bronze foundry of ancient China therefore needed two sets of workers. One group of workers would have been specialized in metal and the other group would consist of workers skilled in handling clay.

The existence of such internal division of labor has led scholars to argue that highly developed managerial control was required to design the production procedures and to operate a workshop with different manufacturing departments (Franklin 1983a, 1983b; Yung-ti Li 2007). Although little is known about bronze workshops, judging from the manufacturing technique and the presence of monumental structures, a top-down managerial control must have existed already during the Erlitou period. The massive rammed-earth enclosure, the locations of the bronze workshops, and the apparent attempt to secure resources outside of the Central Plains suggest that the state played an important role in the bronze industry of Erligang. The deliberate placement of bronze workshops with other craft industries to form production precincts and the ample evidence of the presence of a powerful kingship and a protobureaucratic system in Anyang also speak to the possibility that there was a conscious effort to control or manage the craft industries, especially bronze production, by the ruling elite.

From the Western Zhou, thanks to contemporary and transmitted texts, we know much more about how the state and the bureaucratic system functioned. Even though transmitted texts present a retrospective and idealized version of the Zhou government, by using bronze inscriptions we can see indications that

bureaucratic offices may have been established to be in charge of state-sponsored craft production. As the nature and content of bronze inscriptions became more mundane in the Eastern Zhou, inscriptions, particularly those on weapons, began to record the artisans who were responsible for different stages of the manufacturing process and the official who was in charge of production. The same practice was closely followed and the content of the inscriptions became more detailed in Qin and Han lacquer production. What we see now is a full-fledged bureaucratic system that was in charge of the various state-sponsored craft industries. In other words, the state apparatus that enabled the large-scale production of the Qin terracotta soldiers and Han lacquer wares in early imperial China had its roots in the early Bronze Age.

Concluding Remarks: The Waning of the Bronze Age and the Beginning of the Use of Iron

Meteoritic iron was already used in the Erligang period around 1300 BC, but the earliest cast-iron object in the Central Plains region is dated to 800 BC, about two hundred years after the appearance of smelted iron in Xinjiang. After its appearance in the late Western Zhou, iron technology overlapped with bronze technology for a considerable time before it finally replaced the latter in most practical uses. Indeed, iron technology developed along with the bronze technology. For instance, once it appeared in the Central Plains regions, iron objects were made by casting, in the same manner as bronzes, without going through the early stage of bloomery iron as seen in other parts of the world. Iron was also first used as an accessory material for bronze objects, such as the blades of swords or the legs of *ding* vessels, perhaps to add value and desirability to the bronzes because of its color and rarity (Wagner 1993, 2008).

If bronze was the metal for the elite, iron eventually became the metal for the masses. By the Warring States period, iron shed its exotic and precious metal appearance and became the metal for utilitarian functions. Production became much larger in scale, and iron was widely used to make tools, implements, and weapons. The readily available iron tools, farming implements, and weapons allowed for and enabled greater agricultural productivity, more efficient transport technologies, and indeed more effective and murderous large-scale warfare, all of which are possible factors that fostered the political consolidation of larger territories that we see in early imperial China.

Sanyangzhuang:
Life and Death in the Yellow River
Floodplain

Tristram R. Kidder and Haiwang Liu

In the late summer of AD 15, the Yellow River broke its banks in the northeast part of modern Henan Province. The terrain here is flat; when the Yellow River surged through its banks, sediment-rich water inundated the low terrain east of the river channel. Like water filling a bathtub, the flood slowly spread across the low-lying basin. At Sanyangzhuang, a small cluster of farmhouses set in the midst of plowed fields was covered by the floodwaters; people were forced to abandon their houses, leaving behind almost all their belongings. Historical records tell us that this flood engulfed a large part of the Yellow River floodplain, killing and displacing untold numbers of people such as at Sanyangzhuang, and leading millions into starvation, banditry, and rebellion against the emperor. Scholars now recognize that this flood triggered a civil war that resulted in the formation of a new government known as the Eastern Han.

But before the flood, life was good, finally. The ceaseless wars of the previous centuries—dubbed the Warring States period (475–221 BC)—had given way to a time of remarkable prosperity under the rule of China's first long-standing unified

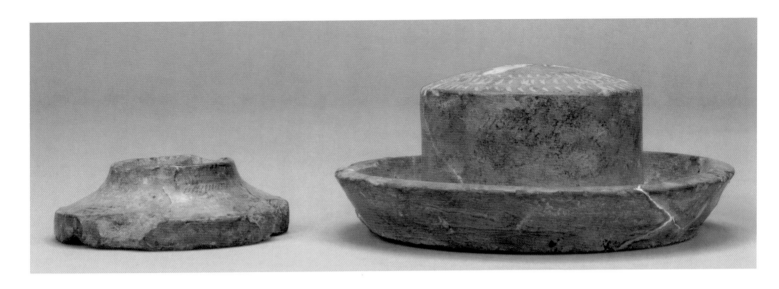

FIGURE 69

Han Dynasty tomb model of a grinding
stone, similar to those found at Sanyang-
zhuang. © The Field Museum. Catalog No.
118224. Photographer Gedi Jakovickas.

empire, the Han (206 BC–AD 220). At Sanyangzhuang, peace brought stability and wealth previously unimaginable. Residences consisted of tile-roofed buildings, or compounds, surrounded by thick earthen walls that kept the interior cool in the hot summer and warm in the cold winter. The compounds were all alike; latrines were always located on the north side (the upwind side in the summer), whereas on the south side, outside the gate, there was an open patio with a brick-lined well. Fossilized casts of tree stumps show that trees were planted in rows just outside the walls to shade the houses in the summer. Inside the compound walls, a detached kitchen building was adjacent to an open-air patio. Agricultural tools, food preparation equipment such as grinding stones (fig. 69), and ceramic vessels lined the walls beneath the overhanging roof. As in rural Chinese villages today, these open areas were the focal points of social interaction. A low wall separated the kitchen and front patio from a series of connected rooms used for sleeping and storage.

In one compound, the roof tile ends over the entrance of one room were stamped with the Chinese characters for "Long and Prosperous Life." These eave tiles, or *wadang* (fig. 70), are common in Han China but are usually associated with well-to-do residents. Their presence in this small community suggests at least one family enjoyed measures of wealth and status. The ceramic tile roof would have kept out the rain but needed periodic repairs. In one compound we found neatly stacked roof tiles (fig. 71) and next to these a small pit that was used to mix mud slurry, which was laid over the timber roof and under the ceramic tiles. Once dry, this mud held the tiles in place and insulated the roof. Clearly the residents of this compound were repairing their leaky roof when the site was abandoned.

Outside the south gate lies a courtyard with a deep, brick-lined well. The well was probably surrounded by a wooden frame with a winch and bucket (fig. 72). Large ceramic water vessels, including a pan or basin, were found adjacent to one

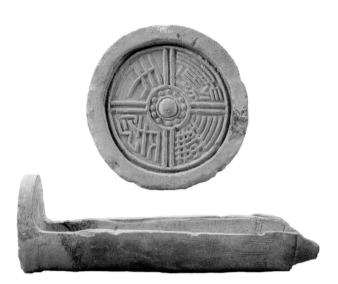

well. At one house, a trail of used bricks and broken pottery pieces, all turned with their sharp edges down, formed a path from the well into the compound so the inhabitants could stay relatively mud free when they used the well. Not far from the well in one compound were also found the remains of a loom, the legs of which were supported by four brick supports. Within these brick supports we found a series of notched pebbles, known as loom weights, lying in a row. The loom weights would have held vertical strings (the weft) tight, so horizontal fibers (the warp) could be strung. Because the loom weights were found in a line, we suspect there was a textile being made, with the weft under tension at the time the flood arrived.

Without the fear of war and raids, the houses at Sanyangzhuang were widely spaced among the plowed fields rather than clustered together behind walls, as was the case in the Warring States period (fig. 73). Although some houses were relatively close to one another, others were hundreds of feet apart. Trails connected the houses, and well-made, packed earth roads linked the community to more distant places (fig. 74). Cart tracks and ruts in the roads indicate bustling traffic within and through the settlement.

Farming was central to the Sanyangzhuang community. Just beyond the compounds and patios at Sanyangzhuang, we have uncovered exceptionally well-preserved fields with distinctive ridges and furrows made by large iron plows pulled by oxen. These fields are distributed over a large area—probably hundreds of acres in total—suggesting intensive production. The farmers grew wheat, millet, and beans and raised pigs, chickens, and probably sheep or goats.

The preservation at Sanyangzhuang is so exceptional that imprints of grass, elm, and mulberry leaves survived (figs. 75 and 76). The mulberry leaf impressions

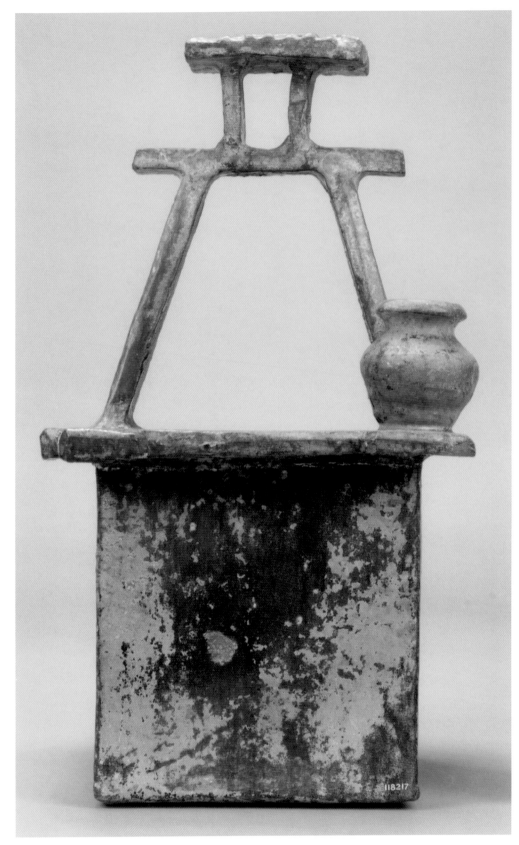

FIGURE 72
Han Dynasty tomb model of a well. © The Field Museum. Catalog No. 118217. Photographer Gedi Jakovickas.

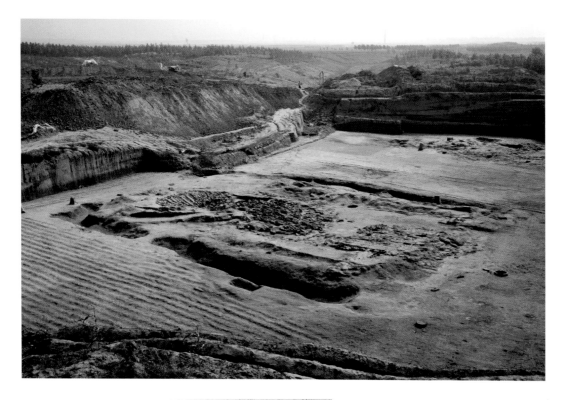

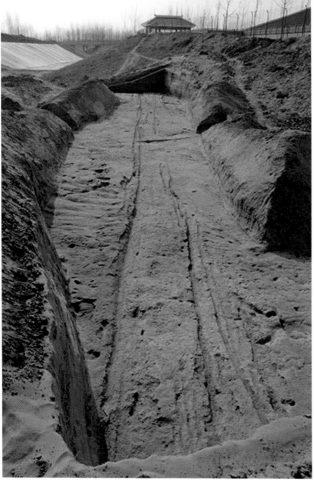

FIGURE 73
Image of Sanyangzhuang showing remains
of plowed fields and Compounds 3 and 4.
Henan Provincial Institute of Cultural Relics
and Archaeology, courtesy of Dr. T. R. Kidder,
Washington University in St. Louis.

FIGURE 74
Road with cart tracks at Sanyangzhuang.
Henan Provincial Institute of Cultural Relics
and Archaeology, courtesy of Dr. T. R. Kidder,
Washington University in St. Louis.

are especially important for two reasons. First, the residents were raising mulberry trees, and mulberry leaves are used to feed silk worms. The large ceramic tub next to one of the wells was used to soak silkworm cocoons so their threads could be unraveled while looms were used to weave the thread. This indicates that a tiny rural site such as Sanyangzhuang was actually the beginning point of the famous Silk Routes (see Lin and Zhang, this volume). Second, the leaves were all mature when the flood buried and preserved them, suggesting the flood hit in the late summer or early fall. The flood thus struck at around the harvest, which is an especially vulnerable time for a farmer because the previous year's crop would have been largely depleted.

The exceptional preservation at Sanyangzhuang also gives us access to the humans who lived at the site when it was buried by the flood. We do not have fossilized human bodies, as at Pompeii, but we do have the footprints of the occupants. In the final days of the site's existence, it had been raining heavily. As people walked on the patios and in the fields, their feet sank into the mud, leaving deep footprints behind. These filled with the fine-textured, flood-borne silts, preserving them intact. In one field, we have many footprints in a jumbled pattern, possibly the result of a resident or residents desperately trying to harvest grain before the flood inundated the area. Animal tracks also are preserved. In one instance, a trail of oxen tracks runs between the wheel ruts of the cart the animal was pulling as it plodded along a road through the site.

FIGURE 75

A fossil cast or impression of a mature elm leaf (*Ulmus parvifolia*) found at Sanyangzhuang. The leaf is approximately 7 centimeters (2.75 inches) long. Henan Provincial Institute of Cultural Relics and Archaeology, courtesy of Dr. T. R. Kidder, Washington University in St. Louis.

FIGURE 76

A mulberry leaf (*Morus alba*) impression from Compound 3 at Sanyangzhuang (9.5 centimeters [3.75 inches] long). Image courtesy Dr. T. R. Kidder, first published as figure 6 in the journal *Antiquity* 86 (2012): 30–47.

Sanyangzhuang provides us with a rare and wonderful glimpse into the world of a small rural Han-period community. Despite being far from the capital at Chang'an (modern Xi'an), the people at Sanyangzhuang lived well and were surprisingly integrated into the Han economy. Further work will help us to better understand this community and the lives of the people who lived where many would argue the Silk Route began.

Written on Bamboo and Silk, Inscribed in Metal and Stone: Varieties of Early Chinese Writing

Edward L. Shaughnessy

Western tourists who have been to China recently may find it difficult to relate the material culture on display in The Field Museum's *Cyrus Tang Hall of China* with the bullet trains that now speed across the country or with the skyscrapers of Beijing and Shanghai. It seems that the most notable feature of those cities is their aggressive modernity. True, the cuisine there, in all of its splendid variety, remains distinctively Chinese, but it is hard to capture those flavors in a museum exhibition. Besides, to many young people of Chicago, *kung pao* chicken is as much an American dish as spaghetti and meatballs or tacos. Nevertheless, everyone who has been to China—or even to Chicago's Chinatown—has been met at once with one defining feature of "Chineseness" that persists to the present: Chinese writing. Scholars may debate whether Chinese characters should properly be termed pictographs or ideographs or zodiographs or logographs, but everyone can see at a glance that 唐仲英中國館 is a fundamentally different form of writing from "Cyrus

Tang Hall of China," even if the modern form of these characters may no longer reveal the pictographic origins of the script (the simplified characters used today in mainland China differ from those on display at the entrance to the hall only in the last two characters, 國 being written as 国 and 館 as 馆).

Visitors to the 2008 Beijing Olympics would have had little difficulty understanding the pictographs that were used to identify the various sports (fig. 77). Sports enthusiasts would have seen in 🏊 a swimmer going through water, in 🤿 a diver diving into the water, and in 🤽 a water polo player rising up out of the water to throw a ball. Of course, water polo was probably not played when Chinese people first began to write, just over three thousand years ago, and so there would have been no need for a pictograph such as this. But people did run, and so the Beijing Olympics pictograph for track races, 🏃, looks uncannily like the way the word for "run," now written 走, was first written: 𢌳. And people also fought with each other, and so the Chinese character for "fight," written 鬪 in the standard script but 鬥 in the simplified characters used in mainland China today, was originally written 𫞩, not much different from the Olympic pictograph for wrestling: 🤼. Indeed, we know that the creators of the Beijing Olympic pictographs self-consciously incorporated elements of early Chinese writing in their designs as a way of identifying those games as "Chinese."

The earliest writing that we know of from China, dating to about 1200 BC, takes the form of records of divination—essentially prayers to the ancestors—inscribed into turtle shell and ox bone, which is why in Chinese it is usually called "writing on shell and bone" (甲骨文 jiaguwen), though in English it is more often referred to as "oracle-bone inscriptions." Examples of these oracle-bone inscriptions were first seen at the very end of the nineteenth century. Their publication in 1903 not only opened a new field in the study of Chinese writing, but also helped to develop modern archaeology in China. Scholars and antiquarians alike sought the source of these shells and bones and within a few years traced them to the modern city of Anyang in Henan Province, about 500 kilometers south of Beijing. This was known to historians as the final capital of the Shang Dynasty (c. 1550–1045 BC), the second of ancient China's Three Dynasties (i.e., the Xia, Shang, and Zhou), and the writing on the shells and bones was quickly identified as coming from that dynasty. In the century or more that has followed, archaeological excavations at Anyang have continued almost without a stop. They have revealed that Anyang was indeed a major metropolis, the capital of a more or less extensive state with a mature Bronze Age civilization (see Li, this volume). To date, as many as two hundred thousand pieces of inscribed oracle bone have been unearthed, bearing divination records from the reigns of the last nine kings of the dynasty (c. 1200–1050 BC). These records concern affairs of interest to the royal house: sacrifices to the ancestors, warfare, agriculture, weather, settlement building, but also royal toothaches, bad dreams, childbearing by royal consorts, and so on. Most of the divinations take the form of statements of intent or desire, apparently seeking to enlist the aid of the ancestors in ensuring a desired outcome.

There are a few examples of these oracle bones on display in The Field Museum's *Cyrus Tang Hall of China*, such as those shown in figures 78 and 79. All of the pieces are fragmentary, as are most oracle bones that have been discovered, but from them we can learn much about the Shang practice of divination. Figure 78 shows both the front and back sides of a turtle shell. The back side illustrates how the piece was prepared in advance for divination. A series of butternut-shaped hollows (◇) was chiseled and drilled into the shell, almost—but not quite—through to the other side. At the time of divination, a red-hot brand was inserted into one or more of these hollows, the heat causing a stress crack to appear on the other side—the front side—of the shell (and often also causing a circular brown burn mark near the crack, as can be seen on the piece in fig. 79). The crack followed from

FIGURE 77

2008 Beijing Olympic pictographs. Image courtesy of the International Olympic Committee.

the shape of the hollow on the back, the chiseled egg-shaped hollow (◊) producing a vertical crack (|), and the drilled round hollow (○) producing a horizontal crack (一) branching from the side of that vertical crack: ⊦. According to later Chinese traditions, the shape and color of this crack determined the interpretation of the divination. Some of these cracks are visible in figure 78. The piece also bears a couple of graphs of writing, but these are too fragmentary to give much sense of the topic of this particular divination.

Figure 79 bears more writing: one complete inscription and the top half of another. As was Chinese writing throughout most of its more than three thousand years of continuous use, these inscriptions are written from top to bottom (in mainland China today, most publications are written from left to right, though it is still common to see shop signs and other examples of calligraphy written from top to bottom, as most writing is still done in Taiwan, Hong Kong, and American Chinatowns), though whereas most Chinese writing was done from right to left, in this case the columns read from left to right. The top inscription reads: 貞來乙子王勿入 and can be translated as "Affirmed: On the coming *yisi* [day 42], the king ought not to enter."

Simple as this inscription is, it does illustrate some basic aspects about both the nature of oracle-bone divination and also the earliest Chinese writing. It begins with a sort of preface, here just the word "Affirmed" (or "Divined"). The preface often indicates also the day of the divination and the name of the diviner officiating.

Then follows a charge, which is the main portion of the divination, spelling out the proposed action; in this case, that the king would not enter, presumably one or another settlement. Some—though by no means all—longer inscriptions also contain prognostications, the king's interpretation of the result, and verifications, almost always confirming that the king's prediction did indeed take place. While it is true that inscriptions such as "On the coming *yisi*, the king ought not to enter" do not tell us much about the history or religion of the Shang Dynasty, many other inscriptions are much more informative (see highlight 3). By piecing together the many tens of thousands of known inscriptions, historians have been able to reconstruct a surprisingly detailed picture of life at the time.

We can also learn something about the earliest Chinese writing from this simple inscription. The first character, in the upper left-hand corner of the piece (and repeated, somewhat more clearly, toward the bottom left-hand corner) is written something like 鼎. As such, it is doubtless hard to see any pictographic representation in it. However, in some other inscriptions, the same character is written as 鼎, and is fairly clearly a picture of a "caldron" (written 鼎 in modern Chinese script). Indeed, oftentimes this same character is used for the word "caldron." However, when it occurs in the preface of divination inscriptions, as it does here, this character does not represent a caldron, but rather "borrows" the sound of the word for

caldron, now *ding* but originally something like *tieng*, to write a word that can be translated functionally as "to divine," but which might more exactly be rendered as "to affirm." It is now written as 貞 and pronounced *zhen*, but originally was also pronounced more like *tieng*. This principle, known as the rebus principle, will be familiar to anyone who ever watched the television game show *Concentration*. It is more or less the same as using the pictograph 👁 to stand for the English word "I," though the history of the character 貞 is a little more complicated.

The modern forms of 貞 and 鼎 do not appear to share anything more than a basic boxiness. However, another early form of the character was written 𣂤, which gave the later form 鼎. It is easy to see that this form of the graph was composed of two components: ├ over the top of 鼎, the character for "caldron." The component ├ is very interesting in its own right. As mentioned above, the divination cracks in turtle shells and ox bones were made to take the shape ┤, and the character ├ was then used pictographically for the word meaning "turtle-shell divination." It is also worth noting that this word, now pronounced *bu* in Mandarin Chinese, was originally pronounced something like *puk* (and is still pronounced like that in Cantonese). It would seem that this sound was probably onomatopoeia for the sound the shell or bone made as it cracked (just as the English word "crack" was probably originally onomatopoeia for the sound wood or bone makes as it splits). According to traditional theories of Chinese writing, the character 鼎 is a phonogram, with ├ indicating the general category of meaning and 鼎 indicating the pronunciation (masked in the modern character 貞 by the substitution of the simpler 貝 component for the more complicated 鼎). However, this analysis does not take into account either the earliest history of the word, in which, as we have seen, the character for "caldron" was simply borrowed to write the word "to affirm" or "to divine," or the continuing contribution that the meaning "caldron" obviously makes to the meaning of this word. Admittedly, this contribution is not immediately obvious, especially in English, and it would require more space than is available in this catalog to demonstrate it, but there is good reason to believe that caldrons and divination were originally very much part of the same word family. In view of that, it is the combination of the two components "turtle-shell divination" and "caldron" that allows the character to represent the word *zhen*, "to divine" or "to affirm."

Before the discovery of the oracle-bone inscriptions, the oldest known examples of Chinese writing were inscriptions cast into (or sometimes onto) bronze vessels or weapons. The exhibition does not include any very early examples of these bronze inscriptions. However, there are several beautiful inscribed bronze vessels just across Grant Park in the Art Institute of Chicago. One *gui*-tureen dates to the opening years of the Western Zhou Dynasty (c. 1045–771 BC), roughly the second half of the eleventh century BC (fig. 80). It bears an inscription not much longer than the oracle-bone inscription examined above, just eleven characters in all. The inscription reads from top to bottom, right to left, and can be transcribed and translated as follows:

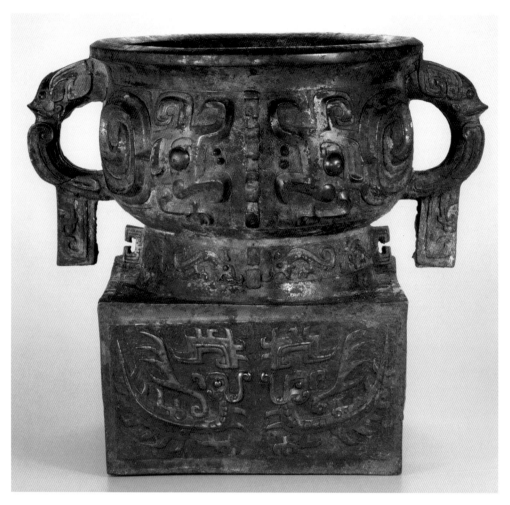

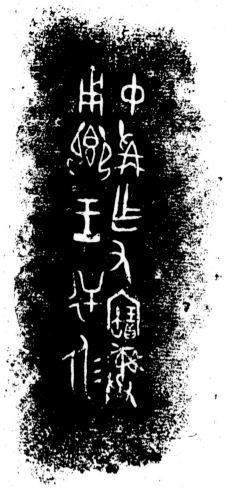

中再乍又寶彝
用鄉王逆永

Second-born Cheng makes his treasured vessel
to use to feast the king's reciprocal immortalizing [him].

Most bronze vessels were at least ostensibly made to be used to sacrifice to ancestors, unlike this vessel, which states expressly that it was to be used "to feast" the king. The graph used for the word "to feast" retains the pictographic quality of the oracle-bone script: 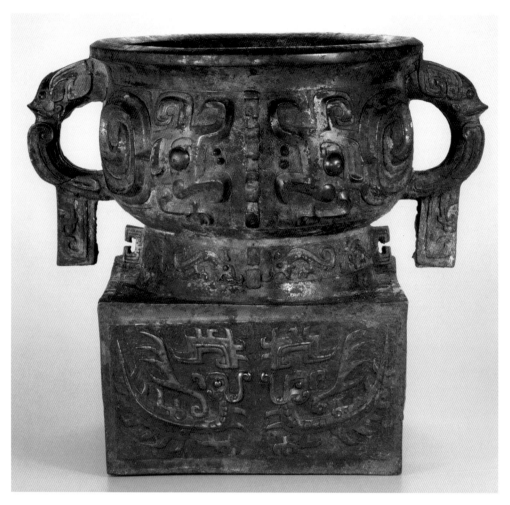 represents two kneeling figures facing each other over a food vessel, similar to the tureen that carries the inscription. The same character was also used to write several related words, all of them pronounced in the same way or very nearly the same way: "to sacrifice," "to face (in a direction)," and "direction."

About this time, or not long thereafter, other inscriptions on bronze vessels could be much longer and much more informative concerning the circumstances

FIGURE 80

Zhong Cheng gui vessel and inscription. China, Grain Vessel (Gui), Western Zhou Dynasty (c. 1050–771 BC), second half of eleventh century BC, Bronze, H. 27.0 cm (10¾ in.); diam. at lip: 22.2 cm (8¾ in.), Lucy Maud Buckingham Collection, 1927.316, The Art Institute of Chicago.

of their casting. One example is the *Ke xu*, probably the most important bronze vessel in the Art Institute's collection. It was part of a cache of more than one hundred vessels unearthed in 1890 at Renjiacun in Fufeng County, Shaanxi Province, not far from the famous Buddhist pagoda Famensi. Unearthed before the introduction of modern archaeological methods, these vessels were subsequently scattered throughout the world, with the Art Institute piece being one of the most important inscribed ritual vessels from China that have come to America. As can be seen in figure 81, the vessel bears a very lengthy inscription of exactly one hundred characters. It begins by specifying the date and place of a royal audience at which the Zhou king received Steward Ke and registered his landholdings. It was to commemorate this audience and award that Ke had this vessel made. Although the king is unnamed, the style of the vessel and information from other vessels made by Ke suggest that it was King Xuan (r. 827–782 BC), and so the date indicates that the vessel was cast in 810 BC. The inscription can be translated as follows:

> It was the 18th year, 12th month, first auspiciousness, *gengyin* [day 27]; the king was at the Zhou Kang Mu Palace. The king commanded Master Yin's associate Scribe Nin to register Steward Ke's fields and men. Ke bowed and touched his head to the ground, daring in response to the Son of Heaven's illustriously fine beneficence to extol, herewith making this sacrificial *xu*-tureen. It is to be used to celebrate Captain Yin's friendship and marriage relations. May Ke use it morning and night to make offering to his great grandfather and deceased father. May his great grandfather and deceased father resoundingly send down on Ke many blessings, a vigorous old age, and an eternal mandate, earnestly to serve the Son of Heaven. May Ke daily be awarded beneficence without bound, and may Ke for 10,000 years have sons' sons and grandsons' grandsons eternally to treasure and use it.

Other inscribed bronze vessels made at about the same time provide still more detailed descriptions of these royal audiences and the role they played in the making of the vessels and their inscriptions. Usually some influential figure escorted the guest into the court and is described as standing "at his right." As here, the king directed one or more officials to read a command to the guest, and then to give him a gift or gifts representing the royal patronage. At the end of the audience, the official turned over to the guest the text of the royal command, which had been written on bamboo strips in advance of the ceremony. Then, after bowing and touching his head to the ground, the guest put the strips in the sash of his robe and exited the court. Later, preparing to have a bronze vessel or vessels made to commemorate the audience and the award, the guest, now the patron of the vessel, composed an inscription. The inscription regularly begins by copying the text of the royal command and then adds, in the patron's own words, a dedication to his ancestors and a prayer that his descendants—"sons' sons and grandsons' grandsons"—might "eternally treasure and use" the vessel.

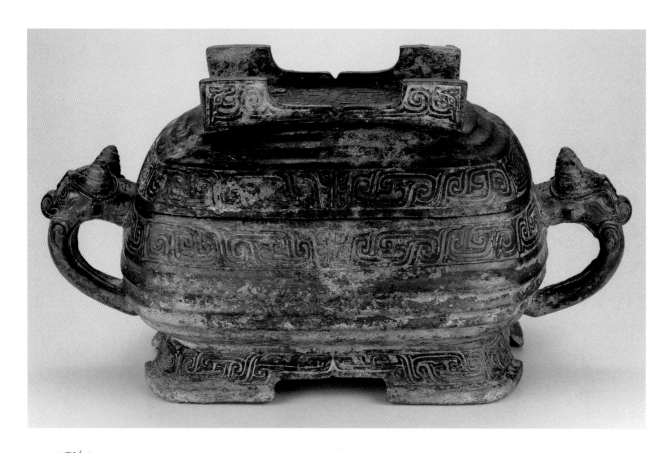

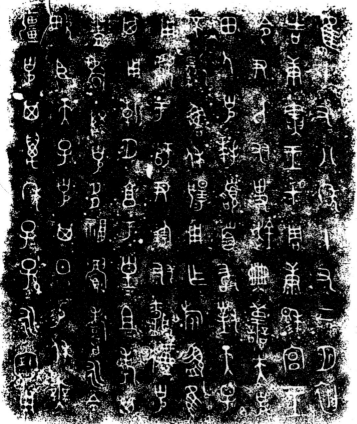

FIGURE 81

The *Ke xu* vessel and inscription. China, reportedly from Qishan, Shaanxi province, Covered Food Vessel (Xu), Western Zhou Dynasty (c. 1050–771 BC), late ninth century BC, Bronze, 19.9 × 21.3 cm (7¾ × 8⅜ in.), Lucy Maud Buckingham Collection, 1928.144, The Art Institute of Chicago.

The difference in content between this inscription on the *Ke xu* and that on the *Zhong Cheng gui*, not to mention that of the oracle-bone inscription, requires no elaboration here. Historians have learned much more about the reign of King Xuan from the *Ke xu* and similar inscriptions than they have been able to learn about the early Western Zhou. Once again, it is also possible to use this inscription to learn something about the development of writing in ancient China. Perhaps worth noting is the "page layout" of the inscription. Not all lengthy bronze inscriptions are as regular as that on the *Ke xu*, composed as it is of ten columns of ten characters each. Nevertheless, a tendency toward regularity becomes a notable feature of almost all inscriptions from the same time period. The inscription as a whole looks as if it were designed to fit within a grid (and indeed many other contemporary inscriptions do reveal underlying grid lines), and individual graphs look almost as if they were typeset, each one of a uniform size and proportion. By this time, not quite four hundred years after the earliest oracle-bone inscriptions, Chinese writing had already lost much of its pictographic quality. Newly created characters—by which I mean characters not attested in the script prior to this time—routinely made use of phonograms: the combination of one element representing the category of meaning with another component representing the sound of the word. For instance, the type of vessel on which this inscription is found, an oblong grain vessel known as a *xu* 盨, was unknown prior to the ninth century BC. Thus, the word used for it must also have been an innovation of that period. The graph 盨 found as the next-to-the-last graph (counting up from the bottom) of the fifth column (counting from the right) of the inscription, is made up of the component 皿, which indicates a shallow container, at the bottom, over the top of which is the graph 須, pronounced *xu*, which indicates the pronunciation of the character. The graph 須 is quite interesting in its own right. It was originally written 𦓐 (in oracle-bone inscriptions) or 𩓣 (in bronze inscriptions), depicting a man with whiskers (the character for "face," now written 首, was written as 𦣻 in bronze inscriptions and 𦣻 or 𦣽 in oracle-bone inscriptions), and thus came to write the word *xu*, "whiskers," though it was used more often—making use of the rebus principle—to represent another word also pronounced *xu* and meaning "to need, to require." As the name of this type of bronze vessel, this component contributes nothing other than the sound of the word. From this time on, most newly created graphs were constructed in the same way, combining a semantic component with a phonetic component. It would be wrong to say that the pictographic origins of Chinese writing were no longer recognizable, but pictographs were no longer sufficient to express all that people wanted to write.

The inscription on the *Ke xu* marks pretty much the high tide of the vogue of casting lengthy inscriptions on the inside of ritual bronze vessels. The practice would continue for another couple of centuries, and inscriptions were certainly added to other metal artifacts, including thousands of bronze mirrors (fig. 82), bronze and iron weapons (fig. 83) and tools (fig. 84), and millions of bronze coins (fig. 85), of all of which the *Cyrus Tang Hall of China* has excellent representative

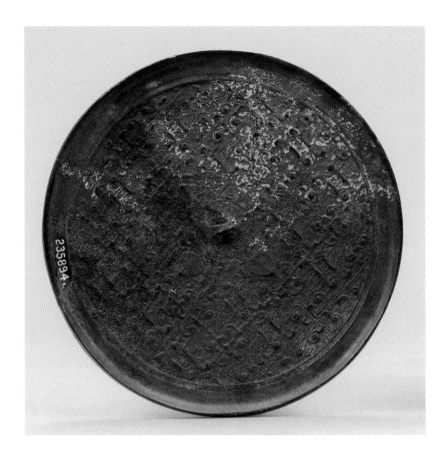

FIGURE 82
A bronze mirror from the Eastern Zhou Dynasty.
Many such mirrors were inscribed with auspicious
sayings. © The Field Museum. Catalog No. 235894.
Photographer Gedi Jakovickas.

FIGURE 83
An iron sword (*top*); a detail of an inscription from
a similar iron sword (*bottom*). The inscription
indicates the sword was made in the year corre-
sponding to AD 112, forged thirty times, and would
be auspicious. Photograph: © The Field Museum.
Catalog No. 120993. Photographer Gedi Jakovick-
as; X-ray: Image from Li 1975:14.

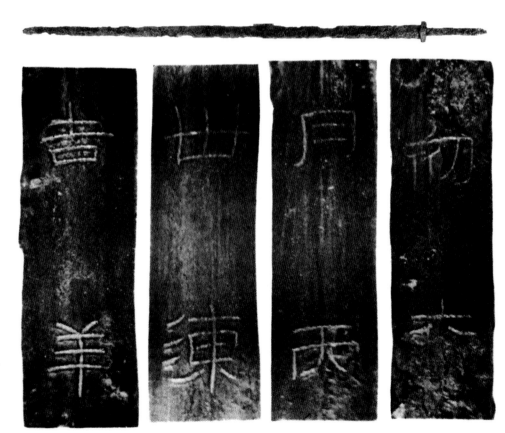

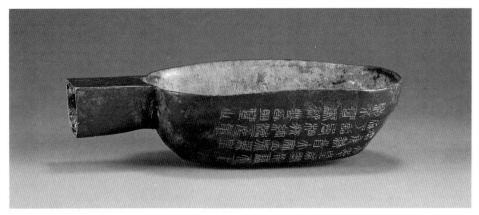

FIGURE 84
Bronze measuring vessel from the Qin Dynasty
(221–206 BC), inscribed with imperial edicts
from the First and Second Emperors. © Shaanxi
History Museum.

FIGURE 85
Round, knife-shaped, and spade-shaped coins
from ancient China. © The Field Museum.
Catalog Nos. 124752, 124751, 124948, 124950.
Photographer Gedi Jakovickas.

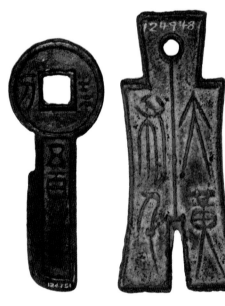
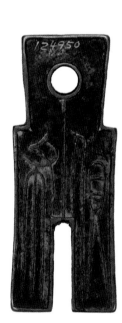

examples. Most of these artifacts afforded space only for more or less short inscriptions, indicating the maker or the value (fig. 86).

Long commemorative inscriptions eventually came to be written on a different medium: stone. Some such inscriptions were carved directly into mountains, but most are found on large slabs of stone called "steles" (sometimes written, incorrectly, as "stelae"). Most inscribed stones are too large ever to be moved, and so The Field Museum contains only one example of this important type of artifact, but it is not on public display in the Museum's exhibition. From no later than the seventh century AD, people in China have made ink rubbings of these inscriptions onto paper and collected these rubbings as faithful reproductions of ancient calligraphy. The Field Museum has one of the Western world's largest and most comprehensive rubbings collections, more than 7,500 items of all different types.

The oldest of the stone inscriptions represented in The Field Museum's collection of rubbings are poems carved onto ten granite boulders, dating to perhaps 400 BC, the period known in China as the Warring States. These boulders were discovered early in the seventh century AD near present-day Fengxiang, Shaanxi. This was the seat of the ancient state of Qin, the state which in 221 BC would complete the conquest of all of the other warring states to unite China into its first empire, and so these boulders are known as the Qin Stone Drums. The inscriptions on them feature poems about hunting and fishing. Although the poetry is not particularly memorable, the calligraphy in which they are written has long been prized as among the finest examples of "seal script," a type of ancient calligraphy that is still occasionally used for formal or decorative inscriptions. The Field

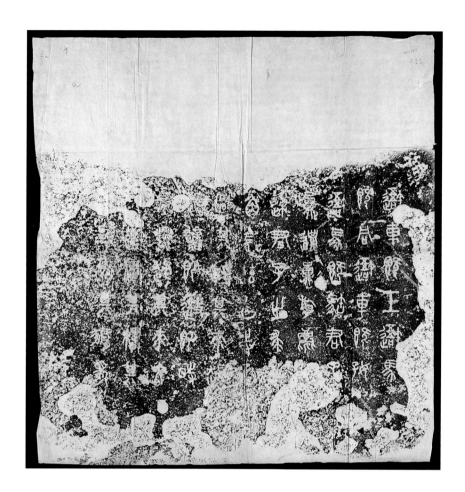

Museum houses a complete set of these rubbings, of which that bearing the poem "Our Chariots" is the most complete example (fig. 87).

Our Chariots

Our chariots have all been worked,
Our horses have all been matched.
Our chariots are all so fine,
Our horses are all so tall.

The lords' sons are going to hunt,
Going to hunt, going to sport.
The hinds and deer so fast, so fast
The lords' sons chase after them.

Well-strung well-strung are the horn bows,
With bow and string we wait for them.
I drive on the bucks among them.
They are coming, pounding pounding.

Scamper scamper, gallop gallop.
Now we're driving, now we're waiting.

The hinds and deer are so frenzied,
They are coming in a great rush.
I drive on the bulls among them.
They are coming, thudding thudding.
We are shooting both bucks and fawns.

A small case on unification under the Qin Dynasty in the second gallery of the *Cyrus Tang Hall of China* features a detail from another of The Field Museum's oldest stone rubbings: taken from a stele originally erected in 219 BC on Mount Yi, in present-day Zouxian, Shandong Province, it commemorated a visit there by Qin Shihuangdi, the First Emperor of China (though it should be noted that the rubbing was taken from a reproduction of the stele made more than one thousand years later, in AD 993) (fig. 88). The recut inscription does seem to preserve the beautiful seal script for which the original was famous. The detail currently featured in the gallery comes from the very beginning of the inscription and mentions the new title by which the emperor was to be known: *Huangdi* 皇帝, which perhaps can best be translated as "August Thearch." The detail featured in figure 89 reads:

皇帝立國
維初在昔
嗣世稱王

The August Thearch has established the state.
It was first in times past
That he succeeded the generations and was called king.

Visitors to the *Cyrus Tang Hall of China* may find even more interesting some of the Museum's later rubbings, including rubbings of Jewish genealogy records from Kaifeng, Henan Province, dated 1512 (fig. 90); Islamic mosque wall tablets, commemoration inscriptions, and prayers, collected from throughout China; as well as more than one hundred rubbings of grave tablets erected for Jesuit priests buried in Beijing during the late Ming (AD 1368–1644) and the first part of the Qing (AD 1644–1911) Dynasties. Figure 91 written in both Chinese and Latin, is a rubbing of the tombstone of the Jesuit priest Johannes Schreck, S.J. (1576–1630), known also by his Chinese name, Deng Yuhan.

The most valuable rubbing in The Field Museum collection is of the *Lanting Xu*, or *Preface to the Poems Composed at the Orchid Pavilion* (see Zhou's contribution on this piece, this volume, highlight section 5), which is one of the most famous examples of Chinese calligraphy of all time. The original text was written, on paper,

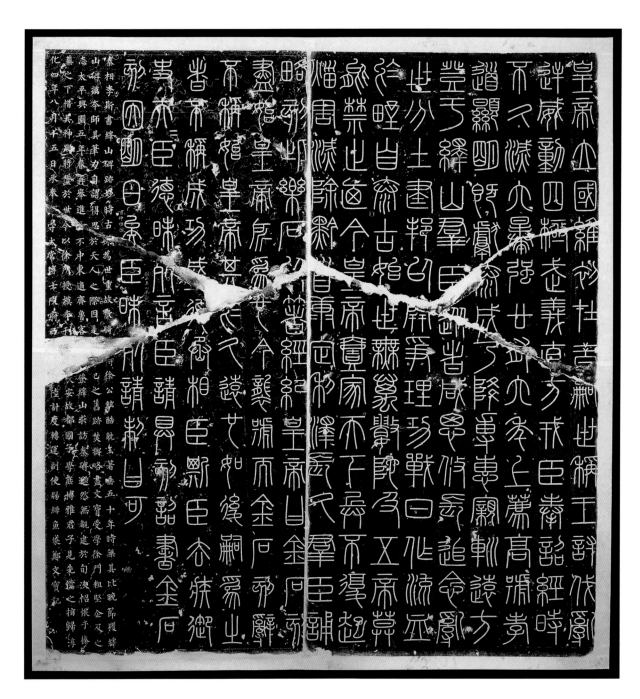

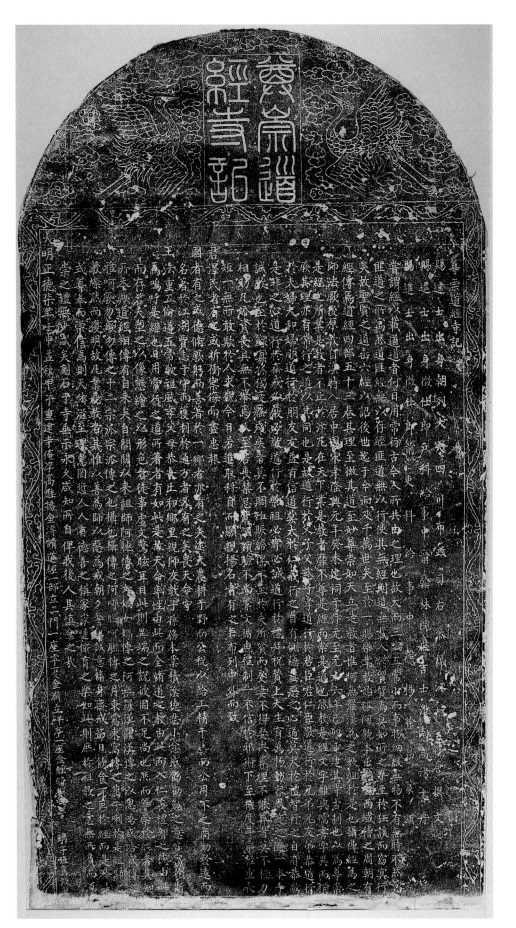

FIGURE 90
Rubbing of a stele commemorating the
rebuilding of the Jewish synagogue
in Kaifeng, Henan Province, AD 1512.
© The Field Museum, A115105d_003.
Catalog No. 245063. Photographer
Karen Bean.

in AD 353 by Wang Xizhi (303–61), known in China as the patron saint of calligraphers, and describes how forty-two scholars gathered at the Orchid Pavilion near Shaoxing, Zhejiang Province, to drink, to play music, and to compose poetry. The calligraphy is said to have been so highly prized by the emperor Taizong (r. 626–49) of the Tang Dynasty (AD 618–907) that he had a copy of it engraved in stone. When Emperor Taizong died, he had the original buried with him. The Field Museum's rubbing from the stone copy was made in the Song Dynasty (AD 960–1279) and was passed down through the centuries, having been owned by some of China's greatest collectors of antiquities. The story of this rubbing and the calligraphy on it perhaps illustrates better than anything else in the exhibition the central place that writing has always had in Chinese culture.

The final media of writing that were used in ancient China—bamboo and silk—are, unfortunately, not represented in The Field Museum's collection. The first portion of the ancient expression "written on bamboo and silk, inscribed in metal and stone" that serves as the title of this chapter refers to these manuscripts. There is indirect evidence from as early as the Shang oracle-bone inscriptions that some records were written on bamboo strips, and there is explicit mention of them in bronze inscriptions from the Western Zhou period. However, it is only under the most favorable of circumstances that bamboo can survive long burial, and silk is of course even more fragile. There were occasional records of ancient bamboo-strip manuscripts being discovered in traditional times, the most important being during a renovation of Confucius's home in the late second century BC, and then during the robbing of an ancient tomb in AD 279 in present-day Jixian, Henan Province. Both of these discoveries had important implications for the development of textual history in China, but in both cases the manuscripts have long since been destroyed or lost.

In modern times, the first discoveries of these sorts of manuscripts all came in Central Asia, where the arid desert provided an ideal environment for the preservation of both wood and silk manuscripts. In 1900, during the first of his expeditions to the area, the Turkic-English explorer Aurel Stein (1862–1943) explored Niya, an oasis on the southern branch of the Silk Road in the southern Taklamakan Desert of present-day Xinjiang Province. There he found wooden tablets (a local variation of Chinese practice, since bamboo does not grow in the desert) bearing records written in Kharoshthi, an ancient Indic language, from the early second century AD, as well as wooden strips written in Chinese from a century or so later (one of the Chinese strips bears a date that corresponds to 269). In the same year that Stein was exploring Niya, much further to the east in the oasis town of Dunhuang, Gansu Province, a Daoist monk by the name of Wang Yuanlu (c. 1849–1931), was restoring one of the many hundreds of Buddhist caves at the site known as Mogao-ku. Opening a side chamber to one cave, now numbered Cave 17, Wang discovered a veritable library of manuscripts written on silk and paper and dating from the fifth through the early eleventh centuries. In 1907, seeking funds to continue his renovation efforts, Wang sold seven thousand of these manuscripts to Aurel Stein,

who was then making his second expedition to Central Asia. Because Stein did not
read Chinese, most of the manuscripts he bought were in various Central Asian
languages. The next year, in 1908, the French Sinologist Paul Pelliot (1878–1945),
having heard of Stein's purchase, arrived in Dunhuang and purchased more than
four thousand Tibetan manuscripts and almost as many Chinese ones. These man-
uscripts, now housed in the British Library in London and the Bibliothèque Na-
tionale in Paris, respectively, have been extraordinarily important for introducing
ancient Chinese writing to the Western world. They also excited great attention
among Chinese scholars. (See Zhou's section on The Field Museum's Dunhuang
manuscript, this volume, highlight section 6, for additional information.) Togeth-
er with the discovery and publication of the Shang Dynasty oracle-bone inscrip-
tions, taking place at the same time, these discoveries of ancient writing ushered
in a new age of archaeology in China—an age that has transformed our under-
standing of ancient China.

Over the course of the last hundred years, Chinese archaeologists have un-
earthed hundreds of thousands more wood and bamboo-strip manuscripts dating
from the fifth century BC through the third century AD. These have come from

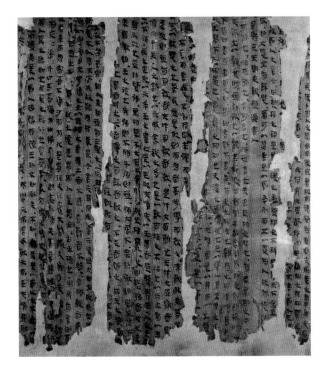

FIGURE 92

Portion of silk manuscript of the *Laozi*, unearthed in 1973 at Mawangdui, Hunan Province. The tomb was sealed in 168 BC, and the manuscript was probably written several decades prior to that. Image courtesy of Hunan Province Museum.

FIGURE 93

Bamboo strips with an essay and illustration discussing divination. Image courtesy of Research and Conservation Center for Excavated Texts, Tsinghua University.

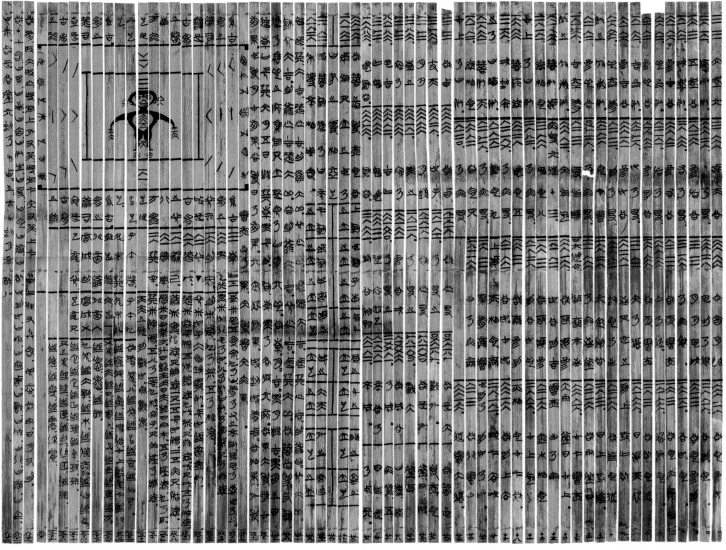

many different parts of China: many more from the deserts of Xinjiang and Gansu, to be sure, but also from areas in central China, especially in the Yangtze River basin, where the high water table also provides an excellent environment for the preservation of organic materials. There have also been a few notable discoveries of silk manuscripts, especially in the Han Dynasty Tomb 3 at Mawangdui in Changsha, Hunan Province (fig. 92), but it is clear that it was bamboo that was the standard medium for all sorts of writing in ancient China (fig. 93). Bamboo-strip manuscripts have come in various sizes, from as short as 8 centimeters to as long as 75 centimeters, and with almost every imaginable content, from copies of the Chinese classics to tax records, from tomb inventories to cooking recipes.

FIGURE 94
Bamboo strips in trays of distilled water at Tsinghua University. Image courtesy of Research and Conservation Center for Excavated Texts, Tsinghua University.

One of the most exciting of these discoveries is just now in the process of publication. In 2006, a major trove of bamboo strips that had been robbed from a tomb somewhere in China arrived on the antique market of Hong Kong. In 2008, an anonymous alumnus of Tsinghua (Qinghua) University in Beijing bought the strips and donated them to his alma mater (fig. 94). The university established a new center to house the strips and brought together an elite team of scholars to preserve them and to edit the texts written on them. They began to publish the strips at the end of 2010. Six volumes have now been published, with another twelve volumes expected over the next fifteen years or so. The manuscripts are among the earliest ever seen, dating in some cases to the middle of the fourth century BC. The volumes published to date have included previously lost chapters of the *Classic of Documents*, early versions of poems included in the *Classic of Poetry*, an annalistic account of Chinese history from the eleventh through the fourth century BC, and an essay on the sort of divination that gave rise to China's *Yi jing*, or *Classic of Changes*. Each new volume to be published has set off an outpouring of scholarship on the internet, where all the latest news and ideas are exchanged.

Ever since writing was invented in China, more than three thousand years ago, writing—in all of its various calligraphic styles and on all sorts of media—has been a central feature of Chinese people's self-identification. A visit to the The Field Museum's *Cyrus Tang Hall of China* offers a wonderful opportunity to see many of these different styles and media, and through the writing to come to a better understanding of Chinese civilization.

Consort Hao's Inauspicious Delivery

Edward L. Shaughnessy

An inscription as simple as that seen in figure 79, "Affirming: On the coming *yisi* (day 42), the king ought not to enter," may not seem to be very informative. In fact, many of the two hundred thousand or so pieces of inscribed oracle bone that have been published provide even less information, more or less resembling the piece illustrated in figure 78. Nevertheless, there are at least thousands, if not quite tens of thousands, of larger pieces with more complete inscriptions. The first case in Gallery 2, "Ritual and Power, War and Unification," includes images of one famous example excavated at Anyang in 1936 by Academia Sinica and still housed at its Institute of History and Philology in Taiwan. The piece was part of a large cache of more than seventeen thousand turtle shells from six hundred or more original turtle plastrons—the belly plate of the turtle—that was apparently discarded at one moment in time, perhaps at the time that the king, Wu Ding (r. c. 1210–1190 BC), died. This piece had been used more than a decade earlier, and bears two inscriptions—one positive and one negative—concerning the birth of a child to one of his principal consorts, a woman named Fu Hao, or Consort Hao. Fu Hao was very active in her own right at the court of King Wu Ding, being the topic of numerous

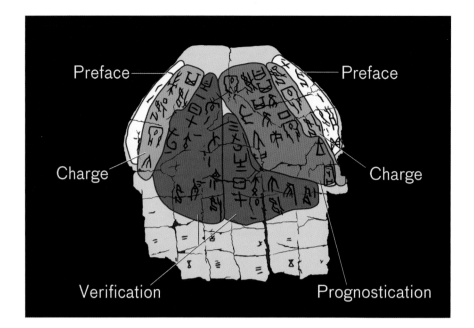

ritual activities and even leading troops into battle. The discovery of her tomb in 1975 filled with an array of riches was a sensation in Chinese archaeology.

The display in the first case in Gallery 2 shows that this particular piece includes prefaces and charges both to the right and to the left, and also a prognostication and verification (fig. 95). These are the four parts of a complete inscription. The prefaces and charges, to the right and to the left, are part of a paired divination. The preface states the day on which the divination took place (indicated by the day in a cycle of sixty days that was used in ancient China) and the name of the official in charge of the divination. The charge is the heart of the divination: the topic was announced with two different possible outcomes, one positive and one negative. In this case, it is clear that it was the positive outcome that was desired. After the charge to the turtle plastron was announced, a sizzling brand would have been inserted into one of the hollows in the back of the shell, producing a crack on the front. The king interpreted whether this crack would be auspicious or not for the topic of the divination. The preface, charge, and prognostication all would have been announced orally, with perhaps a written record made on some other medium (such as a piece of wood or bamboo strip). Then, sometime after the divination had been concluded, when the outcome of the event was known, this record was carved into the shell, and a final verification might be added to it. In this case, verifications were added to both positive and negative parts of the divination. Almost always, the verification confirms the accuracy of the king's prognostication. In this case, it does so as well, but only in a negative way: the outcome was neither as desired nor as predicted by the king, but the bad result occurred on a different day from the day for which the king had predicted a good result.

The two parts of this paired divination can be translated as follows:

Crack-making on *jiashen* [day 21], Que affirmed: "Consort Hao will give birth and it will be advantageous." The king prognosticated and said: "If it be a *ding* day that she gives birth, it will be advantageous. If it be a *geng* day that she gives birth, there will be extended auspiciousness." On the 31st day, *jiayin* [day 51], she gave birth and it was not advantageous; it was a girl.

Crack-making on *jiashen* [day 21], Que affirmed: "Consort Hao will give birth and it will not perhaps be advantageous." On the 31st day, *jiayin* [day 51], she gave birth and it really was not advantageous.

Despite the disparagement of females seen in this inscription, it is clear from the remarkable riches placed in her tomb that Consort Hao was held in very high regard by King Wu Ding and his descendants.

Shifting Power,
Enduring Traditions

6

Along the River during the Qingming Festival:
A Living Painting with a Long History

Lu Zhang

Introduction

The earliest *Qingming shanghe tu*, also known as *Along the River during the Qingming Festival* (*Qingming* scroll for short), is attributed to Song Dynasty painter and member of the literati Zhang Zeduan (1085–1145), and is considered one of the most recognizable paintings in the history of Chinese art. The painting is in the collection of the Palace Museum in Beijing. Unlike Western-style landscape painting, which is usually painted as a "window" through which to view a scene, the *Qingming* scroll very likely depicts panoramic views of Bianliang (present-day Kaifeng in Henan Province), the capital of the Northern Song Dynasty (AD 960–1127) at that time. The landscape in and around the city is filled with people from all levels of society, performing activities from their daily lives (fig. 96). In the Ming (AD 1368–1644) and Qing (AD 1644–1911) Dynasties, cityscape paintings were widely

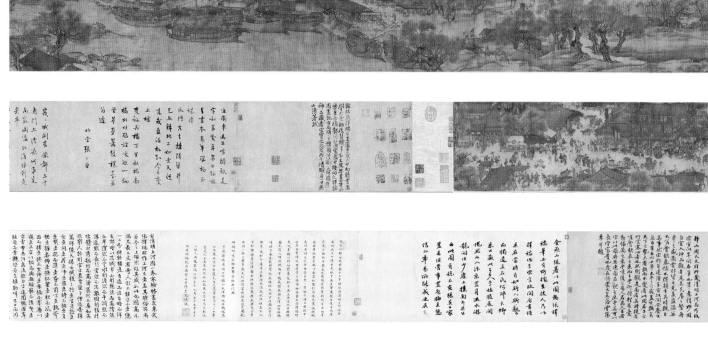

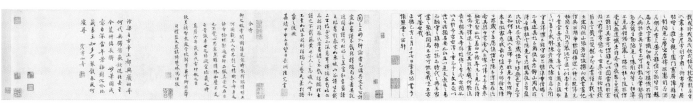

produced by both local professional artists and formal court painters (Wang 2011, 295–96). With the increasing popularity of Zhang Zeduan's scroll, some artists even went so far as to give their works the same title. "*Qingming* scroll," therefore, came to mean a category of landscape paintings showing people's daily life, and depicting the social, commercial, and agriculture activities that occurred within a city's landscape.

Collecting The Field Museum's Scroll

The Field Museum's painting (catalog no. 33723) displayed in the *Cyrus Tang Hall of China*'s Gallery 3, "Shifting Power, Enduring Traditions," is a Ming Dynasty interpretation of the original *Qingming* scroll. The painting was formally acquired in December 1912. George Amos Dorsey (1868–1931) purchased the scroll in Beijing in 1911, and a donation to support its purchase was made by members of Chicago's Tuesday Art and Travel Club the following year. Dorsey was curator of anthropology at The Field Museum, and in addition he served as an editorial staff member and foreign correspondent for the *Chicago Tribune* newspaper reporting on political conditions in India, China, Japan, Australia, and South Africa (Cole 1931, 413–14).

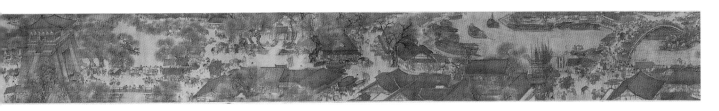

The Museum's *Qingming* painting was acquired during Dorsey's trip to China in 1911, the final year of China's last dynasty. The painting was displayed after Dorsey's return to Chicago, and it is mentioned in the annual report for 1914. By 1932, however, the painting had been taken off display. Fortunately, almost a century later, the newly opened *Cyrus Tang Hall of China* offers Field Museum visitors an opportunity to see the scroll once again.

The painting shares a format, composition, and motif similar to those of the original image. Designed as a long, horizontal handscroll, the 27-foot-long painting should be read from right to left, section by section. With each section, the viewer unrolls an arm's-length portion of the painting, gradually illustrating a meandering narrative that reveals an entire cityscape. The river is the main narrator, as it crosses the entire painting, linking a farm in the countryside with a market on the central Rainbow Bridge, and then on through the inner most sections of the city (fig. 97). The painter also uses a bird's-eye view to organize the entire scroll, allowing viewers to see a great variety of detailed urban activities in one image. Although it carries the forged signature of Zhang Zeduan, the painting was probably made in the late Ming Dynasty (late sixteenth to early seventeenth century) by an anonymous professional artist (or artists) from Suzhou, a city in the center

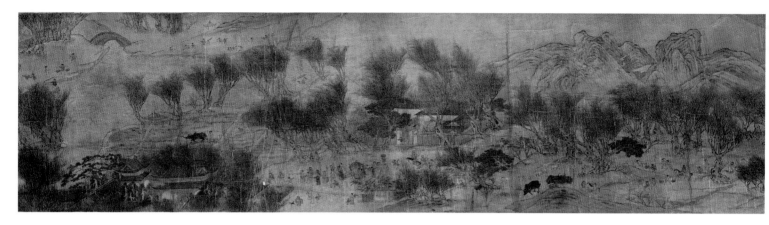

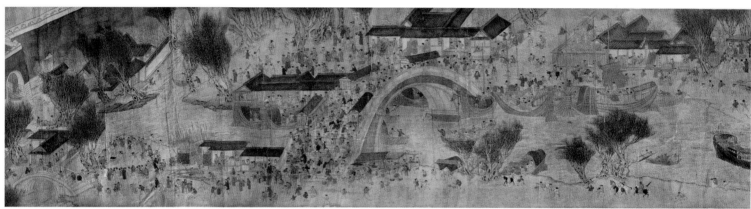

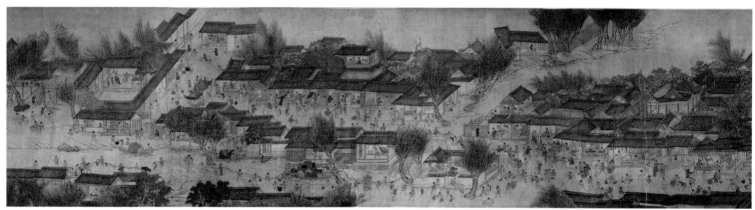

我遠張文友新圖妙入神
素縑該象就綠筆畫聯
民始自青春早成年白
髮新至今披玩者究在
上河濱

沛未妥題

翰林張擇瑞宇正道東武人也
幼讀書好學于京師後習繪事
工于界畫尤嗜舟車市橋郭境
別成家數藏者寶之

沈度

看山好看畫駐水好於
其好流駐溪繡山高白宣
溪佰仰天代間蒼豹奔若
八清全訊往來再我僻
煩檬

沿明書

FIGURE 97
Handscroll, *Along the River during the Qingming Festival*. Late sixteenth–early seventeenth century. © The Field Museum. Photo ID No. A115260d. Catalog No. 33723. Photographer Karen Bean.

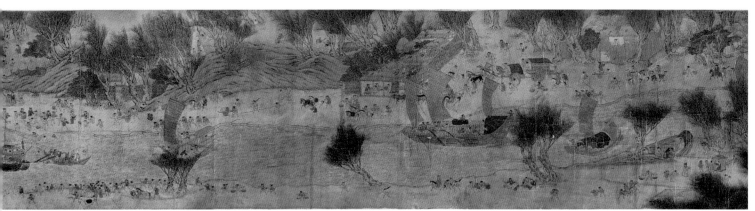

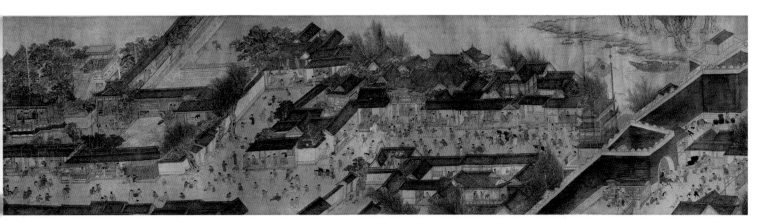

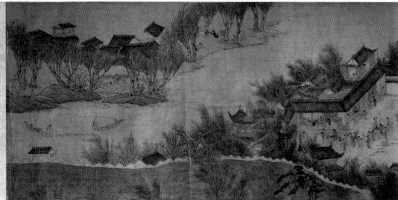

of the Yangtze River Delta; the blue-green brushwork style is exemplary of late Ming-period design.

Qingming paintings, as an encyclopedic style of images, provide abundant visual materials for scholars working in various disciplines to study the art, history, culture, and society of the time periods in which they were made. During the past sixty years, major scholarship has primarily focused on the original Song Dynasty scroll, considering the later Ming and Qing versions to be simple copies and forgeries. Most scholars have until recently overlooked the important historical information stored in the later paintings. This chapter explores the historical, political, and social significance of the *Qingming* painting style as it relates to three phenomena. First, this section will explain why the original *Qingming* scroll was treated as a monumental work of art following its creation during the Northern Song Dynasty. Second, it will demonstrate how it later developed into a major category of painting during the Ming and Qing periods. Third, it will reveal how the painting became a favorite for collectors from different socioeconomic and political classes including emperors, elites, and merchants.

The Field Museum's *Qingming* scroll, along with other Ming Dynasty versions, presents viewers with a journey to an idealized yet realistic city in the Jiangnan area (Yangtze River Delta) during the springtime. By comparing The Field Museum's scroll with the well-known Song Dynasty scroll, we see that the later painting serves as an urban ethnography illustrating the social changes that occurred in the centuries following the Song Dynasty. It includes a flourishing urban, market-oriented economy, changing roles of women, the increasing significance of social hierarchy, and peoples' pursuit of diverse entertainment as part of their daily life. Ming-period artists might have gained their initial inspiration from Zhang Zeduan's masterpiece, but ultimately they reflected their own contemporary perspectives and environments in the historic river landscapes that they painted. The later periods' *Qingming* scrolls are not simple fakes or forgeries; instead, they are creative reinterpretations of the original scroll. As the well-known Chinese idiom says, the artists were "putting new wine into old bottles" (*jiuping zhuang xinjiu*).

The Creation and Impact of the Original *Qingming* Painting

A handscroll painting is traditionally made from one or several lengths of silk or paper mounted on a backing material, usually also made of paper. The painting is rolled up into a scroll when not being viewed. The main focus and body of the scroll is the central painted image. This image is flanked on either end of the scroll by a colophon section. In Chinese artistic tradition, the colophons contain inscriptions and seals written not only by the artist but also by later generations of collectors and connoisseurs who encounter the painting. These annotations comment on the painting's significance and meaning and can be used to track the provenance of the scroll over time. These colophons provide an interactive communicative space between the original artists and viewers from different generations, yet they also

function as an autobiography of the painting by providing records displaying the scroll's attribution, date, title, viewers' responses, and collecting history (Zhang 2013, 55–63).

Although the *Qingming* scroll has been intensively studied for generations, there is still ongoing debate regarding many aspects of the work. For example, some scholars think the painting shows the Qingming (Pure Brightness) Festival, also known as the Tomb-Sweeping Festival, a day to remember and honor ancestors at the gravesites, while others argue the term *qingming* in the title means *shengshi qingming*, "a prosperous age under a peaceful reign" (Pan 2011, 29–32). This is also why the painting's title has various translations, such as *Along the River during the Qingming Festival*, *Peace Reigns over the River*, and *Spring Festival along the River*. The *Cyrus Tang Hall of China* artifact label uses the first translation of the scroll, since it is the most widely known and accepted.

Besides the subject matter, scholars also hold different opinions on the original scroll's theme. Some scholars argue that the original scroll was painted during the Xuanhe Reign (AD 1119–25) to praise the prosperous golden age of the Northern Song Dynasty under the rule of Emperor Huizong (r. 1100–1125) (Whitfield 1965, 56). Another possibility is that the scroll was made in the early or mid-eleventh century, roughly before the reign of Emperor Shenzong (r. 1067–85). This interpretation sees the painting as a depiction of the social struggles of the time and encourages the emperor to persevere along with his people (Tsao 2012, 5–6). Other scholars think the scroll was painted during the Jin Dynasty (AD 1115–1234), postdating the occupation of the Northern Song region by the Jurchen people. From this perspective, the painting is meant to harken back to the great age of the Song and, by implication, criticizes Jurchen rule (Cahill 1988, 14).

Although various scholars seem to present different interpretations of the original *Qingming* scroll, they all agree that it was never seen as a simple river landscape painting, but clearly carried strong social and political meanings. The history documented in the colophons serves to illustrate this significance. The earliest inscription we see today on the original *Qingming* scroll was written by Zhang Zhu, dated to 1186. According to this colophon, Zhang Zeduan was a Northern Song Dynasty Hanlin imperial academician who was talented in rule-lined-style paintings (*jiehua*), which feature intricate architecture as the principal subject. As an artist he was especially talented at depicting boats, carts, markets, bridges, moats, and paths. Since the creation of a more than 17-foot-long handscroll would have necessitated support from influential and powerful patrons, it is possible that these patrons may have come from the Song imperial family (Hansen 1996, 190–91). Master Xiang Zonghui, famous for his essay *Master Xiang's Comments on Paintings*, was connected to the imperial family through marriage as the brother of Empress Xiang of the Song Dynasty Emperor Shenzong. In all likelihood, Master Xiang Zonghui was one of the earliest collectors of the painting. The painting was later in the collection of Emperor Huizong, the successor to Emperor Shenzong. Thus, the biographical and collection information provided in the colophons demonstrates

that there is very possibly a connection that existed among Zhang Zeduan, Xiang Zonghui, and Emperor Huizong.

Colophons of a more literary vein also speak to the importance ascribed to the painting. For example, Jin Dynasty scholar Wang Jian (no date) inscribed a poem (Whitfield 1965, 160):

> Singing girls fully filled the song houses and the wine shops,
> and millions of families lived in the city.
> Who had made the place into a ruin with wilderness of weeds?
> The dictatorship of the crafty and evil grand preceptor was a
> major reason.
> Under the two bridges there was no day without boats crossing the river,
> and songs and *sheng* music were singing around the area.
> However, as far as we can see today, all the areas are millet land now.
> I have to open the handscroll to view the original prosperous
> city scenes.

In the poem, Wang Jian compared what he saw as his period's desolate city scenery with the golden period of the Northern Song depicted in the scroll. The colophon expresses his impressions on the rise and fall of the empire, as well as his own political ambitions. Half the fourteen inscriptions written by scholar-officials from the Jin Dynasty to Ming Dynasty belong to this type of romantic outlook.

The political message Zhang Zeduan's work reflected is that an enlightened ruler is the key to maintaining a peaceful, prosperous, and well-ordered society. This idea was widely supported by the ruling elite, and paintings inspired by Zhang Zeduan's original masterpiece became common commissions from a wide range of social classes, purchased by everyone from members of the imperial family down to local officials and merchants. Consequently, by the Ming and Qing periods many *Qingming* images were made by anonymous professional artists from the Suzhou area, carrying either the signature of Zhang Zeduan or the well-known Ming Dynasty Suzhou artist Qiu Ying (1494–1552) (Yang 1990, 72–73).

Later Ming- and Qing-Period *Qingming* Scrolls

Compared to the Song Dynasty *Qingming* scroll, the later paintings are not exact line-by-line reproductions. Instead, painters took artistic liberties in their depictions, often contemporizing the subject matter. The original painting probably illustrates the ancestor memorial festival Qingming Day, as the painting title indicates, but later versions focus on general springtime scenes. The overall tone of the later paintings is brighter and more joyous and festive than the original image, since most of the images include a wedding procession and various kinds of entertainments, which more often took place on lucky and celebratory days, rather than on a sorrowful day for worshiping ancestors and sweeping tombs (see fig. 99).

Although later *Qingming* paintings vary significantly, they all share a conceptual structure. More than fifty copies survive today (Kohara 2007, 322–46). These each adopt certain key features from the original masterpiece, using the river as a narrative cue that provides viewers with a panoramic vista along which we can see the activities of daily life from the countryside to the city. The paintings also all incorporate the Rainbow Bridge market as the center of the painting to present a centrally located perspective on a flourishing urban economy.

Today, it is difficult to identify the original painter who created the model for the later *Qingming* scrolls. Among all the Ming-period *Qingming* paintings, only the scroll made by the artist Zhao Zhe in the Hayashibara Museum collection is believed to carry an authentic signature, dated 1577. Although Zhao Zhe's work is one of the earliest *Qingming* interpretations that survive today, it is probably also a copy of an even earlier image. The Field Museum's scroll is very similar to Zhao Zhe's work, both for its structural frame and detailed subject matter, so it may well also have been painted in the late Ming period, probably in the late sixteenth to early seventeenth century. In addition, a *Qingming* scroll attributed to artist Qiu Ying is a comparable example for studying the framework of The Field Museum's painting, since it is one of the most complete versions among the existing Ming Dynasty *Qingming* scrolls. The scroll was once kept in the Manchu imperial collection and currently is housed in the Liaoning Provincial Museum (fig. 98) (Ma 2009, 35–40). In comparison to Qiu Ying's scroll, The Field Museum's painting looks incomplete, lacking the last section depicting a magnificent imperial palace and garden complex in the center of a lake. It was either eliminated by the painter or perhaps cut out by a later collector. Handscroll paintings periodically need to be remounted, and if the last section of the painting was not in good condition it may have been trimmed during the effort to remount the silk image onto its paper backing.

In the Qing Dynasty, *Qingming* scrolls remained a favorite of the Manchu emperors. One illustrative example is that Emperor Yongzheng (r. 1722–35) so feared that the original Song work had been lost that he appointed five court painters to re-create a complete version of the scroll, a project that took eight years (Chen 2010, 6–8). Emperor Yongzheng's scroll, which depicts an idealized imperial city at peace, is almost 37 feet long and now in the collection of the Palace Museum in Taipei (fig. 99). Derived from both Ming Dynasty *Qingming* scrolls and probably also Qing Dynasty artist Shen Yuan's line drawing copy (Tong 2010, 196–200), this painting has the same structure and layout as The Field Museum's scroll.

The *Qingming* paintings ordered by Qing Dynasty emperors carry stronger political overtones than their Ming Dynasty predecessors. During the Qing Dynasty, the ethnically Han-Chinese population, the majority of the population at that time, was ruled by a minority people, the Manchu from northeastern China. The Manchu emperors attempted to associate their rule with the utopian imperial cities of the *Qingming* art form. In contrast, Ming Dynasty *Qingming* scrolls were produced by professional artists who had more freedom. They were not limited to

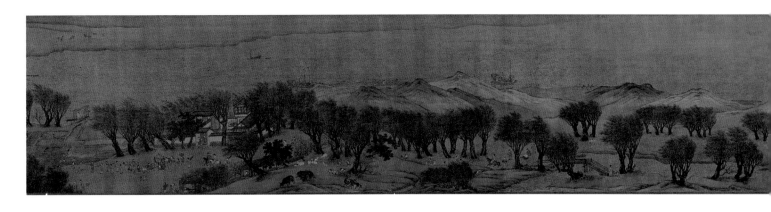

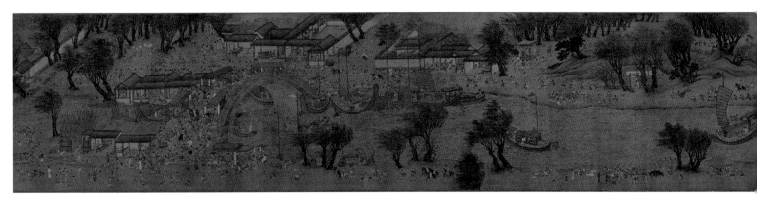

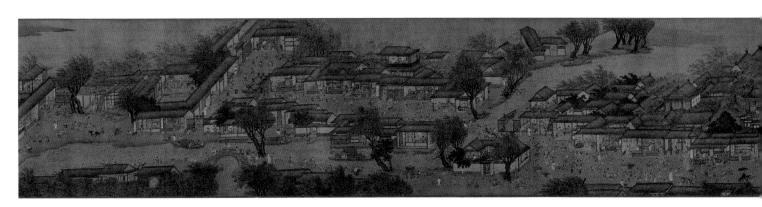

FIGURE 98

Qiu Ying (AD 1494–1552) (Attributed to). Handscroll, *Along the River during the Qingming Festival*.

Sixteenth century. © Liaoning Provincial Museum.

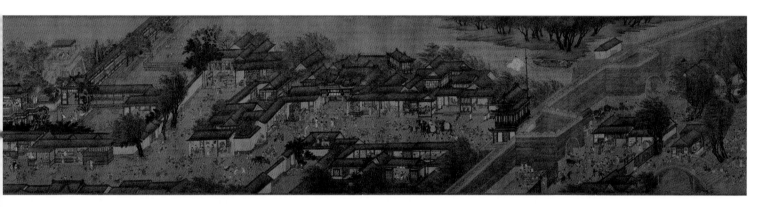

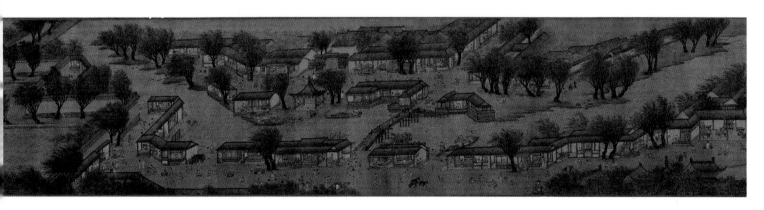

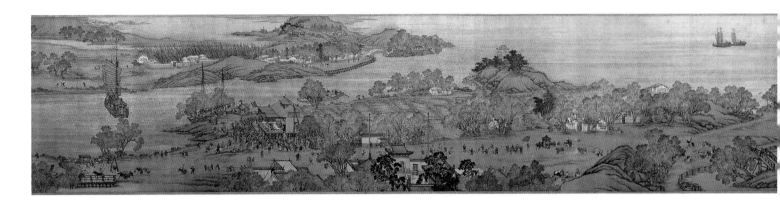

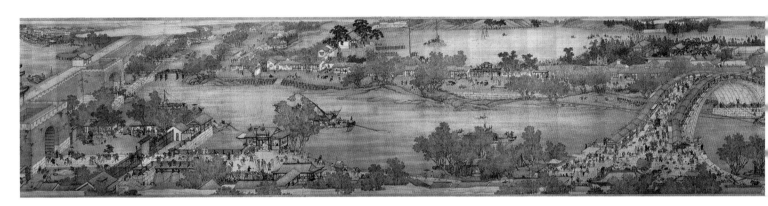

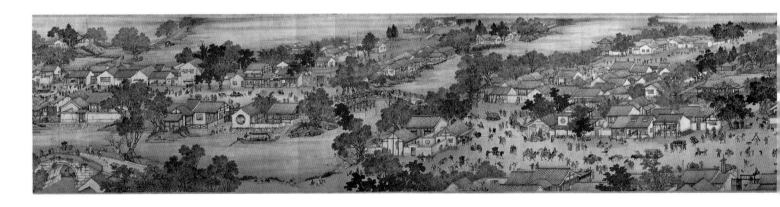

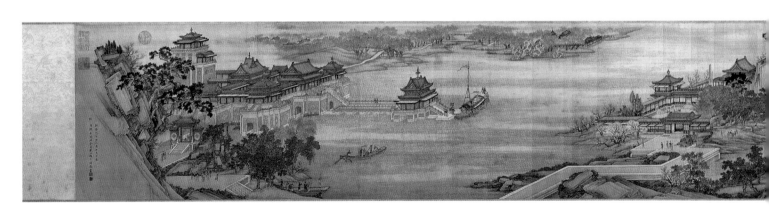

FIGURE 99

Chen Mei, Sun Hu, Jin Kun, Dai Hong, and Cheng Zhidao.
Qing Dynasty court version of handscroll, *Along the River
during the Qingming Festival*. AD 1736. Painting in the collection
of National Palace Museum. Image in Public Domain.

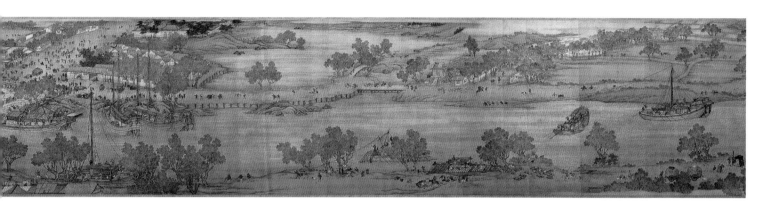

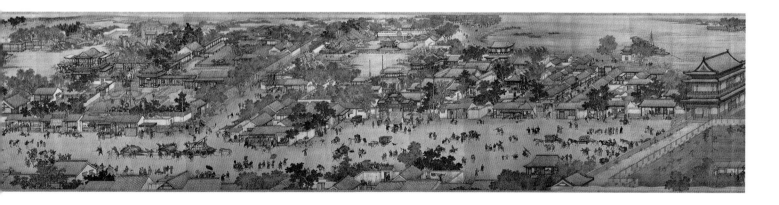

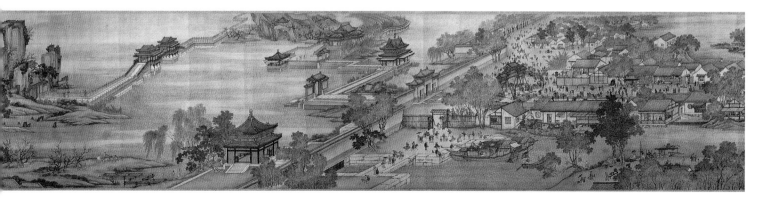

utopian depictions for their cityscapes, and, as a result, their paintings were free to depict social tensions and changes that affected society.

The long chronology of *Qingming*-style cityscape paintings raises an important question: why did later *Qingming* scrolls become popular subjects in the late Ming and Qing Dynasties? The most plausible explanation for the popularity of this genre of scrolls is that in the late imperial and early modern period the development of a more prominent market-oriented, urban society led to an increased interest in folklore-themed art that had a strong link to everyday experience. Thus, *Qingming*-style landscape paintings that represented cultural and material affluence within an urban setting were widely appreciated.

A Visual Urban Ethnography: The Field Museum's *Qingming* Scroll

The handscroll format of *Qingming* paintings allows artists to create a continuous visual journey from the country into the city. Unlike religious-motif paintings, the depiction of everyday activities serves as a kind of dynamic visual diary. The entire scroll offers later generations of viewers an opportunity to travel back in time, to late Ming-period China through the painting. Cityscape paintings serve as visual ethnographies with which to study urban society in the late imperial period. The different subjects depicted on the original scroll in comparison to The Field Museum's version of the painting provide the viewer with a perspective on social changes that occurred from the Northern Song Dynasty to the late Ming Dynasty, such as a developing sense of imperial urban life, a more strictly hierarchical social structure, and the changing roles of women.

The diverse subject matter of *Qingming* paintings not only attracts the attention of general visitors, who are probably seeing the scroll for the first time, but also of researchers. For years, scholars have examined the later *Qingming* paintings to identify the cities and locations they depict. If we examine The Field Museum's scroll from this perspective, the architecture, shops, and locations depicted on the image are relatively generic. Although the artist inscribed banners on diverse types of shops to promote their goods and services, such as "calligraphy mounting and painting," "bronze vessels," and "book store," there are no specific landmarks that could link the painting to an actual city. The city that is presented is an idealized imperial city somewhere in the Jiangnan area (Yangtze River Delta) that enjoyed a flourishing economy supported by river transport and abundant resources.

The artist who painted The Field Museum's *Qingming* scroll also drew upon his visual experiences for reference. The wooden Rainbow Bridge seen in the original scroll has been replaced by a stone bridge, a design that was commonly in use during the Ming Dynasty (fig. 100). The painter also illustrated the inner-city gates, the city walls, and the imperial city defenses, including barbican walls (*wengcheng*) and a lookout tower, some of which are not seen in the Song Dynasty *Qingming* scroll (fig. 101). Unlike the original Song Dynasty scroll, which only depicts a land gate, the city gate tower featured in The Field Museum's painting includes both

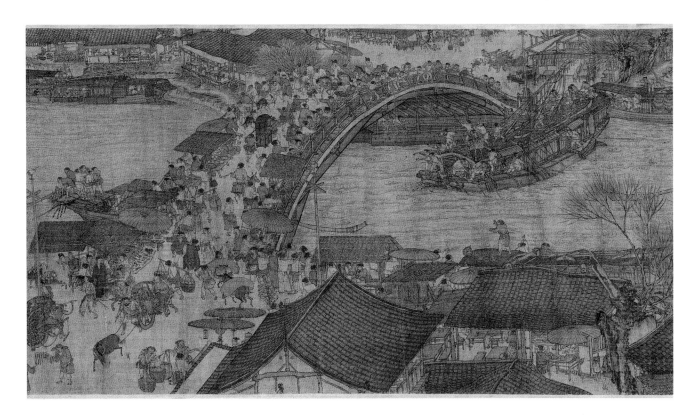

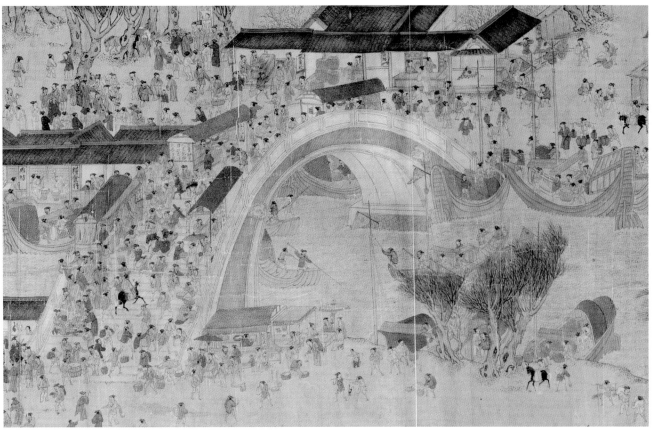

FIGURE 100
Detail of Rainbow Bridge on Zhang Zeduan's original *Qingming* scroll and The Field Museum's scroll.

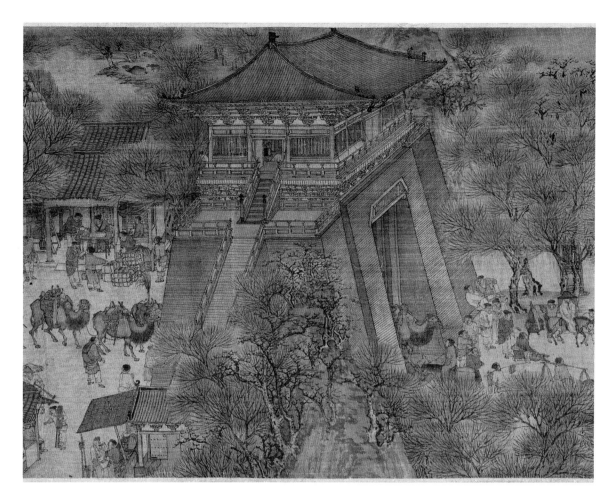

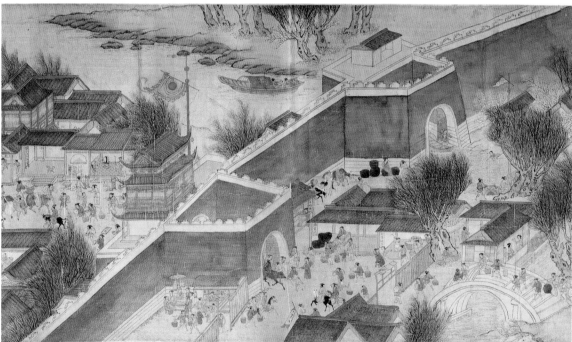

FIGURE 101

Detail of City Gate on Zhang Zeduan's original *Qingming* scroll and The Field Museum's scroll.

a land gate and water gate. So many contemporary elements were added by the Ming-period painters that the length of the scrolls tended to increase. Examples such as The Field Museum's scroll stretch to 27 feet long, and the Liaoning Museum's scroll is more than 32 feet long. Historical records show most of the Ming Dynasty *Qingming* scrolls were produced by professional painters from the Suzhou area (Chang 2013, 63–78); not surprisingly, the paintings share many characteristics with the city of Suzhou.

Although the city depicted on The Field Museum's scroll cannot be identified definitively, the scroll shows a city with a flourishing urban economy, but one that also has clear social tensions. On the scroll we can find farmers bringing

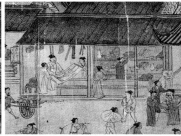

FIGURE 102
Details of textile store, dyeing house, antique shop, and street fighters depicted on The Field Museum's scroll.

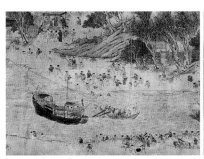

FIGURE 103
Details of a military official and female figures depicted on The Field Museum's scroll.

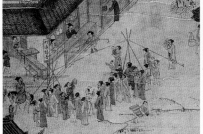

FIGURE 104
Details of religious activities and secular entertainments depicted on The Field Museum's scroll.

agricultural goods from the countryside to sell in the urban markets, such as the central Rainbow Bridge market. Farmers also come to town to work as laborers in commercial shops, like the dyeing house (fig. 102). In comparison to the Song Dynasty scroll, the diversity of commercial activities depicted on The Field Museum's scroll is greater, including dyeing houses and textile stores selling silk and cotton products as well as ready-to-wear garments. Social tensions are also depicted, such as in a street fight in front of one of the shops (fig. 102).

Social roles and social hierarchies are more prominent in the Ming-period *Qingming* scrolls (see fig. 103). Examples include an elaborate palace and garden not seen in the original Song Dynasty scroll. A boat carrying a military official also carries a banner stating that people should "stay away," and the swimmers close to the boat can be seen quickly trying to swim to shore. The original Song Dynasty painting did not depict many women, but later Ming paintings show women from different social strata, including a view of a courtesan house that can be seen in figure 103.

The Field Museum's scroll also illustrates scenes of religious activities and secular entertainments (see fig. 104). The scroll depicts a temple with a woman at her devotions, as well as a pair of monks, one of them wearing a pagoda-shaped hat, begging for donations. In addition, secular entertainments, such as a wrestling match, may be seen, hinting at the diverse pursuits and opportunities for city dwellers during the late Ming period.

Linking Past to Present: *Qingming* Scrolls in Contemporary Context

Qingming scrolls have never been treated solely as historical paintings. Rather, the original painting, along with its later reinterpretations, is often treated as the iconic graphic identity of China. Since 1949, the founding of the People's Republic of China and a new chapter of China's history, the country has undergone astonishing political, social, and economic transformations. The landscape of China, both within metropolitan cities and the rural countryside, is likewise changing dramatically. Contemporary Chinese artists working in diverse media have drawn inspiration from *Qingming*-type cityscape imagery to create works that express their views on China's continued urbanization and to explore how industrialization influences the development of modern cityscapes.

As just one example, *Spring Festival along the River* produced by contemporary artist Hong Hao (b. 1965) illustrates how contemporary artists have updated the *Qingming* scroll (fig. 105) (Hearn 2013, 109–10, fig. 84; Tan 2008, 161–72). In his work, Hong Hao provided a side-by-side parallel presentation of details reprinted from the original *Qingming* scroll and photographs depicting similar scenes of Beijing in the late 1990s. The photographs included well-known landmarks such as the Great Wall, Tian'anmen Gate, Qianmen Ancient City Gate, and traditional narrow alleys known as *hutong*. He also included snapshots of crowded streets shadowed by rising skyscrapers, freeways, high bridges, and marketplaces. All of this imagery can

FIGURE 105

Hong Hao (b. 1965). Thirty-two leaves from an accordion
album of thirty-four, *Spring Festival along the River*. 2000.
Hong Hao 2016, courtesy of Pace Beijing.

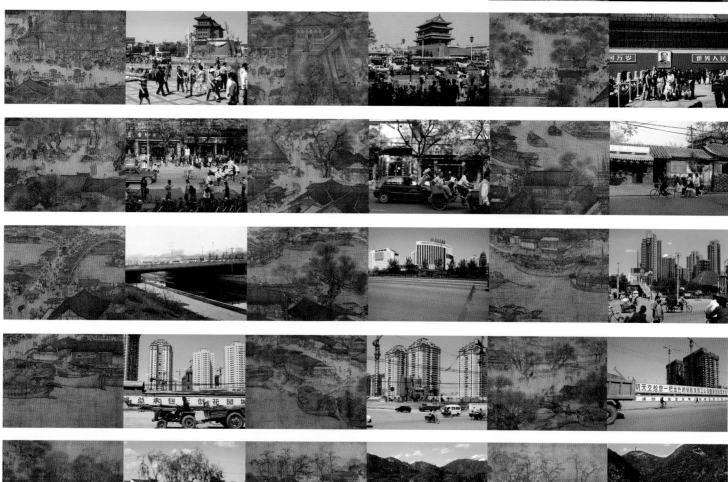

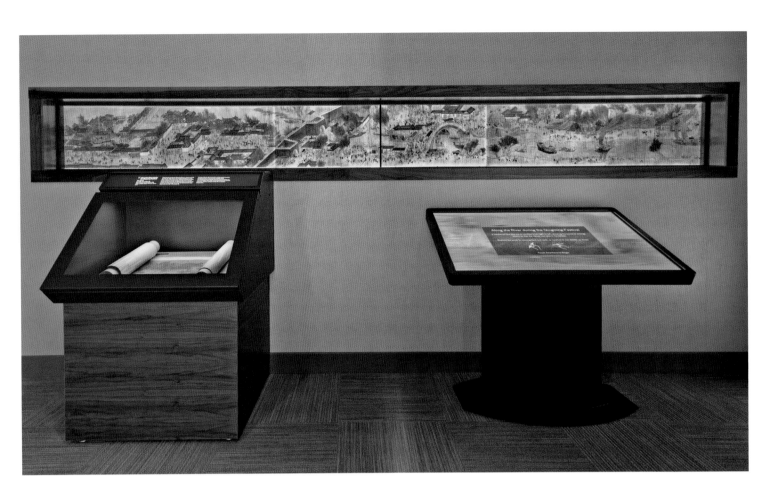

be seen in any large city in China. In his comparison of the urban landscapes in the Northern Song capital Bianliang and contemporary Beijing, the artist presents similar types of scenes but with a sharp contrast. The overall tone of Hong Hao's photographs is not festive or celebratory. Instead, the artist seems to criticize Beijing's urbanization. When linking all the photographs together, the viewer sees that the historic landmarks have been surrounded and isolated by modern buildings. They no longer exist in a cohesive landscape; modernity has interrupted their original harmony.

In contemporary exhibitions, epic *Qingming* scrolls are made more accessible to the public through the use of modern technology. One such example is the digital scroll developed by The Field Museum for use in the *Cyrus Tang Hall of China* (fig. 106). Due to conservation concerns regarding fragility and light exposure, the Museum is not able to unroll and display the scroll to its full length indefinitely. Consequently, the Museum created a high-resolution digital version of the painting presented on a touch table, providing visitors with the opportunity to view and interact with the scroll in its entirety. The viewer can take a virtual tour through the ancient city and explore hundreds of figures and scenes in extraordinarily detail. The Field Museum is certainly not the only institution to develop digital tools to enhance visitor access. The Palace Museum in Beijing and the National

CHAPTER SIX

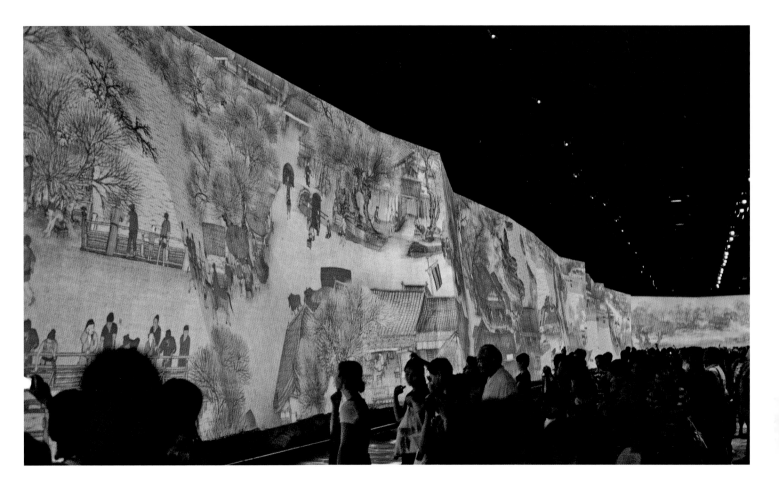

FIGURE 107
Photograph taken in the exhibition
*A Moving Masterpiece: The Song Dynasty
as Living Art*. Image courtesy of Nik
Gaffney, FoAM.

Palace Museum in Taipei have both used dynamic digital *Qingming* scrolls in their exhibitions.

A particularly ambitious example was unveiled in 2010, when a large-scale (128 meters long and 6.5 meters high) digital reproduction of the original *Qingming* scroll was installed in the China Pavilion at the Shanghai World Expo, becoming one of the most visited exhibitions of the year (Huang 2012, 6). The exhibition, *A Moving Masterpiece: The Song Dynasty as Living Art*, is an example of how technology can facilitate the appreciation of an ancient work of art and an era far in the past (fig. 107).

Conclusion

The Field Museum's handscroll *Along the River during the Qingming Festival* is an exemplar of a long tradition of *Qingming*-style paintings, a genre that is still very much alive today. These paintings underpin interpretations by contemporary artists who wish to offer their insights on the social realities of today. For visitors to the *Cyrus Tang Hall of China*, a glimpse at the painting provides not only a window into the past, but also a frame from which they can gaze forward and reflect as well.

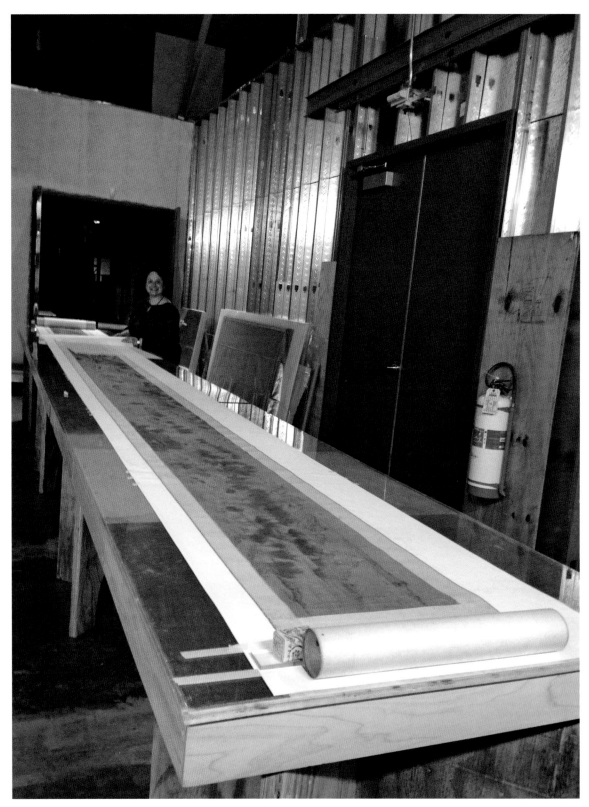

FIGURE 108
Conservator Rachel Freeman works on the scroll on a custom-made 36-foot-long table. © Shelley R. Paine.

Conserving a Treasure:

Preparing *Along the River during the Qingming Festival* for Display

Rachel Freeman and Shelley R. Paine

The road that an object travels from a Field Museum collection storage room to an exhibition display case can be a winding one. In the case of the Museum's Ming Dynasty scroll painting *Along the River during the Qingming Festival*, the piece was carefully researched, examined, photographed, conserved, and placed on a custom support in a very special display case. The story of how the scroll passed through this process involved the talents of a team of curators, researchers, developers, conservators, designers, mount makers, photographers, and wood and metal fabrication specialists.

Once the scroll was selected for exhibition it was studied for many months by curators, researchers, and developers in order to decide which stories would be highlighted for visitors. At the same time, conservators reviewed the condition of the *Qingming* scroll to determine what conservation treatment would be needed for the scroll's safe display. The conservation process began with thorough examination and photodocumentation as well as the fabrication of a 36-foot-long table for its treatment (fig. 108).

The late sixteenth- to early seventeenth-century *Qingming* scroll is characteristic of traditional Chinese handscrolls. It consists of several long lengths of joined painting silk. The painting silk was probably sized with a dilute animal skin glue and alum mixture prior to the ink and paint application. After drying, the size prevented the paint from penetrating too deeply into the silk threads. Traditionally, the paint and ink are water based, probably consisting of pigments mixed with an animal skin binder. The ink is composed of soot that was mixed with glue and dried in hard cakes. Colored paints could be made in the same manner, or the ground pigment particles could be mixed with the glue on an as-needed basis.

Aside from the painting silk, the scroll consists of layers of a thin, smooth-surfaced paper. These are attached to the silk with a paste, which formed a flexible bond and allowed the silk and paper layers to move together. There are yards of paper that extend beyond the end of the painting, for reasons that will be discussed below. The last step in the scroll-mounting process is lightly waxing and burnishing the back of the paper, and the addition of decorative silk borders attached to the edges. The paper at the end of the scroll is then attached to a wooden dowel that provides a hard surface for rolling. Creasing is a serious problem with scrolls, and the yards of paper at the end of the scroll wrap around the roller bar, creating a larger-diameter roll and slight cushion for the pictorial portion of the artwork. When not in use, the scroll was rolled for storage, and a cloth ribbon with a toggle was wrapped around the scroll to secure it.

As mentioned above, creasing is a common and serious problem with scrolls. If left unaddressed, the creases turn into breaks that extend through the paper layers and into the painting or mounting silks. The *Qingming* scroll exhibited creases throughout, with a single long tear in the paper closest to the wooden dowel. There were also tack holes along the outer edges of the scroll. These may be evidence of previous display where the entire painting was unrolled. In order to display the scroll, the tears and holes required repair, and the creases needed additional support. To create a cohesive appearance, the scroll also required flattening.

Treatment began with the choice of a thin paper that closely resembled the original in appearance and texture. This was important because the mends and crease reinforcement on the reverse side are visible on the rolled portion of the scroll during exhibition. After a light surface cleaning, strips of the paper were attached over the tears and the creases on the reverse side. A very thin layer of weak adhesive was used during the mending process, since a stiff adhesive can prevent the scroll from rolling properly. The tack holes in the edges of the piece were reduced in appearance by applying deionized water and pushing the paper fibers back together. On occasion a small mend was placed over a tack hole.

The treatment was completed by humidifying the scroll and then allowing the scroll to dry under weight. The 36-foot-long table was useful for this process: the entire scroll was unrolled, and the humidification package (polyester batting misted with deionized water and a vapor permeable membrane) was placed under the artwork at one end (fig. 109); as the humidified portion of the artwork became

FIGURE 109

Layers of materials support the scroll during humidification and flattening.
© Shelley R. Paine.

slightly damp and relaxed, it was placed under weight and the humidification material was shifted to the next section. Drying actually took several weeks, because if the artwork is removed from the weight too early, it forms unfortunate undulations.

To properly maintain its condition over time, appropriate environmental and display criteria were determined for the scroll. The scroll, like many other objects made from paper and silk in the exhibition, is best preserved in a controlled environment. Temperature and relative humidity fluctuations will cause the paper and silk to expand and contract, often resulting in creases and tears, or ink separation from the surface. To minimize these changes sophisticated temperature and relative humidity controls and equipment are present in the gallery. Should the exhibition environment go out of range an automatic alert is sent to conservators and building engineers so corrections can occur immediately. In addition, the scroll is in a tightly sealed display case to further buffer it from any climate changes in the gallery. A small temperature and relative humidity meter inside the case monitors the case environment.

The scroll is easily damaged by visible and ultraviolet light, which will cause permanent photochemical degradation. Therefore, a light fixture that does not emit ultraviolet light was selected. The scroll is displayed at a low light level of 5 foot candles, and lighting is only activated when a visitor is present, thus further reducing the overall amount of light received during the day. The scroll will also be advanced regularly so over the term of the exhibition no area will be seen more than twice.

A display case was thoughtfully designed to create a tightly sealed chamber for the scroll. Tested using a carbon dioxide data logger, the leak rate for the carbon dioxide confirmed that the case was indeed sealed properly. The materials used to fabricate the display case chamber and the scroll display mount also were carefully tested since they can potentially deteriorate and harm the scroll. The test used is called the Oddy Test. This test places a sample of the material, metal coupons, and a measured amount of water in a test tube that is placed in an oven at 100°F for thirty days. If the metal coupons do not corrode, then the material passes this accelerated test.

Once the case was ready and the treatment completed, the scroll was installed on a custom made adjustable exhibition mount. Each end of the scroll was gently

FIGURE 110
Detail of mount showing tubes on which the scroll is rolled and supported.
© Shelley R. Paine.

rolled onto an acrylic tube. Each tube had a slit that permitted the stave and end ties of the scroll to be safely stored inside. End caps were made for each end of each tube that positioned the tube above the surface of the display deck, preventing any pressure on the scroll. A metal fitting in each end cap was made to be adjustable up and down and side to side, permitting the proper installation of the scroll no matter what portion of it is on view (fig. 110).

Three years of work were devoted not only to the selection and preparation of the *Qingming* scroll but also to more than 420 objects for the exhibition. These artifacts will be examined regularly to ensure their safety for many, many years to come.

Note

This highlight section is presented with gratitude to all those that participated in the presentation of the *Qingming* scroll. They include Gorge Alejandre, Alvaro Amat, Karen Bean, Robert Belote, Deborah Bekken, Richard Bisbing, Daniel Breems, Michelle Burton, Sarah Crawford, Gary Feinman, Eric Frazer, Pam Gaible, Hector Gonzalez, Gediminas Jakovickas, Kristen Kleckler, Eric Manabat, Jillian Mayotte, Kyoji Nakano, Lisa Niziolek, John Parr, Taylor Peterson, Libby Pokel-Hung, Ann Prazer, Sarah Sargent, Dan Schilling, Tom Skwerski, Lori Walsh, Christina Yang, John Zehren, and Lu Zhang.

Men of Culture: Scholar-Officials and Scholar-Emperors in Late Imperial China

Fan Jeremy Zhang

Among the works in the Chinese collection of The Field Museum, a Tang Dynasty stele attracts considerable attention, not only as a rare early example of Daoist art, but also as a valuable historical record documenting the great interest in antiquity among Chinese officials in late imperial China (fig. 111). Featuring the supreme Daoist deity Yuanshi tianzun 元始天尊 (the Celestial Venerable of the Primordial Being) on a lotus throne accompanied by a pious couple and their four children, this limestone carving (on display in Gallery 3 of the *Cyrus Tang Hall of China*, "Shifting Power, Enduring Traditions") was commissioned in AD 726 by a father in memory of his daughter, who passed away at a young age. The text inscribed on the back is very important because it indicates that the inscriber and collector of this stele, Duan Fang 端方 (1861–1911), a high-ranking Manchu official, was also a distinguished art connoisseur and antiquarian. His strong interest in antique

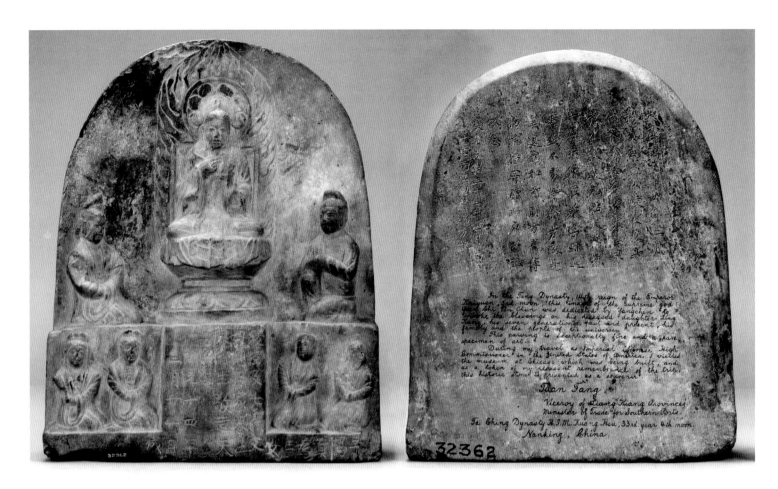

collecting, classical scholarship, and public education opens a window for explo-
ration into the Chinese intellectual tradition and cultural heritage that had been
shared among both the rulers and the ruled in China for centuries. Viewing it as
emblematic of Chinese history, Duan Fang presented this stele as a gift to The Field
Museum in 1907, soon after he returned home from an eight-month tour of the
United States and Europe. This antique-collecting official was probably impressed
by his visit to the old Field Museum, which was founded after the 1893 World's
Columbian Exposition in Chicago (see Bekken, this volume). He transcribed his
interpretation of the memorial text and stated that this stele, one of only three in
his cabinet of curiosities, was indeed very rare and worthy to be collected by The
Field Museum (Pearlstein 2014, 8).

Duan Fang is perhaps one of the most well-known historical figures of the
Qing Dynasty both in China and abroad, due to his reform efforts, his superior
antique collection, and his tragic demise. In late 1905, troubled by tremendous in-
ternal and external crises, the Qing court sent Duan Fang and four other high-rank-
ing officials on a special mission to survey political, commercial, and educational
institutions in the West as possible models for constitutional reform in China.
Notably, the civil service examination system, which had lasted more than 1,300

CHAPTER SEVEN

years, had been officially abolished only a few months prior to their trip, and the court was eager to develop new Western-style schools to train and select prospective officials. As one of the few influential Manchu officials who publicly supported such reform, Duan Fang became viceroy of Zhili (*Zhili zongdu* 直隸總督) in 1909, the most powerful chief governor in the empire, who oversaw the capital region and administered reform-related issues at the court. Confronting political and social upheaval, he strove to sustain Manchu rule in the final years of the regime and actively supported introduction of Western industrial technologies and business opportunities, as well as modern schools and libraries.

It is noteworthy that Duan Fang, a Manchu, surpassed many of his Han-Chinese peers in his profound knowledge of traditional Chinese scholarship, excelling in *jinshi xue* 金石學 (literally, "studies of metal and stone objects"), a scholarship of antiquarianism that had reached its height during the eighteenth century. His rich collections of bronzes, books, and steles, and his scholarly catalogs of the collections based on thorough evidential research, exemplify the literati mind and scholarly quality that he and other educated elite had pursued during their lives. To some extent, this stele functioned as a Manchu official's subtle statement of his elegant taste and intellectual accomplishment, which enabled him not only to govern the empire, but also to preserve and promote the essence of traditional culture and scholarship. However, Duan Fang was unexpectedly killed during an anti-Manchu mutiny by the Chinese army on November 27, 1911, just weeks before the final collapse of the Qing Empire, which marked the demise of the two-thousand-year-old imperial system in China. Starting with Duan Fang's legacy, one can explore the tremendous influence of Confucian culture and the dominating role of literati in political and cultural life in traditional Chinese society. Both the educated Han and non-Han elite embraced literati traditions and dedicated themselves to scholarly activities of writing, compiling, painting, and collecting to distinguish their status and privilege.

Scholar-Official Status and the Civil Service Examination

In a photograph taken in a large reception hall in 1907 (fig. 112), Duan Fang and his colleagues and friends are gathered in front of a family treasure he proudly presents to his guests—the famous ritual bronze set of the early Western Zhou period (c. 1046–770 BC), which he acquired soon after it was unearthed at Baoji, Shaanxi Province, in 1901 (Lawton 1996, 72). This bronze set includes an altar table and thirteen different vessels, possibly used for storing, heating, and drinking wine for important events and ceremonies (Barnhart 1989, 51). Duan Fang valued this rare possession so highly that he brought it with him when he moved to his new position as viceroy of Liangjiang (*Liangjiang zongdu* 兩江總督), the wealthiest and most developed province in Jiangnan 江南 (the Yangtze River Delta region). He probably followed a tradition of gathering a group of friends for a special viewing of one's treasure trove. Unlike those rich and powerful merchants who exhibited

showy taste by acquiring luxurious objects and exotic materials, the scholarly elite believed that classical books and stone steles, antique bronzes and jades, and old paintings and calligraphy were essential for demonstrating the owner's genuine knowledge and connoisseurship. Because possession of ancient objects ultimate-ly stood for one's link with wise sages of the ancient past, the collecting of art, antiques, and rare books functioned as a cultural and social investment for those literati who wanted to gain their peers' praise and respect.

These guests, except for one person dressed in Western attire, were Qing offi-cials from local or provincial governments. They came from the three major com-ponents of traditional government in late imperial China—the civil administra-tion, the military apparatus, and the supervisory agency (Wilkinson 2012, 258–61). Living in a world of symbols and protocols, these officials had various accessories to indicate their different ranks, titles, and privileges. Violation of these codes and regulations could lead to admonition or punishment from the court. Starting from the head, they wore conical summer hats made of bamboo, which had top finials of semiprecious stones or glass of prescribed colors to indicate status and rank. Their

official necklaces, which are reminiscent of Buddhist prayer beads, constitute another component of Qing governmental uniforms. These necklaces are normally made of 108 carved fruit kernels and glass beads of different sizes, with four large beads dividing the smaller ones into four sections representing the four seasons (fig. 113). There are also four pendants, with one long strand at the back to counterbalance the weight of three short ones at the front that mark the three sections of a month.

On the occasion of a formal gathering, or while on duty, officials wore court robes that represented their ranks and privileges within a nine-rank system for

FIGURE 114

Embroidered silk rank badge with crane design among auspicious symbols. Qing Dynasty, eighteenth–nineteenth century. © The Field Museum. Photo ID No. A115139d_005B. Catalog No. 278482. Photographer John Weinstein.

civilian and military positions. The mandarin squares are the major markers of status on their uniforms, and they are often made of elaborate embroidery or *kesi* 緙絲 silk tapestry and used in pairs on the front and back of the robes. Civilian officials used birds to indicate specific ranks, from a crane (the highest, or first, rank) to a flycatcher (the lowest, or ninth, rank), whereas military officials used animals, from a mythical *qilin* 麒麟 (first rank) to an imagined sea horse (ninth rank). If birds suggest literary elegance, then animals symbolize fierce courage (Thorp 1988, 82–85). A beautiful square rank badge in the collection of The Field Museum (fig. 114) shows a white crane flying toward the red sun and has borders defined by alternating patterns referring to characters of *fu* 福, meaning fortune, and *shou* 壽, meaning longevity. The embroidered square is also filled with auspicious symbols such as flying bats, *ruyi* 如意-shaped clouds, and rugged rocks in ocean waves.

Different from officials' court robes, the emperor's dragon robes were usually in imperial yellow color and had medallion designs of five-clawed flying dragons that were exclusively reserved for the imperial use. On nonritual occasions, the emperor wore an ordinary dragon robe made of embroidered silk satin and decorated with the symbols of imperial authority, including the twelve insignias (Vollmer 2002, 103–11). Divided into three groups at the neck, waist, and knee levels of the dragon robe, these insignias show the sun, moon, constellations, and mountains; dragon, phoenix, *fu* 黻 mark, axe; and temple cups, aquatic grass, millet, and flames. The Field Museum's example of a full-size dragon robe showcases the elaboration of courtly couture and the quality of imperial textiles, which were primarily made by the best weavers from Suzhou or Nanjing in the Jiangnan region (fig. 115). A typical Manchu feature of this robe—the horse-hoof cuffs—indicates that the Qing rulers modified traditional dragon robes to promote their unique cultural identity and style (Watson and Ho 1995, 206).

Furthermore, the scholarly background of Duan Fang reminds us that government officials in late imperial China were most likely scholars who had successfully earned their degrees via various exams. China's feudal bureaucracy constantly reproduced itself through an official selection and appointment system, which included four major components: dynastic schools (*xuexiao* 學校), civil and military exams (*kemu* 科目), recommendation (*jianju* 薦舉), and governmental appointment (*quanxuan* 銓選) (Elman 2000, 126–27). During the Sui Dynasty (AD 589–618), the court realized that a public examination system based on talent and merit, rather than a closed selection system depending on status and origin, was a more efficient and fair method to find the most talented students and establish a large bureaucracy to govern a vast empire. A standard examination system, continuously refined over the centuries, was thus developed to select civil and military officials, transforming educated local elites into a serving class. It also assisted rulers in maintaining strict cultural control while building their dynastic power (Elman 2000, 65). Because literary talent and writing ability had become a new standard for gauging one's capability for serving the court, scholarly skills, which brought success in imperial examinations, were naturally admired.

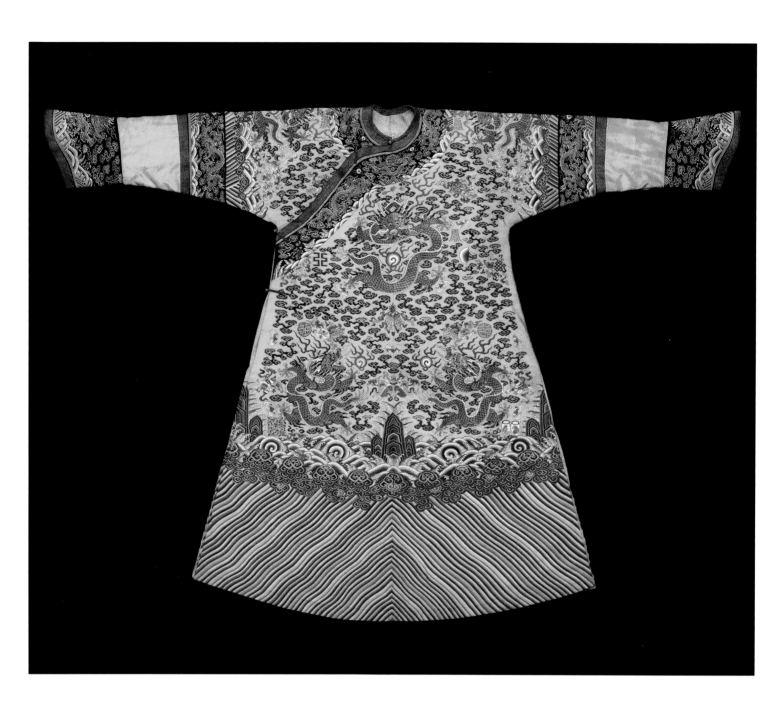

Constituting the uppermost social class, scholars and officials were followed
by farmers and landowners, laborers and craftsmen, and tradesmen and mer-
chants in a descending order of social and legal privileges. Unlike people from
other hierarchies controlled by the state, the educated elites administered the
state and dominated cultural and social life, utilizing education and examina-
tion to maintain their social distinction (Fong and Watt 1996, 32–33). Because of
the institutionalization of the imperial examination system, the scholar-gentry
class rose in power from the Song Dynasty (AD 960–1279) onward. For young men,

a steppingstone to entering the elite class and becoming court officials was going through the civil service examination system, which normally included four levels—local, provincial, metropolitan, and palace exams—and were offered in a cycle of every three years (Elman 2000, 659).

Most of the imperial exams took place at government sites or special examination halls that were tightly guarded by watchmen and soldiers (Elman 2000, 175–91). For better security and supervision, all students were required to stay in door-less cells for days, sleeping and eating in the same place until they finished their essays. They were forbidden to pass messages to each other or to take in any reference texts that could be used to cheat. The only furniture was a set of boards that could be arranged as a desk and a bench during the day and a simple bed at night (fig. 116). The provincial (*xiangshi* 鄉試) and metropolitan (*huishi* 會試) exams mainly included three sessions, with each lasting at least a day. Using a lacquered bamboo basket (fig. 117), the students had to bring their own writing tools, clothing, and a multiday supply of food. In the competitive provicincial examinations of Jiangnan, most students had to stay in the cell for a total of seven nights and nine days to finish all topics of the three sessions—the classics, state policy, and government documents and judicial texts. Due to these harsh conditions and stressful atmosphere, students sometimes got seriously ill and some even died during the ordeal.

To standardize the content, imperial exams of the classics had been restricted, since the Chenghua 成化 reign (1465–87), to the Four Books and Five Classics

FIGURE 116
Drawing of the cells in which exams were taken at an examination hall. © The Field Museum. Illustrator Sayaka Isowa.

FIGURE 117
Bamboo basket with the character *fu*. Qing Dynasty, eighteenth century. © The Field Museum. Catalog No. 126200. Photographer Gedi Jakovickas.

(*sishu wujing* 四書五經), the Neo-Confucian canon annotated by a Southern Song (AD 1127–1279) scholar named Zhu Xi 朱熹 (1130–1200). Serving as the basis of the civil service examination in the following centuries, the Four Books included the *Analects, Mencius, Doctrine of the Mean,* and *Grand Learning*; and the Five Classics consisted of the *Book of Odes, Book of Documents, Book of Changes, Book of Rites,* and the *Spring and Autumn Annals* (Elman 2000, 380–99; Wilkinson 2012, 371). Most Chinese rulers believed that a student's careful recital of the classics represented an act of faith in moral values, which would produce political loyalty and cultivate submission to imperial sovereignty (Elman 2000, 65). Students were also required to write "eight-legged essays" (*baguwen* 八股文), which had to be in a fixed eight-part style to interpret classical texts and comment on exam topics. Although the system examined very narrow intellectual and literary content, students normally had to spend more than two dozen years preparing for these exams. The majority of the highest degree holders were in their thirties (Elman 2000, 704–5).

According to historical records, the imperial exam competition was usually ferocious. Of the tens of thousands of students who studied and prepared for them, only a small number were successful in the highest metropolitan and palace exams and eventually obtained eminent governmental positions (Elman 2000, 647, 661–65). For instance, fewer than one hundred final selectees of the palace exam (*dianshi* 殿試) could obtain the *jinshi* 進士 degrees on average every year, with the first one called *zhuangyuan* 狀元, the highest degree in the imperial examination. Still, generations of male students from both rich and poor families strove for this once-in-a-lifetime opportunity for advancement. Like Han-Chinese students, Manchu students also studied for civil service exams during the Qing: Duan Fang earned his *juren* 舉人 degree in a provincial exam in 1882; his grandfather was a *jinshi* degree holder in 1819.

Although the preparation process was arduous and the examination was tough, the reward of fame and privilege was appealing, especially for poor students living in remote towns. Those who passed local qualifying exams and got entry-level educational degrees obtained the status of gentility (*xiucai* 秀才) and were exempted from labor service to the state. Those who received the highest degrees in the palace exam were entitled to have their names and titles inscribed in gold on red banners in their hometowns, a source of pride and glory for their clans and neighborhoods. Wealth, privilege, and power would soon flow to them after their assignments to governmental positions (Smith and Weng 1978, 223–24). Thus, the worship of Confucius (551–479 BC), an honored philosopher and educator known as "teacher of all teachers," was widespread in Chinese society and still is today. People from all walks of life, especially those who wish to be successful in various exams for a better life and career advancement, will piously make offerings to this virtuous ancient sage who is often portrayed as a deity with "sagely divinity bestowed by heaven" (*shengshen tianzong* 聖神天縱) (fig. 118).

FIGURE 118
Unknown artist. *Portrait of Confucius as a Sage King along with His Disciples*. Qing Dynasty, c. 1900. Woodblock print, ink on paper. © The Field Museum. Photo ID No. A115193d_001. Catalog No. 233224. Photographer Karen Bean.

Scholarly and Imperial Interests in Antiquity

Duan Fang's photograph is similar to other earlier paintings of literati gatherings that feature appreciation of antiques in a garden or a studio setting (*bogu tu* 博古圖). Based on the values and beliefs of both Confucianism and Chan (Zen) Buddhism, Chinese literati developed a refined lifestyle surrounded by symbols of antiquity and emblems of cultivation (Watson and Ho 1995, 47). The *Gentlemen Enjoying Antiquities*, an album leaf attributed to Qiu Ying 仇英 (c. 1494–1552), a famous professional painter from Suzhou, depicts three Song Dynasty gentlemen entertaining themselves in a bamboo garden (fig. 119). Their attendants have prepared a variety of things for their masters' leisure pursuits, including two large, standing screens before a garden rock (*Taihu shi* 太湖石), three tables full of ritual bronze vessels, a *weiqi* 圍棋 game board and a tea set, and a desk for viewing paintings and calligraphy. These gentlemen are sharing their connoisseurship of

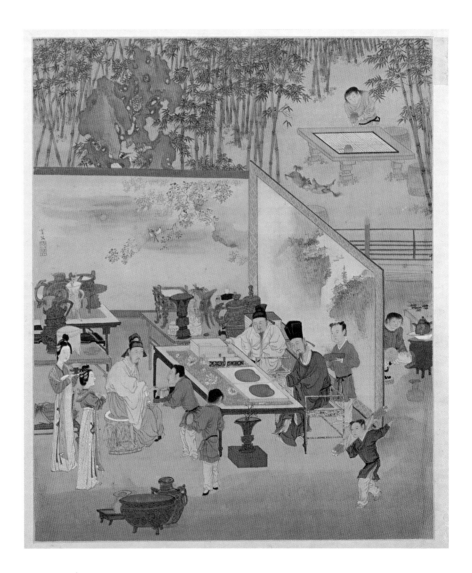

FIGURE 119
Qiu Ying (c. 1494–1552). Album leaf, *Gentlemen Enjoying Antiquities*. Ming Dynasty, sixteenth century. Ink and colors on silk. © Palace Museum, Beijing.

CHAPTER SEVEN

antiques and paintings, which were essential for literati pursuits and intellectual enjoyment. While taking such leisure, they would also practice activities of the four scholarly accomplishments, namely, music, board games, painting, and calligraphy. Their connoisseurship of paintings and bronzes and pursuit of the four scholarly skills clearly convey the message that these elegant gentlemen are also men of culture.

Although the study of antiquity was a continual preoccupation of Chinese scholars, they looked back to the past as never before during the Qing Dynasty, partly because the Manchu regime placed strict censorship upon their scholarship and publications on contemporaneous political and social issues. To avoid potential trouble or persecution from the regime, many scholars turned their interest to the remote past and pursued research on ancient subjects, along the way amassing large collections of old books and antiques. The wealthy Jiangnan region gathered the most talented traditional scholars, who were leaders in the fashion of collecting art and antiques in the secular world. The Field Museum's *Qingming shanghe tu* scroll (catalog no. 33723), probably painted by a Suzhou artist of the late sixteenth or early seventeenth century, has an interesting detail that reflects such fashion in the Jiangnan region (fig. 120) (see Lu Zhang, this volume). A vender of antiques

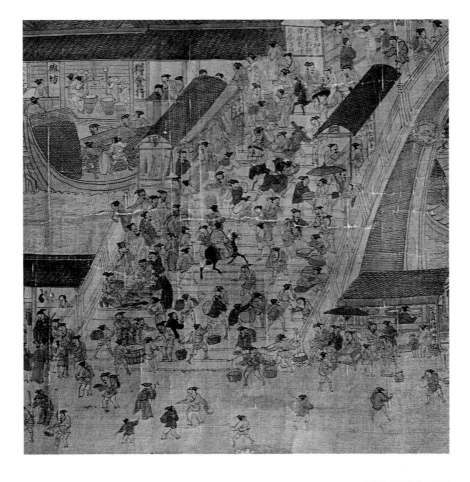

occupies a major spot on the left side of the bridge, and his collectibles attract attention from many passersby. This detail, which is not seen in the Song Dynasty original, demonstrates renewed interest in antique collecting among townspeople of that time. In particular, the scholarly elite eagerly amassed collections of ancient bronzes, steles, jades, and books to prove their ownership of the symbols of cultural heritage, to justify their elegant taste as connoisseurs, and to demonstrate their commitment to historical traditions.

If Duan Fang's photograph indicates a Manchu scholar's interest in antiquarianism and a collector's role as a preserver of cultural heritage, some imperial portraits of Manchu emperors further suggest that non-Han rulers had used Chinese antiquity as a means of legitimizing their rule. From at least the Eastern Zhou period (770–256 BC), generations of Chinese kings and emperors had deployed ancient jades and bronzes to advance their claims to authority and supremacy (Wu 2010, 342). Like tasteful Han-Chinese predecessors, such as Emperor Huizong 徽宗 (r. 1100–1125) of the Song Dynasty, Emperor Qianlong 乾隆 (r. 1736–95) of the Qing Dynasty built one of the most celebrated imperial collections of Chinese antiques as evidence of the legitimacy of his rule. This Manchu emperor also sponsored numerous publications and research projects on bronzes and paintings, leading a revival movement of antiquarianism. The painting *One or Two* best demonstrates

FIGURE 121
Anonymous court painter. Hanging scroll, *One or Two (Emperor Qianlong Appraising Antiques)* (Yangxin dian version, c. 1750). Qing Dynasty, Qianlong reign (1736–95). © Palace Museum, Beijing.

his identity as a connoisseur who liked to survey the past (fig. 121). Instead of wearing an imperial dragon robe as the Son of Heaven, Qianlong dressed himself as a traditional Han-Chinese recluse in his studio, surrounded by treasures that mark the taste and wealth of the court. On the European-style round table at the side are small antiques of bronze and jade for his private enjoyment and appreciation, including a bronze *gu* 觚 beaker, a bronze *ding* 鼎 cauldron, and a jade *bi* 璧 disc. Both ancient and archaistic works are displayed as visual means to evoke past glory and bolster imperial legitimacy, signifying Qianlong's role as a preserver of China's cultural heritage.

Arguably, Emperor Qianlong's enthusiasm for antiquity manifests an ambitious vision for creating a new golden age modeled on an idealized past (Wu 1995, 53). He and other Qing emperors developed their understanding of antiquity through systematic education in Chinese classics and valued the significance of possessing objects of antiquity as a sign of legitimate and righteous rule. They were also aware of the disjuncture between the values of Han-Chinese scholars and Manchu rulers and thus tried to emulate ancient cultural paragons and build public images as successors to the sage kings of antiquity. This partly explains the cultural and political reasons for Emperor Qianlong's launch of enormous projects for collecting antiques and compiling catalogs (Wu 1995, 41). A notable example is Qianlong's authoritative catalog *Xiqing gujian* 西清古鑑 (*Appreciation of Bronzes in the Chamber of Western Purity*), which includes careful illustrations of the imperial bronze holdings and detailed notes on their inscriptions, sizes, and origins. This project significantly advanced evidential research as the dominant trend in critical learning and promoted the courtly passion for antique styles and objects (Rawski and Rawson 2005, 274).

Under the sponsorship of Qing emperors, court artisans invested substantial resources in creating and utilizing archaistic bronze and jade objects for ritual and decorative purposes (Wu 2010, 25). Ancient bronze wine and food vessels such as *gui* and *jue* became popular prototypes for court artisans to copy by using other materials, such as porcelain, lacquer, jade, and glass. Imperial collections of bronze vessels also prompted reproductions of bronze motifs in a wide range of artistic work. Instead of a straightforward copy of the past, however, the reproductions were often modified with new decorative elements and expressive styles applied to cater to royal taste (Watson and Ho 1995, 80). A case in point is a large nephrite jar commissioned by the Qianlong court, which was part of a five-piece altar set that might have served ritual functions (fig. 122). Basing their work on an ancient bronze jar type, court artisans incorporated archaic motifs of cicadas and birds into a stylishly proportioned vessel body with a fashionable lid. At a height of 81.2 centimeters, this impressive vessel testifies to the extraordinary resources and labor dedicated to jade carving and the pursuit of grandeur and luxury in palatial art. The emperor's interest in jade antiques also stimulated the development of the jade-carving industry to an unprecedented extent during the eighteenth century.

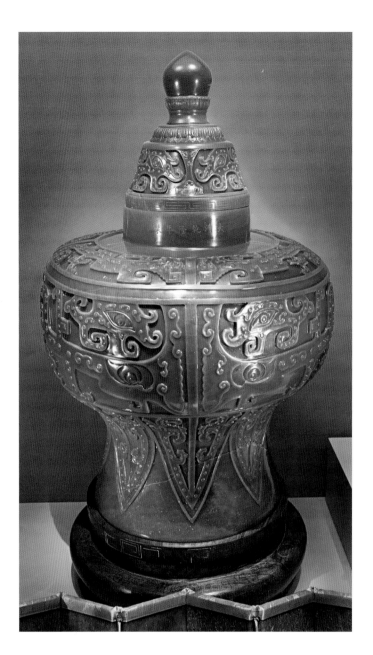

FIGURE 122
Large nephrite jar. Qing Dynasty, Qianlong
reign and mark (1736–95). © The Field
Museum. Photo ID No. A115255d_002.
Catalog No. 235936. Photographer John
Weinstein.

As exemplified by a rock crystal desktop chime hung with silver chains on a wood rack (fig. 123), court artisans often incorporated lucky symbols into archaic shapes while making luxurious table displays. The combination of an archaistic chime (*qing* 磬) with interlaced surface patterns and the cloud shape of an auspicious *ruyi* (or a magical *lingzhi* 靈芝 mushroom) refers to the homonymous phrase *jiqing ruyi* 吉慶(磬)如意, literally, "May there be great joy and may your wishes come true." Because imperial and noble patrons favored a decorative environment filled with auspicious emblems of cultural heritage, a large number of archaistic ornaments were made in expensive materials, including jade, crystal, gold, silver, cloisonné, ivory, and agate. They were used to decorate palace or studio interiors to bring luck and good fortune to all who lived inside.

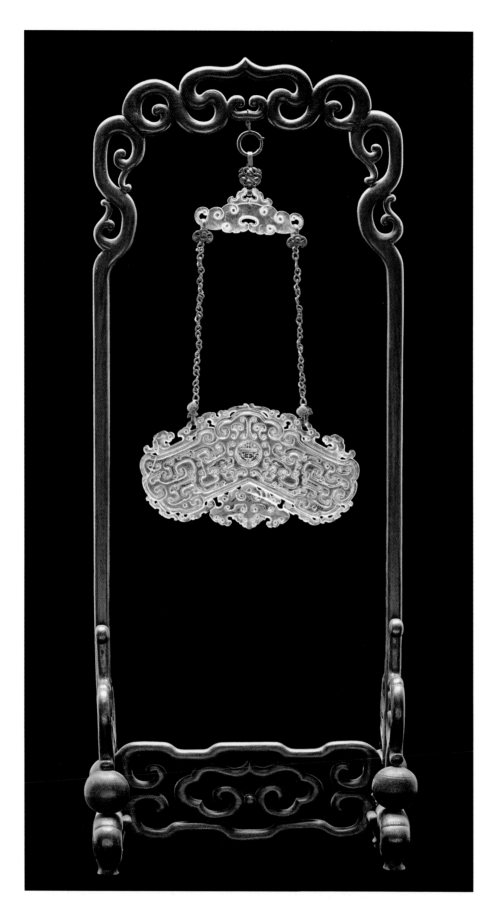

FIGURE 123
Rock crystal desktop chime with silver
chains. Qing Dynasty, Qianlong reign
(1736–95). © The Field Museum. Photo ID
No. A115258d_023. Catalog Nos. 116653.2
and 116624.E. Photographer John Weinstein.

Scholarly Objects and Intellectual Pursuits

In addition to being a tasteful collector, Emperor Qianlong's costume portrait highlights his role as a superior man of letters. This painting is most likely modeled on an anonymous Ming Dynasty portrait of a Han-Chinese scholar (Wu 1995, 39), which, in turn, is probably based on an earlier portrait of the Yuan Dynasty literati painter Ni Zan 倪瓚 (1306–74). This recluse was praised for his unique landscape paintings that featured autumn groves and sparse wildness devoid of people, which conveyed his high-minded detachment from worldly pleasures (Fong and Watt 1996, 312–13) (fig. 124). Portraits of this kind follow a long tradition of depicting literati at their leisure or in scholarly pursuits, creating an idealized studio-library environment full of scholarly objects. Possibly inspired by these prototypes in the imperial collection, the anonymous court artist posed the emperor as a scholar wearing a traditional Chinese outfit in his studio, confirming his passion for scholarly activities and values.

Like Han-Chinese rulers, Emperor Qianlong viewed himself as the highest authority on all aspects of cultural life as well as the arbiter of all matters in his empire. This Manchu emperor learned from Confucian teachings to respect heaven, to take care of the people he ruled, and to encourage learning and respect scholarship (Wu 1995, 28). His effort to preserve classical knowledge is best represented by his project to collect all the great texts of his empire in the *Siku quanshu* 四庫全書 (*Complete Library of the Four Treasures*). During this ten-year statewide effort (1773–82), more than 3,500 books in the four traditional categories (classics,

FIGURE 124
Unknown artist. Handscroll, *Portrait of Ni Zan*. Yuan Dynasty, c. 1340. Image courtesy of National Palace Museum.

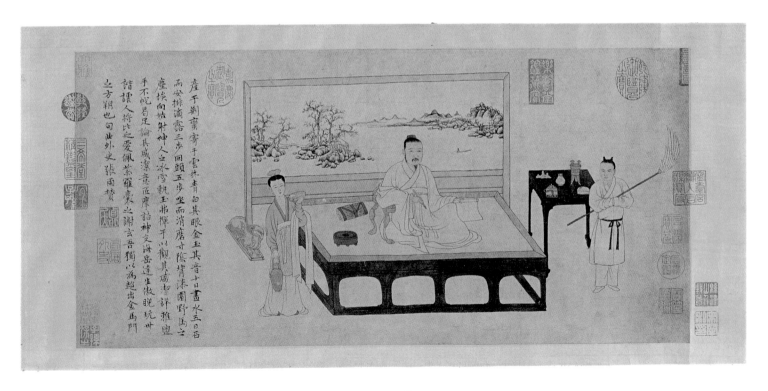

histories, miscellaneous philosophies, and belles-lettres) were collected and copied from libraries of high officials and local gentry throughout the empire (Mote 1999, 922–24). This tremendous cultural project not only reflects the culmination of dynastic greatness under Manchu rule, but also suggests that China was still a land ruled by sage emperors and their scholar-official bureaucracy.

If scholarly objects can be defined by their connection to the core activities and identities of the scholar's circle, there are primarily two types of such objects—the items used in literati studios and works on paper or silk produced by scholars (Watson and Ho 1995, 46–49). Because painting and calligraphy were so central to the scholar's artistic life, the literati selected with great care the tools they used to pursue these arts—brushes, ink, paper, and ink stones—known as the "Four Treasures of the Scholar's Studio" (*wenfang sibao* 文房四寶). They chose the best materials available and decorated them with motifs and imagery with personal significance. These objects were thus often used by their owners to convey personal messages and express individual philosophies. For instance, a scholar's selection of ink often went beyond functional need, since the surface of ink cakes offered an ideal space for decoration with various designs and texts. The Field Museum has a circular ink cake molded on one side with a landscape designed by Guan Huai 關槐 (c. 1749–1806), vice minister of the rites at that time, and on the other side with a poem composed in 1765 by Emperor Qianlong for Guan's landscape (fig. 125). Possibly showing off the favor he had received from the emperor, Guan Huai

FIGURE 125
Circular ink cake, molded with landscape designed by Guan Huai (1749–1806) and poem by Emperor Qianlong in 1765. Qing Dynasty, second half of the eighteenth century. © The Field Museum. Catalog No. 126653. Photographer Gedi Jakovickas.

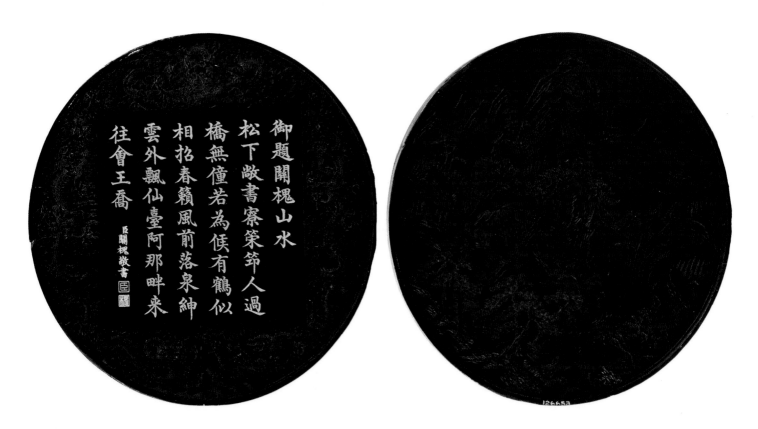

personally transcribed the imperial poem and commissioned the imprinting of his calligraphy, filled in with gold, on the ink cakes, which he possibly gave as gifts to his friends. Both Emperors Kangxi 康熙 (r. 1661–1722) and Qianlong enjoyed using their own calligraphy and poetry to distribute imperial favor among their subjects and disseminate court presence throughout the empire. Their excellence in writing and literature testifies to the Manchu emperors' mastery of those scholarly skills that were central to the culture of their Han-Chinese subjects (Hay 2010, 211–12).

The Chinese scholarly elite dominated the production and appreciation of calligraphy and painting, which embodied the very spirit of the literati class. To validate their intellectual identity and enhanced taste, they collected calligraphic and pictorial works by renowned literati in history. The Field Museum collection has a thirteenth-century album of rubbings of the famous calligraphic work *Lanting Xu* 蘭亭序 (catalog no. 233914), a preface to the poems collected from the Orchid Pavilion near Shaoxing, Zhejiang Province (Chen 2010, 87–88). Wang Xizhi 王羲之, a legendary calligrapher and literati paragon, who wrote this preface in semicursive script in AD 353 to commemorate a well-known gathering at the Orchid Pavilion, where famous scholars gathered to drink wine and compose poetry on the banks of the stream. Many scholars and emperors copied this work on paper or engraved it into stone in order to preserve traces of the original handwriting for enduring appreciation. It is said that Emperor Taizong 太宗 (r. 626–49) of the Tang Dynasty favored the *Lanting Xu* so much that he ordered the original work to be buried with him in his mausoleum (Rawski and Rawson 2005, 275). More than just a replica of the original work, The Field Museum's album served rather as a record of the high-minded literati lifestyle and a memorial to the intellectual paragon who has been worshiped since the fourth century. It embodies the scholarly ideas and virtues from a glorious past, with which later scholars and nobles wanted to be associated. (See Zhou's contribution on the *Lanting Xu*, this volume, highlight 5.)

Like calligraphy, painting was an integral part of one's identity as an intellectual who appreciated and valued China's cultural heritage. Recognizing the significance of calligraphy and painting in formulating literati culture, Manchu rulers believed that their personal engagement with China's finest works of art was necessary to reassure their educated subjects that Chinese traditional values would be sustained and transmitted to future generations (Rawski and Rawson 2005, 272). Another costly project that attests to Manchu rulers' extreme interest in Han-Chinese culture is their project to catalog the imperial painting and calligraphy collections, an endeavor that lasted seventy-four years. This three-volume catalog, *Shiqu baoji* 石渠寶集 (*Precious Collection of the Stone Moat [Pavilion]*), was initiated by the Qianlong emperor in 1745 and was finally finished under the reign of his son, Emperor Jiaqing 嘉慶 (r. 1796–1820). Similar to the above-mentioned catalog of bronzes, this imperial painting catalog guided the scholarship of the past and built an official understanding of Chinese painting traditions.

水色山光風景晩清波浩
萬一漁舟醉去蔵熙

FIGURE 126
Dai Xi (1801–60) (Attributed to). Hanging
scroll, *Landscape*. Qing Dynasty, nineteenth
century. © The Field Museum. Photo ID
No. A115145d_003. Catalog No. 116033.
Photographer Karen Bean.

The traditional way of learning Chinese painting techniques and styles was to copy earlier masters' works. Since the early seventeenth century, the majority of the scholar-painters had followed the ideas of Dong Qichang 董其昌 (1555–1636) and copied works of the few literati artists who were promoted by Dong in his dichotomic reconstruction of a Chinese painting tradition that distinguished amateur literati artists from professional painters. Dong's traditionalist theory soon became the foundation of a conservative school of scholar-painters, as represented by the Four Great Masters of the early Qing (Fong and Watt 1996, 477). The school leader, Wang Shimin 王時敏 (1592–1680), studied with Dong Qichang and passed his spirit on to his own students, Wang Hui 王翬 (1632–1717) and Wang Jian 王鑑 (1598–1677), as well as to his grandson, Wang Yuanqi 王原祁 (1642–1715). The Four Wangs are well known for their veneration and synthesis of the canonized styles of Song and Yuan masters, though their rigid imitation of the past and overemphasis of brushwork techniques dampened any spiritual creativity in their works.

The landscape style of this orthodox school prevailed at the Qing court and beyond. Pleased by their faithful imitation of traditional styles, Emperor Kangxi granted generous imperial support to this group and promoted one of the Four Wangs, Wang Yuanqi, to advise him on developing the imperial painting collection. The orthodox landscape style of this school was also conceived as the amateur mode for the scholarly elite (Rawski and Rawson 2005, 308–9). Another artist, Wang Hui, had many followers among court painters and scholar-officials, including Dai Xi 戴熙 (1801–60), a talented painter who obtained his *jinshi* degree in 1831 and later became vice minister of defense. As shown by a scroll at The Field Museum, Dai Xi paid homage to earlier Song and Yuan literati masters when he composed a serene landscape of reclusion and incorporated characteristic techniques from Wang Hui's paintings (fig. 126).

Figure paintings of popular religious and literati figures were also circulated at court and among the nobility and scholar-officials, indicating the complexity of tastes, beliefs, and values of the cultural elite. A notable example from The Field Museum is *Four Immortals with Three-Legged Toad and Crane* (catalog no. 125935), which has a seal of "General Commander [of Embroidered Uniform Guards]" (*du-zhihui* 都指揮). Given that this kind of honorary title was often granted to Ming Dynasty court painters, this painting was probably made at the court for the enjoyment of the nobility. It depicts Liu Hai 劉海, god of wealth, along with Li Tie-guai 李鐵拐 and Zhang Guolao 張國老, two of the Daoist Eight Immortals (fig. 127), playing with a three-legged toad, which was an auspicious symbol for wealth and luck. A flying white crane of longevity is joining the group, and one can also see a fourth figure carrying a wine jar behind a tree, probably the literati paragon Li Bai 李白 (701–62). This painting is comparable to works by other Ming court painters, including Shang Xi's 商喜 (fl. 1430s) *Four Immortals Honoring the God of Longevity* and Liu Jun's 劉俊 (fl. 1475–1505) *Three Immortals Dancing around a Toad* (Barnhart 1993, 108, 116). Serving various elite patrons, Shang Xi and Liu Jun were versatile court painters, good at both figure and landscape painting. Interestingly, the quartet (or

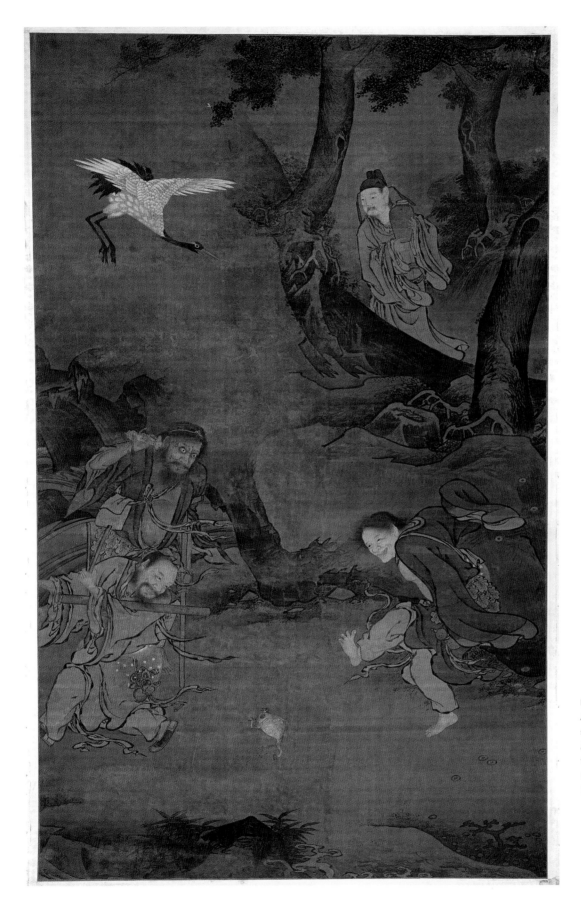

FIGURE 127
Anonymous court painter. Hanging
scroll, *Four Immortals with Three-
Legged Toad and Crane*. Ming Dynasty,
fifteenth century. © The Field Museum.
Photo ID No. A115176d_004. Catalog
No. 125935. Photographer Karen Bean.

trio) of immortals was also paired with scholarly sages by Kano School painters in their Chinese-style landscape paintings to entertain the educated elite in Edo-period Japan (AD 1615–1868) (Bonhams, September 2015, sale 22462, lot 3031). The joint appearances of these popular deities, literati sages, and moral paragons in Chinese and Japanese paintings suggest not only the prevailing pursuit of longevity and good fortune among the cultural elite, but also the fusion of Confucian teaching with other religious teachings in East Asia.

In summary, both emperors and officials of late imperial China were students of Confucianism. To identify their intellectual status and literati taste, these men of letters not only followed Confucian ideology and pursued classical learning, but also involved themselves in a variety of scholarly activities—collecting rare books and antique objects, practicing calligraphy and composing poetry, as well as appreciating music and creating art. With profound interest in antiquity, many of them also conducted studies of history and antiquarianism and eventually took preeminent roles in preserving the essence of Chinese cultural heritage and transmitting the glories of the past. They significantly contributed to the lasting influence of Confucian culture and literati tradition, which, after more than two thousand years, still actively maintains deep roots in East Asian societies today.

Commemorating a Gathering of Friends: The *Lanting Xu* Rubbing

Yuan Zhou

Lanting Xu 蘭亭序 is a short form of *Lantingji Xu* (*Preface to the Poems Composed at the Orchid Pavilion* 蘭亭集序). It is one of the most acclaimed works of calligraphy in Chinese history. Wang Xizhi 王羲之 (AD 303–61), the author and calligrapher of the work, is considered the "Sage of Calligraphy" in China. The preface was supposedly written for an anthology of poems produced at an event in the early spring of the year 353 when Wang and several dozen friends and local literati gathered on the banks of a creek at the Orchid Pavilion in Shanyin County of Kuaiji Prefecture 會稽山陰. The gentlemen drank wine and played a competitive game of poetry composition. Consisting of 324 characters, Wang's preface describes the event and expresses his view on the transience of life.

Subsequently, admirers of Wang's calligraphy began efforts at making replicas of the *Lanting Xu* by copying it by hand in calligraphy or by engraving imitations of it on steles or woodblocks to make rubbings. The imitations made by recognized calligraphers were most desirable. Using paper and ink, rubbing is a technique used in China to replicate the carved inscriptions or images from hard surface to

paper to provide an accurate, full-scale facsimile of the texture. "Rubbing" also refers to the product of this technique. In the Southern Song Dynasty (AD 1127–1279), collecting well-made copies and rubbings of the *Lanting Xu* became popular among the literati and in elite society. For instance, it is said that Emperor Lizong 宋理宗 (r. 1224–64) collected 117 fine copies. You Si 遊似 was another well-known collector of *Lanting Xu* rubbings at the time. Once serving as the prime minister to Emperor Lizong in the Chunyou period 淳佑 (1241–52), You Si is believed to have owned as many as one hundred copies of different versions of *Lanting Xu* rubbings. He is also known for numbering each copy in his collection and making notes on where or how he acquired it.

The copy held at The Field Museum (catalog no. 233914) was number 52 in You's *Lanting Xu* collection (fig. 128). The rubbing was mounted in sections to an album with the "accordion" binding style 經折裝. You Si wrote a short postscript which immediately follows the last section of the inscriptions on the rubbing. He noted that the rubbing was crafted from the steles made by Zhao Buliu 趙不流 based on an imitation of the *Lanting Xu* kept by Buliu's grandfather (fig. 129). Zhao was a known descendant of the Song Dynasty royal family. The album has been kept in layers of protection: first by a beautiful brocade hard cover (fig. 130), then by an elegant hardwood box (fig. 131), and finally by a tailored cotton sack (fig. 132). The protections were added later, perhaps by one or more owners at different times.

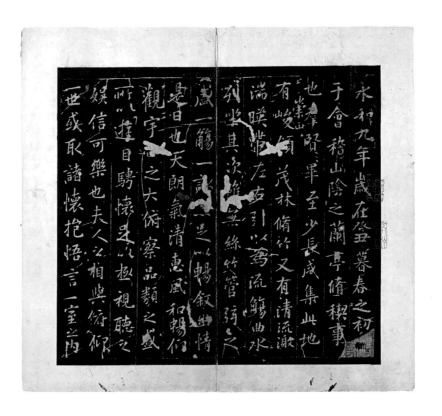

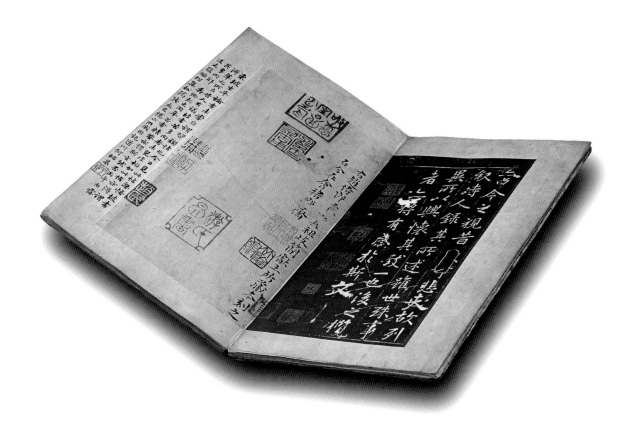

FIGURE 129
The postscript by You Si, the owner of the rubbing in the Southern Song Dynasty, tells about the origin of this particular rubbing. © The Field Museum, A114800d_05B. Catalog No. 233914. Photographer John Weinstein.

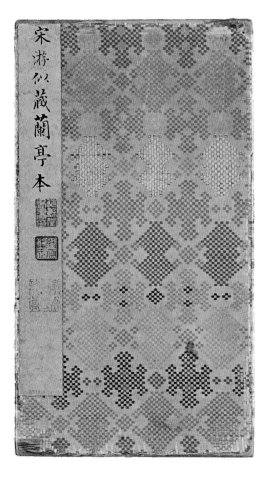

FIGURE 130
Front cover of the *Lanting Xu* rubbing. © The Field Museum, A114798d_002. Catalog No. 233914. Photographer John Weinstein.

FIGURE 131
Wooden box used to store the rubbing.
© The Field Museum, A115257d_003.
Catalog No. 233914. Photographer John
Weinstein.

FIGURE 132
Fabric slipcase used to hold The Field
Museum's copy of the *Lanting Xu* rubbing.
© The Field Museum, A115256d_003.
Catalog No. 233914. Photographer John
Weinstein.

Passed down through a history of more than eight hundred years, the rubbing not only maintains stunning beauty in color for ink and paper but also accumulated a good number of seals and postscripts, which were added by its owners and reviewers at various times. These seals and comments enhance the album's value as well as its beauty. Not only can these additions be used for tracing the rubbing's history, thus furthering its authentication, but these personalized seals and postscripts made by fine calligraphers also bear artistic value in their own right. The most significant of all its previous owners are two princes—Prince Jin, Zhu Gang 晉王朱棡 (1358–98) of the Ming Dynasty, and Prince Cheng, Yongxing 成親王永瑆 (1752–1823) of the Qing Dynasty. The most notable among the commentators is Weng Fanggang 翁方綱 (1733–1818), a renowned Qing scholar and calligrapher. Weng reviewed and wrote comments for several dozen early rubbings of the *Lanting Xu* and was regarded as one of the most knowledgeable scholars of epigraphy of his time. In his postscript, Weng validated that this rubbing indeed once belonged to You Si, since it bore several seals identical to those that Weng had observed on another *Lanting Xu* rubbing once owned by You Si. He also praised the brilliance of its calligraphy, declaring it one of the best among the earliest surviving *Lanting Xu* rubbings. The *Lanting Xu* rubbing is one of the crown jewels in the *Cyrus Tang Hall of China's* exhibition and The Field Museum's rubbings collection.

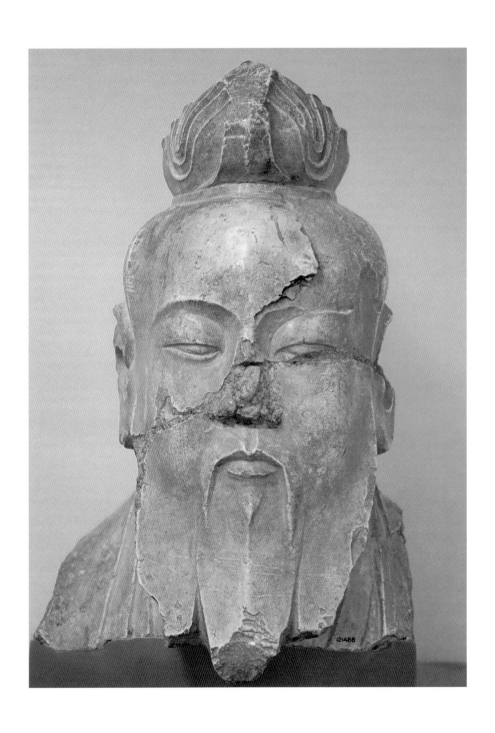

Beliefs and Practices, Symbols and Stories

Daoism and Buddhism in Traditional China

Paul Copp

By any measure, China has one of the richest and most ancient religious cultures known to human history. The roots of this culture lie deep not only in China itself but, importantly, also in the practices of peoples of a much wider Eurasian world. Contrary to the old myth of an isolated China, the states and peoples that have made up Chinese history were always parts of the broad history of Central and Eastern Eurasia. In terms of religious practice and imagination, this was true not only of the great trans-Asian institutional religions that found places in China— Buddhism most famously, but also Zoroastrianism, Manichaeism, Christianity, and Islam. China's indigenous religious traditions, as well, including Daoism and China's diffuse heritage of spirit mediums and shamans, for example, partook in their own ways of geographically far-flung cultures of practice and exchange.

Daoism and Chinese Buddhism were in many ways the greatest, most far-reaching, and—in their often seamless blends of native and imported ideas and practices—most emblematic of China's ancient religious traditions. Both arose as discrete institutions in China during the collapse of the Han Empire's (206 BC–AD 220) temporal and spiritual world order. Both traditions, in fact, but

most directly that of Daoism, can be seen in part as two of many responses to that collapse. Though a stable, unified, and lasting political order comparable to the Han would not reemerge until the foundation of the Tang in AD 618, various reassertions of cosmic order arose as soon as the Han's fall appeared inevitable—and at least one of them, the para-Daoist revolt of a millenarian group known as the Yellow Turbans in AD 184, helped to speed that fall.

Daoism

Daoist tradition relates that it was in the midst of this age of visions, famine, and imperial collapse that the religion began on a mountain in what is now Sichuan Province. In the sky above that mountain in the year AD 142, we are told, Laozi 老子—the shadowy figure associated with the politico-religious text that bears his name (also known as the *Book of the Way and Its Virtue*, or *Daode jing* 道德經)—appeared to the leader of a local religious community named Zhang Daoling 張道陵. Those who claimed to be Zhang's descendants and their followers recounted in later years that at that moment Laozi, now "Lord Lao," revealed himself as no less than the voice of the cosmic Dao, the mystic order of things, whose strict moral law Lord Lao now set forth in a series of precepts and practices that constituted both a new vision of the cosmos and a new way of life within it. This new way rejected the practices of "blood sacrifice to the traditional gods of the community and state," and established both a new pantheon of gods—pure forms of the Dao itself, rather than the blood-hungry gods of existing cults—and a new relation with the divine. As Terry Kleeman described it, the new community was "originally theocratic in concept, seeking to create a utopian state that would replace the Chinese imperial institution" (Kleeman 2008, 981–82) (fig. 133). This religious tradition, which in time came to be known as the Way of the Celestial Masters, is still in existence today, its leaders claiming direct spiritual descent from the original Celestial Master, Zhang Daoling.

Celestial Master Daoism was in many ways a repackaging, initially in a millenarian framework related to the Han catastrophe, of traditional Chinese religious beliefs and practices that both preceded and continued to exist separately from Daoist communities (Raz 2012, 5). These included especially the ancient idea of the profound and intimate interrelation of all things in the cosmos. As Isabelle Robinet described it, "Daoists [maintained] that . . . the whole world is a manifestation of the Dao. Moreover . . . the human being is a microcosm related in an analogical and organic way to the pattern of the world" (Robinet 2008a, 53). The importance of the natural world, and especially of China's soaring mountain ranges, to this vision of the Dao and the world is clear in ritual objects such as The Field Museum's *boshanlu* 博山爐 incense burner, which dates to the Western Han Dynasty (206 BC–AD 9), well before the rise of the Celestial Masters. It offers a striking figure of the sacred peaks on which the transcendents of Chinese mythology were said to dwell (fig. 134).

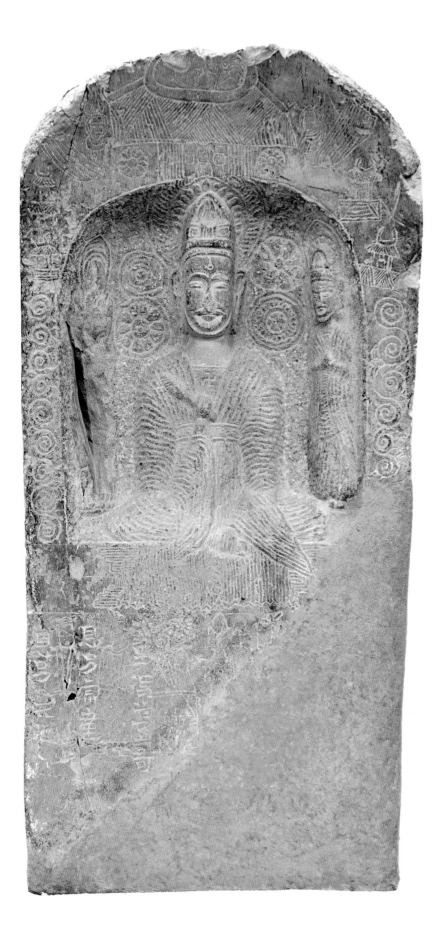

FIGURE 133
Stele showing the deified Laozi flanked by two followers. Possibly Northern Wei period (AD 386–534). © The Field Museum. Catalog No. 121385. Photographer Gedi Jakovickas.

FIGURE 134
Boshanlu incense burner. Western Han Dynasty (206 BC–AD 9). © The Field Museum. Catalog No. 117381. Photographer Gedi Jakovickas.

Celestial Master ritual techniques, many of which were intended to heal body and spirit, were in the same way the heritage of earlier Han and Warring States (475–221 BC) practices and beliefs. They centered, in part, on three kinds of textual objects: petitions, talismans, and seals. Petitions, which showcase the "bureaucratic" vision of the cosmos found in Daoism and other forms of Chinese religion, were written prayers and confessions submitted to the spiritual "offices" of Heaven, Earth, and Water. Closely related to these petitions was another pre-Daoist genre of ritual text that is vividly represented in The Field Museum's collection. This was the "burial-plot purchase contract" (*maidiquan* 買地券), or "tomb contract" (fig. 135). These documents were placed in tombs in order "to protect the claims of the dead to their graves by giving them title they can show in the courts of the underworld" (Hansen 1995, 64). The Field Museum's example, dating to AD 85, again from before the rise of the Celestial Masters, was typical in that it also asserted the mastery of its claimant, whose name was Ma Rong, over any other dead buried who may have been buried nearby: "If other deceased persons were buried in Ma Rong's graveyard, they should be [his] servants."

Talismans were semireadable diagrams, usually written in vermillion or black ink on wood, bamboo, silk, or stone, "conceived as a form of celestial writing that derive their power from their matching celestial counterpart" (Bokenkamp 2008, 35). They came to have a range of uses: in the early period these included especially their ingestion as cures, and their placement in tombs, ritual spaces, and on the person as protective amulets, practices seen in Han-period tombs (Bumbacher 2012, 57–80). Among the most important surviving examples of Han mortuary talismans are those found in the tomb, dated AD 133, of one Cao Bolu 曹伯魯 (fig. 136). The inscription beside them reads, in part,

FIGURE 136
Talismans from Cao Bolu tomb,
dated AD 133. After Raz 2012.

FIGURE 135
Tomb contract. AD 85. © The Field
Museum. Catalog No. 109993.
Photographer Gedi Jakovickas.

The envoy of the Celestial Thearch, on behalf of the family of Cao Bolu, diligently removes danger and expels odium, sending them a thousand *li* away. . . . From today I will ever protect their descendants—their longevity will be as of gold and stones and to the end they will experience no misfortune. In order to prove their oath, they use divine medicines to secure the tomb and seal it with the Conquering Emblem of the Yellow Spirit [*Huangshen yuezhang* 黃神越章]. In accord with the rules and regulations. (Translation adapted from Seidel 1987)

Seals, whose place in Daoist ritual grew more important over the centuries, drew on the basic logic of identity that guided normal uses of seals in commerce and politics, which had been imported into China along with the objects themselves in ancient times. That is, bearers of a deity's seal, such as that of the Yellow Spirit (or, later, Emperor), a practice first seen in Han mediumistic and funerary practices such as those of Cao Bolu's tomb, bore the power of that deity, which could be employed in healing or in protection from beasts or spirits. Early examples of seals inscribed with the words "Conquering Emblem of the Yellow Spirit," whose use was described in Cao's tomb, include a Han-period stamp inscribed on two sides: aside from "*Huangshen yuezhang*," on its sealing face, it bears on its back a longer inscription, now largely illegible, which clearly marks the object as a "demon-killing seal" (*shagui zhi yin* 殺鬼之印) (fig. 137). Other Celestial Master practices with origins in this early age included sexual rites understood as the blending of biospiritual essences, or *qi*; contemplation of one's misdeeds while secluded in special meditation chambers; and the construction of charity houses for social welfare.

The Celestial Masters remained a semiautonomous theocratic community in Sichuan until the year AD 215, when, submitting to one of the warring armies that brought down the Han, they were broken up and their members forced to migrate to various locations across northern China. This event had a profound effect on the history of religious practice in China, for far from being weakened or destroyed by

FIGURE 137
Huangshen Yuezhang seal. Han Dynasty. After Liu 2007.

this act, the Celestial Masters and their ideas came instead to have a lasting impact not only in the north but, beginning nearly a century later, in southern China as well, when many of their adherents, along with much of the northern aristocracy, fled south to avoid Xiongnu armies advancing from the northern steppes. This success was ultimately so great that, even today, as Kleeman notes, "the overwhelming majority of non-monastic priests both within China and in the Chinese diaspora have identified themselves as part of [Celestial Master] tradition" (Kleeman 2008, 982).

For all its success in the north, where Daoism briefly became the state religion of the Northern Wei Dynasty (AD 386–534), it was in the region south of the Yangtze River where Daoism underwent its most important generative transformations and growth in this age. When the Celestial Masters and their followers arrived in the south, fleeing the Xiongnu sacking of Luoyang in AD 311, rather than the easy embrace they had found in the north, they encountered instead an ancient and proud culture of religious practice and an equally old and entrenched aristocracy bent on resisting what they took to be a cultural invasion. A first response was the creation of the Daoist tradition of Upper Clarity (Shangqing 上清) texts and practices, said to have been revelations from purer gods in a higher heaven than those at the heart of the Celestial Master tradition, a move that succeeded in reasserting southerners' supremacy in their home region. The texts, it was said, were revealed to Yang Xi 楊羲 (330–86) in Jurong, near what is now the city of Nanjing, between the years 364 and 370. The divinities who revealed the texts were known as the "Perfected," a term deriving ultimately from the early (southern) philosophical text known as the *Zhuangzi*. The central member of the Perfected for Yang was the goddess Wei Huacun 魏華存 (251–334), who in life had been a Daoist adept and initiate of the Celestial Master teachings. While still among the living, we are told, Wei had herself been visited by divinities who bestowed upon her numerous Daoist texts. The most important of these was the *Dadong zhenjing* 大洞真經, which later, after she revealed it to Yang Xi, became the chief scripture of the Upper Clarity School. The Perfected commanded Yang, in turn, to bestow the texts upon the Xu family, an aristocratic clan of Jurong that claimed descent from the legendary emperor Yao 堯. In time—in part due to their literary and calligraphic brilliance—Yang's texts won great renown in the region, and new revelations were added in later years, some of which became the foundation for the Upper Clarity movement, especially after they were edited and compiled by the Daoist master Tao Hongjing 陶弘景 (456–536), a man himself related to the Xu clan.

As Robinet has noted, the Upper Clarity teachings were a synthesis of "native ecstatic tradition, the late Zhou and Han traditions of immortality seekers, and the religion of the Celestial Masters, imported from the north." All of this was blended into works of "remarkable poetic and literary quality . . . imbued with reminiscences of old Chinese myths and the literary tradition represented by the [*Songs of the South*]" (Robinet 2008b, 858). The new visions presented in the texts are highly spiritualized, featuring ideals of spiritual marriage with the Perfected—a

clear rejection of the sexual practices of the Celestial Masters—and the attainment of spiritual transcendence rather than the bodily immortality extolled in earlier occult literature. Tao's success in editing the tradition is seen in the fact that, as Robinet notes, it became the "foremost Daoist tradition between the sixth and the tenth centuries," its pictures of solitary visionary experience inspiring Tang poets like Li Bai 李白 (701–62) and Wu Yun 吳筠 (d. 778) and gaining it a significant place in the early Song Dynasty (AD 960–1279) compilation of texts for the emperor known as the *Taiping yulan* 太平預覽 (983) (Robinet 2008b, 861–62).

The third and final great creation of what we might term the classical era of the Daoist religion was the Numinous Treasure (Lingbao 靈寶) corpus. The term seems originally to have been a name for people or things imbued with spirits or spiritual power; that is, a spirit medium or a sacred object. Shortly after the first Upper Clarity texts were revealed, however, a new and unified body of scriptures bearing the name appeared in the same region. The texts, which were brought together by the Daoist Lu Xiujing 陸修靜 (406–77) in AD 437, were said to have been revelations granted to Ge Xuan 葛玄 (traditional dates, 164–244), the mysterious uncle and spiritual teacher to Ge Hong 葛洪 (283–343), author of the *Master Who Embraces the Unhewn* (*Baopuzi* 抱朴子), one of the greatest religious classics of China. As Stephen Bokenkamp points out, this attribution was probably a tactic to assert the superiority of the new texts over those of the Upper Clarity, then on the rise. He notes that later records point to a contemporary member of the Ge clan (relatives to both the Xu and Tao families of the Upper Clarity group) named Ge Chaofu 葛巢甫 (fl. 402) (Bokenkamp 2008, 664).

The Numinous Treasure texts greatly expanded the practices of Daoism. Rather than the solitary—and rather aristocratic—visionary techniques extolled in the Upper Clarity texts, these works presented instead the foundation for a universal religion of salvation based in part in communal ritual. The texts, in a way, were an attempt to revise the entire received tradition of Chinese religion according to their logics. As the Celestial Masters had centuries before, they incorporated elements from religious practices then in vogue. In their case, as Bokenkamp notes, these included "*fangshi* practice, Han-period apocrypha, southern practices known to Ge Hong . . . , Celestial Master Daoism, Shangqing Daoism, and Buddhism—sometimes copying entire sections of text and presenting them so as to accord with its central doctrines in order to fashion a new universal religion for all of China" (Bokenkamp 2008, 663). Though, as Bokenkamp notes, this project failed in the short term—Buddhists and Daoists both ridiculed its obvious plagiarisms—in the long term it met with much more success. Its creation of a canon of Daoist scriptures organized according to the logic of the "three caverns," with its own texts presented first, remained the structure for the later Daoist textual tradition, and its communal rites became the basis for later Daoist ritual (Bokenkamp 2008, 663). More broadly, adaptation of Buddhist elements—such as devotional images of Laozi depicted, like the Buddha, with a bodhisattva-like attendant to either side (fig. 138)—became common in Daoism from this period on (see also fig. 143).

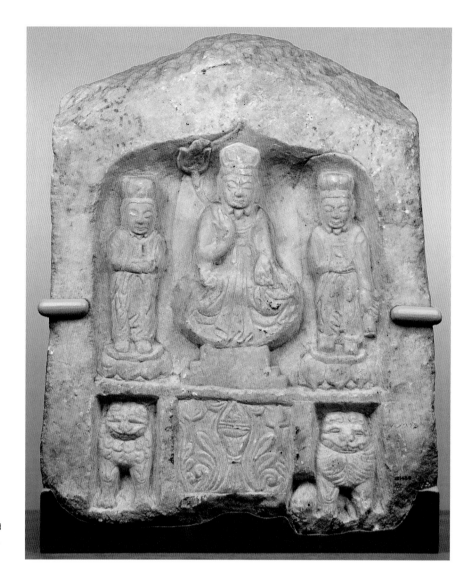

In the Tang Dynasty (AD 618–907) Daoism attained its social apogee in Chinese history, when in many instances it came to shape, or even to replace, the ancient rites central to the establishment and endurance of the state and the imperial clan. These replacements were perhaps most complete in the mountains, such as Taishan (fig. 139), that were sacred both to the imperium and to a range of local religious groups, where Tang emperors proclaimed that the true spirits of the ranges were not the older deities that had been worshipped there for centuries but the newer gods of Daoism. In a very literal way, this was intended to transform China into a Daoist realm. The grounds for this ascendency were set by a coincidence: the new imperial clan shared the same family name, Li 李, with Laozi, now the Most High Lord Lao, the legendary founder of the Daoist religion. Though the Lord Lao's place in the cosmic hierarchy had fallen during centuries of sectarian contestation within Daoism, with his "descendants" now on the imperial throne—the tradi-

CHAPTER EIGHT

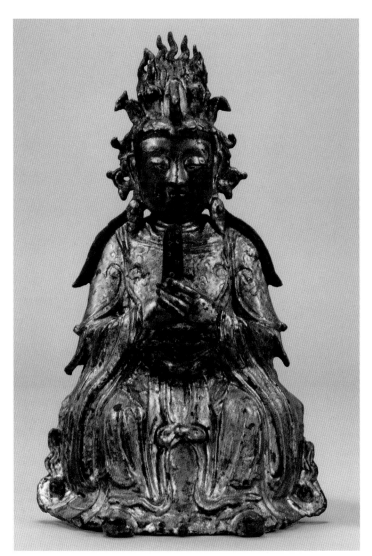

tional intersection of Heaven and the human in Chinese cosmology—the cult of the Most High Lord Lao experienced a remarkable resurgence, both within Daoism and within late medieval Chinese culture as a whole (fig. 140). Daoist priests and adepts, taking advantage of this new glamour, made the Tang the period of their religion's greatest influence upon Chinese political and cultural life. As we have seen, Daoists at other times had had the ears of rulers in China. But not since Han times had the power associated with these relationships been as great as it was in the Tang. The wealth and power of the Tang emperors, especially, brought Daoist practice to new heights of majesty and intricacy.

Mirroring, in part, the imperial court's absorption of the northern and southern cultures that had grown apart in the years of disunity, and the greater unity of aristocratic literati culture that resulted from it, Daoists forged systematic syntheses of their distinct regional traditions in this period, such that today most schol-

FIGURE 139
Figure of Daoist deity Bixia Yuanjun, often worshipped on Taishan. Qing Dynasty (AD 1644–1911). © The Field Museum. Catalog No. 121874. Photographer Gedi Jakovickas.

FIGURE 140
Deified Laozi. Tang Dynasty (AD 618–907). © The Field Museum. Catalog No. 121488. Photographer Gedi Jakovickas.

ars of the tradition speak of "Tang Daoism" as a coherent tradition that existed across China, a marked shift from the emphasis on separate textual and ritual lines in accounts of earlier ages. Among the subtraditions that underwent transformation and increased synthesis were those of "outer" and "inner" alchemy (*waidan* 外丹 and *neidan* 內丹), descendants of ancient techniques for the attainment of transcendence that featured the literal ingestion or imagined incorporation of powerful substances, respectively. In some practices, these were combined into a part-material, part-symbolic art that was at times further combined with the Daoist practices of contemplation and visualization known as "internal contemplation" (*neiguan* 內觀). The Tang, in fact, saw developments that scholars have identified as central to the history of alchemy and contemplation in Daoism and that set the stage for their ascendency in later periods.

The four centuries that followed the collapse of the Tang in 907 saw further growth and systematization in Daoism. These included a new exorcistic ritual system—a "grand scheme laid out in rituals and scriptures and often including compounding the 'inner elixir'" (Skar 2008, 627)—known as "thunder rites." This system, a conglomeration of formerly disparate cults of thunder gods, which appears to have come together in the tenth century, provided a new ritual language for many of the Daoist traditions that arose in the Song, among them the Divine Empyrean (Shenxiao 神霄). Like other Daoist traditions before it, this one took its name from the heaven from which its dispensation was said to originate. Divine Empyrean Daoism was especially favored by the Song Emperor Huizong (r. 1100–1125), known both for his exquisite calligraphy and paintings and for being the emperor who lost the north to the invading armies of the Jin. But as Paul Katz has noted, although Huizong's involvement is the most widely known feature of its history, its true contribution to Daoism was its tradition of ritual practices, which combined popular techniques along with those of the priestly system of thunder rites, many of which, having been absorbed into later Celestial Master tradition, continue to be parts of Daoism today (Katz 2008, 889–90).

By far the most important new school to arise in this time, however, was Complete Perfection (Quanzhen 全真) Daoism, a tradition that "today is the main official branch of Daoism in continental China" (Goossaert 2008, 814). Unlike previous schools of Daoist religious practice, Complete Perfection was, and remains, primarily a monastic tradition whose forms—originally in part under the pressure of the imperial state—were modeled closely on those of Buddhism. The school was founded by Wang Zhe 王嚞 (1113–70), a Daoist adept living in the Zhongnan Mountains in Shaanxi Province, who claimed to have been guided by a group of transcendents, including the famous Zhongli Quan 鍾離權 and Lü Dongbin 呂洞賓 (see figs. 161 and 160 in Liu, this volume). In 1167, having moved east to the Shandong region, Wang took on a group of seven disciples, including Sun Bu'er 孫不二 (1119–83), one of the most famous women in Daoist history, and Qiu Chuji 丘處機 (1148–1227), who would later go on to ensure the survival of the school through the turmoil of the Mongol invasions. Wang taught them Daoist contemplative arts

as well as the often-severe austerities of early Quanzhen practice (going without sleep for extended periods, traveling naked in winter and sitting by roaring fires in summer, standing on one foot for days at a time).

Qiu Chuji proved to be the most capable leader of the early Complete Perfection order, seeing to its survival through the chaos of natural disasters, war, and invasion that characterized his age. He ensured that it would flourish through the coming Mongol Yuan Dynasty (AD 1279–1368), when, answering the summons of Chinggis Khan (1162–1227), he traveled to his court in Central Asia, finally meeting him in 1222 after a journey of nearly three years, and secured privileges for his order. It was during the Yuan that Quanzhen became the main school of Daoism, a position its adherents used, among other things—like the Celestial Masters nearly a thousand years before them—to engage in large-scale social welfare projects.

After lean years in the Ming period (AD 1368–1644), when the Complete Perfection Daoists were integrated into a religious bureaucracy headed by the Celestial Master of the Zhengyi 正一 order, they experienced a strong resurgence during the Qing Dynasty (AD 1644–1911) and thrive to this day. Aside from the standard liturgies important to Daoism of all kinds, central to Complete Perfection are various programs of monastic self-cultivation, including the contemplation of alchemical poems and extended periods of both intensely solitary and communal meditation.

Buddhism

Buddhism first entered China in the midst of the Han Dynasty, and it began to find a lasting place there during the same age of rebellion and dynastic collapse that inspired the birth of the Daoist religion. Whereas Daoism was in many ways a direct response to that collapse—and in particular to the perceived collapse of the cosmic order it entailed—Buddhism's early success in China was more serendipitous. The native imperial Confucian order seeming to have failed so cataclysmically, people—perhaps naturally—were more open to the powerful foreign system of cosmology and salvation that Buddhism offered. That openness would have a profound impact on both Chinese religious culture and Buddhism itself. Over the next millennium, Buddhism would not only fundamentally remake many aspects of Chinese practice and worldview, it would itself be fundamentally remade. The resulting product—a truly *Chinese* Buddhism—when imported first to the other cultures of East Asia, where it would be further remade and refined, and then, often via them, to the West, where it is being remade yet again, has become one of the truly pervasive traditions of world religious practice, found in temples stretching from Chengdu to Seoul to Chicago and beyond.

But such transformations would take centuries to accomplish. In Han China, as Buddhism made its slow way eastward along the desert trade routes of South and Central Asia, where it was already thriving, the religion appears mainly to have been practiced within expatriate communities of merchants or in small groups led by newly arrived foreign priests. Although early practitioners of the religion

in China are mentioned briefly in texts from the period, the clearest traces of the early history of Buddhist practice in China are found in the images and structures, mainly caves, they left behind. One can follow a line of cave-shrines filled with Buddhist images in China extending along the trade and pilgrimage routes that have been known since the nineteenth century as the "Silk Roads" (see Lin and Zhang, this volume; Niziolek, this volume). Such sites include those now in the modern province of Xinjiang, part of the broad Central Asian region often known, due to its historical dominance by Turkic cultures, as "eastern Turkestan," such as Kizil, Niya, Khotan, and Turfan, and those extending from there to the ancient Chinese capital of Chang'an (modern Xi'an) along the Hexi Corridor in what is now Gansu Province. These include, among many others, the stunning sites of Binglingsi, Maijishan, Yulin, and—the greatest of all Buddhist sites in China (and among the greatest in the world)—the Mogao caves near Dunhuang, located at the point where the southern and northern desert trade routes converged—the entry point into China in ancient times (Hansen 2012) (see Zhou's section on The Field Museum's Dunhuang manuscript, this volume, highlight section 6). Eastward from there, they are found to the south, in sites such as Dazu and Jianchuan, and eastward, including sites such as Longmen, Yungang, and Xiangtangshan.

The first Buddhist cave at Dunhuang is traditionally dated to AD 366, when, legend tells us, a Buddhist priest wandering by the Mogao cliffs had a vision of a thousand shining buddhas, the origin of one of the traditional names for the site, the Caves of the Thousand Buddhas. This priest dug into the cliffside to hollow out a grotto at the place of his vision, and another traveling priest is said to have made another nearby soon afterward, beginning a nearly thousand-year history of cave-shrine creation there. The earliest remaining caves may have been used for meditation—they contain within them many small niches suitable for solitary sitting—and for this reason have come to be known as "vihāra," or monastic, caves. But these are a small minority at Dunhuang and nearly nonexistent elsewhere in China. The great majority of grottoes at Dunhuang and at all other Buddhist sites in China take the form of shrines, often centering on large sculpted images of buddhas and bodhisattvas. Surrounding these central figures, filling the walls and ceilings of the caves at Dunhuang, are paintings (or further sculptures), many of which can justly be counted among the greatest works of art surviving from premodern China. Such images were intended to inspire wonder and awe at the majesty of buddhas and their teachings—perhaps not unlike the great cathedrals in Europe (fig. 141).

In brief, we might say that the paintings have two main themes. They depict, in soaring images of goddesses, myriad buddhas, and other divine figures, the Buddhist cosmos, the infinite multiverse described in the Buddhist scriptures. This is the world in which sentient beings are said to live, cycling in beginningless time through various forms of rebirth, all of which—even those of gods—are held to be fundamentally marked by suffering. It is the world from which Buddhism offers escape, into one of the perfect realms known as Pure Lands that are described

FIGURE 141
Image of a musician from the Dunhuang
Caves, Cave 112. Image in Public Domain.

as being empty of suffering and want, over which buddhas reign. These are also depicted in the shrines, often in images of great beauty. The most important Pure Land images feature the Buddha of the Western Pure Land, Amitābha, whose cult became central in East Asian Buddhism because of the legend that anyone who called out his name seeking salvation would be granted birth in his Pure Land. This idea became so powerful that the calling out of his name in devotion—"Na-mo Amituofo" 南無阿彌陀佛 in Mandarin Chinese—has become one of the most central practices, and indeed a common greeting, among Buddhists in East Asia.

The other main subject of shrine murals and sculptures consists of Buddhist teachings, often in the form of the tales told in the scriptures of the main figures of Buddhist legend. These include most prominently the selfless acts of the Buddha Shakyamuni in his past lives that led, over eons of rebirths, to his ultimate awak-ening, from the delusion of normal sentient existence, as a buddha (a term that means simply "awakened one"), and the deeds of the bodhisattvas—the cosmic beings whose wisdom and power is said to be second only to buddhas—as they saved sentient beings from lives of ignorance and peril. More broadly across Bud-dhist China, among the most common images were those from the hugely popular

Lotus Sutra, especially that of the two buddhas, one (Shakyamuni) preaching the sutra and another (the ancient Buddha Prabhūtaratna) listening and praising the teachings (fig. 142).

The images in Buddhist shrines and on freestanding steles reveal important aspects of the Buddhism of traditional China. Although in the West we most often encounter Buddhism as a rather pared-down teaching of "mindfulness" and a simple life, in China it has always been first and foremost a religion of vision, devotion, and spiritual power. Among the most frequently encountered images in the shrines and on steles are those of the donors who paid for them. They are figured in processions of families or lay groups, often extending along the lowest registers of the murals, led by their eldest and by priests. On steles with images we find an analogue to this in the lists of the names of donors, often with their positions in lay Buddhist societies, that frequently take up a considerable amount of space on the stones. Here we see traces of the great devotional movements of Chinese Buddhism, many of which were founded in simple doctrines and practices.

At the heart of these practices is the conception of spiritual power known as "merit," the idea that certain kinds of actions are spiritually meritorious in

that they generate power to alter the course of life—and indeed of personhood itself—that had been set by lifetimes of previous actions, in the process known as "karma." Among the most powerful ways to generate merit is the re-creation of the Buddha's "body" in various forms, including his images, name, or speech. The merit resulting from these acts, in many ways the central practices of Buddhism in China, is then either kept for oneself, or, more commonly, given to others, whether to one's own ancestors or to all beings, to bring them ease of suffering and to help them on the path to final awakening as a buddha (Kieschnick 2003, 24–82).

The power this idea has held for Buddhists is visible in the many thousands of buddha and bodhisattva images that survive from earlier periods and that are still being commissioned and made today. These range from the towering images carved into cliffs, usually at imperial behest and often as much signs of dynastic grandeur as of religious piety, such as those of Yungang or Longmen (fig. 143), to smaller stone sculptures of buddhas and bodhisattvas suitable for temples or private homes (fig. 144), as well as often very small metal figures that could be carried with one, for devotional rites or as amulets (fig. 145). Perhaps the humblest are the thousands of stamped or molded clay Buddhist images that have been discovered in a range of devotional contexts (one of the finest collections of which, containing more than 350 items, is found at The Field Museum) (fig. 146). The makers of these mass-produced images took full advantage of the additive logic of Buddhist ritual, according to which the more instances of the Buddha's body that were produced, the more merit was gained. Archaeologists have found small stupas—structures built to contain relics of the Buddha—filled with hundreds of these stamped clay tablets, often with the names of the beneficiaries also stamped on them, in a technique that appears to have contributed to the birth of printing more than one thousand years ago in China.

The Buddhist shrines that contained such images were considered places of great spiritual power. Other places, usually mountains, said to be the actual dwellings of bodhisattvas in China, gained even greater renown as sites of divine presence. Four mountain ranges were preeminent in this regard: Wutaishan, in Shaanxi Province, considered the home of Mañjuśrī, or Wenshu in Chinese; Putuoshan, in Zhejiang Province, of Avalokiteśvara, or Guanyin; Emeishan, in Sichuan Province, of Samantabhadra, or Puxian; and Jiuhuashan, in Anhui Province, of Kṣitigarbha, or Dizang. These mountains became major destinations and supports for pilgrimage, a central practice in Chinese Buddhism, as it had been in India before, where it seems to have developed from the simpler practice of visiting and circumambulating stupas thought to contain relics of the historical Buddha, Shakyamuni.

Without doubt the most widespread of the bodhisattva cults in China was that dedicated to Guanyin, the Chinese form of the Indic figure Avalokiteśvara. Guanyin was a male figure in China, as he had been elsewhere in Buddhist Asia, through approximately the first thousand years of Buddhism's presence there. His cult in this age centered first on tales from the *Lotus Sutra* of his powers to save beings

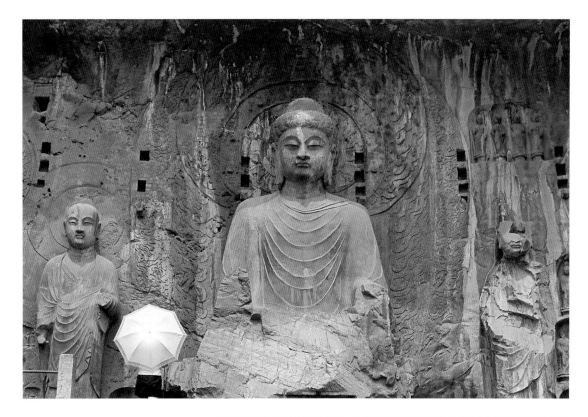

FIGURE 143
The Buddha Mahāvairocana, Longmen, Henan Province. Image courtesy of Paul Copp.

FIGURE 144
Stele showing Shakyamuni buddha with attendant bodhisattvas and guardians, dated AD 560. © The Field Museum. Catalog No. 121447. Photographer Gedi Jakovickas.

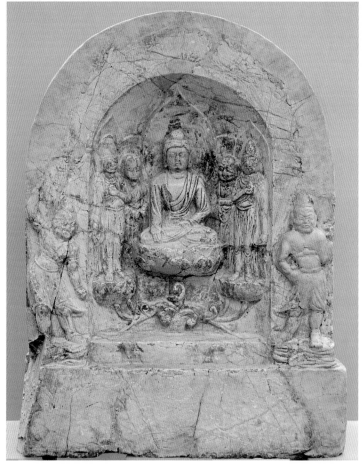

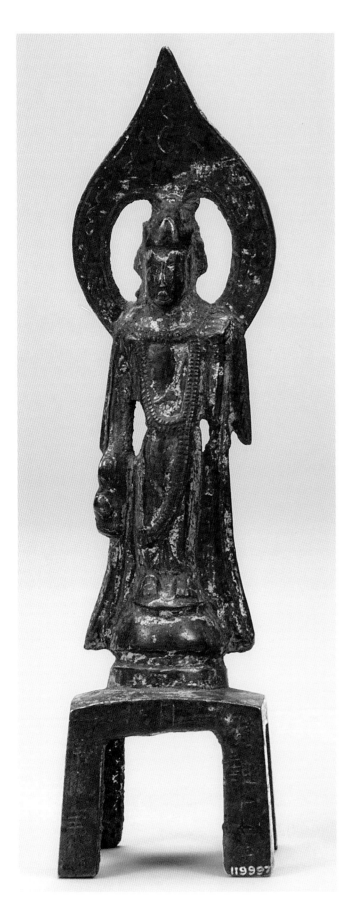

FIGURE 145
Bronze votive with Shakyamuni buddha,
dated AD 643. © The Field Museum. Catalog
No. 119997. Photographer Gedi Jakovickas.

FIGURE 146
Inscription on back of tile depicting buddhas and
stupas. Molded clay tablet, dated AD 762. © The Field
Museum. Catalog No. 121948. Photographer Gedi
Jakovickas.

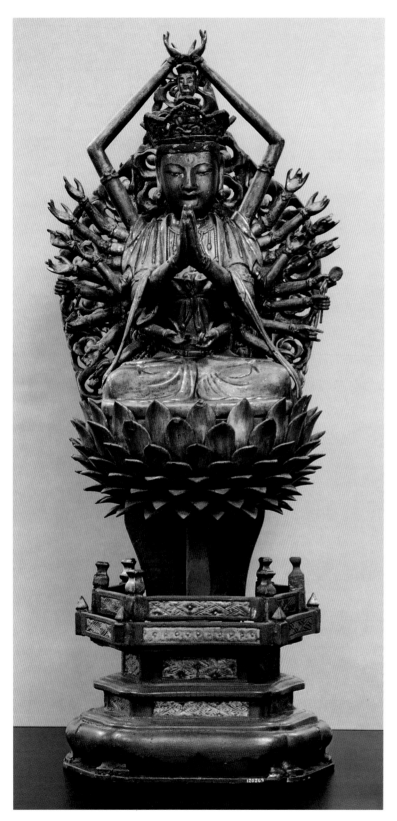

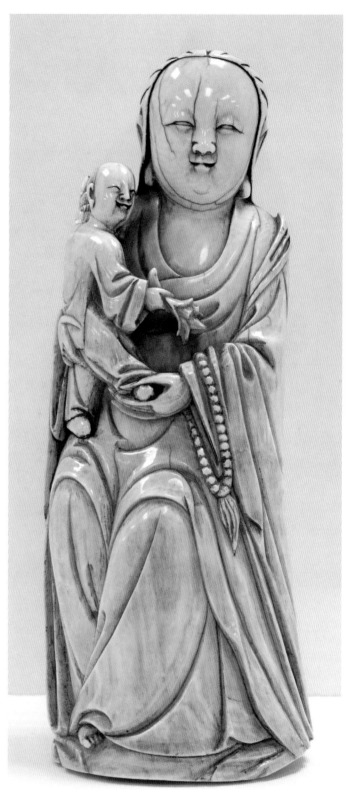

FIGURE 147
Thousand-Armed Guanyin made of wood and lacquer, early nineteenth century. © The Field Museum. Catalog No. 120263. Photographer Gedi Jakovickas.

FIGURE 148
Son-Bestowing Guanyin. Ivory carving, c. seventeenth century. © The Field Museum. Catalog No. 233343. Photographer Gedi Jakovickas.

from numerous perils, and later on his association, in his new thousand-armed form, with the spell, widely popular to this day, known as the *Incantation of Great Compassion (Dabei zhou)* (fig. 147). But then a momentous change occurred. At some point in the Song Dynasty, for reasons that are still not fully clear, Guanyin was increasingly understood to be, and depicted as, female, and it is in this form that she is known throughout China today. Perhaps in part because of this gender affiliation, Guanyin is especially (though by no means only) popular with women, who make up the majority of pilgrims to her seat at Putuoshan, and the majority of supplicants to her cult, especially in forms such as the Son-Bestowing Guanyin (Yü 2000) (fig. 148).

A final way that spiritual power is made manifest in the lives of Buddhist practitioners is through incantations—mantras and *dhāraṇīs*—said to be the speech of the Buddha in its most condensed and potent form. The spells are in Sanskrit, often with interpolations of unintelligible syllables that give them the kind of strangeness found in incantatory ritual speech elsewhere in the world. Their potency is usually said to inhere in their sounds, rather than in any meaning they might have or that might be attributed to them. Thus, in China, they are nearly always transliterated, rather than translated, forming runs of strange syllables said to possess all the transformative and redemptive powers attributed to the Buddha. Practices of healing and spiritual enhancement centering on spells have an ancient history in Buddhism. Simple rites for healing and protection were developed into more complex devotional ceremonies that became among the most commonly practiced forms of Buddhism in premodern China—for example, in the rites dedicated to the *Incantation of Great Compassion* of Guanyin noted earlier. In cataloging the great cache of manuscripts and paintings discovered at Dunhuang, the sinologist Arthur Waley noted that what he called "Dhāraṇī Buddhism" constituted what he considered one of the two principle forms of Buddhism in evidence there, the other being the practices devoted to rebirth in a pure land.

Although, as noted, Buddhist texts often assert that *dhāraṇīs* and mantras are only potent as correctly pronounced sounds, their popularity as written texts achieved great heights in traditional China, especially in the form of incantation pillars (fig. 149). These were stone pillars inscribed with Buddhist spells, most famously the *Incantation of the Glorious Crown of the Buddha*. The warrant for these objects appeared in the scripture for this spell. There it was said that were one to inscribe the spell on a pillar and set it where many could encounter it, then anyone who beheld it, or—fascinatingly—any who came in contact with its shadow, or with dust blown off it, would receive all the miraculous benefits normally gained by hearing or speaking it (Copp 2014, 141–96). This idea took hold in the Tang, and incantation pillars remain among the most commonly encountered Buddhist objects in China, and can, like shrine murals, serve as emblems for its ancient culture of Buddhist devotion and merit-seeking (fig. 150).

Due to its deep involvement with material culture, devotional life is the main aspect of Buddhism one encounters in museum halls. But Buddhism in China, as

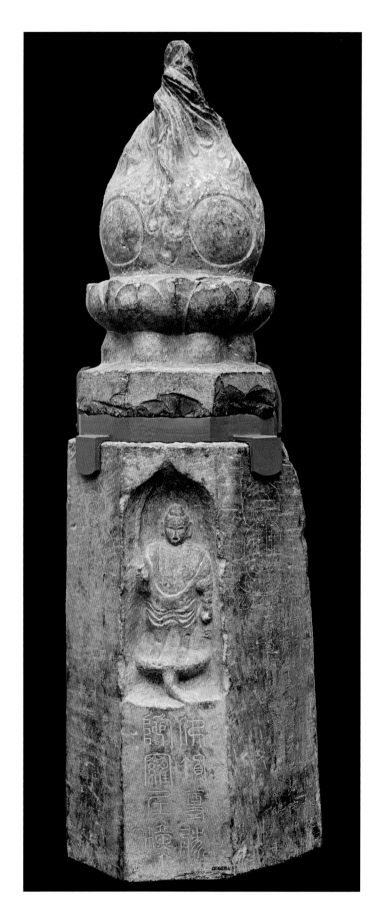

FIGURE 149
Incantation pillar (fragment), Tang Dynasty.
© The Field Museum. Catalog No. 121625.
Photographer Gedi Jakovickas.

FIGURE 150
Incantation pillar. Image courtesy of
Sun-ah Choi.

elsewhere, was of course also a profound philosophical and contemplative tradi-tion, and an exploration of its intellectual side is necessary to any understanding of the religion there. Unlike Daoism, Buddhist doctrines and conceptual practices were transplants to the soil of Chinese culture. The centuries of development and controversy of Buddhism's early Indic history were, for the most, part hidden to the Chinese. This history—in which a relatively simple set of doctrines about the nature of suffering and how to end it grew into a vast intellectual system con-cerning, among a great many things, the nature of the cosmos, knowledge, and the mind and its relation to phenomena—had produced a complex tradition filled with contradictions and seeming contradictions.

Initial movements in Chinese Buddhism (extending in their way well into the Tang and early Song periods) were mainly focused on trying to get the religion correct according to its Indic origins. It was an age of great translation projects, most prominently those of the Kuchean priest Kumārajīva (334–413), who, along with his teams of Chinese assistants, first put Buddhist texts into truly elegant and readable Chinese, and of the Chinese priest Xuanzang 玄奘 (602–64), whose translations, particularly of Yogacāra texts on the nature of mind and phenomena, reached new levels of accuracy and faithfulness to their Indic originals. Another, and more direct, way Chinese Buddhists of this period tried to get things right was

by traveling to India to see for themselves how the tradition was lived there. Along with Xuanzang, whose journey was later popularized in fantastic form in the great Ming novel *Journey to the West* (presented in Gallery 4 of the *Cyrus Tang Hall of China*, "Beliefs and Practices, Symbols and Stories"), were many other pilgrim monks, including Faxian 法顯 (337–422), the first great Chinese Buddhist traveler, and Yijing 義淨 (635–713), who was among the last, and who compiled a collection of traveler accounts that remains, with those of Xuanzang and Faxian, among our best sources for the social history of Buddhism in India and Central Asia.

The great Buddhist intellectual movements of the Sui (AD 589–618) and Tang, which brought Chinese Buddhism truly into its own, achieved a new phase in Chinese Buddhist practice. Like the earlier age of travel and translation, they were also in part direct responses to the difficulties presented by the confusing welter of texts and doctrines imported from India. The first was the Tiantai 天台 tradition, founded by the monk Zhiyi 智顗 (538–97) and carried forward by monks such as Zhanran 湛然 (711–82) and Zhili 知禮 (960–1028), which took the *Lotus Sutra* as the chief teachings of the Buddha. Zhiyi, in his *Great Calming and Contemplation* (*Mohe zhiguan* 摩訶止觀), one of the greatest achievements of Chinese Buddhism, set out maps of meditation practice that were taken as standard by all later schools of Buddhism in China, and also doctrines of the interplay between mind and world in which both have equal status. Another important school was known as the Huayan 華嚴, after the scripture of the same name, which was given its foundation by Fazang 法藏 (643–712), a Tang monk of Sogdian descent, and later extended, and in many ways transformed, by Chengguan 澄觀 (738–839) and Zongmi 宗密 (780–841). Whereas in its earliest forms, as set out by Fazang, it was often close to Zhiyi's pictures, in later years it came more and more to hold positions seen as opposite to them, featuring doctrines—partially drawn from tremendously influential native Chinese Buddhist texts such as the *Awakening of Mahāyāna Faith* (*Dasheng qixin lun* 大乘起信論) and the *Scripture of Perfect Enlightenment* (*Yuanjue jing* 圓覺經)—asserting the primacy of inherently pure mind as the true nature of all things. Based to some extent on Indic Yogacāra teachings, this idea came to be seen (unfairly to the Tiantai tradition) as perhaps the defining idea of Chinese Buddhist thought, featured not only in Huayan writings but also in those of Esoteric (or Tantric) Buddhism in China, as well as in Chan 禪, the tradition known in the West mainly through its Japanese version of Zen.

The idea that all things are always already inherently pure—that is, empty of the conditions that lead to suffering and delusion—and that, because of this, the task of the Buddhist practitioner is not to purify herself, or transform himself in any way, but simply to see the way things always actually are, is at the heart of Chan. This idea was made vivid in the tales that are the chief scriptures of Chan tradition. To take one of the earliest and simplest of these tales as an example, a monk asks his teacher to free him. The teacher replies that if the monk can show him what binds him, he will free him. The monk reports that after deep meditation he can find no such thing. "I have freed you," says the teacher. Such tales of Chan

teachers such as Mazu 馬祖 (709–88) and Linji 臨濟 (d. 866) remain central to the tradition to this day.

These tales marked an important shift in the history of Buddhism in China. Echoing the results of Han dynastic collapse centuries before, the collapse of the Tang imperium in the early tenth century brought a corresponding collapse not only in those forms of religion that were most tied to it—Huayan and Esoteric traditions, in the case of Buddhism—but even more fundamentally in faith in the classical culture and literary heritage that had been the core of China's elite society since the Han. With this, in Buddhism and more broadly, came a rise in vernacular cultures and literatures. Chan, whose greatest age of textual production occurred in this period, was very much a part of this. Its tales and dialogues, which should be taken as idealized teachings rather than historical accounts, were primarily composed in Song vernacular language, rather than in the somewhat more classical registers of earlier Buddhist texts, and came more and more to be characterized by a new emphasis on a wild freedom in behavior and thought. The new tales were in marked contrast with the elegant, controlled, and often intensely difficult philosophical works, usually treatises or scriptural commentaries, characteristic of Tang and earlier periods (though many later Buddhists continued to compose in this vein). The texts associated with the great Chan teacher Mazu offer a clear example of this. Works attributed to him from the Tang feature a teacher much in line with other Buddhists of the classical age, while those dating to the Song depict the kind of wild behavior and cryptic speech that have come to be associated with the "Zen Master" (Poceski 2007).

Many scholars have seen this as the final phase of the "Sinification," or the "making Chinese," of Buddhism in China. It corresponded with Buddhism's greatest age of demographic, institutional, and cultic growth there. But rather than an end, in many ways it marked a new beginning for Buddhism in China. With the Mongol invasion and rule as the Yuan Dynasty, and on into the Ming and Qing periods, and indeed down to today with the recent resurgence of religious practice in continental China, Buddhism in China has continued to grow and develop, more and more alongside Tibetan forms of the religion that became, and remain, important elements of this ever-evolving tradition.

Conclusion

Beginning in the second century AD, an age of turmoil and imperial collapse, Daoism and Buddhism began to take shape in traditional China. Daoism grew organically out of China's native religious culture. Its first form, that of the Celestial Masters, developed initially as a small theocratic polity in western China, inspired in part by the desire to re-create the sense of cosmic order lost with the fall of the Han Empire, but it eventually spread across the north. Its rites, which followed the inherent logics of China's rich ancient culture of spiritual practice and cosmology, centered especially on talismanic writs and prayerful petitions made to deities of

the spiritual bureaucracies, as well as on practices of the confession of misdeeds and charitable works. All of these practices were said to be overseen by the great cosmic Dao itself, the laws of which had been relayed to the founding Celestial Master by the newly deified Laozi. The Celestial Master tradition was taken to the south by northerners fleeing invasion in the early fourth century, where it inspired and shaped new developments in the religion, especially the new textual and ritual dispensations of the Upper Clarity and Numinous Treasure traditions, both of which represented in part the south's own ancient religious culture of spirit mediums and occult techniques. These new Daoist traditions in turn grew, in part shaped by the encounters of their members with Buddhist ideas and practices then gaining popularity in China, and in part due to their own logics, eventually giving rise to new forms of Daoist religion, including especially the traditions of Thunder Rites, the ascetic paths of Complete Perfection adepts, and the reformulated Celestial Master tradition known as Zhengyi—styles of Daoist practice that are very much alive today.

Buddhism, though a transplant at first, also grew organically within Chinese history and culture, quickly becoming a tradition in many ways distinct from its Indic and Central Asian sources. A religion of devotion, of the spiritual grace and power known as merit, and of astonishing visionary art, as much as of philosophy and quiet contemplative practice, Buddhism spread quickly beyond the small expatriate communities of traveling merchants and priests that planted its seeds in China. Like Daoism in its way, it provided an alternative cosmos to the failed Confucian imperium of the Han. This cosmos is vivid in Buddhism's most dramatic and lasting monuments in China: the great cliff and cave shrines, such as Longmen, Yungang, and Dunhuang, many of which became sites of pilgrimage, dedicated to spiritual and earthly visions of its nearly omnipotent bodhisattvas, and of the countless buddhas of the infinite multiverse described in its scriptures. For its more elite practitioners, Buddhism was also a religion promising a path of spiritual perfection, understood in terms of awakening to the true nature of things, and in particular of the self. For many Chinese Buddhists, this meant awakening to the fact that the world and the self, just as they are, are inherently perfect, are what the tradition describes as the very body of the Buddha itself. The worldly turn implicit in such ideas is manifested in part in an embrace of Chinese vernacular literary and cultural forms, and in part in the increasing "Sinification," or "Chineseness," of Chinese Buddhism.

Sealed in Time:

A Manuscript from Dunhuang

Yuan Zhou

The term "Dunhuang manuscripts" refers to nearly fifty thousand documents discovered in a sealed cave located in the famous Mogao Caves 莫高窟 of Dunhuang 敦煌 in the northwest of China in 1900. The great majority of these are handwritten papers, although there are a small number of woodblock prints and rubbings too. Most of the manuscripts are in the Chinese or Tibetan language and were made as early as the fourth century AD and as late as the twelfth century. The discovery of the Dunhuang manuscripts was one of the greatest archaeological finds of the twentieth century in China.

Among the manuscripts uncovered that were written in Chinese, about 90 percent are Buddhist texts. Most are hand copied on paper and kept rolled up as scrolls. The Dunhuang manuscript owned by The Field Museum (catalog no. 233000) is about 1 foot wide (about 30 centimeters) and just over 5½ feet long (1.68 meters) (fig. 151). It consists of four pieces of paper that were glued together to form one scroll. The text is a Chinese translation of the *Aparimitayus Sutra* (*Wuliang shouzong yaojing* 無量壽宗要經), also known in Chinese as 大乘無量壽經 or 大乘

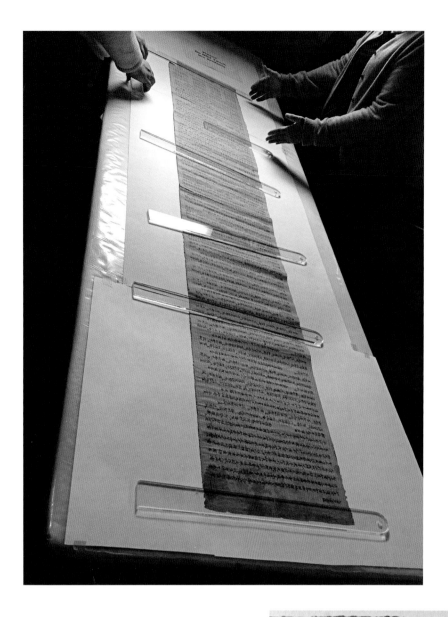

FIGURE 151
The Field Museum's Dunhuang manuscript of the
Aparimitayus Sutra. © The Field Museum. Catalog
No. 233000. Photographer Lisa C. Niziolek.

FIGURE 152
A close-up view of the beginning of The Field
Museum's Dunhuang manuscript. © The
Field Museum. Photo ID No. A3606_23300.
Photographer Karen Bean.

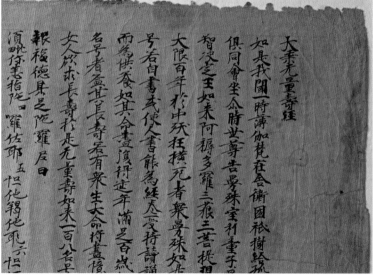

無量壽宗要經. The text of the manuscript was hand copied. It begins with the title "大乘無量壽經" (fig .152) and ends with an alternative title, "佛說無量壽宗要經." In Buddhism, reproducing and distributing Buddhist sutras was considered a charitable action that would accumulate virtue, or merit, for people who made or paid for such effort. During the Tang Dynasty (AD 618–907), reproducing Buddhist sutras by hand was particularly active in Dunhuang. Among the large number of Buddhist manuscripts discovered in the cave, some are copies of the same text. The *Aparimitayus Sutra* accounts for the highest number of duplicate copies discovered in the Dunhuang manuscripts in either the Chinese or the Tibetan language.

Some Dunhuang manuscripts were signed by the scribe who copied them, although the great majority of them were not. The piece held at The Field Museum is fortunately among the ones with a scribe's signature. It was signed by Zhang Luemozang 張略沒藏 at the very end of the manuscript (fig. 153). Zhang Luemozang is believed to have been a man from an ethnic minority group rather than from the majority Han ethnicity. Furthermore, there are at least six other copies of *Wuliang shouzong yaojing* among the Dunhuang manuscripts that were signed with the same name. Similar signatures, such as Zhang Limozang 張力沒藏 and Zhang Limo 張力沒, were found in more copies of the same sutra and are believed to have

FIGURE 153
A close-up view of the scribe's signature at the end of the manuscript. © The Field Museum. Photo ID No. A3606_23300. Photographer Karen Bean.

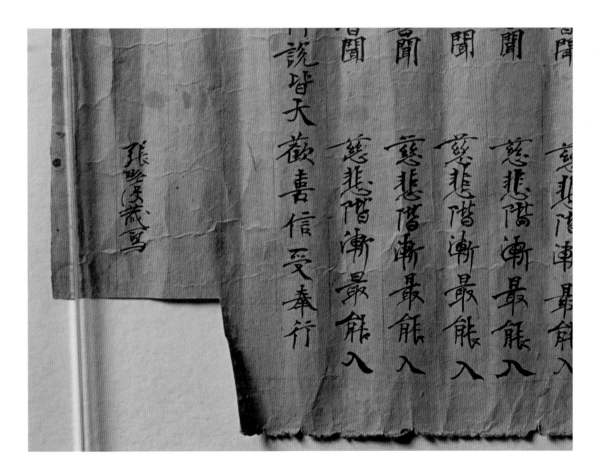

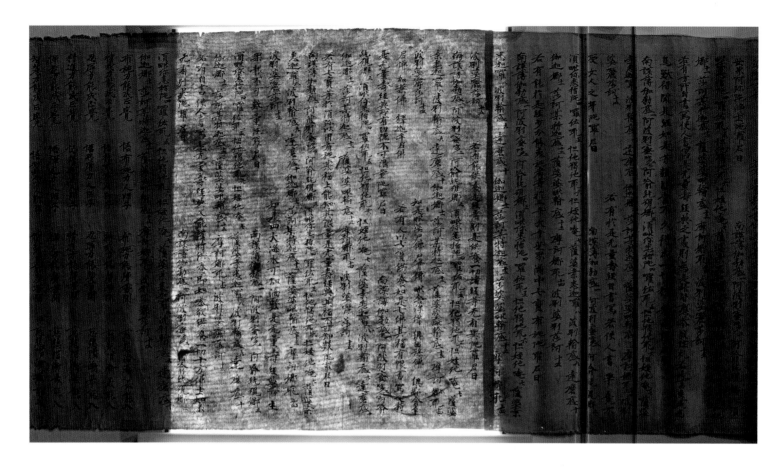

FIGURE 154

Observing a section of the manuscript under transmitted light. © The Field Museum. Photo ID No. A3606_23300. Photographer Karen Bean.

been made by the same individual. This scribe also copied sutras in Tibetan, which indicates that he was literate in both Chinese and Tibetan. The identification of the scribe is significant for authentication of this manuscript.

From 786 to 848, Dunhuang was ruled by a Tibetan regime known as the Tubo 吐蕃, rather than China's Tang government. It is known that during that period, the quality of paper used for copying sutras in Dunhuang declined because of intermittent war and conflicts between the two regimes, which disrupted the distribution of good paper to Dunhuang from more developed areas of Tang China. Subsequently, coarser paper, perhaps locally made, was used. The paper used for The Field Museum's manuscript appears to be from this period. It is tan in color and looks rather thick, though the thickness of the paper is quite uneven when observed under transmitted light (fig. 154). The surface of the paper looks somewhat rough, with visible "bumps" here and there from undissolved pieces of papermaking materials. The paper—along with other clues found—indicates that the manuscript was probably made more than one thousand years ago, in the late eighth or ninth century.

The Buddhist manuscripts uncovered in Dunhuang document, for centuries, the practice of introduction, adoption, and localization of Buddhism to China. The manuscripts are also invaluable codicology materials for understanding the

Chinese writing system, calligraphy, translation, papermaking, and distribution of texts before printing. Although not currently on display in the *Cyrus Tang Hall of China* for conservation reasons, the Museum is fortunate to have a manuscript from Dunhuang in its China collection.

9

Shadows between Worlds: Chinese Shadow Theater

Mia Yinxing Liu

The History of Shadow Theater in China

The Field Museum holds an impressive collection of Chinese shadow theater puppets, several of which are included in the *Cyrus Tang Hall of China* exhibition. Chinese shadow theater is most commonly known in China as *yingxi* (shadow play) or *piyingxi* (literally, "leather shadow play"). The manipulation of puppets to create moving shadows on a screen is a tradition found in many other cultures and civilizations including Greece, India, Egypt, Persia, and Java. As a result, there are competing theories about the origins of Chinese shadow theater. Some believe that it was an import from either India or Persia during the Tang Dynasty (AD 618–907), but others are convinced that it is indigenous to China. They claim that shadow theater appeared independently, maybe first, in China as early as the Tang, or even the Han Dynasty (206 BC–AD 220) (Gu 1983; Jiang 1992; Kang 2003; Sun 1953; Tong 1934). Berthold Laufer (1874–1934), the anthropologist behind the excellent Chinese shadow theater collection at The Field Museum, stated that it is "without doubt, indigenous to China" and was later transmitted to Central Asia

and other places (Laufer 1923, 36). Others lean toward the theory that it was an art form developed in parallel with cultures all over the world, having no singular origin (Li 2013, 2).

In spite of the debates regarding origin, most scholars concede that textual records including the term *yingxi* appeared in the Song Dynasty (AD 960–1279) and that the form was popular in the eleventh century. A Song encyclopedia, *Shiwu jiyuan* (*The Origin of Things*), recorded that *yingxi* was popular as street theater during the reign of Song Renzong (1023–63), performing the stories of the Three Kingdoms, the romantic saga of lords and warriors from the end of the third century, near the end of the Han Dynasty (c. AD 220–80) (originally in Gao Cheng [1080?], cited in Zhang 2010, 2; see also Meng et al. [1127?] 1956, 30). *Yingxi* (*qiaoyingxi* is the full word used) is also mentioned in Meng Yuanlao's *Dongjing menghua lu* as one of the popular attractions performed in popular entertainment venues side by side with other theatricals or vaudeville-like forms of entertainment in the streets of the Song capital. Interestingly, in this record the authors listed famous performers' names, indicating this type of entertainment had a star system in place in the Song. Besides holding the simple allure of entertainment, shadow theater also was described as part of the ritualistic performances in temples during festivals (Meng et al. [1127?] 1956, 377–78). Three surviving visual art pieces testify to the popularity of shadow theater in the Song: two paintings titled *A Hundred Boys Playing in Spring* (*Baizixichuntu*) and *Children at Play* (*Yingxitu*), and a bronze mirror depicting what looks like a shadow play, collected by the Chinese History Museum in Beijing (Liao 1996).

It is reasonable to surmise that, given the popularity of shadow theater in the Song, it might well have been in development in the late Tang (early tenth century) or earlier. However, historians also note a curious absence of records before the Song and even in the Mongol Yuan period (AD 1279–1368) after the Song (Zhang 2010). The absence of shadow theater in Yuan history is probably due to the Mongol rulers' prohibition of theater in general. However, the discovery of a mural in a tomb in Xiaoyi, Shanxi Province, seems to indicate that shadow theater might have been alive in certain areas during this period. The mural dates to 1298 and depicts a scene of family activities: some people are farming while small children play with shadow puppets (Kong 2002, 165–66). In the Ming Dynasty (AD 1368–1644), private patronage of shadow theater was clearly on the rise. Rich families invited shadow troupes to perform at their private residences to celebrate important family events or serve the ritualistic needs of thanksgiving or prayers. These continued in the Qing Dynasty (AD 1644–1911). The late Qing and early Republican (AD 1912–49) eras, right around the time when many of the puppets in The Field Museum's collection were purchased, saw the beginning of a general decline of the shadow theater. However, according to Jiang Yuxiang's study, the form enjoyed another brief rise in popularity as an urban entertainment in theaters and other public venues before it rapidly lost its appeal in the 1920s in the face of the soaring attraction of other forms of popular entertainment such as cinema (Jiang 1999, 128).

Shadow theater experienced another revival under the cultural policies of the People's Republic of China in the 1950s and early 1960s. At that time, it was primarily advocated as a form of children's art (copying the Soviet model of puppetry as children's theater). During those years, a systemic reform and "sanitization" movement was also underway as part of the opera reform campaign, during which many old elements that smacked of "superstition" or eroticism were prohibited, while new plays were made to embrace the shadow theater's new image as an art form for the children of the People's Republic. Some of today's popular children's shadow plays, such as *The Tortoise and the Crane*, are directly imitative of the Soviet puppet theater during this period. *The Tortoise and the Crane* was created in 1952 by two puppeteers: He Derun and Tan Degui. They were inspired by the work of a Soviet delegation of puppeteers that visited Hunan in 1952, especially the performance of Sergey Vladimirovich Obraztsov (1901–92) (Jiang 1999, 159–61). However, during the Cultural Revolution (1966–76), shadow theater was banned along with many other folk art forms. The puppets were burned and the performers persecuted.

We should note that shadow theater has a long history in many parts of China, such as Shaanxi, Gansu, Qinghai, Sichuan, Hubei, Hunan, Guangdong, and Fujian Provinces, among other regions, and the styles and conventions vary. The Museum's collection is composed primarily of the puppets that Laufer secured during the Blackstone Expedition to China in 1908–10 (Polikoff 1954). Many of the shadow puppets on display were purchased by Laufer in Sichuan. Shadow theater scholar Jiang Yuxiang points out that many of these puppets bear the characteristics of Sichuan shadow theater, as Sichuan puppets tend to have a high and full forehead, and a round facial profile, in contrast to the more angular shapes often seen in northern Chinese puppets (Jiang 1999, 377).

Construction and Performance

Although today shadow theater is known for its puppets cut out of animal skin, it is believed that parchment is a later development from the earlier use of paper materials, or even plant leaves (Li 2013, 62). To make a leather puppet, the first step is to treat the animal skin until it reaches transparency by soaking it for a week or two in either clear water or a lime solution, then scraping it clean and stretching the skin to dry in the shade. The next step is to draft the carving plan for the shape of the puppet onto the skin with a needle, and then the pattern is carved out with knives and other tools. After buffing and polishing, the next task is the application of color, usually on both sides, traditionally with black, green, red, and yellow dyes. After drying, the puppets are varnished with tung oil. Finally, the artisan connects the parts of each figure together and installs controlling sticks. Usually the body of a human figure is joined at the shoulders, elbows, wrists, and knees using knotted thread and controlled by means of wires attached to the neck and the tip of each hand. Often the head, called *toucha*, is detachable; the body is called *yingshen* (shadow body). Human or synthetic hair is added to certain characters,

such as Zhang Fei for the story of Three Kingdoms, a character known for his unruly facial hair. Some puppets (in Lufeng and Taiwan, for example) are given fabric sleeves (Deng 2009, 29).

Given the popularity of the operatic theater, puppets made during the late Qing often were given costumes similar to those on the operatic stage, and they followed the conventions of stock roles from operas. Shadow puppets were made to resemble operatic makeup, although shadow puppets are mostly in profile. (Some are three-quarters; very few are frontal.) Young characters' faces are usually hollowed out with lines indicating eyes and other features, while clowns and "painted faces" (*jing*) are usually uncarved but painted with colors. As in opera, the moral merits of the character are often indicated in the facial features and the clothing.

The shadow theater includes not only movable human figures and animals, but also intricate and spectacular landscape settings (*jingpian*) as well as interior decor and prop pieces (the pagoda piece in the White Snake ensemble is a good example). Large set pieces are usually carved as one whole piece. In performance, they are propped against or pinned to the screen, as they are static and do not need manipulation. On the traditional opera stage, the environment is often suggested by stylized movements and the narration of the actors rather than directly represented as backdrops. Shadow theater, however, usually creates the actual set on the screen.

All these pieces are organized, stored, and carried in a trunk, or "shadow chest" (*yingxiang*). A Song work titled *Baibao zongzhen* described a trunk that contained more than a thousand head pieces and hundreds of sets of puppets, all neatly

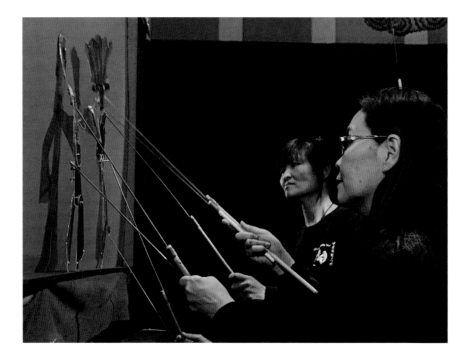

organized in one trunk (anonymous, cited in Jiang 1992, 77). The trunk often includes special features and sometimes doubles as an expedient stage (Zhang 2010, 50).

During a performance, a white, scrim-like screen (*yingchuang*) is set up to separate the spectators and the performers. The size of this screen varies, and it is made of a rectangular wooden frame and a piece of white silk, cloth, or paper that allows light to pass through. (Shadow theater is usually performed at night, although there are troupes that play during the day as well [Chen 2007, xvi].) An oil lamp is hung between the screen and the performer to avoid projecting the performer's shadow. Traditionally the lamp was made with a big container of clear oil and several wicks; however, it has been replaced by fluorescent lights at the top of the screen in contemporary performances. Wires behind the screen allow the performers to hang the puppets in order, organized in a way to facilitate speedy changes. The performance only takes about three to five people, and sometimes even a single person can produce a show (fig. 155).

In the Qing Dynasty, Zhou Yuanding in his *Yingxi yang xiaozi zhuan* vividly described the performances in Shaanxi's Sanyuan County:

> When the performance starts, one person makes the voice for many. Two hands can save lives, conduct war, make the figures enter and leave, kneel down and bend backward. . . . Spears, knives, swords, all sorts of weapons, fight in a dazzling way. Meanwhile, immortals, monsters, dragons, fish, tigers and leopards appear and disappear, form and transform. . . . The apprentices are three or four, playing instruments, improvising with the story. (Cited in Li 2013, 73)

Genevieve Wimsatt also provided an account of a courtyard performance she witnessed in Beijing in the early twentieth century, in which the shadow show differed very little from the Qing accounts even though its clientele and setting belonged to a markedly different social class (Wimsatt 1936).

Shadow Theater as a Religious and Ritualistic Space

The shadow theater trade has its patron gods and creation lore. Some revere the god called Laolangshen, often taken to be the Tang emperor Ming Huang (r. AD 712–56), who was thought by his adherents to be the first patron and inventor of the theater. Others attribute the creation of the theater to the Han emperor Wu (r. 141–87 BC), who allegedly resorted to the powers of a necromancer to summon Lady Li, a favorite concubine, back from the dead using shadows. A similar story was recorded in *Records of the Grand Historian*, Sima Qian's (c. 145–86 BC) *Shiji*, *Xiaowu benji*, which was cited also by Laufer in his writings on the shadow theater and the collection now housed at The Field Museum. Treating this legend as lore connected to the shadow theater, Laufer wrote, "The shadow figures . . . were the shadows or

souls of the departed, summoned back into the world by the art of professional magicians. This conception of ancestors as shadow-souls is so characteristically Chinese that it goes far to prove the priority of this performance in China. Its inception, therefore, is purely religious and traceable to spiritistic séances" (Laufer 1923, 37). There are contesting views as to whether or not the necromancer's trick "performance" in this story should be understood as a "shadow play" or "shadow witchcraft" (Jiang 1999, 61–63). Chen Fan Pen, for instance, examines the popularity of this story among those who wrote about Chinese shadow theater and suggests that it is rather an imaginative stretch to misconstrue the original story, in which the love-stricken emperor is merely shown a woman circling behind a curtain, that is, as shadows being projected onto a screen (Chen 2007, 25); however, Laufer is acute in his observation of the religious and spiritualistic elements in shadow theater.

Yet another popular story about a patron god attributes the origins of the shadow theater to Guanyin, the Bodhisattva of Mercy. Guanyin is said to have either preached a sutra through the aid of shadows or saved a town from peril by conjuring a shadow performance in the air, attesting to a strong Buddhist connection in shadow theater. Historically, Sun Kaidi suggests that the "transformation" expositions expounded by Buddhist monks at nighttime were the origin of the shadow theater (Sun 1953), whereas Weng Ouhong claims that during the Tang Dynasty shadow figures were used to elaborate and spread religious concepts, specifically citing the term "proselytizing by hanging shadows" (*xuanying xuanjiao*) (cited in Chen 2007, n. 108).

However, judging from the shadow theater tradition practiced today, there are few explicitly Buddhist traits. Instead, the shadow theater is overall marked by a mysticism and ritualistic reverence that is difficult to attribute to a single religion, but is best described as popular religion or, in the words of A. W. Barber, the "polymorphous Chinese spiritual culture." On the religious aspect, Chen Fan Pen's book is the most informative in the English language. She emphasizes the liturgical function of the shadow theater and argues that "popular religion informs the traditional shadow theatre . . . and shadow theatres served a primarily religious function in the countryside" (Chen 2007, 15).

The apparatus of shadow theater lends itself easily to mysticism. The performance takes place during the night, with an illuminated screen to set itself apart from the darkness, and the puppets come alive, enchanting the audience with a vision of the threshold between animate and inanimate. The oil lamp is an ideal light source because of the flickering effect that heightens the mystery on the screen. (Sometimes the oil fire will even be blown around to create atmosphere [Zhang 2010, 44].) The plays are often stories of immortals, visions of hells, or tales of the supernatural prowess of warriors and monsters.

However, more than an enchantment with a thrilling promise to glimpse into the world beyond, shadow theater is also attributed supernatural agency. In the

Zhejiang area, where raising silkworms is an important trade, families would hire shadow troupes for *canhuaxi* (silkworm plays) to pray for a good harvest. Families who have recovered from illness will hire a performance to thank the gods, called *huanyuanxi* (vow fulfillment play). To start construction of a new house there will be a *shangliangxi* (setting the roof beam play), and a child reaching his first birthday will have *zhousuixi*. During a funeral, when the surviving family keeps vigil beside the coffin for a night before internment, a shadow performance is often set up for the wake. Shadow theater therefore functions as a ritual of prayer and thanksgiving, providing a channel between humanity and gods. Even during performances that are not clearly designated for an occasion, a traditional performance starts and ends with blessings, prayers, and incense burning. The actual shadow theater for shadow plays often looks like a temple (Deng 2009, 23). According to the customs in many regions, the stage needs to be open to the nearest temple altar, indicating that this performance is made for the enjoyment of the gods. In private homes, the screen will face the front gate. These conventions and rituals create in shadow theater a special space of sanctity, preparing for the ritual playlets where "actual" deities such as the Eight Immortals arrive at the performance.

In some areas, shadow theater itself is even thought to have power to ward off evil. In Lufeng, Guangdong Province, shadow theaters are used as *daochang* (sites of religious activity) to drive away evil spirits, exorcise, and heal. The opening ritual for the performance involves sprinkling chicken blood, spreading rice, and installing talismans, therefore creating a "clean" and uncontaminated space. For this purpose, a puppet that has supernatural power and inimitable prowess, usually the figure of the Monkey King (Sun Wukong) from the story *Journey to the West*, will be used to perform the act to fight away evil, with loud gongs and other percussion music (Zhang 2010, 55). The performers in fact also work as community shamans, performing *fengshui* and other services (Deng 2009, 49).

Why is shadow theater considered to have these healing effects? One of the explanations dates back to the original lore and highlights the concept of shadows. Because shadows are associated with the spirit or soul of living people as well as with the dead, a play of shadows becomes the perfect threshold to connect the living and the dead. The deceased Lady Li, the beloved concubine of Han Wudi, for example, can be temporarily summoned onto the screen through these shadows. Another bit of lore tells of a colicky baby prince who lost his soul due to nightmares but regained it through the palace ladies' performance of shadow plays. According to Liu Jilin's study, Hebei and Beijing performers believe it was one of the Han princes who was colicky as an infant and could only be soothed by shadows on the floor. Therefore, the palace ladies invented shadow theater to entertain him and heal him (Liu 2004). Today there are areas where a shadow puppet, usually one of the Monkey King, will be given to a sick child and hung behind the bed curtain with the same hope of warding off evil spirits and summoning back a lost soul (Li 2013, 379).

J. J. M. De Groot in *The Religious System of China* also wrote about how the Chinese avoid casting their shadows over a coffin, fearing that the living person's spirit will be sealed with the dead (De Groot 1901, 83–88). In the nineteenth century, anthropologist Edward Burnett Tylor ([1871] 2010) described how many different cultures associated the shadow with the soul. Tylor's explanation of animism as the primitive form of religion notes it is a common belief among animists that when one is asleep, the soul has left the body temporarily, and if dead, permanently. The story of Lady Li is an example of how shadow and the soul (*hunpo* in Chinese) have been connected. Han Wudi might have lost the lady, but the magicians can summon back the shadow, or soul, temporarily.

Shadow theater is thus treated as the mediating space where the dead and lost souls can find their way back. Shadow is in itself a thing existing in between the real and the unreal: it is connected to the real, yet it has no substance of itself. In a way, the shadow is very much like the concept of the human soul. Soul is not tangible substance itself, yet it is also immanent in and reliant on the body. The body is the master of the soul; the body is also the master of the shadow.

The Communal Theater of the Non-Elite

There is a popular notion in the West that Chinese shadow theater is private theater for secluded women in the big houses of the rich. This perception is largely owing to Genevieve Wimsatt's description of her experience with such a performance in Beijing in the early twentieth century. However, in truth, private performances constitute only a small portion of shadow theater culture, while the majority of the performances take place in the vast countryside, where peasants, male and female, adult and child, all enjoy the theater as a communal event.

The simplicity and mobility of the shadow theater is probably both a cause and result of its popularity among peasants in the countryside. With a few performers (sometimes just one) and one or two trunks, there is no call for elaborate setup or demand for facilities. Because of this, and because the cost is low compared with a human-actor theater troupe, shadow theater can reach the most remote and poorest regions. The ritualistic and supernatural function is also woven firmly into the fabric of the almanac year of the peasants. Traditionally, with the exceptions for "rain-praying plays" or "locust plays" during the busy months, shadow theater is put on during the free times of the agricultural calendar, due to the needs of both the performers (who are also farmers) and the audience. The traveling troupe starts the first season usually on the first day of the lunar New Year, and returns home to harvest during the fourth month. They go out again after the busy field work is finished. A year typically includes several such theater "seasons."

Performances are requested for wedding banquets, birthdays, and funerals, among other domestic occasions in the countryside. But shadow theater is also brought in as a more affordable substitute for human-actor theater to perform

civil and agricultural functions: to appease the god of earth, pray for rain, ward off evil spirits, and ensure a good harvest. In the sixth month, many areas will invite troupes to perform "locust plays" to appease the god of insects in hopes of a locust-free season. These are usually performed on an expedient stage in the fields, sometimes by the peasants themselves with homemade puppets (Chen 2007, 45). In Lufeng, a Big Head Kan puppet will appear before the main performance, or during intermission, to provide a comic short act and issue community notes and edicts, such as "Do not steal the sugar cane" (Deng 2009, 78). The performers are often noted for their quick wit and improvisation in connecting the story with current affairs.

Although many performers learn the trade to earn a living, payment for shadow theater varies widely, according to the investigations and interviews conducted by Li Yuezhong. In Hunan's Liuyang, in the 1940s, one performance earned four *sheng* (metric liters) of rice, several Chinese dollars (*yuan*) in the 1970s, and up to thirty *yuan* in the 1980s (Li 2013, 427). But in Shaanxi Province, in the early twentieth century, a performance could earn forty *dayang* (silver dollars) a day, incentive enough for performers to give up farming entirely to devote their efforts to the theater (Jiang 1999, 254–57).

Traditionally, shadow theater performers, and most of their audiences in the countryside, were not educated, and many were even illiterate. They learned their scripts by oral transmission and memorization. The performances, therefore, are often at their most exhilarating with tales of fantastic history and lore, love stories, and supernatural tales, reaffirming the rich deposit of oral culture that has been passed down from generations past. Although shadow theater serves the important function of communicating with deities, it is also an immensely enjoyable popular entertainment. And The Field Museum's sets of puppets from *The Journey to the West*, *The Eight Immortals*, and the *Legend of White Snake*—some of which are exhibited in Gallery 4, "Beliefs and Practices, Symbols and Stories," of the *Cyrus Tang Hall of China*—are salient reminders of this fact.

The Eight Immortals are a group of figures from Chinese Daoism and popular religion (see Copp, this volume). The cast normally includes Li Tieguai, Zhongli Quan, Lü Dongbin, Zhang Guolao, He Xiangu, Cao Guojiu, Han Xiangzi, and Lan Caihe, with slight variations in the list according to different regions and different historical periods. In the legends, these eight were once mortals but reached immortality in their colorful lives, and each has his or her own iconography also seen in paintings, New Year's prints, textiles, figurines, and other forms of art. Zhang Guolao is based on the story of Zhang Guo, and often portrayed as an old man with a long, silver beard (fig. 156); Lü Dongbin appears as a middle-aged Daoist priest with black hair (fig. 157); and Zhongli Quan is depicted as sporting two buns on his head with a ruddy complexion and big eyes to suggest his unruliness and eccentricity (fig. 158). (Because the heads are usually carved separately and different heads might share the same body, the identifying features of a character are often

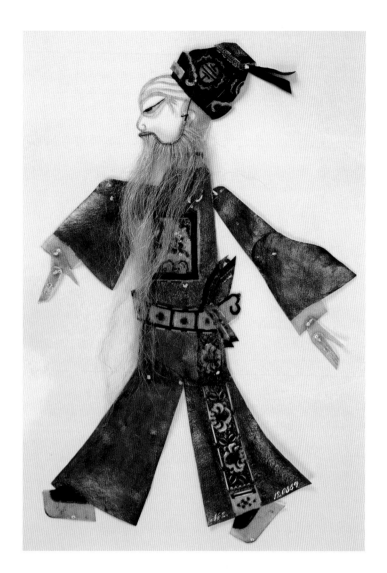

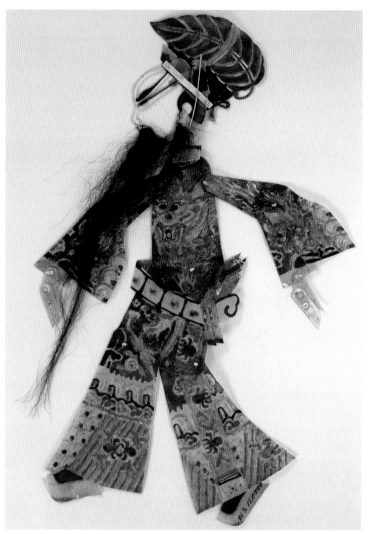

focused on the heads in shadow theater.) The set of wooden figures of the Eight Immortals displayed in the fourth gallery of the exhibition reflect very similar iconography. Zhang Guolao wears his folded hat with a small triangle in the front and appears to be a genteel elderly man (fig. 159); Lü Dongbin appears chivalrous in his signature accordion headwear (fig. 160); and Zhongli Quan bares his chest, exhibiting martial prowess (fig. 161). They are beloved figures among the Chinese populace, because they seem to be straddling the two worlds: they are immortals, yet they are also full of humanity and not too unlike ourselves. Lü Dongbin is a womanizer, while Tieguai Li loves his wine.

The Eight Immortals is usually considered an auspicious play to be performed as an opening play, particularly during birthday celebrations, when the Eight Immortals will appear to offer their benediction for the birthday person (baxian qingshou), a tradition based on the story of the Eight Immortals' annual trip to the Queen Mother of the West to celebrate her birthday. According to Chen Fan Pen's study,

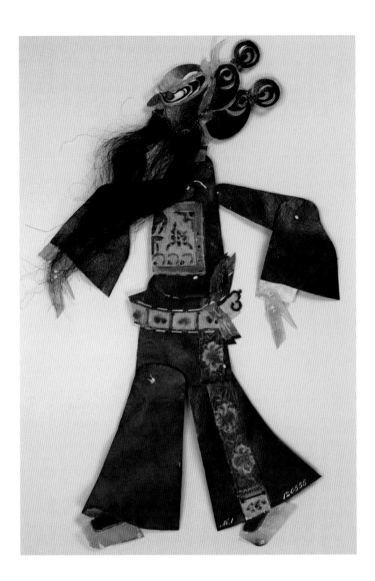

there are Daoist troupes in Lingbao, Henan, whose instruments represent objects associated with the Eight Immortals. For instance, one of the musicians would play a bell-like *shuizi* associated with He Xiangu (Chen 2007, xviii).

Besides being an integral part of the popular and plebian religious culture, shadow theater also enthralls its audience with dazzling spectacle and "special effects," and with enchanting love stories that traverse the worlds of men and gods. The *Legend of the White Snake*, a highly popular shadow play in all regions of China, is a spectacular story in the oral literature tradition that has captured the Chinese imagination for centuries, at least since the Song Dynasty. The most popular version of the story is centered on Lady White Snake and her attendant, Lady Green Snake (or Blue Snake in some versions), both creatures who can transform themselves into human likenesses. White Snake falls in love with Xu Xian (or Xu Xuan), a mortal, and marries him. However, Xu accidentally sees the snake form of his wife and is literally scared to death. To revive her husband, White Snake

FIGURE 159
Zhang Guolao. Wooden figurine with silver inlay. © The Field
Museum. Photo ID No. A115118d_001B. Catalog No. 127938.
Photographer John Weinstein.

FIGURE 160
Lü Dongbin. Wooden figurine with silver inlay. © The Field
Museum. Photo ID No. A115119d_003B. Catalog No. 127939.
Photographer John Weinstein.

FIGURE 161
Zhongli Quan. Wooden figurine with silver inlay. © The Field
Museum. Photo ID No. A115117d_003B. Catalog No. 127937.
Photographer John Weinstein.

(who has taken the human name Bai Suzhen) battles her way through the celestial realm to steal a magical herb, and eventually Xu is saved. However, the monk Fahai, who had a feud with the Snake in his previous life, keeps Xu captive in his Jinshan Temple. The two snakes therefore use their magic to flood the temple. Xu later escapes and is reunited with his pregnant wife, who gives birth to a son. The indomitable Fahai, however, eventually finds White Snake and captures her under Leifeng Pagoda (the Pagoda of Thunder Peak), an actual structure beside the West Lake in Hangzhou. The story ends with the son attaining the highest degree in the imperial examination and rescuing his mother from her prison. (For an English translation of the story, see Idema 2009.)

White Snake is very popular in its other theatrical forms; however, the shadow theater has its own inimitable attractions, and in many ways this play showcases perfectly the powerful art that shadow theater is. It is often performed during *Duanwujie* (the Dragon Boat Festival), the day when White Snake supposedly showed her true form to Xu. It not only brings the community together, marking an important day on the rural calendar, and relating an affecting love story; it is also a great vehicle for dazzling "special effects." Like other popular plays, the story includes many scenes of transformation and fights in fantastic settings. White Snake's transformation, and many other transformations between the characters' "true form" and human form, can be achieved believably on the shadow screen through the agile switching of figures; the spectacular vistas of the celestial realms are realized through the employment of elaborately carved set pieces. Smoke can be blown across the screen to create the illusion of characters flying in clouds. Flood scenes are rendered by shaking a piece of translucent fabric on the screen. The monk's magical gourds fight with the Snakes' enchanted swords in midair. Heavenly hosts appear on the wind at an incantation. Figures move with breathtaking and surreal speed in their fights. And the Leifeng Pagoda, which is included in The Field Museum's set, can actually be seen falling onto the White Snake (figs. 162 and 163). In the key scene when the hot-tempered Green Snake burns the Leifeng Pagoda, carbon sticks are used to create lightning and thunder; special flammable powder is used to create smoke and fire, carefully controlled to avoid ruining the screen; the bricks and tiles, all in separate pieces, are assembled and dismantled to create the burning effect (Zhang 2010, 266). (In contemporary performances, however, one might see more image projections on the screen than these traditional sleight-of-hand techniques.) (For a clip of the fight between the two snakes and the Monk Fahai, see http://v.youku.com/v_show/id_XMjkyMTcxMDk2.html.)

Jiang Yuxiang, a shadow theater expert who is particularly knowledgeable about the Sichuan shadow plays, provides us a detailed study of the play *White Snake* in Sichuan shadow theater. (The Field Museum has a fine White Snake figure collected from Sichuan currently included in the exhibition [fig. 164].) His study provides an example of how shadow theater flourishes on its own, departing from conventional literary sources. In the Sichuan shadow theater version of the narrative, according to Jiang Yuxiang's record, the two women are especially fiery

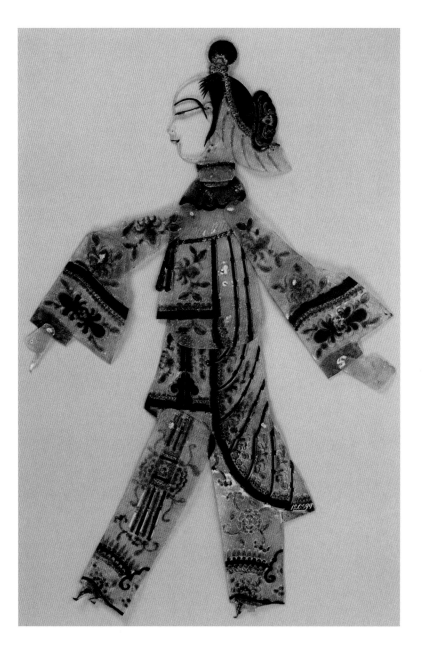

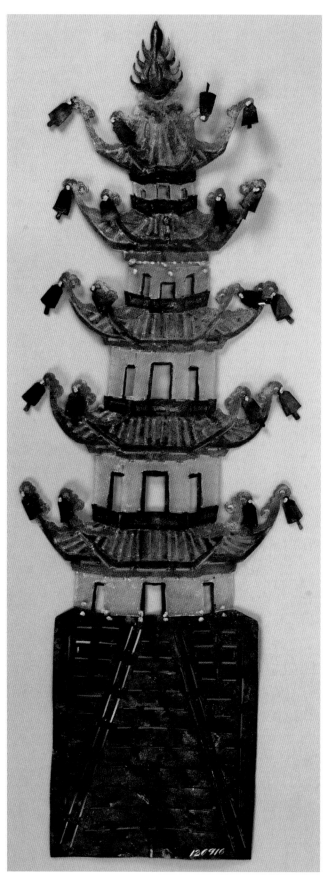

FIGURE 162

Lady White Snake. Shadow puppet, painted parchment. Late Qing, Sichuan, China. © The Field Museum. Catalog No. 120899. Photographer Gedi Jakovickas.

FIGURE 163

Leifeng Pagoda. Shadow puppet, painted parchment. Late Qing, Sichuan, China. © The Field Museum. Catalog No. 120916. Photographer Gedi Jakovickas.

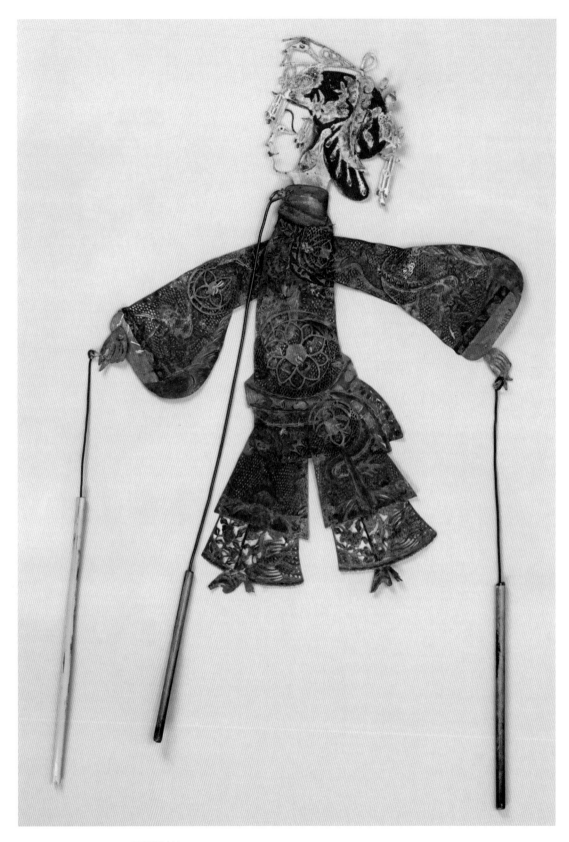

warriors, one out of her passion, and the other, her loyalty. An exhilarating scene shows that when White Snake is imprisoned in Leifeng Pagoda, Green Snake continues her sister's vengeful mission all the way to the Buddha's temple in heaven. When the Buddha refuses her demands, she chops off his head. Undaunted by the Buddha's power to regrow a head each time, she repeats the chopping act three times, and finally decides to strip off her own clothes in hopes of breaking him with the "obscenity" of the female body (Jiang 1999, 358). We can imagine the spectacular performance on the shadow screen with such gripping scenes of quick and dazzling violence as the Buddha's head rolls off and the angry female warrior bares her chest.

Even during the national drama reform period of the 1950s, when superstitious content in theater was under strict scrutiny, White Snake and the Monkey King survived, despite the effort to "revise" and cleanse. As Mei Lanfang wrote in 1954, *White Snake* was revised by the Ministry of Cultural Affairs: "Inexperienced revisers with a dogmatic, unhistorical and unrealistic approach changed the snake-spirit in the *White Snake* into an ordinary girl." However, the revision was rescinded immediately, because it simply did not work (Polikoff 1954, 4). The People's Republic of China's campaigns against superstition and pornography were not the only, or even the first, censure from a cultural or ideological elitism that shadow theater endured. But it seems the basic appeal of the "low-brow" or the "backward and uneducated" survived most of the reform, especially if such revisions failed to capture the imagination of the audience.

Between Reality and Illusion

Chinese shadow theater seems to be at its most brilliant when relating fantastic tales and legends that bridge this world and the unseen realms. Because shadow theater often depicts stories of immortals and gods, people believe that the puppets themselves can be a channel for supernatural power (Deng 2009, 61). In some areas, this power is attached even to the cloth screen due to the fact that thousands of these gods have appeared on it. The cloth is therefore used to make outfits for children in order to ward off evil (Li 2013, 427). The shadow puppet of the Monkey King is accorded a special place of honor in the shadow trade, and some believe that one nickname for shadow theater, *pihou* (leather monkey), comes from the unfailing presence of *Journey to the West* in the shadow theater repertoire (Deng 2009, 66) (fig. 165). Not only can a Monkey King puppet be used to protect a child from nightmares; it is also revered by the troupe as a supernatural presence in the trunk, put in a premium space and handled with great care.

On the other hand, it seems that shadow performers are very aware of the materiality of their theater. As in human-actor theaters in China, where the audiences are constantly reminded that what is shown on stage is "unreal," the shadow theater also highlights the fact that all these dramas and excitements on the screen are but illusions. The screen is the fragile barrier between the enthralled audience

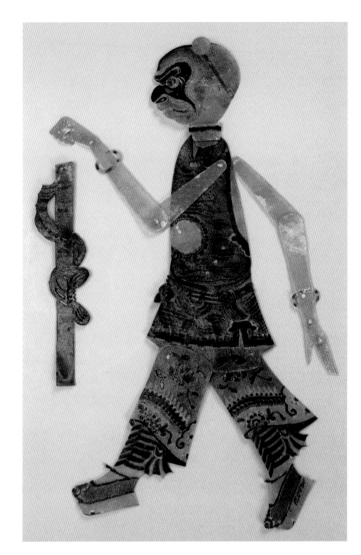

FIGURE 165
Monkey King (Sun Wukong). Shadow puppet, painted
parchment. Late Qing, Sichuan, China. © The Field
Museum. Catalog No. 120930. Photographer Gedi
Jakovickas.

FIGURE 166
Screenshot from *To Live*. 1994, Director Zhang
Yimou.

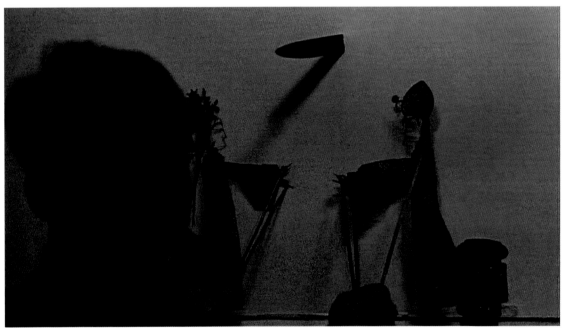

and the laborious acrobatics of the performers. Therefore, when the temperamental You Sanjie in *Dream of the Red Chamber* warns the slick dandy Jia Lian not to fool her with florid talk and lies, she sneers at him with the popular saying, "If you bring a shadow puppet to the stage, make sure you don't rip the paper screen." According to Deng Qiying's study, in the Lufeng *piying* tradition, at the end of the performance, a clown puppet called Big Head Kan will poke open the paper screen and announce "The End" (Deng 2009, 29). Such a shocking "end" by penetration is also seen in Zhang Yimou's film *To Live* (1994), a film centered on a peasant shadow theater artist, except that, in the film, it was the presence of war in the form of a bayonet violently piercing the screen (fig. 166). The broken screen announces the end of this suspension of time and this special space reserved as the threshold between the realm of now, the present and real, and that of the unknown and the inaccessible.

Note

I would like to thank Lisa Niziolek and Deborah Bekken for their assistance in the writing process.

Crossing Boundaries, Building Networks

10

The Silk Road: Intercontinental Trade and the Tang Empire

Lin Meicun and Ran Zhang

Introduction

The beginning of trade between China and Central Asia cannot be well dated. Yet there is no question that economic and social relationships between these areas had developed long before the westward travel of Zhang Qian (200–114 BC), who, in the second century BC, was the first Chinese imperial envoy to the world outside of China. When he returned to China with the first reliable information about the so-called Western Region 西域 (today's Central Asia), the transcontinental trade between Han China (206 BC–AD 220) and the Western Region had been officially established. The routes along which this trade ran are now known as the Silk Road. In addition to trade, manufacturing techniques, religions, and cultural arts have been exchanged along this route for many centuries. This long-term economic and cultural prosperity might be one of the most important reasons that China has not vanished, as many of its ancient counterparts have done throughout history. In recent decades, following many excellent studies on the Silk Road (Lin 2006,

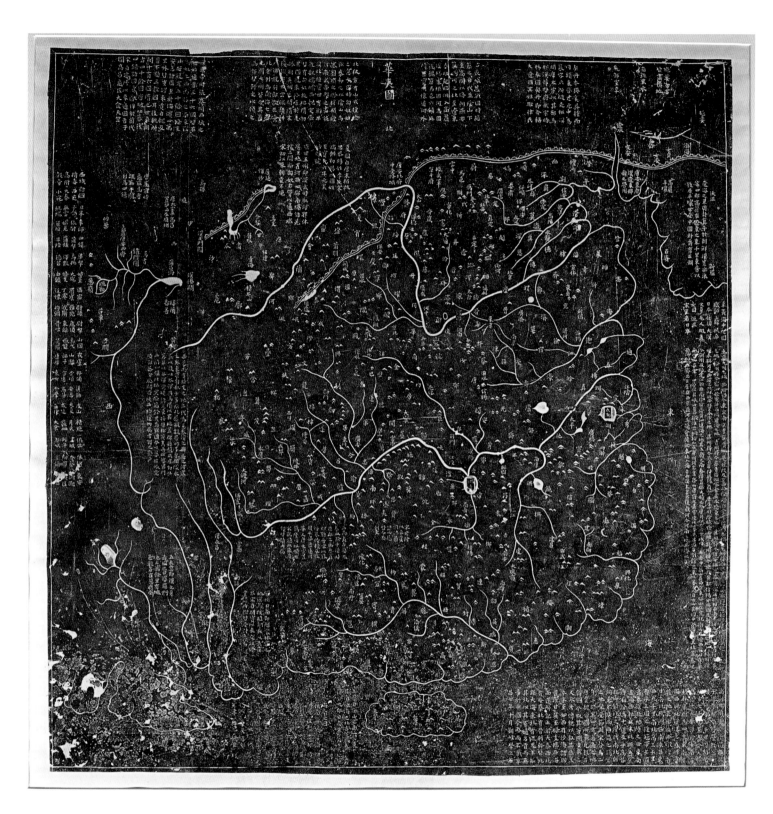

FIGURE 167
A map rubbing of Hua Yi Tu 华夷图. © The Field Museum.
Photo ID No. A115162d_002. Catalog No. 245522.
Photographer Karen Bean.

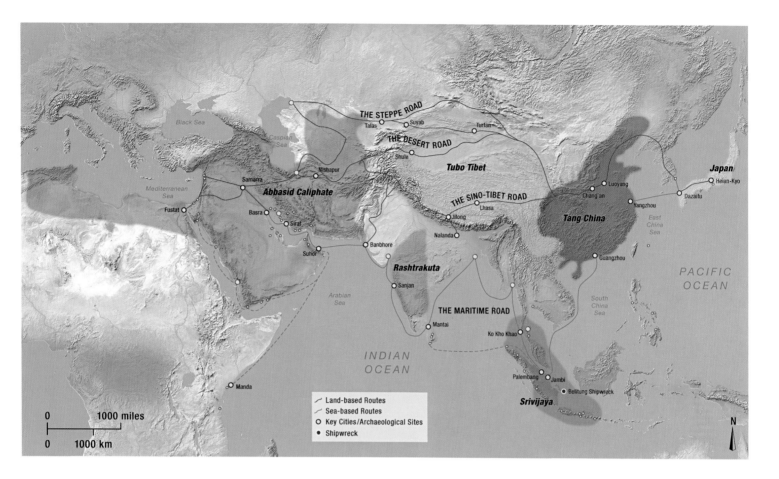

The map labels, reading across the image:

Black Sea · Caspian Sea · THE STEPPE ROAD · Talas · Suyab · Turfan · THE DESERT ROAD · Shule · Tubo Tibet · Japan · Luoyang · Heian-Kyo · Nishapur · Chang'an · Dazaifu · Samarra · Abbasid Caliphate · THE SINO-TIBET ROAD · Yangzhou · Mediterranean Sea · Fustat · Basra · Lhasa · Tang China · East China Sea · Siraf · Jilong · Nalanda · PACIFIC OCEAN · Suhor · Banbhore · Guangzhou · Rashtrakuta · Sanjan · South China Sea · Arabian Sea · THE MARITIME ROAD · Mantai · Ko Kho Khao · INDIAN OCEAN · Manda · Palembang · Jambi · Belitung Shipwreck · Srivijaya · N

Legend:
- Land-based Routes
- Sea-based Routes
- ○ Key Cities/Archaeological Sites
- ● Shipwreck

0 1000 miles
0 1000 km

FIGURE 168

A map of suggested trade routes in Eurasia in approximately the late eighth century. © The Field Museum. Illustrator David Quednau.

2011; Xinru Liu 2010; Waugh 2007, 4; Wood 2004), it has been seen that the Silk Road developed and expanded in the *longue durée* from prehistory to the fifteenth century.

The Tang Dynasty (AD 618–907), during this long term, was an era when the leaders of China had significant political clout both at home and abroad, while great cultural innovations and advances took place. A rubbing made during the Song Dynasty in 1136 from a map based on the work of Tang geographer Jia Dan (AD 801) illustrates China's geographic territory and political divisions (fig. 167). It includes the names of neighboring nations and indicates that Tang China had already become the center of an East Asian world linked by economic and political activities.

This economic and political boom of Tang China allowed the Tang Empire, which was linked to Japan to the east and the Islamic world to the west, to develop trade further into four major routes, including the maritime route via the Indian Ocean (Qin 2013; Whitehouse and Williamson 1973; Zhang 2013). Consequently, the period from the seventh to ninth centuries has been seen as a golden age of trade between China and the rest of the world.

Following recent archaeological finds and studies, this chapter introduces the trade routes that linked Tang China to places far beyond its borders. The Tang Chinese Silk Road primarily consisted of the Steppe Road, the Desert Road, the Sino-Tibetan Road, and the Maritime Road (fig. 168). Each of these will be discussed separately, after describing the capitals of Tang China, which were the starting points of these trade routes.

Capitals of Tang China

Chang'an City (present-day Xi'an City in Shaanxi Province) was the old capital of the Sui Dynasty (AD 589–618) and continued to play an important role under Tang rule. It was one of the most important starting points of the trade routes from Tang China to other civilizations and became one of the most significant cosmopolitan cities at that time. The scale of Chang'an was huge, with an east-west span of 9.5 kilometers and a north-south span of 8.5 kilometers, giving the city a slightly rectangular form. The city itself contained an imperial palace, an imperial section with government offices, two markets (eastern and western), and a gridded and walled residential block (Fu 2001, 318; Lewis 2009, 86–88).

Chang'an functioned as an intercontinental center along the Silk Road, rather than merely a starting point. One set of archaeological finds in particular demonstrates this. Two large buried jars were found in the Xing Hua Fang block 兴化坊 in the residential area in the Tang-period remains of Chang'an. Within them were many jade wares, gems, silver ingots, and herbal medicines, as well as more than 265 pieces of gold and silver. It has been suggested that all these finds are the treasures from the Prince of Bin's palace 邠王府, whose owner, Li Shouli 李守礼 (672–741), was one of the grandsons of the Tang Emperor Gaozong 唐高宗 (Guo 1972, 2). Among these treasures, the most interesting finds are the gold and silver coins, which have been attributed to the coinages of the Eastern Roman Empire, the Sasanian Empire, and Japan (Chen 1984, 31–32; Guo 1972, 2). This discovery provides clues that Chang'an held an important "international" role. In addition, some of the gold wares have a shape similar to those of imported metal works from Central Asia, again suggestive of the region's cosmopolitan role (Sun 1996).

This intercontinental position of Chang'an is also supported by the presence of foreign merchants and ambassadors. With more than one million residents in Chang'an, many were the so-called Hu Shang 胡商, foreign merchants, although some became "permanent residents" as citizens of the city (Xiang 1979). The historical records show that the hospitality policies toward Hu Shang merchants, from countries such as India and Persia, included providing them with free food for six months (Pu Wang 1955, vol. 100). Moreover, one of the paintings in Prince Zhanghuai's tomb 章怀墓 shows foreign ambassadors from the Eastern Roman Empire, Korea, Siberia (proto-Mongolian), and other counties, identifiable by their different traditional garments, being received by three Tang Chinese officers (Lin 2013, 2) (fig. 169).

Chang'an was also very open in many other aspects, such as religion and foreign communications. Temples established for Buddhism, Daoism, Confucianism, Zoroastrianism, and Nestorianism can all be found in the city. Temple steles unearthed from the city confirm this rich diversity of religions (Lin 1995; Rong 1998). A good example of cultural exchange can be seen at the Ximing Si Temple site 西明寺遗址 (An 1990), where Japanese monks lived and were inspired by Chinese architecture to design Japanese temples in the eighth century (An 2000).

As important as Chang'an, the city of Luoyang (present-day Luoyang City in Henan Province) was the secondary capital of Tang China, and it was built at the previous eastern capital site of the Sui Dynasty. Luoyang shared structural features with Chang'an, with the imperial palace and imperial city walled off from the residential area, and the use of a gridded plan. There were three markets in Luoyang, all situated with access to water transport by rivers and canals (Lewis 2009, 100–101). Foreign merchants were settled together near the southern market (Chengyong Ge 2009; Mao 2014).

As Chang'an did, the palaces and city layout and architecture in Luoyang also strongly influenced Japanese architectural traditions. For instance, the remains of the imperial palace in Luoyang gave inspiration to a similar layout of the octagonal pavilion at Eizan-Ji Temple in Nara, Japan (Fu 2001, 646). Outside the palace, a decorative monument called *Tian Shu* 天枢, or Heaven Center, was built by Persian and Sogdian settlers, as suggested by historical records and the dragon-shaped architectural decorations recently found in Xi'an (Lin 2012). All these features of Luoyang make it reasonable to suggest that the city, like Chang'an, was a well-developed cosmopolitan city situated near the beginning of the trade routes from Tang China to the rest of the world, via both land and water.

The Steppe Road

The Steppe Road was the earliest trade route between China and the west. Evidence for this comes from a Pazyryk cemetery in the north of the Altai Mountains, where different types of unearthed finds, such as bronze mirrors and silks, have been attributed to Chinese manufacturing during the Warring States period (c. fifth to third centuries BC) (Rudenko 1971).

For many centuries the Steppe Road was a strong link between China and the hinterland of Eurasia and was an important route through Mongolia and southern Russia. It is certain that Tang Chinese emperors maintained relatively stable protection along this road from the seventh century, and military troops were sent to conquer the oasis kingdoms in current western Xinjiang Province and northern Kyrgyzstan, which were opposed to Tang rule. By 659, the Mengchi Protectorate General 濛池都护府 had been established together with the *Jimi* system 羁縻制 to further control the Steppe Road (Sima Guang [1084?] 1956, vol. 200). The *Jimi* system refers to an administrative system of self-rule for foreign rulers or chiefs to naturalize them under the Tang Chinese court. Historically, the prefectures and counties belonging to the Mengchi Protectorate General were not clearly recorded by historical sources, but the territory was probably situated in present-day Kazakhstan and Kyrgyzstan, according to the records in *Travel to Central Asia* by Yelu Chucai in about the thirteenth century (Yelu 1997, 674).

Additional archaeological evidence can further develop this understanding of the western reach of Tang Chinese control of the Steppe Road trade routes. A

FIGURE 170
A section of a Tang Dynasty stele unearthed in the Burana ruin. Image courtesy of Nurlan Kenzheakhmet.

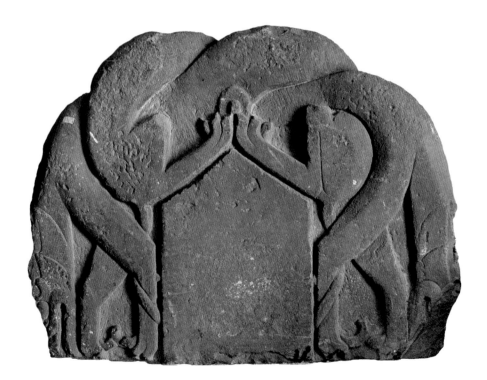

tombstone of Abraham, a Persian tribal chief and ambassador to Tang China, was unearthed in Luoyang City. The inscription reveals that a stele was set up on the western border of the area controlled by the Tang Chinese (Gharib 2004, 107; Lin 1995). This could be parallel evidence to confirm that the Burana ruin in Kyrgyzstan was located in the center of the Mengchi Protectorate General and of Tang Chinese protection of the Steppe Road. The inscription also suggests that this ruin might be the westernmost point of Abraham's travels because he erected such a stele to mark his final destination (fig. 170).

Stable control and protection of the Steppe Road by Tang China did not last very long, due to the rise of the Abbasid Caliphate in the west, as well as the decline of the Western Turkic Khaganate, which strongly controlled Central Asia until the early eighth century. Although one of the Turkic tribes that then occupied the Ili River in Kazakhstan founded the Turgesh confederation, which became an ally of Tang China (Jiang 1994, 123–29), conflict between China and the Abbasid Caliphate finally occurred in 751, at the so-called Battle of Talas River (fig. 171).

FIGURE 171
Landscape view of the Talas River.
Image courtesy of Lin Meicun.

This clash may have been because the two expansionist empires of the Abbasid Caliphate and Tang China grew enmeshed in complicated political conflicts. During the reign of the Tang Emperor Xuanzong (712–56), Chinese territory reached its maximum (Lewis 2009, 158; Park 2012, 191–92). Historical records cannot provide a fixed and reliable number of the Chinese losses during this conflict; however, it appears that no fundamental harm or destruction was suffered by the Tang Chinese military, political, and economic power inside China. This battle also brought about a positive, although limited, impact for the victorious Abbasid Caliphate, where it is simply recorded via the exaggerated description "decisive winning defeated Tang China" (Bartol'd and Bosworth 1988, 195–96; Tieying Ge 2003, 51). The loss of the Talas battle negatively affected the Tang Chinese geopolitical economy, and China's military power in Central Asia began to gradually decline, although the historical significance, impact, and details of this battle remain subjects of debate (Tieying Ge 2003, 51).

During the period from the late eighth to the early ninth century, Tang allies, such as the Turgesh and Uyghur Khaganates, both declined. The remaining Uyghur people relocated to areas in and near the cities of Qocho near Turfan and Kucha, which became the strong and powerful Uyghur kingdom, with a history spanning three hundred years (Gabain 1980).

The Desert Road

For many centuries, the Desert Road, as one of the major routes of the Silk Road, was mainly controlled by Sogdian merchants. These merchants created strong trade links and enabled cultural exchanges among China, India, and the Byzantine Empire. The Sogdian states were situated in the area between the Amu Darya and Syr Darya Rivers and included the fertile valley of Zeravshan. The Sogdian merchants had a long tradition of trading across Central Asia between China and the Western Regions 西域. Ancient Sogdian letters, discovered in the Great Wall remains dating back to the Han Dynasty at Dunhuang, have provided evidence that confirm that these trade activities occurred as early as the fourth century AD (Henning 1948; Sims-Williams 1996). After the sixth century, following the rise of the Western Turkic Khaganate and the decline of the Hephthalite Empire, Sogdian merchants were supported and controlled by Western Turks and monopolized trade on the Desert Road from China to the west. Because of the strong protection afforded the Sogdian traders, the Sasanian and Indian merchants found it hard to access this key trade route into China.

With the rise of Tang China in the seventh century, many attempts to control trade along the Desert Road were made by Emperor Gaozong (r. 649–83). During the period from 632 to 648, Tang Chinese control had expanded to the western area of current Turfan in Xinjiang Province. Architectural tiles made in Tang China unearthed from the ancient remains of Kucha are indicative that this area might have been under the control of the Grand Protectorate General to Pacify the West 安西都

护府 (Lin 2015) (fig. 172). During the second half of the seventh century, on at least four occasions, Tang Chinese governors, as well as ambassadors, who frequently traveled to the Western Turkic Khaganate, were sent to the Western Region to further exert China's influence on the Desert Road. At that time, Tang Chinese control of Central Asia had expanded as far as modern Kyrgyzstan and Afghanistan (Jinxiu Li 2005; Zongjun Li 2010).

This expansion in Central Asia enabled the Tang Dynasty's border to approach the Abbasid Caliphate of the Islamic world. Both communications and conflicts resulted following the rise of these two great empires on opposite sides of Asia. By 679, four Chinese outposts under the control of the Grand Protectorate General to Pacify the West had been established at Kucha, Suyab, Khotan, and Shule (Kashgar), in current western Xinjiang Province and Kyrgyzstan, with the aim of overseeing the security of the Desert Road. Evidence of trade and communications from the Abbasid Caliphate also can be seen by the many finely made Islamic glass dishes unearthed from the underground palace of Famensi Temple 法门寺地宫 in Fufeng County of Shaanxi Province (Han et al. 1988) (fig. 173).

In 755, the An Lushan Rebellion 安史之乱, a devastating attack against the Tang Dynasty, suddenly stopped Chinese expansion to the west (Lewis 2009, 42–43). Tang Emperor Xuanzong had to abandon Chang'an and flee to Sichuan Province in order to escape the violence (Lewis 2009, 43–44). This seven-year-long

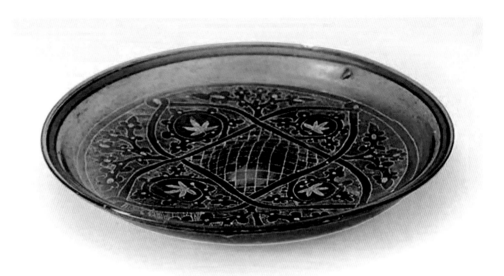

rebellion had a significant impact and badly reduced Tang Chinese power along the Desert Road (DeBlasi 2001, 7; Wei 1999, 53), while Chinese control of Central Asia was gradually lost to Tibet and the Uyghurs from 763 onward (DeBlasi 2001, 7; Franke and Twitchett 1994, 5–6; Lewis 2009, 157–58; Wei 1999, 53).

The Sino-Tibetan Road

There was a route that linked Tang China to India through the Tibetan Empire—the Sino-Tibetan Road. This route has been nearly completely forgotten due to the rarity of historical records mentioning it. Detailed information mainly comes from a cliff inscription dated to 658, which was found in northern Jilong County in Tibet. It describes a visit by the Tang Chinese ambassador, Wang Xuance, to India via the Tibetan Empire (Lin 2000) (fig. 174).

The Tibetan Empire, which existed from the seventh to ninth century, exerted control over the Sino-Tibetan Road. Its territory was larger than the Tibetan Plateau, stretching into other areas, including the Tarim Basin to the north and including parts of Gansu, Qinghai, and Yunnan Provinces to the east, and some parts of Central Asia to the west. In the north, some Tibetan forts have been discovered near the Miran oasis and the Mazartag Mountains in Xinjiang (Stein 1921, 1928). In order to defeat and maintain a good relationship with the Tibetan Empire, the Tang Chinese court sent military troops to control the Sino-Tibet borders and proposed (political) marriages with Tibetan chiefs.

An octagonal pillar of sandstone 石堡战楼颂碑 (catalog no. 121938) (fig. 175), on display at The Field Museum, reveals the competition between the Tibetan Empire and Tang China. The pillar was dug up in 1906 on a farm at the Yangba Village 羊巴古城 of Zhuoni County 卓尼县, close to Taozhou in south Gansu Province (Man Liu 2011), by a Qing Chinese member of the scholarly gentry named Zhou Zhaonan 周肇南, who was a convert to Christianity (Hai 1997, 800). He was the owner of the

stone and ceded it to Berthold Laufer on December 18, 1909. The inscription on this pillar describes the battle over the city of Shipu 石堡, or Shibao, an ancient Chinese stronghold on the Tibetan border, which had been taken by the Tibetans in the twenty-ninth year of the Kaiyuan era (AD 741). Historically, it has been recorded that the recapture of the city was accomplished by Geshu Han, who was a Tang Chinese general. The recovery of this stronghold was in June of the eighth year of the Tianbao era (AD 749) (Sima Guang [1084?] 1956, vol. 23). This date parallels the inscription on the pillar, which indicates that the sandstone piece was erected on July 21 of the same year, with the description of that "after thirty days [of the battle, the stronghold has been] reconstructed" 三旬而成 (Fan 1999, 18).

The most significant historical event between China and Tibet was when the Tang Chinese Princess Wencheng was given by Emperor Taizong to King Songtsan Gampo of Tibet in 641. Both religious and cultural communications between Tang China and Tibet were opened up, and it is believed that this was the beginning of the Sino-Tibetan Road, with Monk Xuanzhao recording that "thanks to Princess Wencheng, the way toward the Tibet Empire has no obstacle" (Bangwei Wang 1988, 10–19).

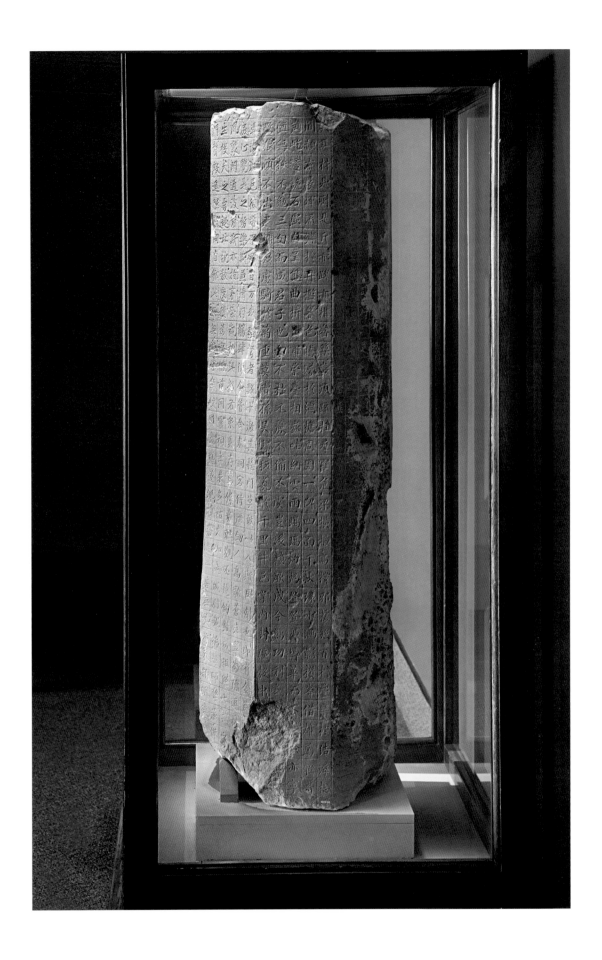

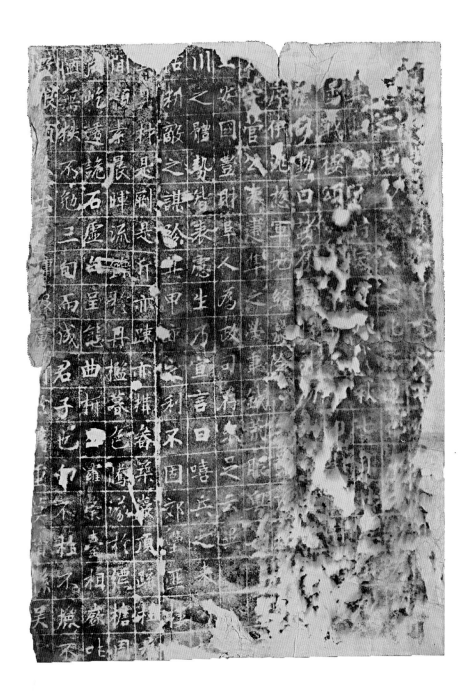

FIGURE 175

The octagonal pillar of sandstone and a rubbing of its inscription
about the battle of Shibao. © The Field Museum, A115254d_010.
Catalog Nos. 121938, 121938.2C. Photographer John Weinstein.

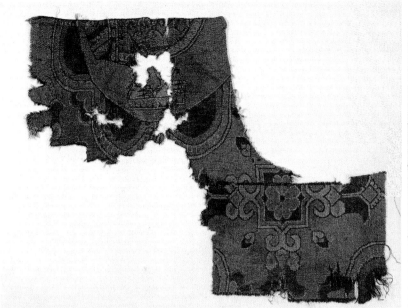

However, trade relationships between Tang China and Tibet and India were
not stable. Due to the Battle of Talas and the An Lushan Rebellion, Chinese control
of Central Asia was now shared by Arab troops, Tibetans, and Uyghurs. Some Sog-
dian merchants had escaped to the Tibetan Empire to seek protection, taking with
them metalworking skills and silk-weaving techniques. Their mastery can be seen
on a large silver ewer, with Tibetan inscriptions and in the Sogdian style, which
is housed in the Jokhang Temple in Lhasa. After the Battle of Talas, the Tibetan
Empire expanded to current-day western Xinjiang. Guided by Sogdian craftsmen,
two silk-weaving centers were established in Khotan and Dunhuang, the silk prod-
ucts of which were specially designed for markets in the west, displaying the lion
pattern common in the Byzantine art style. In contrast, the Khotanese-style silk
was called "Hu Silk" and was aimed at Chinese markets. The Sogdian-style was
called "Fan Silk" and was manufactured primarily for Tibetan consumers. Figure
176 pictures examples of these two styles of silk. Other silk fabrics with Islamic
patterns, aimed for central Asian markets, have been found in many remains in
Xinjiang and are attributed to the late ninth century (Lin 2008).

The Maritime Trade Route

Due to the decline in trade via land-based routes, as well as political and military
instability (e.g., the Battle of Talas and the An Lushan Rebellion), maritime trade
became increasingly important for the Tang Chinese court, and the economic cen-
ter of China switched from north to south. Consequently, the port cities in south-
ern China grew in size and importance, and large-scale maritime trade between

China and the Persian Gulf via the Indian Ocean started about AD 800 (Whitehouse and Williamson 1973).

The Indian Ocean in the eighth to tenth centuries was notable for the smooth long-distance voyages from the port of Guangzhou in southern China to Basra in the Persian Gulf (Hourani 1995, 61). It is hard to describe the prosperity of Basra, as there is little archaeological evidence (Rougeulle 1996, 162); however, from historical accounts, it is clear that Basra played an important strategic role in the military protection of the caliphate from sea attacks by Oman or even Hindustan. It was also the major trading port that was linked to Baghdad, the later political and economic base of the Abbasid Caliphate (Chaudhuri 1985, 47).

In contrast, under Islamic expansion, merchants and caravanners from the Red Sea struggled to reach Damascus and other western destinations other than Yemen when bringing goods from the east. Pirates were a constant threat to Red Sea voyagers at this time (Chaudhuri 1985, 42). The lack of historical resources means that archaeological finds, such as Chinese ceramics from Athar on the southwestern coast of Saudi Arabia and Aqaba on the Gulf of Aqaba, are important for providing a small glimpse into China's prosperous trade with Red Sea merchants, who probably controlled much of this trade (Rougeulle 1996, 166–67).

In terms of Tang Chinese participation in maritime trade or voyages, Chinese travelers, monks, and officials all visited India and the Near East via sea routes. For example, the Tang Chinese monk I-Ching visited India on an Arab merchant ship in 671, and his first stop was in Palembang in Sumatra (Bangwei Wang 1988, 8). During a return voyage from Heiyi Dashi 黑衣大食 (Abbasid Caliphate) to Guangzhou, a Chinese general, Du Huan, a prisoner from the Battle of Talas, traveled to China by merchant ship in 762 (Jinming Li 1996, 120; Park 2012, 29). However, no clear description supports the ownership of this ship as either Chinese or Arab, due to the loss of the writings of Du Huan.

There is some new archaeological evidence of Chinese voyages to the Gulf in the eighth century. A stone stele unearthed in front of the Yang Liangyao's tomb in Jingchuan County in Shaanxi Province might be helpful to further understand Chinese visits to the Gulf. The inscription of this stele clearly describes the official visit of Yang Liangyao 杨良瑶 as a Tang Chinese ambassador to the Abbasid Caliphate (Rong 2012; Schottenhammer 2014) (fig. 177).

In terms of trade routes from China to the Gulf, limited archaeological evidence is available from shipwrecks. Based on a comprehensive study of shipwrecks in the Indian Ocean collected by Roxanna M. Brown (2009, 161–81), it can be seen that the Belitung Shipwreck, found off the east coast of Sumatra, provides the only such evidence of long-distance Indian Ocean trading before the tenth century—it is the earliest archaeological find of an Arab or Persian merchant vessel in the Indian Ocean (Flecker 2001; Guy 2005; Krahl et al. 2010). This wreck has been confirmed as belonging to Muslim merchants (Omani, Yemeni, or Iranian) (Flecker 2001, 345–48, 53; Krahl et al. 2010, 118), but once again there is nothing to indicate that Tang Chinese merchants directly participated in Indian Ocean trade.

FIGURE 177
A rubbing of part of the inscription from
the Yang Liangyao stone stele. Image
courtesy of Zhao Liguang.

Although it provides a limited understanding of larger trade patterns in the Indian Ocean, the Belitung Shipwreck yields some fascinating details on other topics: the ship's structure has been well preserved, which indicates that the wood material of this (probably) Omani ship was imported from India, and more than sixty-seven thousand Tang Chinese artifacts have been discovered in its cargo, including about fifty-eight thousand pieces of Chinese ceramics and nearly seventy pieces of metalwork and other luxuries (Flecker 2001; Krahl, et al. 2010) (figs. 178 and 179). Combining this information, such as the merchants' nationality, the shipbuilding material, the trade route, and the commodities traded, we can see that many areas of the Indian Ocean were involved; consequently, the significance of the find of the Belitung Shipwreck is substantial.

In addition to the Belitung Shipwreck, nearly one hundred littoral and inland archaeological sites across the Indian Ocean are providing evidence of the prosperity of maritime trade routes from China to the Gulf. Similar to the commodities found in the cargo of the Belitung Shipwreck, Chinese ceramics have been found at these sites, including celadon wares (green-glazed stonewares) made in the Yue kilns in Zhejiang Province and white porcelain made in the Xing kilns in Hebei Province. Green-splashed pottery, blue-and-white pottery, and so-called *sancai*

FIGURE 178
A Tang Dynasty bronze mirror housed at The Field Museum, similar to items recovered from the Belitung Shipwreck.
© The Field Museum. Catalog No. 117193.
Photographer Gedi Jakovickas.

FIGURE 179
A blue-and-white ceramic dish from the
Belitung Shipwreck. Image courtesy of Lin
Meicun.

wares (tricolor pottery) were also traded along this sea route. The sites located in Southeast Asia, India, and Sri Lanka, such as Palembang, Jambi (in Sumatra), Ko Kho Khao (in Thailand), Sanjan (near Mumbai of India), and Mantai (in northern Sri Lanka), have yielded a large number of Chinese ceramic sherds (Carswell et al. 2013; Harkantiningsih 1994; Ho 1994; Ho et al. 1990; Nanji 2011; Ridho 1994). Due to the rarity of Chinese ceramic finds in the inland sites of Southeast Asia, India, and Sri Lanka, it is reasonable to suggest that these port sites were intermediate stops along this sea route. The imported Chinese ceramic consumption in these areas was thin and rare (Prickett-Fernando 1994; Zhang 2013). In contrast, more sites, both along the littoral area and in the inland area, under the rule of the Abbasid Caliphate have yielded Chinese ceramics rich in diversity and quantity. It can therefore be seen that the Abbasid Caliphate was probably the true destination of this sea trade from China (Zhang 2013). After they arrived at the Gulf, Chinese commodities, such as ceramics, would have been reexported to Fustat (an ancient city near Cairo and the first capital of Islamic Egypt) in the eastern Mediterranean Sea (Yuba 2014) and Manda in eastern Africa (Chittick 1984).

Siraf (an important port city in what is now southern Iran) was integral to the prosperity of the Persian Gulf trade with Tang China in the eighth and ninth centuries (Tampoe 1989), but historical descriptions of Siraf are curiously lacking in comparison to those for other large cities in the Gulf. However, the few paragraphs contained in historical accounts reveal that, despite its poor geographic environment, Siraf was a town of a considerable size and as large as Shiraz. This

port was sufficiently attractive for long-distance merchants to trade there (Chaud-huri 1985, 48), and rich merchants and people from Siraf funded the construction of a great Friday mosque, which was completed around 820. The mosque was more than 2,000 square meters in size and raised on an artificial terrace 2 meters high (Rougeulle 1996, 162; Whitehouse 1979, 56).

The sea route to Japan in the east displays a different pattern. It has been suggested that Yangzhou in Jiangsu Province might have been the port used for sea trade from China to the Dazaifu area on the southern Japanese island of Kyushu, due to the rarity of discoveries of Guangdong-made celadon wares along this route (Qin 2013). Merchants to the east were highly likely to have left from Yangzhou rather than Guangzhou for Japan. Not only Chinese ceramics, but also silk and fabrics from China and the Islamic world were traded with Japan, and examples are housed in the Shoso-in belonging to the Todai-ji Temple and Horyu-ji Temple in Nara (Lin 2006, 3).

Conclusions

The Tang Dynasty has long been considered one of the most open and cosmopolitan periods of Chinese history. It was a time of great economic prosperity, when the arts flourished, especially in the capitals of Chang'an and Luoyang. The Silk Road during the Tang Dynasty, which linked China with Japan to the east and the Mediterranean to the west, has been described based on its major land and sea routes. After the middle of the eighth century, there was a slight decline in the land routes due to Tang China's losing control of Central Asia, although trade and communication with the outside world never ceased.

With the shifts from land route trade to maritime trade in the late Tang Dynasty, a significant Chinese sea power was established for the following five centuries (Lo 2012). Particularly in terms of the expansion of the Mongol Empire, from the thirteenth to fourteenth centuries, it played an important role in maritime trade in the Indian Ocean, as well as reconnecting the land-based route from China to the west, which had been disrupted for more than a hundred years during the Chinese Song period due to the unstable diplomatic relationships among Song China, Liao, Jurchen, and the Mongols (Franke and Twitchett 1994; Kuhn 2009; Lin 2011). And from the early Ming era, during the late fourteenth to the early fifteenth centuries, some Chinese foreign trade items, such as pepper, sapanwood, and other luxuries, were imperial monopolies, closely guarded to ensure that all the profits went to the Ming court (Lin and Zhang 2015; T'ien 1981, 188).

11

The Java Sea Shipwreck and China's Maritime Trade

Lisa C. Niziolek

Visitors to The Field Museum's *Cyrus Tang Hall of China* may be familiar with the Silk Road, a translation of the German term *Seidenstraße*, which was used by geographer Ferdinand von Richtofen in the 1870s to denote a network of ancient trade routes between China and Rome. Less familiar might be the overland Silk Road's maritime counterpart, variably called the Maritime Silk Road (or Route) or the Porcelain Road, with which many of the objects displayed in the fifth gallery ("Crossing Boundaries, Building Networks") are associated (fig. 180). These oversea routes linked China to other areas of the world, near and far, and were the conduits through which not only goods moved but also ideas and people (see Lin and Zhang, this volume). The colorful Peranakan belts (fig. 181), for instance, are the products of communities who emigrated from China to Malaysia, Indonesia, and Singapore starting in the fifteenth century to take advantage of opportunities presented by trade. Into the mid-twentieth century, a woman would use tiny, European glass beads (seed beads) to embellish beautiful belts, handkerchiefs, purses, slippers, and other objects in preparation for her wedding. These objects represent a mix of Chinese and Malay cultural traditions, incorporating Chinese symbols (attributes

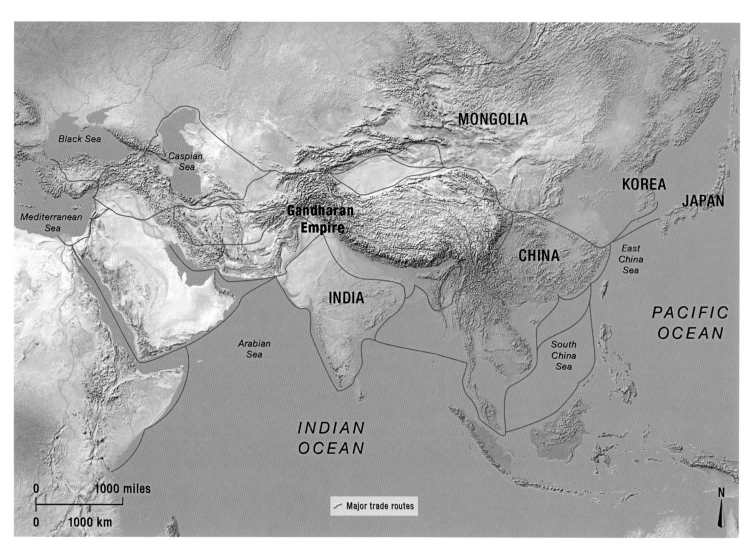

FIGURE 180

Map of overland and maritime trade routes. © The Field Museum. Illustrator Erica Rodriguez.

FIGURE 181

Peranakan beaded belt. Nineteenth–twentieth century, Malaysia. © The Field Museum.
Photo ID No. A115063d_001. Catalog No. 180024. Photographer Karen Bean.

of the Eight Daoist Immortals, for example) and bright, flamboyant colors, which are markedly similar to Peranakan ceramics.

Around the same time as Peranakan communities were beginning to be established in the Straits region of Malaysia, the famous Ming Dynasty admiral Zheng He embarked on his transoceanic voyages. Born a Muslim and made a eunuch (castrated) during the tumultuous transition from the Yuan (AD 1279–1368) to the Ming (AD 1368–1644) Dynasty, Zheng He became a confidant and companion to the young Prince Zhu Di. When Zhu Di became the Yongle emperor in 1402, Zheng He had earned his trust and demonstrated his ability to manage state affairs. As a result, he was asked to lead a number of imperial voyages in order to promote China's hegemony, collect tribute from vassal states, and oversee China's trade at foreign ports. Between 1405 and 1433, Zheng He and his fleets, sometimes composed of more than one hundred ships and twenty-seven thousand men, made seven voyages from China to Southeast Asia, India, East Africa, and the Arabian Peninsula. His ships became the stuff of legend: dubbed "treasure ships," they were rumored to be close to 450 feet long. The model of one of Zheng He's ships (catalog no. 357836), based on a modest length of 200 feet, is considered to be one of the most accurate depictions of one of his seagoing vessels made to date (fig. 182). (The ships Columbus sailed later that century were probably about 60–100 feet long.) Although these travels are often considered to be explorative and diplomatic in nature (Zheng He often conferred honorific titles on rulers abroad), they served to advertise China's political power and military might. Thus, maritime routes also were a means by which China, and other countries, signaled their prowess to each other. Zheng He's voyages represent the high point of China's maritime activity, and, notably, they took place before the Ming imperial court implemented a series of major naval and maritime trade restrictions. After Zheng He's last voyage, China's participation in maritime endeavors foundered. Some scholars cite as the reason for this the strain that the voyages placed on the imperial coffers and how such extravagance was misaligned with Confucian ideals, which underpinned

Chinese society and politics; others point to the need that China's rulers had to refocus resources on defending its northeastern frontiers from Mongol invaders (see Dreyer 2007; Peterson 1994; Wade 2005).

The story of China's role in the maritime realm does not end with Zheng He, nor did it begin with him. Historical records include accounts of Buddhist pilgrims, such as Faxian (c. 337–422), traveling by sea between China and India, typically by merchant ships, in order to bring Buddhist teachings back to China (Sen 2014). Although maritime routes served multiple purposes, it seems likely their primary purpose was related to economics—that is, the production, distribution, and consumption of goods (and services). Whereas many people may be very aware that China is the top producer of many of the world's manufactured goods today, few may know of the deep history of China's position as such. Until relatively recently, researchers relied primarily on historical records and archaeological sites on land to reconstruct past societies and their cultural, economic, and political practices and relationships, but over the past couple of decades, archaeologists

FIGURE 182
Model of Ming Dynasty "treasure ship," built by Nicholas Burningham. © The Field Museum. Photo ID No. GN92167_004d. Catalog No. 357836. Photographer Karen Bean.

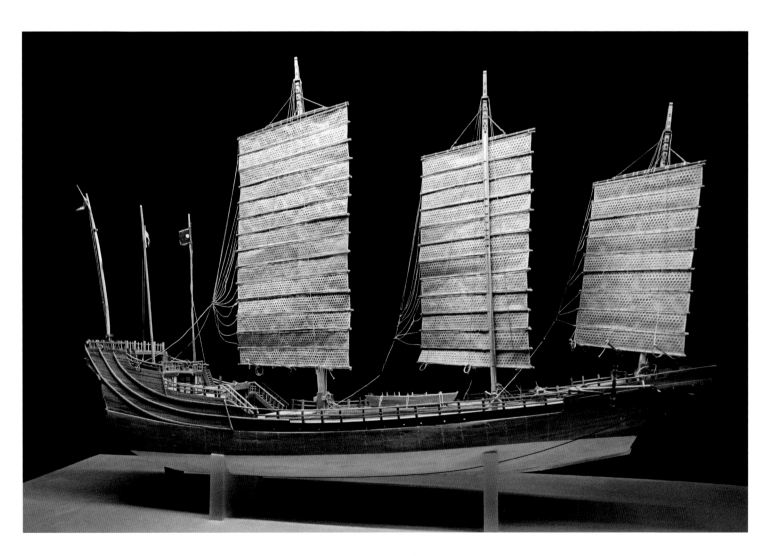

have begun to recognize the important contributions shipwrecks can make to understanding ancient trade and exchange. The cargoes of many of these wrecks, including that of the twelfth- to thirteenth-century Java Sea Shipwreck, which is housed at The Field Museum, also attest to the huge scale and high intensity of the production of goods made for export taking place in China centuries ago. In addition, these finds demonstrate the need to discourage looting and prioritize the protection of cultural material that can be used to tell the stories of multiple human pasts.

The Java Sea Shipwreck

The Java Sea Shipwreck was discovered in the waters between Java and Sumatra in the late 1980s by fishermen (fig. 183). After being subjected to years of looting by local divers and salvage operations, in 1996 the cargo was recovered and the site mapped by Pacific Sea Resources, a U.S.-based commercial salvage company, which legally excavated the remains. Based on their agreement with the Indonesian government, half of the recovered cargo was given to Indonesia; the other half was donated to The Field Museum under the curatorship of Dr. Bennet Bronson. Unfortunately, much of the Indonesian half remains unaccounted for and has

FIGURE 183

Map of possible route and location of the Java Sea Shipwreck. © The Field Museum. Illustrator Erica Rodriguez. Redrawn by David Quednau.

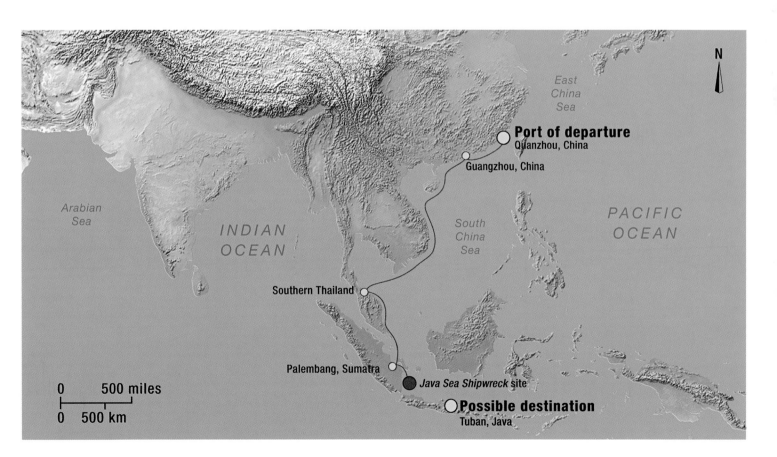

probably been sold off piecemeal, diminishing its research value (and frustrating scholars). The Museum, however, is fortunate to have more than 7,500 pieces from the wreck in its collection for research and display. Some of these artifacts can be found throughout the last gallery of the exhibition. Efforts to document and study the wreck material began during its initial recovery, led by Mr. William Mathers and Dr. Michael Flecker (Mathers and Flecker 1997), and they continue today at The Field Museum.

Excavations at the wreck site lasted approximately two months, after which time the artifacts were brought to facilities in Singapore to be cleaned, desalinated, and cataloged. After having been submerged in saltwater for centuries, removing salts that would have accumulated in the materials was essential for their long-term preservation. This process took several months and required soaking the objects in large containers of freshwater that were changed periodically until the pieces appeared to be free of harmful salts that could lead to further corrosion or breakdown of material.

Although the majority of objects recovered were made in China, several lines of evidence point to the ship's having been built in Indonesia (see Flecker 2003). Only several small pieces of wood survived, and two of these were especially criti-

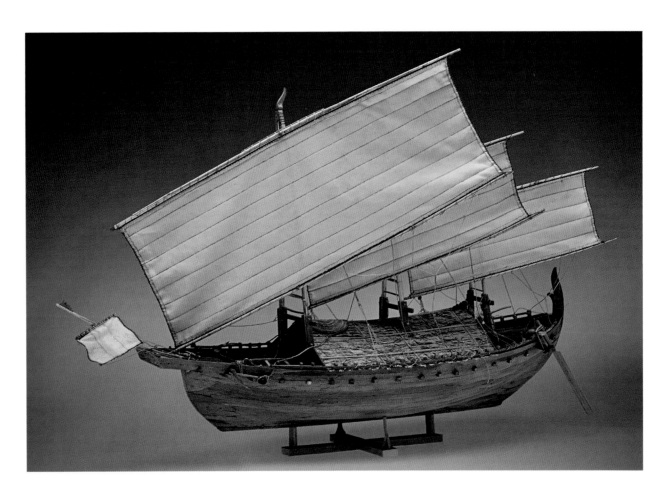

cal to reconstructing the vessel, a fine model of which, built by Nicholas Burningham, is displayed in the fifth gallery of the *Cyrus Tang Hall of China* (fig. 184). Both of these pieces are from tropical wood species, *Parastemon urophyllus* and *Alstonia scholaris*, which tend to be found more in Southeast Asia and the Pacific than in China (or India or the Middle East). Furthermore, both pieces appear to have dowel holes through which wooden nails or pegs, not metal ones as on Chinese ships, would have been driven or rope lashed—this is an important point. Such a technique, called "lashed-lug construction," is consistent with shipbuilding traditions in Southeast Asia at the time and ones that were practiced in parts of Indonesia until relatively recently. Similar lashed-lug hulls are suspected in the earlier, tenth-century Intan and Cirebon Wrecks, which were found in the same region and carried cargoes as large as the one the Java Sea Shipwreck carried. (See Liebner 2014 for a detailed reconstruction of the Cirebon.) Also critical to reconstructing the Java Sea vessel were the massive iron concretions that were formed as the cargo of iron bars on board corroded and combined with marine sediment after the ship sank. Whereas the iron concretions more or less withstood the test of time, the wooden hull did not. Fortunately, before the timber structure disintegrated, the iron had already molded around it. When mapping the site, researchers were

FIGURE 185
Iron concretion formed from bundle of iron bars from the Java Sea Shipwreck. © The Field Museum. Catalog No. 351784. Photographer Gedi Jakovickas.

able to see where the wood originally would have been based on spaces between the iron blocks.

The two main types of materials being transported by the merchants of the Java Sea Shipwreck vessel were Chinese ceramics and iron. Flecker (2003, 397) initially estimated that there may have been as many as one hundred thousand ceramic pieces in the cargo—if this is accurate, this means that the Museum only has about 5–7 percent of the original ceramic cargo in its collections and that about 85–90 percent of the full cargo may have been lost to looting, human disturbance, and natural processes. The ship also may have been carrying about 200 tons of iron, primarily in the form of iron bars packed as bundles that were wrapped in plant material and bound in rattan (fig. 185). Both products were probably bound for islands in Southeast Asia, Java in particular.

Chinese products were not the only items recovered at the wreck site. About 360 *kendis* and *kundikas*, which are spouted, handle-less vessels used in Buddhist, Hindu, and Islamic rituals and in the preparation of medicines, were found scattered over the wreck site. This distribution has been interpreted as evidence that these pieces were placed throughout the ship's cargo where there was available

FIGURE 186
Foreign envoys and tribute bearers in the capital city of Chang'an (Xi'an) in AD 631. *Portraits of Periodical Offering of Tang*, Song copy. Painting in the collection of National Palace Museum. Image in Public Domain.

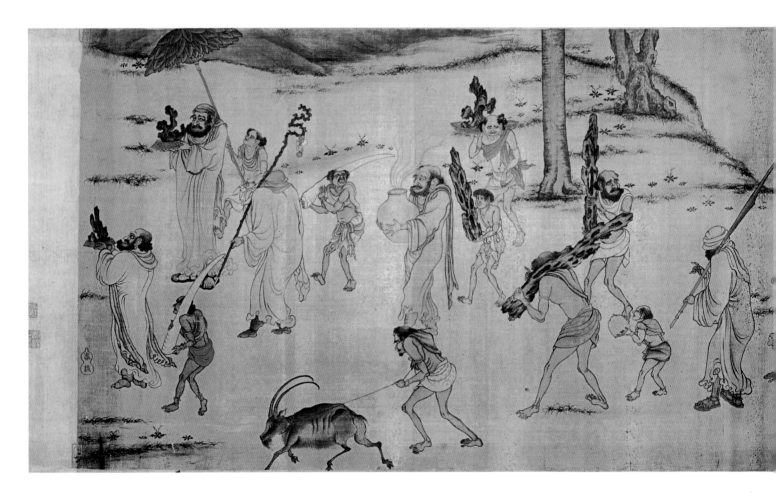

space, rather than together in a single section (Flecker 1997, 70). It also is assumed that they were loaded onto the ship after the Chinese pieces, since they would have been picked up en route from Quanzhou in Fujian Province (China) to Java, possibly in southern Thailand. The *kendis* and *kundikas* were made from a fine ceramic paste and were individually modeled rather than mass produced using molds.

Some organic items were recovered from the wreck as well. These include several chunks of aromatic resin (a sticky substance, somewhat similar to amber, exuded by certain plants or trees) and sixteen pieces of unworked elephant tusk (see figs. 197 and 198 in Respess, this volume). It is uncertain whether the tusks came from Southeast Asia or were transshipped from East Africa or India (i.e., transported to an intermediate port); however, we know that ivory was a major trade item at the time. It also served as a form of tribute given to Chinese emperors by foreign leaders and emissaries (fig. 186). Such tribute helped its bearers earn more favorable trade status with China and also reinforced China's position as the world's central power. Like ivory, aromatic resin would have been considered a luxury item. The resin primarily would have been used as incense, burned at temples as offerings and as an aid to contemplation and prayer. It, like ivory, also may have

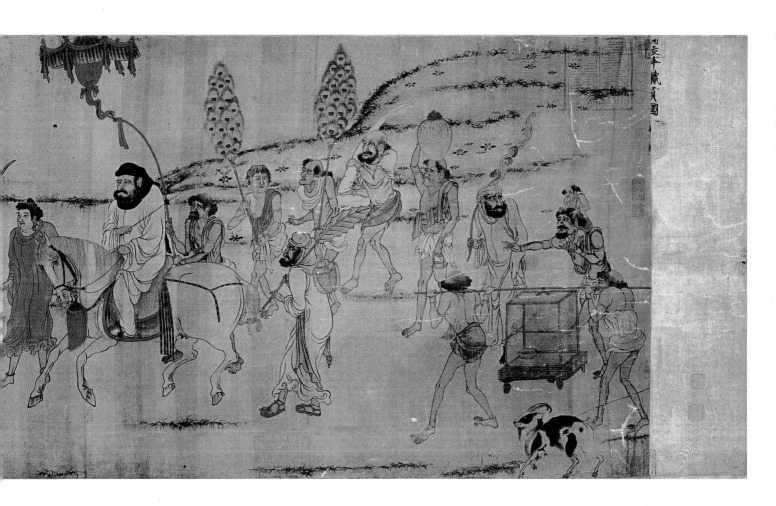

been used in medicinal preparations (see Respess and Niziolek 2016). Although initially it was thought that the resin from the shipwreck originated in Southeast Asia, probably Sumatra (Miksic 1997, 29), more recent analysis using nuclear magnetic resonance (NMR) undertaken by colleagues at Trinity University in San Antonio, Texas, points to more distant sources as possibilities—the Gujarat area of India or Japan (Levy et al. 2015). If either of these is the source, we need to rethink the potential route taken by the vessel and consider that transshipment may have played a larger role in trade than initially thought in this instance.

In addition, there are several objects found at the wreck site that are associated with the merchants, sailors, and travelers on board. For example, fourteen weights that might have been used by merchants for economic transactions at various ports of call were recovered (fig. 187). These range in size from a small, stone weight, to scalloped and plain metal weights, to a large quartz weight. It is thought that these follow an Indonesian weight system (Flecker 2003, 396); however, researchers now think that, based on isotope analysis, the metal pieces were manufactured in China (Kimura et al. 2015). It is unclear whether the merchants were from Indonesia, China, Persia, or elsewhere—in fact, they may have represented a combination of countries and ethnicities. Also recovered were several metal figures that may have been possessions of the crew or other travelers. One appears to be a woman riding a sea creature (fig. 188), which John Miksic (1997, 85) has linked to a Hindu myth from *Sri Tanjung*, an ancient Javanese text. The story describes a princess who is wrongly accused of being unfaithful to her husband and is killed by him. Because she did not have time to make adequate preparations for the afterlife, she is carried away by a monstrous fish. Another figure, on display in the exhibition, is a seated individual who looks as though he is being crushed under the weight of a table or platform he would have been supporting. It is possible that he was holding up a personal altar at which acts of worship would have been performed while at sea. Another two metal pieces are finials, similar to those that would have been mounted on top of the staffs of Buddhist monks. It is intriguing to think that these may have belonged to religious figures traveling on board the ship, given the long tradition of monks using merchant vessels for transportation between India, China, and other places of pilgrimage, learning, and worship. More functional items associated with the ship's passengers and crew are sharpening stones, which would have been used to hone tools and weapons, and earthenware stoves for cooking.

At the Center of Ongoing Research

Although some research was done in the late 1990s and early 2000s on material from the Java Sea Shipwreck, more in-depth work on the collection started in earnest around 2011. In particular, researchers have been focused on examining the high-fired ceramics from China and some of the metal materials found at the wreck site. Ceramic research on The Field Museum's collection has centered on three

FIGURE 187
Scale weights from the Java Sea Shipwreck. © The Field Museum, Anthropology Collections. Photographer Pacific Sea Resources.

FIGURE 188
Metal figure of a woman atop a sea creature. © The Field Museum. Catalog No. 351348. Photographer Pacific Sea Resources.

projects so far: (1) providing detailed measurements and descriptions of the more than 1,400 ceramic covered boxes, the most numerous type of ceramic form after bowls; (2) translating inscriptions found on the boxes and other ceramic materials; and (3) conducting compositional analysis on the materials used to make the high-fired ceramics (e.g., pastes and glazes) at the Museum's Elemental Analysis Facility.

The first project—measuring and describing the covered boxes—primarily has served as a form of documentation. This information will be helpful for future research on a number of topics, including the distribution of similar design motifs (and cultural traditions) across space and time in China, Southeast Asia, and other parts of the Indian Ocean World and the effects of mass production and large-scale trade on the standardization and quality of commodities such as ceramics. This information also can help us formulate hypotheses related to the organization of production and the functioning of family workshops (hinted at by inscriptions found on some pieces).

The second project, involving the translation of inscriptions found on a number of the ceramics, has begun to shed light on a number of different topics. Several inscribed ceramic box bases are on view in the exhibition (fig. 189). These include one that we think has revealed where the box was made (catalog no. 344404). Its relatively lengthy inscription reads: 建宁府大铜峰汪承务宅印(?) *(Jianning Fu Da-tongfeng Wang Chengwu zhai yin(?))*. From this, it appears this piece was manufactured in Jianning, a prefecture located in Fujian Province. Just as we may see "Made in China" on the bottom of our coffee mugs today (or any number of things we use every day), almost eight hundred years ago manufacturers were marking their products in a similar fashion—in effect, advertising. Furthermore, there appears to be a surname mentioned in the inscription, Wang, which may be indicative of the family who owned the workshop where the piece was made.

The characters on another ceramic box (catalog no. 345133) in the exhibition clearly reveal at which family workshop the piece was produced. These types of

FIGURE 189
Inscriptions (enhanced) on the bases of three ceramic covered boxes from the Java Sea Shipwreck. © The Field Museum. Catalog Nos. 344404, 345133, 345103. Photographer Gedi Jakovickas.

CHAPTER ELEVEN

marks are sometimes called "hall" marks (Burton and Hobson 1909, 129–31). On this piece, the first three characters (reading from the top right down, then from the top left down) are decipherable: 陳 (surname Chen), 宅 (*zhai*, house or residence), and 印 (*yin*, seal or inscribe)—meaning that this is the seal of the Chen family household or workshop. The inscriptions on both of these boxes support the image of production that we have from historical accounts and depictions of ceramic workshops. From these materials, we know that the manufacture of export ceramics, which were required in large quantities, was specialized, often at the village level—meaning that the majority of households in entire villages were dedicated to making ceramics. Certain families may have been in charge of organizing and overseeing production, and it is likely that these are the names we see in the inscriptions. (In some of the kilns fed by these family workshops, twenty thousand to two hundred thousand pieces could be fired at one time.) It is interesting to note that signing or stamping manufactured goods with the name of the producer or supervisor has a long history in China and is a measure of quality control. In the Qin Dynasty (221–206 BC), for instance, figures from the First Emperor's famous terracotta army are signed by the individuals responsible for their production. Bricks dating to the Ming Dynasty used in constructing segments of the Great Wall bear similar stamps. If sufficient levels of quality were not met, punishment for the producers and their supervisors would ensue. (Thus, the idea of "advertising" mentioned earlier could be a good thing if the quality of pieces was good but a bad thing if they were not up to snuff.)

Another inscribed box (catalog no. 345103) presents intriguing evidence of the presence of Muslim or Arab merchants along these trade routes. On the base of this piece, there appears to be an inscription in Xiao'erjing, شن (*saa*), a simplified form of Chinese based on Perso-Arabic script (Niziolek and Respess 2017). In addition to inscriptions' use in indicating where pieces were manufactured, they and other types of markings were sometimes used by producers to track which merchants may have ordered particular pieces—in these instances, they are referred to as "merchant's marks" (Burton and Hobson 1909, 27). Merchant's marks also can take the form of numbers, although numbers might also relate to the "type" of ceramic ordered (e.g., a six-sided, green-glazed box). Inscriptions in languages other than Chinese speak to the multiethnic makeup of the players along maritime routes.

A third major research project that has been undertaken at The Field Museum on the Java Sea Shipwreck collection is the compositional analysis of some of the ceramic material (Niziolek 2015). At the Museum's Elemental Analysis Facility, scientists are able to use techniques including laser ablation–inductively coupled plasma–mass spectrometry (LA-ICP-MS) to determine the elemental signature of artifacts and raw materials used to make them. In doing so, we can figure out which ceramics, for example, were made at the same kiln site using the same materials. We also can compare the compositions of ceramics found at the Java Sea Shipwreck site with the compositions of ceramics from other shipwrecks and archaeological sites on land to track the distribution of pieces made in a particular

production area—basically reconstructing trade routes from the point of production, through transit, and to the point of consumption. Compositional analysis can be a powerful tool archaeologists can wield to uncover social and economic connections between communities as well as examine technological changes over time and space.

Investigations of the elemental compositions of some of the ceramics from the shipwreck have confirmed that almost all of the high-fired ceramics (many of which would be classified as porcelains today) were manufactured in the southern part of China, where clays used to make ceramics tend to have lower amounts of Al_2O_3 (aluminum oxide) and higher amounts of K_2O (potassium oxide) than clays from northern China (Pollard and Hatcher 1994). Not surprisingly, compositional analysis has shown that the different styles of high-fired ceramics from the wreck tend to have different elemental signatures, which could be an indication that they were made in different production areas. Somewhat unexpectedly, though, analysis also showed that two different styles and forms of ceramics—light green-glazed bowls (fig. 190) and *qingbai*-type covered boxes (fig. 191)—have similar elemental compositions. Based on this evidence, we can hypothesize that the same raw materials were being used, probably in the same production area, to make the bodies of different types of ceramics. The same workshops where simple bowls were manufactured might have been where more intricately designed covered boxes were made. Furthermore, the compositions of many of the shipwreck ceramics are similar to those manufactured at kilns near Dehua in Fujian Province and Jing-dezhen in Jiangxi Province.

Export ceramics, specifically those in the *qingbai*-style, were produced at kilns in both of these areas, but the quality of the pieces from the two places is very different. Jingdezhen is considered to be the porcelain capital of the world, and, although most famous for its later blue-on-white porcelains beginning in

FIGURE 190
Light green-glazed ceramic bowl from the Java Sea Shipwreck. © The Field Museum. Catalog No. 349352.

FIGURE 191
Qingbai-style covered box from the Java Sea Shipwreck. © The Field Museum. Catalog No. 344284.

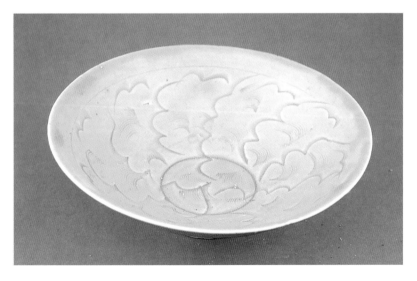

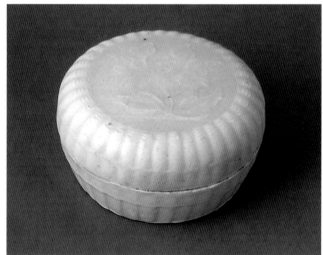

the fourteenth century, in the tenth century the city was renowned for its *qingbai* ceramics. *Qingbai* means "blue-white," referring to the pale blue glaze that covers the surfaces of some of Jingdezhen's pure, sugary-white porcelains. Some believe that this type of porcelain was made to imitate jade. Pieces produced at the many kilns surrounding major ports such as Quanzhou could generally be described in a similar way; however, in addition to elemental differences, a number of features separate *qingbai* pieces made at Jingdezhen from those made in Fujian Province and elsewhere. The ceramics from Jingdezhen are more finely crafted, with greater symmetry of form, thinner edges, and a more even and controlled application of glaze. The designs on the Jingdezhen pieces tend to be incised or impressed rather than molded onto the surface of the piece. Such an execution allows Jingdezhen's translucent *qingbai* glaze to pool in the outlines of the hollowed out shapes of flowers, clouds, fruits, animals, and even anthropomorphic figures, highlighting their shapes and the delicate lines used to create them (fig. 192). The bluish-white

FIGURE 192
Qingbai dish with anthropomorphic figure from the Java Sea Shipwreck. © The Field Museum. Catalog No. 345841. Photographer Gedi Jakovickas.

glazes on the majority of ceramics from kilns such as Dehua tend to be milkier (or opaque), thicker in consistency, and more hastily applied. Most of the high-fired ceramics recovered in 1996 from the Java Sea Shipwreck are the latter. While Jing-dezhen potters may have been imitating jade, Fujian potters may have been imitating imitations of jade—or, they may have been making what they considered to be their own unique products. Regardless, these ceramics were in high demand in overseas markets and examples nearly identical to those found on the Java Sea Shipwreck have been recovered at archaeological sites in Japan, China, and Southeast Asia (fig. 193).

Additional research projects focusing on The Field Museum's Java Sea Shipwreck collection include historical and archaeological research on objects related

FIGURE 193
Map showing distribution of maritime sites with ceramic covered boxes in the *qingbai* style nearly identical to those found at the Java Sea Shipwreck site. © The Field Museum. Illustrator David Quednau.

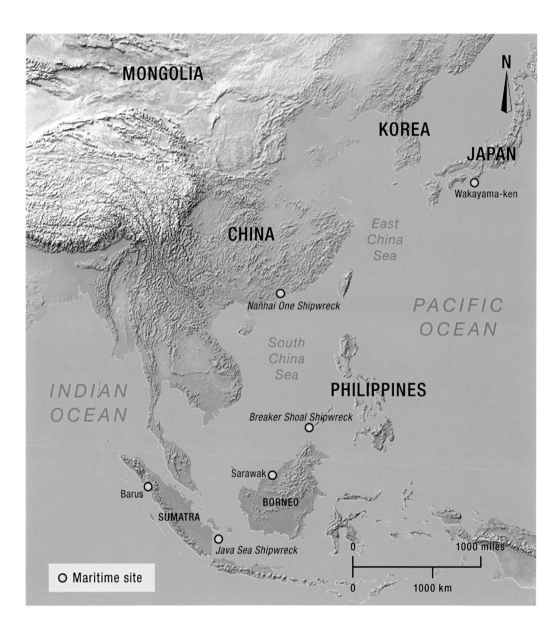

CHAPTER ELEVEN

to medical practices (Amanda Respess at the University of Michigan, Ann Arbor), compositional and isotopic analyses of metal artifacts (Jun Kimura at Tokai University, Japan, and Laure Dussubieux at The Field Museum), redating of organic material to confirm the initial date range obtained from a single radiocarbon test (Niziolek and Gary Feinman at The Field Museum, Kimura, Respess, and Lu Zhang at the Art Institute of Chicago), determination of potential sources for the resin found at the wreck site (Niziolek and Feinman and Joseph Lambert and Allison Levy at Trinity University, San Antonio, Texas), and stylistic and compositional comparisons of similar objects from other maritime and terrestrial archaeological sites and museum collections (Niziolek and Wenpeng Xu at the University of Illinois at Chicago).

Part of a Larger Picture

The Java Sea Shipwreck is only one among many mercantile ships sailing the waters of Asia that met an untimely fate, and it is by no means the earliest one. Perhaps the most impressive shipwreck found to date, and one of the most contentious, is the Belitung Wreck (see Krahl et al. 2010). The Belitung vessel foundered in the same area as the Java Sea vessel did—near the islands of Bangka and Belitung in the Java Sea—and was salvaged in 1998 and 1999. The ninth-century ship was richly laden with Chinese ceramics, mostly Changsha bowls from massive kilns in Hunan Province in southern China. Wares from other southern Chinese kilns also are represented in the cargo, and researchers believe the ship probably stopped at the port of Guangzhou in Guangdong Province. More spectacular goods being transported include rare gold and silver boxes, bowls, and cups, probably produced near Yangzhou in Jiangsu Province. Some scholars have suggested that these pieces might link the Belitung to the Tang imperial court (Worrall 2014, 45). Not only does research on the ship's recovered cargo, composed of more than sixty thousand artifacts, lend itself to discussions on mass production and the exchange of "elite" goods, but it also makes major contributions to our understanding of the importance of maritime trade between China and the Middle East, which was controlled by the Abbasid Caliphate at the time. Importantly, the vessel carrying this precious cargo was not Chinese or Southeast Asian—it was an Arab dhow, probably traveling from China back across the Indian Ocean to the port of Basra in the Persian Gulf. From there, the gold, silver, and other Tang treasures would have made their way to the capital of the Islamic caliphate at Baghdad.

Two other earlier wrecks, both from the Java Sea, have provided researchers with important data for understanding early maritime trade networks. These are the tenth-century Intan and Cirebon Wrecks. The Intan Wreck was excavated in 1997 by Flecker (Flecker 2002). Like the later Java Sea Shipwreck, the vessel was of lashed-lug construction, and the presence of Chinese coins has helped date the wreck to around 918. Also recovered at the site were Chinese ceramics (pots, jarlets, dishes, bowls, covered boxes, ewers); mirrors; Thai *kendis*; Middle Eastern ceramic

jars; tin ingots from Kedah, Malaysia; bronze and silver ingots; bronze statues and finials; ivory, deer antler, aromatic resin, and candlenuts from Sumatra; and gold coins and jewelry—an incredibly diverse cargo. Because many of the non-Chinese commodities lay beneath the Chinese materials, Flecker has hypothesized that the ship was sailing from an entrepôt port on Sumatra, probably Palembang, where it loaded its cargo, to Java, which would have been deficient in many of the metals on board.

The Cirebon Wreck lay east of the Java Sea Shipwreck and was recovered around 2005. The cargo consisted of Chinese ceramics (stoneware ewers, boxes, jars, bowls, plates, platters, lamps); terracotta; glassware; silver, tin, and iron ingots; ritual objects (bells, statuettes, finials); mirrors; and Chinese coins. The ceramics were mostly from the southeastern part of China (Yue and Longquan kilns in Zhejiang). Other production areas probably are represented as well, including Fujian and Guangdong Provinces. Ceramics associated with the northern Liao Dynasty (AD 907–1125), which was established by the nomadic Khitans from the northeastern regions of China, were found on board too. Horst Liebner's impressive work on creating a 3-D rendering of the ship and re-creating the original placement of its cargo has proved to be some of the most detailed to date in terms of understanding Southeast Asian lashed-lug construction and the nature of maritime trade during the mid- to late tenth century (Liebner 2014). The distribution of the cargo at the wreck site supports both the scenario of small-scale "peddling" and centrally organized, large-scale trade. Peddling is indicated by the smaller quantities and scatter of specialized products (e.g., beads, jewelry, perfumes, and glassware from the Middle East). The homogeneity and distribution of Chinese ceramics, however, does not lend support to the idea that individual merchants were transporting their own specialized cargo. Instead, it appears that the Chinese cargo was loaded more or less all at once in a nautically efficient way—that is, pieces were loaded along horizontal planes rather than vertically, as would be expected if each merchant had his own stowage space. It is believed that the ship was sailing from China to Java.

One wreck that is contemporaneous with the Java Sea Shipwreck was recovered at Breaker Shoal off the southern tip of Palawan Island in the Philippines in 1991. Although the Breaker Shoal Wreck was initially estimated to have preceded Java Sea Shipwreck by a century, its ceramic cargo is strikingly similar, which has led us to reevaluate the original dating for the Museum's collection. Unlike the Java Sea Shipwreck vessel, however, the Breaker Shoal Wreck ship, as suggested by Dupoizat (1995) based on anchor type, appears to have been built in China (see Kimura et al. 2011). (Securely assigning an origin to this boat, however, is difficult, given that none of the hull survived.) Chinese ceramics make up the majority of the cargo and, like the Java Sea Shipwreck cargo, these ceramics include green-glazed (celadon) and olive-green-glazed bowls and dishes (or saucers); dark-brown- to black-glazed (*temmoku*) teabowls; *qingbai* bowls, dishes, covered boxes, and small "Marco Polo" vases with characteristic light blue glaze; storage bottles (probably

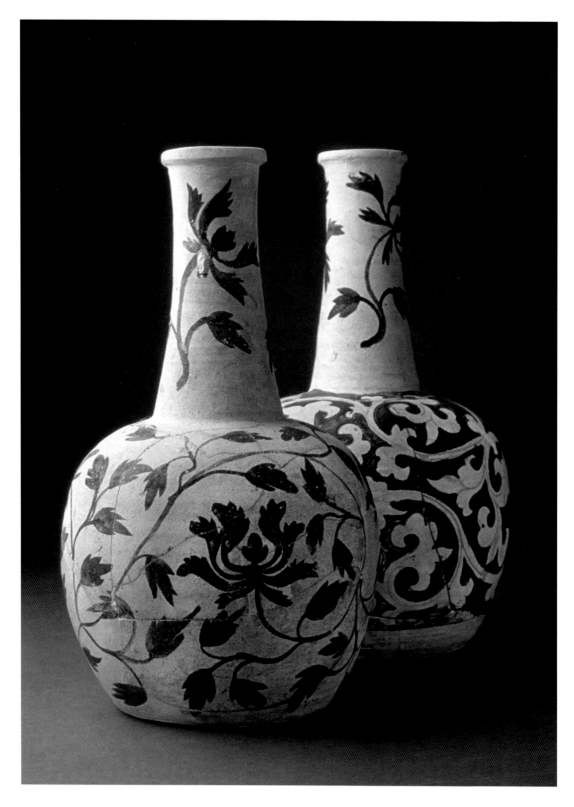

FIGURE 194
Ceramic vases from the Breaker Shoal Ship-
wreck in the Philippines, similar to ones from
the Java Sea Shipwreck. © Franck Goddio/Hilti
Foundation. Photographer Dirk Reinartz.

used to transport mercury or wine); ambrosia bottles; and painted ewers and vases (fig. 194). Although it appears that large pots were used to transport some of the smaller ceramics, few stoneware or earthenware storage vessels were recovered at the wreck site, indicating there may not have been a high volume of perishable items stored in such jars on board. Perhaps the vessel had not yet visited the ports where these kinds of trade goods would have been loaded. Flecker (2003) has hypothesized that the Breaker Shoal Wreck could have been traveling to the Philippines, Borneo, Sumatra, or Java. In places such as the Philippines, high-fired ceramics from China (and later from Thailand and Vietnam) are often found in mortuary contexts; however, in other parts of Southeast Asia, including Sumatra and Java, similar ceramics would have been used in other religious contexts as well, and many are found at port sites throughout the region (Miksic 2011). Flecker (2003, 41) asks, "If the end use of the ceramics was different, and certainly the cultural context of the two markets was, why were the cargoes nearly identical? Did the Chinese exporters, rather than the Southeast Asian importers, select the types of ceramics to be shipped to Southeast Asia?"

Many of the medieval shipwrecks discovered in East and Southeast Asia were transporting goods from China (or entrepôts holding Chinese goods) to elsewhere. This does not mean that commodities were not being traded into China as well. The issue is that many of China's imports were perishable items, such as spices, forest products, marine delicacies, and animal products, which tend to leave few easily detected traces archaeologically. Ceramics are more robust and tend to survive better—they also can fetch a pretty penny at the market or at auction. An amazing discovery from 1973 from Quanzhou Bay in Fujian, however, illustrates the import cargoes of natural products that were being shipped to China at that time (Green 1983; Green et al. 1998; Stargardt 2001). Because the Song Dynasty vessel sank in shallow water and was quickly covered by silt, its delicate cargo survived the centuries as did much of its hull. The ship is a hybrid construction, incorporating aspects of Chinese shipbuilding techniques (e.g., bulkheads) and Southeast Asian traditions. What is most remarkable, however, is the ship's preserved cargo, the bulk of which consisted of aromatic woods (more than 2.5 tons). Spices such as black pepper as well as ambergris (possibly from Somalia), frankincense (traditionally from the Middle East but also known from the islands of Southeast Asia), and minerals including mercury and hematite also were recovered.

Closing Thoughts

Over the past few decades, shipwrecks have become an increasingly important source of information on early trade and life along the Maritime Silk Road. A single wreck can lend insight into preferred commodities at a particular point in time, be used to reconstruct potential trade routes, provide data for the investigation of the manufacturing of goods and the organization of production, and present a "snapshot" of certain aspects of multiple societies. En masse, especially when

considered along with terrestrial sites, shipwrecks can help researchers track larger-scale changes in social and economic relationships over time and space. Unfortunately, shipwrecks also have become an increasingly popular source of materials for looters, local and foreign. Once a site is destroyed by looters, it cannot be pieced back together, nor can its artifacts be tracked down. In order to preserve the research integrity of these sunken treasures, it is important that work that promotes the use of archaeological methods and knowledge be made a priority by local and international communities of professionals and scholars. It is also essential that, after being carefully mapped, artifacts from a wreck be kept together so that research can be done on each of a cargo's component parts and the site can be understood as a whole. Perhaps most importantly, maritime archaeologists need to work with local communities, the members of which are the people who most often discover shipwrecks, to better understand how they can become partners in recovery efforts and the preservation of the world's underwater heritage.

Note

I am grateful to many people for their assistance but would like to especially acknowledge the help of Deborah Bekken, Gary Feinman, Jamie Kelly, Tom Skwerski, Amanda Respess, Peter Gayford, Laure Dussubieux, Lani Chan, Wenpeng Xu, and Lu Zhang. I also would like to thank the Commander Gilbert E. Boone and Katharine Phelps Boone family, whose generous support has made much of this research possible.

FIGURE 195
The physiology of a healthy body mirrored the landscape of a balanced ecosystem. © The Field Museum. Photo ID No.
A115177d_007. Catalog No. 125948. Photographer Karen Bean.

Herbs and Artifacts:
Trade in Traditional Chinese
Medicine

Amanda Respess

Medicines made from plant and animal sources have been used for centuries in traditional Chinese healing to treat disease and bring the internal landscape of the body into harmony with the external forces of nature. Herbal medicines were prized for their practical utility as remedies and for their symbolic resonance with the cosmological principles of yin and yang at work in the environment (Wiseman and Feng 1998, 705). A balanced body functioned like a balanced landscape, with every element in its proper place (Kaptchuk 2000, 1–5). The landscape painting at the beginning of the first gallery of the *Cyrus Tang Hall of China*, "Diverse Landscapes, Diverse Ways of Life," reflects the balance between yin and yang in nature (fig. 195). A skilled physician could manipulate the complementary qualities of dark and bright and feminine and masculine represented by yin and yang through the careful combination of herbs administered to a patient, bringing physical relief and cosmological unity to the afflicted (Wiseman and Feng 1998, 705).

Medicines harvested from the natural landscape were transformed into important perishable commodities that circulated across China's trade routes. As China's relationships with places and people beyond its borders expanded during

the Tang Dynasty (AD 618–907), new herbal remedies grown in far-flung locations became more readily available (Miksic 1997, 14). In the Song (AD 960–1279) and Yuan (AD 1279–1368) Dynasties, storage jars like the ones found in the last gallery of the exhibition, "Crossing Boundaries, Building Networks," were used to transport herbs and spices to and from bustling maritime ports (fig. 196). A robust trade in medicinal plant and animal products connected healers and patients in China with a world of cures circulating throughout South and Southeast Asia, the Near East, and the African coast.

FIGURE 196
Storage jars like these were used to transport herbs and spices used in compound medicines. © The Field Museum. Catalog Nos. 350503, 354475. Photographer Gedi Jakovickas.

FIGURE 197
Aromatic resins were used in religious rituals, in herbal formulas, and for their medicinal smoke. © The Field Museum. Catalog No. 351443. Photographer Gedi Jakovickas.

Spices, dried plants, and animal products were used in herbal formulas to treat ailments ranging from stomachaches to seizures. Perishable goods such as nutmeg, anise, and pepper from Java were combined with other herbs to make compound medicines that could be ingested as teas, eaten with food, applied topically, and burned for their medicinal smoke (Zhao [1225?] 2012, 77–78, 81, 223). Aromatic resins were valued across the trade routes for their healing qualities, and in the exhibition visitors can find a sample recovered from the Java Sea Shipwreck that is more than seven hundred years old (fig. 197).

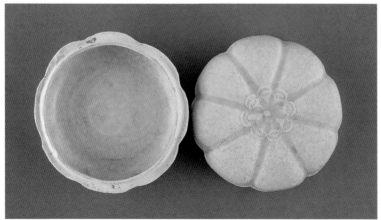

FIGURE 198
Ivory was used in a medical formula to treat fever and hemorrhage. © The Field Museum, Anthropology. Photographer Pacific Sea Resources.

FIGURE 199
Small boxes like this one were used to hold medicine, cosmetics, and mirrors. © The Field Museum. Catalog No. 344425.A-.B. Photographer Gedi Jakovickas.

Also recovered from the Java Sea Shipwreck, but not on display, are unworked pieces of ivory (fig. 198). Berthold Laufer, The Field Museum's curator of Asian anthropology from 1907 to 1934, wrote that powdered ivory was used in the Chinese medicinal formula *lóng gǔ*, or dragon's bone, to treat conditions including fever and hemorrhage (Laufer 1925, 16, 25–26). Several cups carved from rhinoceros horn (see fig. 16), collected for the Museum by Laufer, can be seen in the exhibition. Rhinoceros horn was valued for its beauty and, according to an early Song Dynasty formulary, the *Taiping Shenghuifang*, for its use as *xī jiǎo san*, a medicinal powder used to clear heat from the body (Wang [978?] 1982; Wiseman and Feng 1998, 731).

Other medical objects on view in the galleries of the exhibition include incense censers used for the fumigation of medicinal and ritual herbs, teabowls, medicine boxes, and *kendis*. Tea bowls were essential for the ingestion of herbal formulas brewed in pots, and wide-mouthed *kendis* (handle-less, spouted vessels) were used for brewing medicines, performing ablutions, and other purification rituals (Brown 1997, 172). Ceramic boxes, like the one shown here (fig. 199), were used to contain medicines, cosmetics, and mirrors. The melon shape of this box employs a fruit-fertility motif popular in Song Dynasty ceramics that may hint at the nature of its intended contents and use (Respess and Niziolek 2016, 98).

Note

This material is based upon work supported by the National Science Foundation Graduate Research Fellowship under Grant No. DGE 1256260.

CONCLUSION

Legacies of Qin Unification:
A Hinge Point of Chinese History

Gary M. Feinman

In the concluding essay of this collection concerning China's history and the longevity of both China (as polity or nation) and its cultural traditions, I take the opportunity to step back, explore, and decouple the different meanings of China. I also examine the contexts in which certain core cultural traditions associated with China and Chinese civilization were constructed and factors behind their temporal endurance. The *longue durée* of China's history is placed in contrast to Europe's historical pathway over the same general time frame.

China as a national or political entity did not always exist. It was first politically unified under the Qin (221 BC), conquerors of the other states that had warred during the prior centuries. During the short reign of the Qin Dynasty (221–206 BC) and the longer imperial rule of the subsequent Han Dynasty (206 BC–AD 220), the core territorial domain that became (and that we know today as) China was established. Following the Han Dynasty, China's core domain was repeatedly disassembled and reassembled. Ultimately, the territorial extent of the nation also was expanded to its present size. Across these political breakdowns and reunifications, the capital centers of China shifted at times, as did the specific dynastic families that dominated. Nevertheless, this historical path differs from Europe's, which

basically never saw political unity at any scale or for any significant duration following the collapse of the Roman Empire.

Before I address these historical differences, it is important to clarify what is meant (and not meant) by "political unification." A unified polity refers to a state, empire, or other form of governance that generally corresponds with or has a form of dominion over a specific geographic extent. The boundaries of that domain need not be entirely finite over time, nor does everyone within the polity have to recognize the governance of the polity with equal reverence or enthusiasm. More importantly, political unity should not be conflated with biological, linguistic, or ethnic uniformity or lack of diversity (cf. Fiskesjö 2015). The governments of many past and present polities exercised rule over diverse populations. In fact, the governance of a diverse populace is basically a definitional tenet of the concept of empire (Sinopoli 2001, 444).

All polities are underpinned by traditions regarding governance, sets of conventions that define roles and responsibilities, social contracts, systems of writing and communication, constructs and beliefs that link polities and their governors to the supernatural world, and other covenants and practices that define ways of life and cooperation. Collectively, these conventions can be thought of as a "civilizational tradition" (sensu Yoffee 1988), and often they extend well beyond the span of a specific government or polity. Chinese civilizational tradition has its roots in the Neolithic period and Bronze Age; thus, elements of this tradition predate the Chinese polity and its unification. Yet here I propose that the steps taken and processes initiated just before, during, and in the centuries right after China's political unification are a key element for understanding the subsequent durability of China and its associated civilizational traditions.

Political Unification: China and Europe

Two millennia ago, empires situated at the opposite ends of Eurasia dominated their respective regions (Scheidel 2009). To the west, Rome was in the process of expanding its conquests across Europe, while, to the east, the Han, having assumed power following the short-lived Qin Dynasty, ruled over most of what is today China. At their peaks these polities were roughly comparable in spatial extent; however, their subsequent histories and the political legacies that followed their declines were markedly different (Ko et al. 2014). The bounds of the Roman Empire were never historically reconstituted after that empire cleaved into eastern and western sectors that then splintered into smaller pieces. Initially, the fall of the Han Empire also was similar to the fall of the Roman Empire: it first split into large subunits. But Chinese regions, after the initial Qin unification in 221 BC, were reintegrated repeatedly into one political unit, despite intermittent periods of disunity (Turchin 2009). From the founding of the empire to its dissolution in the early twentieth century, the area from the Mongolian steppe to the South China

Sea was ruled by a single authority for roughly half this period (Ko et al. 2014; Ko and Sng 2013; Scheidel 2009).

Why humans cooperate in large, often relatively durable social groupings is a key question for contemporary research (Blanton and Fargher 2008; Carballo et al. 2014; Kennedy and Norman 2005). Thus, the repeated historical renegotiation of China's continent-scale political consolidations remains a scholarly focus after more than a generation of attention (Barfield 1989; Ko and Sng 2013; Lattimore 1962; Turchin 2009). One perspective (Ko and Sng 2013; Turchin 2009) places great emphasis on biogeography and defensive concerns, specifically the persistent, perceived military threat of mobile peoples along China's northern frontier. Yet although northern invasions did occur periodically during China's history (Barfield 1989; Turchin 2009) and military threat does provide strong incentives for collective action (Blanton and Fargher 2008; Turchin 2006, 2009), many questions remain unanswered. Why, in China, was the military challenge met by successful, albeit not always long-lived, political reconstitutions (threats from mobile peoples had no such collaborative effect in Europe) (Scheidel 2009)? Why did areas distant and less threatened by the northern frontier reintegrate, and why did the repeated reestablishment of empire reunify a landscape close to the limits achieved originally by the Qin? These unanswered questions belie a problematic but oft-held premise: that widespread cooperation was somehow easy to attain in China, perhaps, because the populace shared a long-standing cultural tradition or ethnic identity (Eisenstadt and Giesen 1995).

In contrast, it is my central proposition that Chinese collective identities (Yates 2001), which became social building blocks of large-scale political integration, were constructed, as evidenced elsewhere (Emberling 1997; Nagel 1994), and certainly were not somehow primeval or "natural." I recount processes and events, both prior to and after the initial Qin unification, that fostered the making of more overarching Chinese collective identities, subsuming strong elements of local customary diversity (Pines et al. 2014). In other words, social, political, and economic practices and institutions have repeatedly underpinned the polity of China, interweaving axes of biological, linguistic, ethnic, and subsistence diversities, the roots of which extend back to the Neolithic (e.g., Liu 2004).

To assess this sequence, I examine multiple analytical scales. First, I synthesize and consider documentary histories (which generally reflect the perspectives of rulers and elites) in context with archaeological overviews that recapitulate the historical sequences that ran from diverse networks of agricultural communities across China during the Neolithic to the Qin unification. Then, to assess the ways in which political edicts and governance practices played out for lives on the ground, I review the findings from one region of China (the coast of Shandong Province), eventually conquered and integrated by the Qin-Han, where my colleagues and I are conducting a systematic regional archaeological settlement pattern survey (Fang et al. 2015; Fang et al. 2012; Feinman et al. 2010; Underhill et al.

2008). Through this multiscalar investigation, I evaluate both shifting strategies of governance and the ways that they were negotiated and received by people on the landscape in one local context.

Paths from Village Life to Political Unification

Over the last three decades, the advent of new findings has led to a dramatically revised understanding of the transitions from mobile hunter-gatherers to sedentary farmers in China (Cohen 2011; Shelach 2015; Zhao 2011; Crawford, this volume; Feinman et al., this volume). A prior generation of models that envisioned the radiation of agricultural villages from China's Central Plain, surrounding the Yellow River, out to the rest of the continent have been roundly rejected and are in the process of being reworked to reflect new data and understandings (Shelach 2000, 2015). A deeper time and more spatially mosaic Neolithic era is evidenced (Crawford, this volume; Feinman et al., this volume), characterized by significantly different subsistence preferences, sequences of change, community patterns, modes of leadership, and even symbolic representations across the diverse landscapes of China (Bettinger et al. 2010; Falkenhausen 2007; Liu 2004; Shelach 2015). The extent of variation extended well beyond the variability in subsistence regimes that favored rice in the south and varieties of millet in the north. By 5000 BC, across China, there was marked diversity in the ways that power was funded, materialized, and communicated between emergent leaders and associated subalterns with seemingly more collectively oriented governance in some regions, such as the Central Plain, and more ruler-centric political formations in others, such as the Yangtze River Delta (Xinwei Li 2013; Liu 2004; Qin 2013; Shelach 2015; see also Feinman et al., this volume).

By the advent of the second millennium BC, what is today China was divided into many small polities that, although interacting in down-the-line socioeconomic networks, had distinctive ways of manifesting power and communicating their identities through the use of diverse ceramic and other artifact traditions (Bagley 1999). Subsequent textual accounts place the roots of early Chinese civilization in the Central Plain, principally with the Shang Dynasty (c. 1600–1046 BC) (fig. 200). Shang rule was aristocratic, based on the veneration of clan ancestors, access to metal resources, the production and distribution of bronze vessels, writing, and the materialization of powerful symbols. During the second millennium, precocious developments in urbanization, high-intensity metal production, and early writing did occur on the Central Plain (Bagley 1999; Liu 2009). Yet the first experiments in metalwork for China occurred outside this area (Bagley 1999; Shelach 2015, 146; Yao 2010), and massive population centers also arose elsewhere associated with highly different indigenous cultural traditions (Bagley 1999).

The initial conception of ancient Shang military expansionism has narrowed from earlier interpretations as detailed archaeological investigations have been undertaken in regions adjacent to the Shang heartland (Liu 2009; Yates 2001).

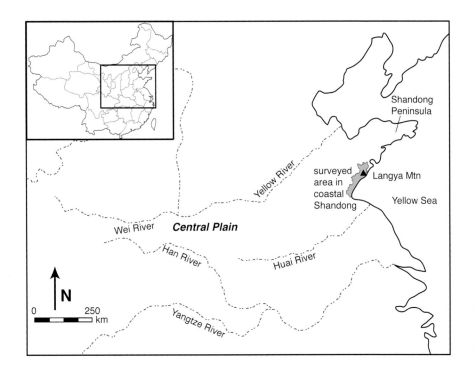

FIGURE 200
China, showing places mentioned in
the text. Map by Linda Nicholas and Jill
Seagard.

Although involved in the acquisition of metals, and so extended networks of trade, the geographic extent of Shang conquest was limited. Texts do confirm that the Shang viewed their enemies, especially those who were able to successfully withstand their military forays or lay beyond them, as "barbarian" peoples, with distinctive collective identities (Fang 2013). For example, according to Shang oracle bones, the barbarian peoples to the east (in Shandong Province) had their own distinguishing rituals, supernatural spirits, religious objects, and ceremonies and sacrifices (Fang 2013).

The defeat of the Shang by the Zhou, whose homeland was in northwest China, was the first episode of several during Chinese history where outsiders invaded and conquered the Central Plain but then adopted many of the governing and cultural practices of that region (Falkenhausen 2006; Yates 2001). The epoch of Zhou rule was the longest-enduring Chinese dynasty, albeit also a time of cataclysmic change. Many of the institutions and practices that underpinned later notions of Chinese identity and governance were first implemented during that era (Falkenhausen 2006; Feng Li 2006), but the most significant of these shifts occurred after the Western Zhou period (c. 1046–771 BC). Western Zhou rulers made near-continuous efforts to vanquish the people of Shandong, in the east, and while they conquered some areas and disrupted others, people still referenced in texts as "eastern barbarians" were able to rebuff their military efforts, especially in coastal Shandong (Fang 2013; Feng Li 2006).

The subsequent centuries of the Zhou period (Eastern Zhou, 770–256 BC) were marked by both political consolidation and significant shifts in the principles and practices of governance and rulership (Falkenhausen 2006; Yates 2001).

As typified by the writings of the great philosopher-politician Confucius, there was a shift in leadership and governance from more aristocratic forms that were legitimized through linear clan-based ties to more explicit moral codes and defined social expectations for rulers, the ruled, and those who administered the functions of government (Blanton and Fargher 2008; Falkenhausen 1999, 2006). An emergent nonhereditary bureaucracy implemented systems of taxation and legal codes (Falkenhausen 1999, 2006). The Eastern Zhou Dynasty endeavored to expand its political hegemony in all directions through conquest and political alliance but met perpetual resistance, and in the latter centuries of this era centralized authority largely broke down, leaving five to ten formerly vassal states across the Chinese landscape to vie for power and territorial control during the Warring States era (475–221 BC) (fig. 201) (Falkenhausen 2006; Pines et al. 2014; Shelach and Pines 2006). Growth in the size of polities along with the challenges of ruling over increasingly diverse populations in the face of persistent political and military competition probably prompted fiscal reforms and the adoption of the somewhat more collectively oriented policies and practices, such as investments in public goods (Blanton and Fargher 2008; Deng 2012, 338–39). As diverse populations were integrated into ever-larger states during this era, the contrasts expressed in documents of the time between Zhou peoples and the "barbarians" outside the bounds of the empire were sharpened (Falkenhausen 1999). The long Zhou era was the time when "the Chinese defined for themselves a culture as well as a world" (Hsu 1999, 550).

FIGURE 201
Polities of the Warring States period and location of the Qi wall. Map by Linda Nicholas and Jill Seagard.

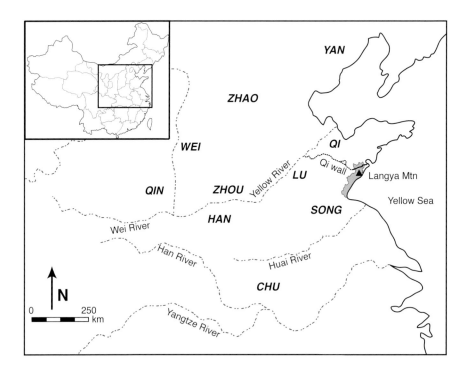

CONCLUSION

Qin Reforms, Han Programs, and Shifting Notions of Identity

In China, there was no collective Chinese identity at the outset of the Warring States period; rather, traditional affiliations, including language, funerary customs, and notions of time (almanacs), often were associated with local states, albeit polities then growing in size (Yates 2001). The Qin state, one of these local polities, was vassal to the Zhou and situated northwest of the latter's core (Shelach and Pines 2006; Yates 2001). During the fourth century BC, the Qin began an episode of conquest that culminated in China's political unification. Although subsequent Qin imperial rule was exceedingly short, the changes set in motion during these times contingently underpinned a national identity and the course of subsequent Chinese history (Lewis 2007; Pines et al. 2014; Shelach and Pines 2006; Yates 2001).

With military conquests, the Qin state instituted new governmental policies. An array of initiatives was designed to reorder long-standing social relations, thereby severing the ties between subalterns and aristocratic local lords. Other reforms were meant to strengthen the Qin state by increasing its tax base, expanding its armies, and redirecting the loyalties and affiliations of all its constituents to a national identity, the Qin state (Lewis 2007; Yates 2001). The reforms were fundamental and multifaceted, including diminishment of rituals associated with ancestor veneration, binding households into groups of five that were intended to share responsibility for each other's behavior, naming commoners, and placing greater expectations on farmers to join the military (Shelach and Pines 2006). Military prowess and governmental service became means for subaltern social mobility (Lewis 2007; Shelach and Pines 2006).

Later Qin changes fundamentally altered the rhythms of life and networks of communication. A uniform system of coinage was introduced. A census was implemented. The written script was unified to enhance communication across language and dialect communities. Registries and tolls were imposed to limit and track personal movement. Daily and yearly almanacs were synchronized, with the impact of harmonizing rituals and commemorations over broader spatial realms (Lewis 2007; Yates 2001), thereby promoting cross-regional movement and communication.

Some Qin directives, both in the century before and immediately after unification, were intended to break down and reorient existing socialized landscapes. Numerous roads were built, and river transport was improved. Efforts were made to connect the defensive walls that had been built at the northern limits of three of the warring states, which became the genesis of China's Great Wall (Lewis 2007; Yates 2001). After the defeat of the last competing state, the Qi, in eastern Shandong, thirty thousand families were moved to the coast to establish a new regional capital at Langyatai (Feinman et al. 2010; Sima 1993a, 47). Similar mass relocations were ordered elsewhere as well (Bodde 1986).

Overall, the reforms instituted by the Qin were geared for persistent war, conquest, and the bureaucratic redefinition of an expansive domain (Kiser and Cai

2003). Qin governance both was underpinned by, and in certain respects rejected, prior Zhou statecraft, including certain fundamental social contracts and moral codes (Shelach and Pines 2006). Although early texts state that the Qin rulers recognized that the world had changed with unification, their policies and practices were legitimized and guided by claims that the emperor was unique in possessing godlike powers, destined for eternal life (Lewis 2007). Faced with many potential royal rivals and a massive empire, the Qin Dynasty endured only a few years following the death of the First Emperor, Qin Shihuang (also known as Shihuangdi). Infrastructural investments could not keep up with the rapid tempo of expansion (Bodde 1986).

Dynastic power shifted to the Han, who maintained many of the unifying initiatives of their immediate predecessors but readopted key elements of Zhou statecraft and morality, including the "Mandate of Heaven," which proclaimed the emperor's place as a product of supernatural authority rather than cosmic process (Lewis 2007). The Han tax regimes on land, on labor service, and for capitation (health services) were broadly levied but relatively low (Lewis 2015, 282, 304). In contrast, Roman fiscal extractions were unevenly applied and tended to focus on extractive resources (such as mining) as well as trade (Scheidel 2015, 251–54).

Even though greater degrees of power were shared with local despots during the first centuries of the Han Dynasty, the imperial authority of the centralized empire was reaffirmed (Bodde 1986). Unity and unification were preferred and associated with leadership. The overarching imperial order gave primacy to universality but did not mandate uniformity, thus integrating elements of diversity (Lewis 2006; Loewe 1994; Pines 2005–6).

At the same time, investment continued in many public goods projects begun by the Qin. These initiatives and others pushed and pulled peasants to intensify farming, thereby reaching previously unprecedented levels of agrarian production (Anderson 1989; Bray 1979–80). In the AD 2 census, the first preserved, the population of China exceeded 57 million people, which is estimated to be a significant increase from even a few centuries before (Bodde 1986; Duan et al. 1998). The Han Dynasty bequeathed political, social, and ideological foundations for empire that endured largely intact for two millennia (Bodde 1986).

Integrating Diversity: A Microscale Focus from Coastal Shandong

I have outlined the sequence of changes at the national scale that led to the 221 BC unification of China and the construction of belief systems, ideological constructs, bureaucratic blueprints, and socioeconomic connections that served as the basis for later episodes of political consolidation. Yet the empirical basis for this account is almost entirely top-down, derived from texts, leaving unaccounted for the perspective and presence of more than 90 percent of the population. Voice cannot be given to the majority, but in this section we are able to gain novel insights into how this massive grand-scale transition interfaced with lives on the ground for at

least one local region, coastal Shandong, that has been systematically investigated through regional archaeological settlement pattern survey (Fang et al. 2015; Fang et al. 2012; Feinman et al. 2010; Underhill et al. 2008).

Over the past two decades, our collaborative team has implemented a broad-scale walkover of more than 2,400 square kilometers, covering a large coastal basin immediately south of the Shandong Peninsula in eastern China (see fig. 200) (Fang et al. 2015; Fang et al. 2012; Feinman et al. 2010; Underhill et al. 2008). The aim of archaeological survey is to record broad-brush spatial and temporal perspectives on changing settlement patterns and demography for the focal region by systematically recording surface archaeological remnants of ancient settlement that are recovered on the ground and diligently entered on maps (Fang et al. 2012; Kowalewski 2008; Liu 2009, 221–22; Underhill et al. 1998). Pottery, the most abundant artifact recovered during field study, provides a basic means to date the surface remnants of past human landscape use and so ancient settlement patterns across time. Other visible architectural and archaeological features, such as tomb monuments, platforms, ancient walls, and exposed pits also are recorded systematically (Fang et al. 2012; Underhill et al. 2008).

Based on the settlement survey, coastal Shandong was not inhabited by a wide network of farming communities until the latter half (c. 3000 BC) of the Neolithic period (Fang et al. 2012; Underhill et al. 2008). Yet once the area was settled, the population grew rapidly, and by the Early Longshan period (c. 2600 BC) the regional population aggregated around three large settlements, Yaowangcheng in the south, Liangchengzhen in the center, and Hetou in the north, with population rather evenly distributed across the area (fig. 202). Although the material culture inventory between these three sectors appears homogeneous, these areas each have somewhat different topographic and environmental settings. The southernmost area is very flat, with wide rivers that empty into the coast, and is used to farm mostly rice today. The middle sector includes somewhat more rolling topography, with narrower watercourses, and the farming economy is mixed, including wheat, with only patches of rice. The northernmost area is most dissected and hilly, although the suite of crops today is broadly similar to that immediately south of it, with greater representation of cold-tolerant plants, such as cabbage.

By the subsequent Middle Longshan period (c. 2400 BC), the population in and around Hetou in the north markedly declined as the two other centers continued to exceed all others in size (fig. 203). The ceramics and other material culture in the coastal basin was different from that found on the Shandong Peninsula to the north (Luan 1997), and so we propose that the northern end of our survey region may have become a kind of buffer or shatter zone between people affiliated with these different traditions. Likewise, although the size of these central communities and the density of overall settlement on the coast were not at all indicative of mobile "barbarians referred to in documents," the ceramic, polished stone, and symbolic traditions on the coast were sufficiently distinct from those found on the Central Plain at this time that they could have been viewed by the people on

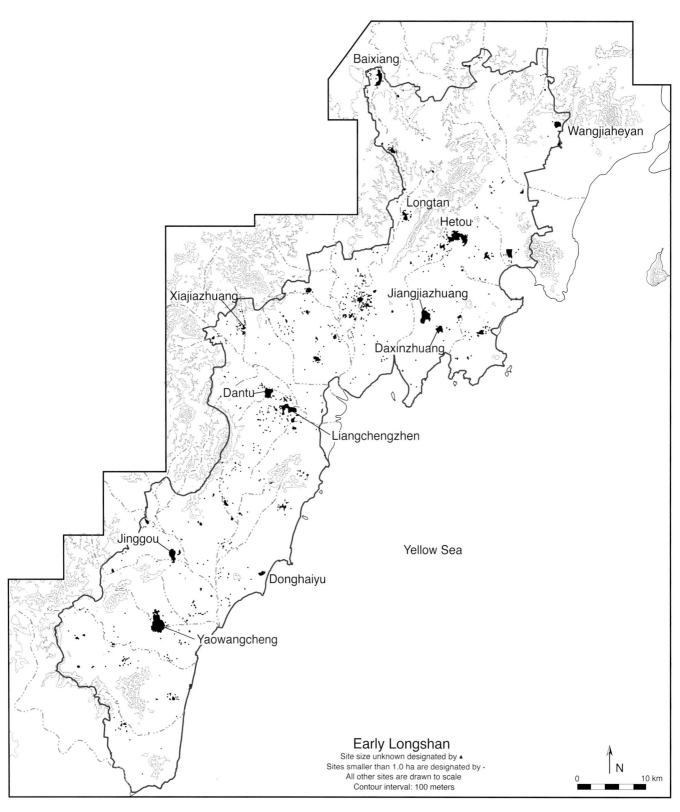

Baixiang

Wangjiaheyan

Longtan

Hetou

Jiangjiazhuang

Xiajiazhuang

Daxinzhuang

Dantu

Liangchengzhen

Jinggou

Yellow Sea

Donghaiyu

Yaowangcheng

Early Longshan

Site size unknown designated by ▲
Sites smaller than 1.0 ha are designated by ·
All other sites are drawn to scale
Contour interval: 100 meters

N

0 10 km

FIGURE 202

Early Longshan settlement in southeastern coastal Shandong.

Map by Linda Nicholas and Jill Seagard.

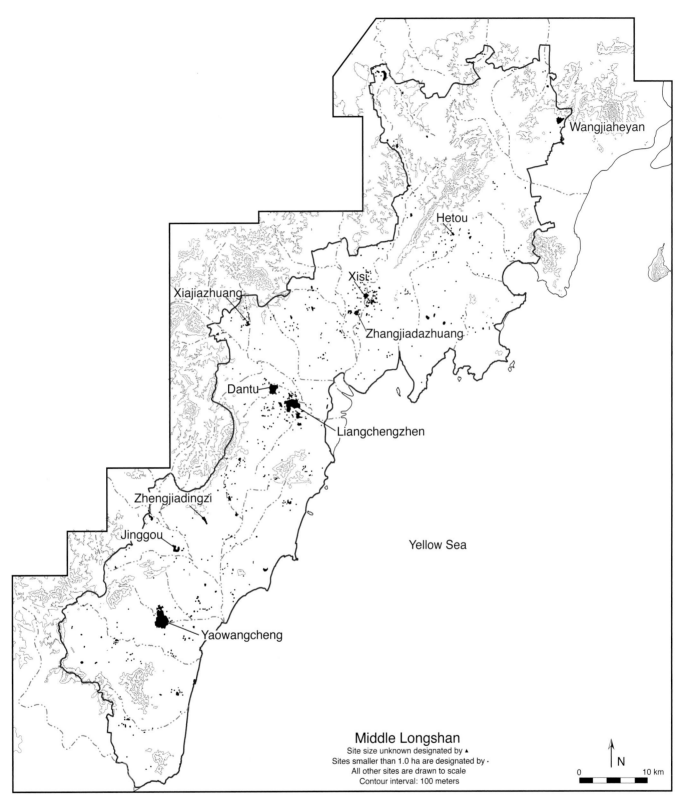

Wangjiaheyan

Hetou

Xist

Xiajiazhuang

Zhangjiadazhuang

Dantu

Liangchengzhen

Zhengjiadingzi

Jinggou

Yellow Sea

Yaowangcheng

Middle Longshan

Site size unknown designated by ▲
Sites smaller than 1.0 ha are designated by ·
All other sites are drawn to scale
Contour interval: 100 meters

0 10 km

N

FIGURE 203

Middle Longshan settlement in southeastern coastal Shandong.

Map by Linda Nicholas and Jill Seagard.

the opposite side of the Shandong mountains as ethnically "other." Furthermore, in accord with the texts, we found no artifactual or other material indication of a Shang invasion or direct, persistent presence on the Shandong coast early in the Bronze Age (Fang 2013).

Later in the Bronze Age, incursions and influences from the west did have significant effects on the Shandong coast, although at least during the Western Zhou period, we do not think that most of the coastal population was incorporated into expansive polities with capitals outside the investigated region. Nevertheless, by late in the second millennium BC, the settlement patterns on the Shandong coast shifted markedly, as both the size of the largest centers and the region's overall population declined (fig. 204). During the Western Zhou period, many of the larger communities were moved to elevated, somewhat defensible, locations along the western edge of the study region. Together these communities define an alignment of settlements that extended from the western edge of the basin to the coast (north of where Liangchengzhen is situated). The placements of these settlements define or demarcate the southern two-thirds of the surveyed region from the north and west. Most of the area north of this west-east line of settlements continued to be sparsely occupied as it had been since the decline of Hetou following the Early Longshan period.

By Eastern Zhou times, there was another significant shift in the settlement pattern of the coastal basin where we are surveying (fig. 205). Many of the earlier Western Zhou defensible settlements that appear to have defined a coastal domain were abandoned or diminished in size. Yet overall, the coastal population increased (Fang et al. 2004) (see figs. 204 and 205). At the same time, the head towns or central places in the region remained relatively small. In accord with the political consolidation established in documents, the coastal basin probably was incorporated into one or more larger states whose capitals were located outside the study region. Although the regional population expanded during the Eastern Zhou period, the population along the northern edge did not, remaining sparse as it was for more than a millennium.

The Great Wall of the Qi State (seemingly China's first great wall) was erected early in the Warring States era in a basically east-to-west direction across much of what is today Shandong Province (see fig. 201). The rammed-earth wall, which was lined or bolstered by stones in places, extends more than 600 kilometers. It defined the southern limits of the Qi polity, which was the last of the large warring polities to be engulfed by Qin armies prior to unification. During the survey, we followed the easternmost extension of the Qi wall for 50 kilometers where it crosses the northern limits of our study region (fig. 206). Therefore, the political border that the wall demarcated in Warring States times probably had been a kind of boundary for more than 1,500 years. At least for its easternmost 50 kilometers, the Qi wall was erected along ridgetops and followed the highest contours possible, descending to lower elevations only when there was no other option. The Qi wall was not exceedingly tall and probably was most effective as a means to slow down

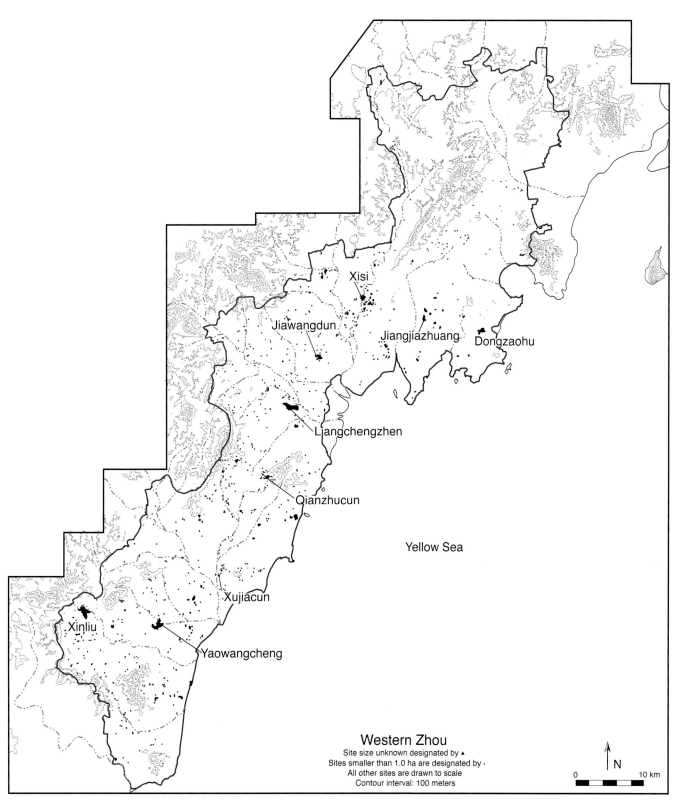

Xisi

Jiawangdun

Jiangjiazhuang

Dongzaohu

Liangchengzhen

Qianzhucun

Yellow Sea

Xujiacun

Xinliu

Yaowangcheng

Western Zhou

Site size unknown designated by ▲
Sites smaller than 1.0 ha are designated by ·
All other sites are drawn to scale
Contour interval: 100 meters

N

0 10 km

FIGURE 204

Western Zhou settlement in southeastern coastal Shandong.

Map by Linda Nicholas and Jill Seagard.

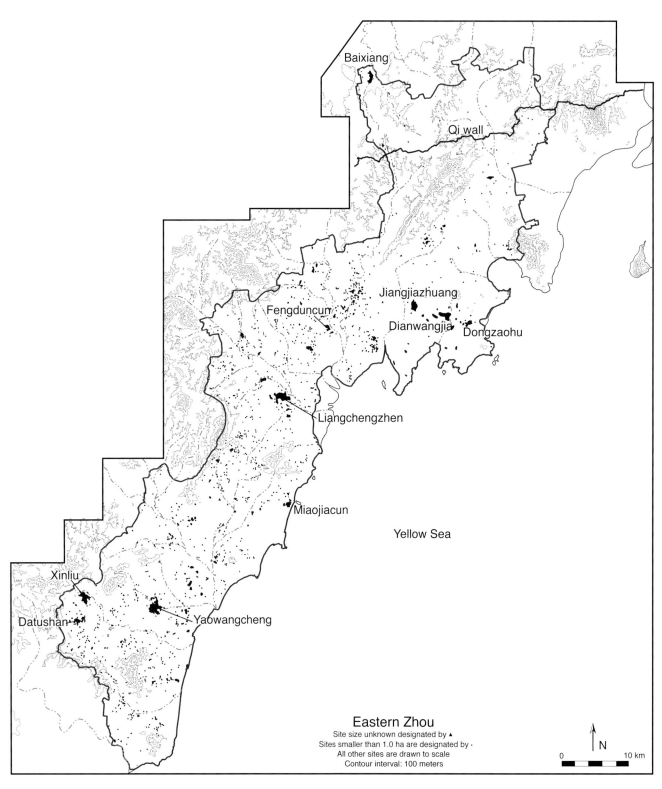

Baixiang

Qi wall

Jiangjiazhuang

Fengduncun

Dianwangjia

Dongzaohu

Liangchengzhen

Miaojiacun

Yellow Sea

Xinliu

Datushan

Yaowangcheng

Eastern Zhou

Site size unknown designated by ▲
Sites smaller than 1.0 ha are designated by ·
All other sites are drawn to scale
Contour interval: 100 meters

N

0 10 km

FIGURE 205

Eastern Zhou settlement in southeastern coastal Shandong.

Map by Linda Nicholas and Jill Seagard.

FIGURE 206
Survey crew walking on the Qi wall as
it winds its way up the hilltop in front of
them. Image courtesy of Linda Nicholas.

the giant military infantries that are reported in textual accounts of the Warring States period (Lewis 1999).

The Qin breached the wall and defeated the Qi. Qin Shihuang, China's first emperor, commemorated his victory with a visit to these new conquests and the eastern coast. He climbed Langya Mountain, overlooking the sea, and below on the coast erected a stele to proclaim his rule (Feinman et al. 2010; Kern 2007; Sima 1993b). Later, according to textual accounts, as an expression of his delight with the region and the sea, he relocated thirty thousand families to Langyatai (Bodde 1986, 47; Sima 1993a). But in line with other programs to construct a more unified imperial domain, it seems likely that Qin Shihuang was intent on breaking down long-lived cultural and political divisions by placing a hub of economic and political activity in an area that for generations had been settled sparsely. These Qin reforms, largely reaffirmed by the Han, appear to have achieved their aim. The population grew rapidly in the region during Qin-Han times, with the greatest expansion in the northern sector, surrounding the emergent local capital of Langyatai (fig. 207). Han settlements were established in what was the earlier shatter zone, as the harbor and salt resources around the provincial capital fostered local economic growth (Feinman et al. 2010). Across the coastal basin, the Han population reached

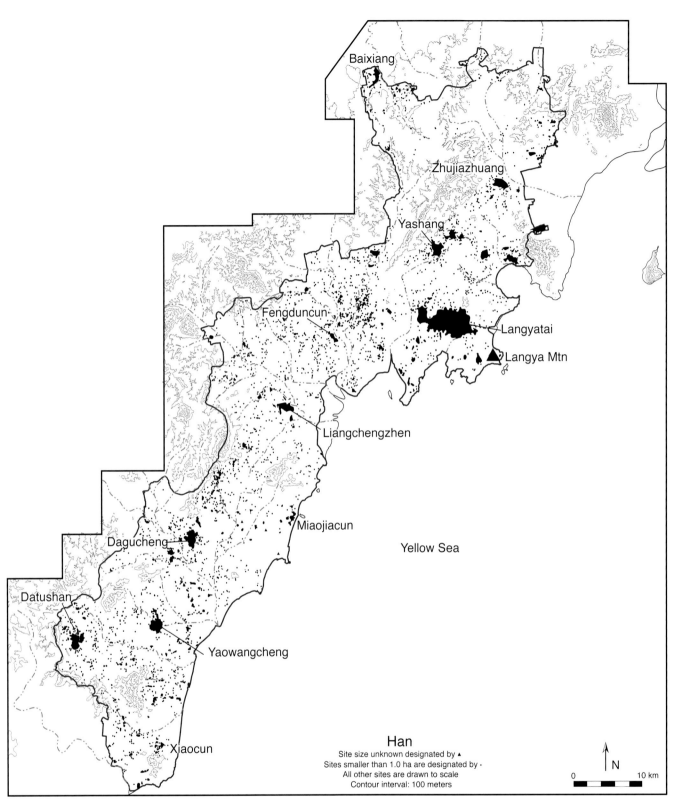

Baixiang

Zhujiazhuang

Yashang

Fengduncun

Langyatai

Langya Mtn

Liangchengzhen

Miaojiacun

Yellow Sea

Dagucheng

Datushan

Yaowangcheng

Xiaocun

Han

Site size unknown designated by ▲

Sites smaller than 1.0 ha are designated by ·

All other sites are drawn to scale

Contour interval: 100 meters

N

0 10 km

FIGURE 207

Qin-Han settlement in southeastern coastal Shandong.

Map by Linda Nicholas and Jill Seagard.

levels not achieved earlier. A number of towns grew up near natural routes and passes to the west. These new second-tier settlements, such as Dagucheng, probably served as nodal communities that linked the coast to more inland areas at a time of increasing communication and socioeconomic integration.

Concluding Thoughts and Implications

The evidence of diachronic change (at two analytical scales) in China from the Neolithic to the nation's first episode of unification has been marshaled to document how a diverse landscape inhabited by people with a multitude of different traditions and economic pursuits were ultimately unified into one of the largest imperial domains that the world had seen to that date. There was nothing preordained or strictly biogeographic that led to these consolidating trends, nor were such factors sufficient when the rulers and people of China reintegrated themselves into a single polity in the subsequent two millennia. Local variation in dialect, culinary traditions, and other customs also were maintained, but these elements of diversity did not crystalize into long-standing episodes of political fragmentation (Skinner 1985). Rather, the globally unique tendency for China to be politically unified so repeatedly at a near continental scale (Ko et al. 2014; Ko and Sng 2013; Scheidel 2009; Turchin 2009) was in large part the consequence of the social construction of an amalgam of broadly held political ideals, institutional structures and ties, public goods expenditures, unified communication technologies and commerce networks (Skinner 1977, 23), and collective traditions and memories that were initially negotiated and adopted during the Shang, Zhou, Qin, and Han eras. Although these practices and institutions certainly did not remain entirely stagnant, they did become part of the fabric of Chinese collective identities underpinning subsequent efforts for the reformulation and sustenance of political unity.

More specifically, the forging of new moral codes and sociopolitical contracts and institutions during the Bronze Age that reworked relations between states, elites, and ordinary citizens was a foundation and catalyst for subsequent and repeated episodes of political consolidation (Deng 2012; Kiser and Cai 2003). In Europe during a comparable period of political expansion, Roman governance, with mostly smaller-scale enemies, a focus on resource extraction, and little attention to investments in pubic goods did not institute or negotiate comparable shifts in these fundamental interpersonal relations (Ertman 1997; Scheidel 2009, 16–17). During the Roman Empire, patronage and patrimonialism remained key pillars of imperial power (Scheidel 2009), and the legacy after imperial collapse left a much more culturally and politically fragmented landscape. As a consequence, subsequent military threats that required a defensive response served as spurs for more collective action and political response in China, whereas parallel threats still today do not have a comparable effect at the opposite end of the Eurasian land mass.

China as a polity and China as a civilizational tradition are long-enduring human constructions. The Qin unification of China was a foundation and impetus for these persistent entities. For that reason, the initial unification of China also is situated as a well-suited and key hinge point for the *Cyrus Tang Hall of China*, bridging the first two galleries of the exhibition, which have a chronological organization, and the last three galleries, which are more thematic in coverage. Through this structure, and the themes that weave through this chapter and collectively the volume, the authors and collaborators to this project and the exhibition endeavor to capture three central features of China and its traditions—diversity, change, and continuity.

Note

I thank the national, provincial, local, and Shandong University officials who made the Shandong University–Field Museum project possible and assisted us in many ways over the years. I gratefully acknowledge the financial support received from the National Science Foundation, Henry Luce Foundation, Wenner-Gren Foundation, Field Museum, Tang Foundation, Chinese Program to Introduce Disciplinary Talents to Universities (111-2-09), Qingdao City Institute (Shandong, China), and Chinese Project III to Probe the Origin of Civilization. Hui Fang and Linda Nicholas have been wonderful and essential partners during the entire systematic archaeological survey in eastern Shandong. Anne P. Underhill, Fengshi Luan, Haiguang Yu, and Fengshu Cai were vital partners at the project's start. Many other colleagues and students participated in critical ways during the study; although we cannot list them all, their efforts are deeply appreciated.

REFERENCES

Introduction

Davies, D. C. 1925. *Annual report of the director to the board of trustees for the year 1924.* Publication 227, Vol. VI, No. 4, of Report Series. Chicago: Field Museum of Natural History.

———. 1928. *Annual report of the director to the board of trustees for the year 1927.* Publication 248, Vol. VII, No. 2, of Report Series. Chicago: Field Museum of Natural History.

Simms, Stephen C. 1932. *Annual report of the director to the board of trustees for the year 1931.* Publication 306, Vol. IX, No. 1, of Report Series. Chicago: Field Museum of Natural History.

———. 1933. *Annual report of the director to the board of trustees for the year 1932.* Publication 318, Vol. IX, No. 2, of Report Series. Chicago: Field Museum of Natural History.

———. 1935. *Annual report of the director to the board of trustees for the year 1934.* Publication 336, Vol. X, No. 2, of Report Series. Chicago: Field Museum of Natural History.

Skiff, Frederick J. V. 1898. *Annual report of the director to the board of trustees for the year 1897–1898.* Publication 29, Vol. I, No. 4, of Report Series. Chicago: Field Museum of Natural History.

———. 1908. *Annual report of the director to the board of trustees for the year 1907.* Publication 128, Vol. III, No. 2, of Report Series. Chicago: Field Museum of Natural History.

———. 1914. *Annual report of the director to the board of trustees for the year 1913.* Publication 173, Vol. IV, No. 4, of Report Series. Chicago: Field Museum of Natural History.

Chapter 1

Bekken, Deborah A., Gary M. Feinman, Lisa C. Niziolek, and Lu Zhang. 2015. Preface. In *Song You Si cang Lanting ben* 宋游似藏兰亭本 [You Si's version of *Preface to the Poems*

Composed at the Orchid Pavilion]. Beijing: Guojia tushuguan chubanshe.

Bronson, Bennet. 2003. Berthold Laufer. In *Curators, collections and contexts: Anthropology at the Field Museum, 1893–2002*, Fieldiana Anthropology New Series 36, edited by Stephen E. Nash and Gary M. Feinman, 117–26. Chicago: Field Museum of Natural History.

Bronson, Bennet, and Jan Wisseman. 1976. Palembang as Śrīvijaya: The lateness of early cities in southern Southeast Asia. *Asian Perspectives* 19 (2): 220–39.

Haas, Jonathan. 2003. The changing role of the curator. In *Curators, collections and contexts: Anthropology at the Field Museum, 1893–2002*, Fieldiana Anthropology New Series 36, edited by Stephen E. Nash and Gary M. Feinman, 237–42. Chicago: Field Museum of Natural History.

Hummel, Arthur W. 1936. Berthold Laufer: 1874–1934. *American Anthropologist* 38:101–11.

Latourette, K. S. 1936. Biographical memoir of Berthold Laufer, 1874–1934. *National Academy of Sciences* 1936:41–68.

Mathers, William M., and Michael Flecker, eds. 1997. *Archaeological recovery of the Java Sea Wreck*. Annapolis, MD: Pacific Sea Resources.

Nash, Stephen E., and Gary M. Feinman. 2003a. A foundation for the future of Field Museum anthropology. In *Curators, collections and contexts: Anthropology at the Field Museum, 1893–2002*, Fieldiana Anthropology New Series 36, edited by Stephen E. Nash and Gary M. Feinman, 251–53. Chicago: Field Museum of Natural History.

———, eds. 2003b. *Curators, collections and contexts: Anthropology at the Field Museum, 1893–2002*. Fieldiana Anthropology New Series 36. Chicago: Field Museum of Natural History.

Ooi, Yuki. 2009. China on display at the Chicago World's Fair of 1893: Faces of modernization in the Contact Zone. In *From early Tang court debates to China's peaceful rise*, ICAS Publications Series, Vol. 7, edited by Friederike Assandri and Dora Martins, 57–58. Amsterdam: Amsterdam University Press.

Pearlstein, Elinor. 2014. Early Chicago chronicles of early Chinese art. In *Collectors, collections, and collecting the arts of China: Histories and challenges*, edited by Jason Steuber and Guolong Lai, 7–42. Gainesville: University Press of Florida.

Rostoker, William, and Bennet Bronson. 1990. *Pre-industrial iron: Its technology and ethnology*. Archeomaterials, monograph 1. Philadelphia: University Museum Publications.

Schuster, Carl. 1936. A comparative study of motives in western Chinese folk embroideries. *Monumenta Serica* 2 (1): 21–80.

Skiff, Frederick J. V. 1913. *Annual report of the director to the board of trustees for the year 1912*. Publication 165, Vol. IV, No. 3, of Report Series. Chicago: Field Museum of Natural History.

Starr, Kenneth. 2008. *Black tigers: A grammar of Chinese rubbings*. Seattle: University of Washington Press.

Tchen, Hoshien. 1981. Preface to *Catalogue of Chinese rubbings from Field Museum*, Fieldiana Anthropology New Series 3, xvii. Chicago: Field Museum of Natural History.

Walravens, Hartmut, ed. 1981. *Catalogue of Chinese rubbings from Field Museum*. Fieldiana Anthropology New Series 3. Chicago: Field Museum of Natural History.

Wilbur, C. Martin. 1996. *China in my life: A historian's own history*. Studies of the East Asian Institute, Columbia University. Armonk, New York: M.E. Sharpe.

Chapter 2

Bettinger, Robert L., Loukas Barton, Christopher Morgan, Fahu Chen, Hui Wang, Thomas

P. Guilderson, Duxue Ji, and Dongju Zhang. 2010. The transition to agriculture at
　　Dadiwan, Peoples Republic of China. *Current Anthropology* 51 (5): 703–14.

Boaretto, Elisabetta, Xiaohong Wu, Jiarong Yuan, Ofer Bar-Yosef, Vikki Chu, Yan Pan,
　　Kexin Liu, David Cohen, Tianlong Jiao, Shuicheng Li, Haibin Gu, Paul Goldberg, and
　　Steve Weiner. 2009. Radiocarbon dating of charcoal and bone collagen associated
　　with early pottery at Yuchanyan Cave, Hunan Province, China. *Proceedings of the Na-
　　tional Academy of Sciences* 106 (24): 9595–600.

Cai, Dawei, Yang Sun, Zhuowei Tang, Songmei Hu, Wenying Li, Xingbo Zhao, Hai Xiang,
　　and Hui Zhou. 2014. The origins of Chinese domestic cattle as revealed by ancient
　　DNA analysis. *Journal of Archaeological Science* 41:423–34.

Costantini, Lorenzo. 1979. Plant remains at Pirak, Pakistan. In *Fouilles de Pirak*, edited by
　　Jean-Francois Jarrige and Marielle Santon, 326–33. Paris: Diffusion de Broccard.

Crawford, Gary W. 1992. Prehistoric plant domestication in East Asia. In *The origins of ag-
　　riculture: An international perspective*, edited by C. Wesley Cowan and Patty Jo Watson,
　　7–38. Washington, D.C.: Smithsonian Institution Press.

———. 2006. East Asian plant domestication. In *Archaeology of Asia*, edited by Miriam T.
　　Stark, 77–95. Malden, MA: Blackwell Publishing.

———. 2011. Early rice exploitation in the lower Yangzi valley: What are we missing?
　　Holocene 22 (6): 613–21.

———. 2014. Millet in China. In *Encyclopaedia of the history of science, technology, and medi-
　　cine in non-Western cultures*, edited by Helaine Selin. New York: Springer Science+Busi-
　　ness Media Dordrecht. doi 10.1007/978-94-007-3934-5_10171-1.

Crawford, Gary W., Xuexiang Chen, Fangxi Luan, and Jianhua Wang. 2013. A preliminary
　　analysis of the plant remains assemblage from the Yuezhuang Site, Changqing Dis-
　　trict, Jinan, Shandong Province [in Chinese]. *Jiang Han Kaogu* 4:107–13.

Crawford, Gary W., Xuexiang Chen, and Jianhua Wang. 2006. Houli culture rice from the
　　Yuezhuang site, Jinan [in Chinese]. *East Asia Archaeology* 3:247–51.

Crawford, Gary W., Anne P. Underhill, Jijun Zhao, Gyoung-Ah Lee, Gary Feinman, Linda
　　Nicholas, Fengxi Luan, Haiguang Yu, Hui Fang, and Fengshu Cai. 2005. Late Neolithic
　　plant remains from northern China: Preliminary results from Liangchengzhen,
　　Shandong. *Current Anthropology* 46 (2): 309–17.

Cucchi, Thomas, Ardern Hulme-Beaman, Jiarong Yuan, and Keith Dobney. 2011. Early
　　Neolithic pig domestication at Jiahu, Henan Province, China: Clues from molar shape
　　analyses using geometric morphometric approaches. *Journal of Archaeological Science*
　　38 (1): 11–22.

Darwin, Charles. 1859. On the origin of species by means of natural selection, or, the pres-
　　ervation of favoured races in the struggle for life. London: J. Murray.

Deur, David, and Nancy J. Turner. 2005. Introduction: Reassessing indigenous resource
　　management, reassessing the history of an idea. In *Keeping it living: Traditions of plant
　　use and cultivation on the northwest coast of North America*, edited by David Deur and
　　Nancy J. Turner, 3–34. Vancouver: UBC Press.

Eda, Masaki, Peng Lu, Hiroki Kikuchi, Zhipeng Li, Fan Li, and Jing Yuan. 2016. Reevalua-
　　tion of Early Holocene chicken domestication in northern China. *Journal of Archaeo-
　　logical Science* 67:25–31.

Flannery, Kent. 1986. *Guila Naquitz*. New York: Academic Press.

Fuller, Dorian Q., Emma Harvey, and Ling Qin. 2007. Presumed domestication? Evidence
　　for wild rice cultivation and domestication in the fifth millennium BC of the lower

Yangtze region. *Antiquity* 81:316–31.

Fuller, Dorian Q., Ling Qin, Zhijun Zhao, Yunfei Zheng, Leo-Aoi Hosoya, Xuguo Chen, and Guo-Ping Sun. 2011. Archaeobotanical analysis at Tian Luo Shan: Evidence for wild-food gathering, rice cultivation and the process of the evolution of morphologically domesticated rice. In *Studies of eco-remains from Tianluoshan site*, edited by Peking University and Zhejiang Provincial Institute of Archaeology School of Archaeology and Museology, 47–96. Beijing: Wenwu Press.

Fuller, Dorian Q., Ling Qin, Yunfei Zheng, Zhijun Zhao, Xugao Chen, Leo Aoi Hosoya, and Guo-Ping Sun. 2009. The domestication process and domestication rate in rice: Spikelet bases from the Lower Yangtze. *Science* 323:1607–10.

Guo, Ruihai, and Jun Li. 2002 The Nanzhuangtou and Hutouliang sites: Exploring the beginnings of agriculture and pottery in North China. In *The origins of pottery and agriculture*, edited by Yoshinori Yasuda, 119–42. New Delhi: Roli Books.

Hao, Shou-Gang, Xue-Ping Ma, Si-Xun Yuan, and John Southon. 2001. The Donghulin woman from western Beijing: 14C age and an associated compound shell necklace. *Antiquity* 75 (289): 517–22.

Hillman, Gordon, and M. Stuart Davies. 1990. Measured domestication rates in wild wheats and barley under primitive cultivation, and their archaeological implications. *Journal of World Prehistory* 4 (2): 157–222.

Hu, Yaowu, Shougong Wang, Fengshi Luan, Changsui Wang, and Michael P. Richards. 2008. Stable isotope analysis of humans from Xiaojingshan site: Implications for understanding the origin of millet agriculture in China. *Journal of Archaeological Science* 35 (11): 2960–65.

Hymowitz, Theodore. 2004. Speciation and cytogenetics. In *Soybeans: Improvements, production, and uses*, 3d ed., edited by H. Roger Boerma and James Eugene Specht, 97–136. Madison, WI: American Society of Agronomy, Crop Science Society of America.

Jiang, Leping. 2008. The Shangshan site, Pujiang County, Zhejiang. *Chinese Archaeology* 8:37–43.

———. 2013. The Kuahuqiao site and culture. In *A companion to Chinese archaeology*, edited by Anne P. Underhill, 537–54. Chichester: John Wiley & Sons.

Jiang, Leping, and Li Liu. 2006. New evidence for the origins of sedentism and rice domestication in the lower Yangzi River, China. *Antiquity* 80 (308): 355–61.

Jin, Guiyun, Wenwan Wu, Kesi Zhang, Zebing Wang, and Xiaohong Wu. 2014. 8000-year old rice remains from the north edge of the Shandong highlands, east China. *Journal of Archaeological Science* 51:34–42.

Jing, Yuan. 2008. The origin and development of animal domestication in China. *Kaogu* 8:1–7.

Kobashi, Takuro, Jeffrey P. Severinghaus, Edward J. Brook, Jean-Marc Barnola, and Alexi M. Grachev. 2007. Precise timing and characterization of abrupt climate change 8200 years ago from air trapped in polar ice. *Quaternary Science Reviews* 26 (9–10): 1212–22.

Laland, Kevin N., John Odling-Smee, and Marcus W. Feldman. 2001. Cultural niche construction and human evolution. *Journal of Evolutionary Biology* 14 (1): 22–33.

Larson, Greger, Elinor K. Karlsson, Angela Perri, Matthew T. Webster, Simon Y. W. Ho, Joris Peters, Peter W. Stahl, Philip J. Piper, Frode Lingaas, Merete Fredholm, Kenine E. Comstock, Jaime F. Modiano, Claude Schelling, Alexander I. Agoulnik, Peter A. Leegwater, Keith Dobney, Jean-Denis Vigne, Carles Vilà, Leif Andersson, and Kerstin Lindblad-Toh. 2012. Rethinking dog domestication by integrating genetics, archeolo-

gy, and biogeography. *Proceedings of the National Academy of Sciences* 109 (23): 8878–83.

Larson, Greger, Ranran Liu, Xingbo Zhao, Jing Yuan, Dorian Fuller, Loukas Barton, Keith Dobney, Qipeng Fan, Zhiliang Gu, Xiao-Hui Liu, Yunbing Luo, Peng Lu, Leif Andersson, and Ning Li. 2010. Patterns of East Asian pig domestication, migration, and turnover revealed by modern and ancient DNA. *Proceedings of the National Academy of Sciences* 107 (17): 7686–91.

Lee, Gyoung-Ah. 2011. The transition from foraging to farming in prehistoric Korea. *Current Anthropology* 52 (S4): S307–S29.

Lee, Gyoung-Ah, Gary W. Crawford, Li Liu, and Xingcan Chen. 2007. Plants and people from the early Neolithic to Shang periods in North China. *Proceedings of the National Academy of Sciences* 104 (3): 1087–92.

Lee, Gyoung-Ah, Gary W. Crawford, Li Liu, Yuka Sasaki, and Xuexiang Chen. 2011. Archaeological soybean (*Glycine max*) in East Asia: Does size matter? *PLoS ONE* 6 (11): e26720.

Lewis, Henry T., and Lowell John Bean. 1973. *Patterns of Indian burning in California: Ecology and ethnohistory*. Ramona, CA: Ballena Press.

Liu, Li, Sheahan Bestel, Jinming Shi, Yanhua Song, and Xingcan Chen. 2013. Paleolithic human exploitation of plant foods during the Last Glacial Maximum in North China. *Proceedings of the National Academy of Sciences* 110 (14): 5380–85.

Liu, Li, and Xingcan Chen. 2012. *The archaeology of China: From the late Paleolithic to the early Bronze Age*. Cambridge: Cambridge University Press.

Liu, Li, Judith Field, Richard Fullagar, Chaohong Zhao, Xingcan Chen, and Jincheng Yu. 2010. A functional analysis of grinding stones from an Early Holocene site at Donghulin, North China. *Journal of Archaeological Science* 37 (10): 2630–39.

Liu, Li, Wei Ge, Sheahan Bestel, Duncan Jones, Jinming Shi, Yanhua Song, and Xingcan Chen. 2011. Plant exploitation of the last foragers at Shizitan in the Middle Yellow River Valley China: Evidence from grinding stones. *Journal of Archaeological Science* 38 (12): 3524–32.

Liu, Li, Gyoung-Ah Lee, Leping Jiang, and Juzhong Zhang. 2007. The earliest rice domestication in China. *Antiquity Project Gallery* 81 (313). http://antiquity.ac.uk/projgall/liu1/index.htm.

Maher, Lisa A., E. B. Banning, and Michael Chazan. 2011. Oasis or mirage? Assessing the role of abrupt climate change in the prehistory of the southern Levant. *Cambridge Archaeological Journal* 21 (1): 1–30.

Oliver, W., and K. Leus. 2008. *Sus scrofa*. The IUCN Red List of Threatened Species. Version 2015.2. Accessed July 21, 2015. http://www.iucnredlist.org/details/41775/0.

Pan, Yan. 2011. Resource production in the Yangzi Delta and Qiantang drainage from 10,000 to 6000 BP: A palaeoethnobotanical and human ecological investigation [in Chinese]. Ph.D. diss., Fudan University.

Peterson, Christian E., and Gideon Shelach. 2012. Jiangzhai: Social and economic organization of a middle Neolithic Chinese village. *Journal of Anthropological Archaeology* 31 (3): 265–301.

Renssen, H., H. Seppä, X. Crosta, H. Goosse, and D.M. Roche. 2012. Global characterization of the Holocene Thermal Maximum. *Quaternary Science Reviews* 48:7–19.

Rindos, David. 1984. *The origins of agriculture: An evolutionary perspective*. San Diego: Academic Press.

Sasaki, Yuka, Yuichiro Kudo, and Arata Momohara. 2007. Utilization of plant resources reconstructed from plant macrofossils during the latter half of the Jomon period at

the Shimo-yakebe site, Tokyo. *Japanese Journal of Historical Botany* 15 (1): 35–50.

Sato, Yoichiro. 2002. Origin of rice cultivation in the Yangtze River Basin. In *The origins of pottery and agriculture*, edited by Yoshinori Yasuda, 143–50. New Delhi: Roli Books.

Sun, Guoping, Weijin Huang, and Yunfei Zheng. 2007. A brief report of the excavation on a Neolithic site at Tianluoshan Hill in Yuyao, Zhejiang [in Chinese]. *Cultural Relics* 11:4–24.

Vaughan, Duncan A., Bao-Rong Lu, and Norihiko Tomooka. 2008. Was Asian rice (*Oryza sativa*) domesticated more than once? *Rice* 1 (1): 16–24.

Xiang, Hai, Jianqiang Gao, Baoquan Yu, Hui Zhou, Dawei Cai, Youwen Zhang, Xiaoyang Chen, Xi Wang, Michael Hofreiter, and Xingba Zhao. 2014. Early Holocene chicken domestication in northern China. *Proceedings of the National Academy of Science of the USA* 111 (49):17564–649.

Yang, Dongya Y., Li Liu, Xingcan Chen, and Camilla F. Speller. 2008. Wild or domesticated: DNA analysis of ancient water buffalo remains from North China. *Journal of Archaeological Science* 35 (10): 2778–85.

Yang, Xiaoyan, Zhiwei Wan, Linda Perry, Houyuan Lu, Qiang Wang, Chaohong Zhao, Jun Li, Fei Xie, Jincheng Yu, Tianxing Cui, Tao Wang, Mingqi Li, and Quansheng Ge. 2012. Early millet use in northern China. *Proceedings of the National Academy of Sciences* 109 (10): 3726–30.

Zeder, Melinda A., and Brian Hesse. 2000. The initial domestication of goats (*Capra hircus*) in the Zagros Mountains 10,000 years ago. *Science* 287 (5461): 2254.

Zhang, XiaoLing, Chen Shen, Xing Gao, FuYou Chen, and ChunXue Wang. 2010. Use-wear evidence confirms the earliest hafted chipped-stone adzes of Upper Palaeolithic in northern China. *Chinese Science Bulletin* 55 (3): 268–75.

Zhao, Zhijun. 2011. New archaeobotanic data for the study of the origins of agriculture in China. *Current Anthropology* 52 (S4): S295–S306.

Zhejiang Provincial Museum, Natural History Section. 1978. A study of animal and plant remains unearthed at Hemudu. *Archaeology (Kaogu)* 1:95–111.

Zheng, Yunfei. 2007. Characteristics of the short rachillae of rice from archaeological sites dating to 7000 years ago. *Chinese Science Bulletin* 52 (1): 1–7.

Zheng, Yunfei, Gary W. Crawford, and Xuexiang Chen. 2014. Archaeological evidence for peach (*Prunus persica*) cultivation and domestication in China. *PLoS One* 9 (9): e106595. doi: 10.1371/journal.pone.0106595.

Zheng, Yunfei, Guoping Sun, Ling Qin, Chunhai Li, Xiaohong Wu, and Xugao Chen. 2009. Rice fields and modes of rice cultivation between 5000 and 2500 BC in east China. *Journal of Archaeological Science* 36 (12): 2609–16.

Zhong, Hua. 2016. Archaeobotanical research on the Middle Yangshao to Longshan periods in the Central Plains. Ph.D. diss., Graduate School of Archaeology, Chinese Academy of Sciences.

Zong, Y., Z. Chen, J. B. Innes, C. Chen, Z. Wang, and H. Wang. 2007. Fire and flood management of coastal swamp enabled first rice paddy cultivation in east China. *Nature* 449 (7161): 459–62.

Highlight 1

Boaz, Noel Thomas, and Russel L. Ciochon. 2004. *Dragon bone hill: An Ice-Age saga of Homo erectus*. New York: Oxford University Press.

Gao, Xing, XiaoLing Zhang, DongYa Yang, Chen Shen, and XinZhi Wu. 2010. Revisiting the

origin of modern humans in China and its implications for global human evolution. *Science China Earth Sciences* 53 (12): 1927–40.

Shang, Hong, and Erik Trinkaus. 2010. *The early modern human from Tianyuan Cave, China*. College Station: Texas A&M University Press.

Zhong, Maohua, Congling Shi, Xing Gao, Xinzhi Wu, Fuyou Chen, Shuangquan Zhang, Xingkai Zhang, and John W. Olsen. 2014. On the possible use of fire by *Homo erectus* at Zhoukoudian, China. *Chinese Science Bulletin* 59 (3): 335–43.

Chapter 3

Blanton, Richard, and Lane Fargher. 2008. *Collective action in the formation of pre-modern states*. New York: Springer.

Blanton, Richard, Gary M. Feinman, Stephen A. Kowalewski, and Peter N. Peregrine. 1996. A dual-processual theory for the evolution of Mesoamerican civilization. *Current Anthropology* 37:1–14, 65–68.

Center for the Study of Chinese Archaeology at Beijing University and Zhejiang Provincial Institute of Archaeology and Cultural Heritage. 2011. *Integrated studies on the natural remains from Tianluoshan* [in Chinese]. Beijing: Cultural Relics Press.

Chang, K. C. 1986. *The archaeology of ancient China*. New Haven: Yale University Press.

———. 1989. An essay on *cong*. *Orientations* 20:37–43.

Chifeng International Collaborative Archaeological Project, ed. 2011. *Settlement patterns in the Chifeng region*. Pittsburgh: Center for Comparative Archaeology.

Cohen, David Joel. 2011. The beginnings of agriculture in China: A multiregional view. *Current Anthropology* 52:S273–S293.

———. 2013. The advent and spread of early pottery in East Asia: New dates and new considerations for the world's earliest ceramic vessels. *Journal of Austronesian Studies* 4:55–92.

Falkenhausen, Lothar von. 1993. On the historiographical orientation of Chinese archaeology. *Antiquity* 67:839–49.

Fang, Hui, Gary M. Feinman, and Linda M. Nicholas. 2015. Imperial expansion, public investment, and the long path of history: China's initial political unification and its aftermath. *Proceedings of the National Academy of Sciences* 112:9224–29.

Feinman, Gary M. 2013. The emergence of social complexity: Why more than population size matters. In *Cooperation and collective action: Archaeological perspectives*, edited by David M. Carballo, 35–56. Boulder: University Press of Colorado.

Feinman, Gary M., Linda M. Nicholas, and Hui Fang. 2010. The imprint of China's first emperor on the distant realm of eastern Shandong. *Proceedings of the National Academy of Sciences* 107:4851–56.

He, Nu. 2013. The Longshan period site of Taosi in southern Shanxi Province. In *A companion to Chinese archaeology*, edited by Anne P. Underhill, 254–77. Malden, MA: Wiley-Blackwell.

Hunan Provincial Institute of Archaeology and Cultural Relics. 2006. *Report on Pengtoushan and Bashidang sites* [in Chinese]. Bejing: Science Press.

Inner Mongolian Team of Institute of Archaeology, Chinese Academy of Social Science (CASS). 1997. Report on 1992 season excavation at the Xinglongwa site in Aohan, Inner Mongolia [in Chinese]. *Kaogu* 1997 (1): 1–26.

Larson, Greger, Ranan Liu, Xingbo Zhan, Jing Yuan, Dorian Fuller, Loukas Barton, Keith Dobney, Qipeng Fan, Xiao-Hui Liu, Yunbing Luo, Peng Lv, Leif Andersson, and

Ning Li. 2010. Patterns of East Asian pig domestication, migration, and turnover revealed by modern and ancient DNA. *Proceedings of the National Academy of Sciences* 107:7686–81.

Li, Xinwei. 2013. The Later Neolithic period in the central Yellow River Valley area, c. 4000–3000 BC. In *A companion to Chinese archaeology*, edited by Anne P. Underhill, 213–35. Malden, MA: Wiley-Blackwell.

Liu, Jun. 2006. *Hemudu culture* [in Chinese]. Beijing: Cultural Relics Press.

Liu, Li. 2003. "The products of minds as well of hands": Production of prestige goods in the Neolithic and early state periods of China. *Asian Perspectives* 42:1–40.

———. 2004. *The Chinese Neolithic: Trajectories to early states*. Cambridge: Cambridge University Press.

Liu, Li, Xingcan Chen, Kuen Lee Yun, Henry Wright, and Arlene Rosen. 2004. Settlement patterns and development of social complexity in Yiluo region, North China. *Journal of Field Archaeology* 29:75–100.

Luo, Yunbing, and Juzhong Zhang. 2008. Reexamination of pig remains from Jiahu [in Chinese]. *Kaogu* 2008 (1): 90–96.

Ma, Xiaolin. 2005. *Emergent social complexity in the Yangshao culture: Analyses of settlement patterns and faunal remains from Lingbao, western Henan, China (c. 4900–3000 BC)*. BAR International Series 1453. Oxford: Archaeopress.

Olsen, Stanley J., John W. Olsen, and Guo-Qin Qi. 1980. Domestic dogs from the Neolithic in China. *Explorer Journal* 58:165–67.

Peterson, Christian E., and Gideon Shelach. 2010. The evolution of Yangshao village organization in the middle reaches of northern China's Yellow River Valley. In *Becoming villagers: Comparing early village societies*, edited by Matthew S. Bandy and Jake R. Fox, 246–75. Tucson: University of Arizona Press.

Price, T. Douglas. 2000. Europe's first farmers: An introduction. In *Europe's first farmers*, edited by T. Douglas Price, 1–18. Cambridge: Cambridge University Press.

Price, T. Douglas, and Gary M. Feinman. 2010. Social inequality and the evolution of social organization. In *Pathways to power*, edited by T. Douglas Price and Gary M. Feinman, 1–14. New York: Springer.

Renfrew, Colin. 1974. Beyond a subsistence economy: The evolution of social organization in prehistoric Europe. In *Reconstructing complex societies: An archaeological colloquium*, edited by Charlotte B. Moore, 69–95. Supplement to the Bulletin of American Schools of Oriental Research, No. 20. Cambridge: American Schools of Oriental Research.

Savolainen, Peter, Ya-Ping Zhang, Jing Luo, Joakim Lundeberg, and Thomas Leitner. 2002. Genetic evidence for an East Asian origin of domestic dogs. *Science* 298:1610–13.

Shelach, Gideon. 2000. The earliest Neolithic cultures of northeast China: Recent discoveries and new perspectives on the beginnings of agriculture. *Journal of World Prehistory* 14:363–413.

———. 2006. Economic adaptation, community structure, and sharing strategies of households at early sedentary communities in northeast China. *Journal of Anthropological Archaeology* 25:318–45.

———. 2015. *The archaeology of early China: From prehistory to the Han Dynasty*. New York: Cambridge University Press.

Underhill, Anne P. 1996. Craft production and social evolution during the Longshan period of northern China. In *Craft production and social evolution: In memory of V. Gordon Childe*, edited by Bernard Wailes, 133–50. Philadelphia: University of Pennsylvania

Museum.

Underhill, Anne P., Gary M. Feinman, Linda M. Nicholas, Hui Fang, Fengshi Luan, Haiguang Yu, and Fengshu Cai. 2008. Changes in regional settlement patterns and the development of complex societies in southeastern Shandong, China. *Journal of Anthropological Archaeology* 27:1–29.

Wang, Youping, Songlin Zhang, Wanfa Gu, Songzhi Wang, Jianing He, Xiaohong Wu, Tongli Qu, Jingfeng Zhao, Youcheng Chen, and Ofer Bar-Yosef. 2015. Lijiagou and the earliest pottery in Henan Province, China. *Antiquity* 89:273–91.

Wu, Xiaohong, Chi Zhang, Paul Goldberg, David Cohen, Yan Pan, Trina Arpin, and Ofer Bar-Yosef. 2012. Early pottery at 20,000 years ago in Xianrendong Cave, China. *Science* 336:1696–1700.

Yuan, Jing, and Rowan K. Flad. 2002. Pig domestication in ancient China. *Antiquity* 76:724–32.

Yuan, Jing, Jian-Lin Han, and Roger Blench. 2008. Livestock in ancient China: An archaeozoological perspective. In *Past human migrations in East Asia: Matching archaeology, linguistics and genetics*, edited by Alicia Sánchez-Mazas, Roger Blench, Malcolm D. Ross, Ilia Peiros, and Marie Lin, 84–104. London: Routledge.

Zhang, Chi, and Hsiao-Chun Hung. 2008. The Neolithic of southern China: Origin, development, and dispersal. *Asian Perspectives* 47:299–329.

Zhang, Heng, Haiming Wang, and Wei Yang. 2005. Early Neolithic archaeological remains recovered from Xiaohuangshan, Shenzhou, Zhejiang Province [in Chinese]. *Cultural Relics Newspaper*, September 30.

Zhang, Juzhong, Changfu Chen, and Yuzhang Yang. 2014. Origins and early development of agriculture in China [in Chinese]. *Journal of National Museum of China* 126:6–16.

Zhao, Zhijun. 2011. Characteristics of agricultural economy during the formation of ancient Chinese civilization [in Chinese]. *Journal of National Museum of China* 90:19–31.

Chapter 4

Allan, Sarah. 2007. Erlitou and the formation of Chinese civilization: Toward a new paradigm. *Journal of Asian Studies* 66 (2): 461–96.

Bagley, Robert W. 1977. P'an-lung-ch'eng: A Shang city in Hupei. *Artibus Asiae* 39 (3/4): 165–219.

———. 1980. The appearance and growth of regional bronze-using cultures. In *The great Bronze Age of China: An exhibition from the People's Republic of China*, edited by Fong Wen, 111–33. New York: Metropolitan Museum of Art.

———. 1987. *Shang ritual bronzes in the Arthur M. Sackler collections*. Washington D.C.: Arthur M. Sackler Foundation.

———. 1990. Shang ritual bronzes: Casting technique and vessel design. *Archives of Asian Art* 43:6–20.

———. 1993. Replication techniques in Eastern Zhou bronze casting. In *History from things: Essays on material culture*, edited by S. Lubar and W. D. Kingery, 231–41. Washington, D.C.: Smithsonian Institution.

———. 1995. What the bronzes from Hunyuan tell us about the foundry at Houma. *Orientations* (January): 46–54.

———. 1996. Debris from the Houma foundry. *Orientations* (October): 50–58.

———. 1999. Shang archaeology. In *The Cambridge history of ancient China: From the origins of civilization to 221 B.C.*, edited by M. Loewe and E. L. Shaughnessy, 124–231. Cambridge:

Cambridge University Press.

———. 2009. Anyang mold-making and the decorated model. *Artibus Asiae* 69 (1): 39–90.

Chang, Kwang-chih. 1980. *Shang civilization*. New Haven: Yale University Press.

———. 1981. Archaeology and Chinese historiography. *World Archaeology* 13 (2): 156–69.

———. 1983. The origin of Shang and the problem of Xia in Chinese archaeology. In *The great Bronze Age of China: A symposium*, edited by G. Kuwayama, 10–15. Los Angeles: Los Angeles County Museum of Art.

———. 1986. *The archaeology of ancient China*. 4th ed. New Haven: Yale University Press.

Chen, Honghai. 2013. The Qijia culture of the upper Yellow River Valley. In *A companion to Chinese archaeology*, edited by Anne. P. Underhill, 103–24. Malden, MA: Wiley-Blackwell.

Falkenhausen, Lothar von. 1993. On the historiographical orientation of Chinese archaeology. *Antiquity* 67:839–49.

———. 1999. The waning of the Bronze Age: Material culture and social developments, 770–481 B.C. In *The Cambridge history of ancient China: From the origins of civilization to 221 B.C.*, edited by M. Loewe and E. L. Shaughnessy, 450–544. Cambridge: Cambridge University Press.

———. 2015. Antiquarianism in China and Europe: Reflections on Momigliano. In *Cross-cultural studies: China and the world, a festschrift in honor of Professor Zhang Longxi*, edited by S. Qian, 127–51. Leiden: Brill.

Franklin, Ursula M. 1983a. On bronze and other metals in early China. In *The origins of Chinese civilization*, edited by D. N. Keightley, 279–96. Berkeley: University of California Press.

———. 1983b. The beginning of metallurgy in China: A comparative approach. In *The great Bronze Age of China: A symposium*, edited by G. Kuwayama, 94–99. Seattle: University of Washington Press.

Gettens, R. J. 1967. Joining methods in the fabrication of ancient Chinese bronze ceremonial vessels. In *Application of science in examination of works of art*, Museum of Fine Arts Boston Research Laboratory, 205–17. Boston: Museum of Fine Arts.

———. 1969. *The Freer Chinese bronzes*. Vol. 2, *Technical Studies*. Washington D.C.: Smithsonian Institution.

Jing, Zhichun, Tang Jigen, George Rapp, and James Stoltman. 2013. Recent discoveries and some thoughts on early urbanization at Anyang. In *A companion to Chinese archaeology*, edited by Anne. P. Underhill, 343–66. Malden, MA: Wiley-Blackwell.

Karlbeck, Orvar. 1935. Anyang moulds. *Bulletin of the Museum of Far Eastern Antiquities* 7:39–60.

Keyser, B. W. 1979. Decor replication in two late Chou bronze *chien*. *Ars Orientalis* 11:127–62.

Lewis, Mark E. 1999. Warring States: The political history. In *The Cambridge history of ancient China: From the origins of civilization to 221 B.C.*, edited by M. Loewe and E. L. Shaughnessy, 587–650. Cambridge: Cambridge University Press.

Li, Chi. 1977. *Anyang*. Seattle: University of Washington Press.

Li, Feng. 2008. *Bureaucracy and the state in early China: Governing the Western Zhou*. Cambridge: Cambridge University Press.

———. 2013. *Early China: A social and cultural history*. Cambridge: Cambridge University Press.

Li, Xueqin. 1985. *Eastern Zhou and Qin civilizations*. New Haven: Yale University Press.

Li, Yung-ti. 2007. Co-craft and multi-craft: Section-mold casting and the organization of

craft production at the Shang capital of Anyang. In *Craft production in complex societies: Multi-craft and producer perspectives*, edited by Izumi Shimada, 184–223. Salt Lake City: University of Utah Press.

———. 2014. The politics of maps, pottery, and archaeology: Hidden assumptions in Chinese Bronze Age archaeology. In *Art and archaeology of the Erligang civilization*, edited by Kyle Steinke, 137–46. Princeton: P. Y. and Kinmay W. Tang Center for East Asian Art, Princeton University Press.

Liu, Li. 2009. Academic freedom, political correctness, and early civilisation in Chinese archaeology: The debate on Xia-Erlitou relations. *Antiquity* 83:831–43.

Liu, Li, and Xingcan Chen. 2003. *State formation in early China*. London: Duckworth.

Liu, Li, and Hong Xu. 2007. Rethinking Erlitou: Legend, history and Chinese archaeology. *Antiquity* 81 (314): 886–901.

Mei, Jianjun, Pu Wang, Kunlong Chen, Lu Wang, Yingchen Wang, and Yaxiong Liu. 2015. Archaeometallurgical studies in China: Some recent developments and challenging issues. *Journal of Archaeological Science* 56:221–32.

Nickel, Lukas. 2006. Imperfect symmetry: Re-thinking bronze casting technology in ancient China. *Artibus Asiae* 66 (1): 5–39.

Rawson, Jessica. 1990. *Western Zhou ritual bronzes from the Arthur M. Sackler collections*. Washington, D.C.: Arthur M. Sackler Foundation.

———. 1999. Western Zhou archaeology. In *The Cambridge history of ancient China: From the origins of civilization to 221 B.C.*, edited by M. Loewe and E. L. Shaughnessy, 352–449. Cambridge: Cambridge University Press.

Shanxi sheng kaogu yanjiusuo. 1996. *Art of the Houma foundry*. Princeton: Princeton University Press.

Shaughnessy, Edward L. 1999. Western Zhou history. In *The Cambridge history of ancient China: From the origins of civilization to 221 B.C.*, edited by M. Loewe and E. L. Shaughnessy, 292–351. Cambridge: Cambridge University Press.

So, Jenny. 1995. *Eastern Zhou ritual bronzes from the Arthur M. Sackler collections*. Washington, D.C.: Arthur M. Sackler Foundation.

Steinke, Kyle, ed. 2014. *Art and archaeology of the Erligang civilization*. Princeton: P. Y. and Kinmay W. Tang Center for East Asian Art, Princeton University Press.

Stoltman James B., Zhichun Jing, Jigen Tang, and George (Rip) Rapp. 2009. Ceramic production in Shang societies of Anyang. *Asian Perspectives* 48 (1): 182–203.

Tan, Derui. 1999. Study of Bronze Age clay mold casting techniques in China [in Chinese]. *Kaogu Xuebao* 2:211–50.

Wagner, Donald B. 1993. *Iron and steel in ancient China*. Leiden: E.J. Brill.

———. 2008. *Science and civilisation in China*. Vol. 5, *Chemistry and chemical technology*. Part 11, *Ferrous metallurgy*. Cambridge: Cambridge University Press.

Wu, Hung. 1999. The art and architecture of the Warring States period. In *The Cambridge history of ancient China: From the origins of civilization to 221 B.C.*, edited by M. Loewe and E. L. Shaughnessy, 651–744. Cambridge: Cambridge University Press.

Xu, Hong. 2013. The Erlitou culture. In *A companion to Chinese archaeology*, edited by Anne. P. Underhill, 300–22. Malden, MA: Wiley-Blackwell.

Yuan, Guangkuo. 2013. The discovery and study of the early Shang culture. In *A companion to Chinese archaeology*, edited by Anne. P. Underhill, 323–42. Malden, MA: Wiley-Blackwell.

Chapter 5

Li, Zhong [pseud.]. 1975. Zhongguo fengjian shehui qianqi gangtie yelian jishu fazhan de tantao 中国封建社会前期钢铁冶炼技术发展的探讨 [The development of iron and steel technology in ancient China]. *Kaogu Xuebao* 2:1–22.

Chapter 6

Cahill, James. 1988. *Three alternative histories of Chinese painting*. Lawrence: Spencer Museum of Art, University of Kansas.

Chang, Su-chen. 2013. Improvised great ages: The great creating of Qingming shengshi. Ph.D. diss., University of British Columbia.

Chen, Yunru. 2010. Zhizuo zhenjing: Chonggu "Qing yuanben Qingming shanghe tu" zai Yongzheng chao huayuan zhi huashi yiyi [Producing a realm of truth: Reexamining the art-historical significance of the *Qing court version of Up the River during Qingming* at the Yongzheng Painting Academy]. *National Palace Museum Research Quarterly* 28 (2): 1–64.

Cole, Fay-Cooper. 1931. George A. Dorsey. *American Anthropologist*, n.s., 33:413–14.

Hansen, Valerie. 1996. The mystery of the Qingming scroll and its subject: The case against Kaifeng. *Journal of Sung-Yuan Studies* 26:183–200.

Hearn, Maxwell K. 2013. Past as present in contemporary Chinese art. In *Ink art: Past as present in contemporary China*, edited by Maxwell K. Hearn, 34–177. New York: Metropolitan Museum of Art; New Haven: Yale University Press.

Huang, Judith. 2012. The new old river. *China Daily*, March 11. Accessed August 20, 2015. http://www.chinadaily.com.cn/sunday/2012-03/11/content_14806438.htm.

Kohara, Hironobu. 2007. Qingming shanghe tu yanjiu [Studies on the *Along the River during the Qingming Festival*]. In *Qingming shanghe tu yanjiu wenxian huibian* [Research material collection of *Along the River during the Qingming Festival*], edited by Liaoning Provincial Museum, 322–46. Shenyang: Wanjuan chuban gongsi.

Ma, Baojie. 2009. Qiu Ying and *Along the River during the Qingming Festival*. In *Fanhua dushi: Liaoning sheng bowuguan canghua zhan* [The prosperous cities: A selection of paintings from the Liaoning Provincial Museum], edited by Hong Kong Museum of Art, 35–40. Hong Kong: Kangle ji wenhua shiwushu.

Pan, An-yi. 2011. Qingming Shanghe tu xue de qishi [Inspiration from *Along the River during the Qingming Festival*]. In *Qingming Shanghe tu xinlun* [New perspectives on *Qingming Shanghe tu*], edited by The Palace Museum, Beijing, 23–34. Beijing: Gugong chubanshe.

Tan, Chang. 2008. Playing cards with Cezanne: How the contemporary artists of China copy and recreate. Ph.D. diss., University of Texas at Austin.

Tong, Wen'e. 2010. *Huiyuan qiongyao: Qing yuanben Qingming shanghe tu* [A gem of Chinese painting: The Qing court handscroll of *Up the River during Qingming*]. Taipei: Guoli gugong bowuyuan.

Tsao, Hsingyuan. 2012. *Tongzhou gongji: Qingming shanghe tu yu Beisong shehui de chongtu tuoxie* [Crossing the river in the same boat: *Along the River during the Qingming Festival* and the conflict and compromise in the Northern Song society]. Hangzhou: Zhejiang daxue chubanshe.

Wang, Cheng-hua. 2011. Guoyan yunyan: Wan Ming chengshitu, chengshiguan he wenhua xiaofei de yanjiu [Passing as transient as a fleeting cloud: Studies on the cityscape

paintings of late Ming Dynasty China, the urban concepts and the cultural consumption]. In *Qingming Shanghe tu xinlun* [New perspectives on *Qingming Shanghe tu*], edited by The Palace Museum, Beijing, 281–302. Beijing: Gugong chubanshe.

Whitfield, Roderick. 1965. Chang Tse-tuan's Ch'ing-ming shang-ho t'u. Ph.D. diss., Princeton University.

Yang, Chenbin. 1990. Tan Mingdai shuhua zuowei [Discussion on forging Ming Dynasty painting and calligraphy]. *Wenwu* 8:72–87, 96.

Zhang, Hongxing. 2013. Inscriptions and seal marks. In *Masterpieces of Chinese painting, 700–1900*, edited by Zhang Hongxing, 53–63. London: V&A Publishing.

Chapter 7

Barnhart, Richard. 1989. *The Metropolitan Museum of Art: Asia*. New York: Metropolitan Museum.

———, ed. 1993. *Painters of the Great Ming: The imperial court and the Zhe School*. Dallas: Dallas Museum of Art.

Chen, Songchang. 2010. Meiguo Zhijiage Feierde bowuguan cang Song ta Lantingxu ba [Postscripts of *Preface to the Poems Composed at the Orchid Pavilion* collected at The Field Museum in Chicago, United States]. *Wenwu* 2:87–95.

Elman, Benjamin A. 2000. *A cultural history of civil examinations in late imperial China*. Berkeley: University of California Press.

Fong, Wen C., and James C. Y. Watt. 1996. *Possessing the past: Treasures from the National Palace Museum, Taipei*. New York: Metropolitan Museum.

Hay, Jonathan. 2010. *Sensuous surfaces*. Honolulu: University of Hawai'i Press.

Lawton, Thomas. 1996. John C. Ferguson: A fellow feeling of fallibility. *Orientations* 27 (3): 65–76.

Mote, Frederick W. 1999. *Imperial China: 900–1800*. Cambridge, MA: Harvard University Press.

Pearlstein, Elinor. 2014. Early Chicago chronicles of early Chinese art. In *Collectors, collections, and collecting the arts of China: Histories and challenges*, edited by Jason Steuber and Guolong Lai, 7–42. Gainesville: University Press of Florida.

Rawski, Evelyn S., and Jessica Rawson, eds. 2005. *China: The three emperors, 1662–1795*. London: Royal Academy of Arts.

Smith, Bradley, and Wan-go Weng. 1978. *China: A history in art*. New York: Doubleday & Co.

Thorp, Robert L. 1988. *Son of Heaven: Imperial arts of China*. Seattle: Son of Heaven Press.

Vollmer, John E. 2002. *Ruling from the Dragon Throne: Costume of the Qing Dynasty (1644–1911)*. Berkeley: Ten Speed Press.

Watson, William, and Chuimei Ho. 1995. *The arts of China: After 1620*. New Haven: Yale University Press.

Wilkinson, Endymion. 2012. *Chinese history: A new manual*. Cambridge, MA: Harvard University Press.

Wu, Hung. 1995. Emperor's masquerade: "Costume portraits" of Yongzheng and Qianlong. *Orientations* 26 (7): 25–41.

———, ed. 2010. *Reinventing the past: Archaism and antiquarianism in Chinese art and visual culture*. Chicago: University of Chicago Press.

Chapter 8

Bokenkamp, Stephen. 2008. Lingbao. In *The Routledge encyclopedia of Taoism*, edited by Fabrizio Pregadio, 663–69. London: Routledge.

Bumbacher, Stepthen Peter. 2012. *Empowered writing: Exorcistic and apotropaic rituals in medieval China*. St. Petersburg, FL: Three Pines Press.

Copp, Paul. 2014. *The body incantatory: Spells and the ritual imagination in medieval Chinese Buddhism*. New York: Columbia University Press.

Goossaert, Vincent. 2008. Quanzhen. In *The Routledge encyclopedia of Taoism*, edited by Fabrizio Pregadio, 814–20. London: Routledge.

Hansen, Valerie. 1995. Why bury contracts in tombs? *Cahiers d'Extrême-Asie* 8:59–66.

———. 2012. *The Silk Road: A new history*. Oxford: Oxford University Press.

Katz, Paul. 2008. Shenxiao. In *The Routledge encyclopedia of Taoism*, edited by Fabrizio Pregadio, 889–91. London: Routledge.

Kieschnick, John. 2003. *The impact of Buddhism on Chinese material culture*. Princeton: Princeton University Press.

Kleeman, Terry. 2008. Tianshi Dao. In *The Routledge encyclopedia of Taoism*, edited by Fabrizio Pregadio, 981–86. London: Routledge.

Liu, Zhaorui. 2007. *Kaogu faxian yu zaoqi Daojiao yanjiu* [Archaeological discoveries and the study of early Daoism]. Beijing: Wenwu chubanshe.

Poceski, Mario. 2007. *Ordinary mind is the Way: The Hongzhou School and the growth of Chan Buddhism*. Oxford: Oxford University Press.

Raz, Gil. 2012. *The emergence of Daoism: Creation of tradition*. London: Routledge.

Robinet, Isabelle. 2008a. Cosmogony: Taoist notions. In *The Routledge encyclopedia of Taoism*, edited by Fabrizio Pregadio, 48–51. London: Routledge.

———. 2008b. Shangqing. In *The Routledge encyclopedia of Taoism*, edited by Fabrizio Pregadio, 858–66. London: Routledge.

Seidel, Anna. 1987. Traces of Han religion in funeral texts found in tombs. In *Dōkyō to shūkyō bunka*, edited by Akizuki Kanei, 23–57. Tokyo: Hirakawa.

Skar, Lowell. 2008. Leifa. In *The Routledge encyclopedia of Taoism*, edited by Fabrizio Pregadio, 627–29. London: Routledge.

Yü, Chün-fang. 2000. *Kuan-Yin: The Chinese transformation of Avalokiteśvara*. New York: Columbia University Press.

Chapter 9

Chen, Fan Pen Li. 2007. *Chinese shadow theatre: History, popular religion, and women warriors*. Montreal: McGill-Queen's University Press.

De Groot, J. J. M. 1901. *The religious system of China*. Vol. 2, *On the soul and ancestral worship*. Leiden: E. J. Brill.

Deng, Qiying. 2009. *Guangying suihua: Lufeng piyingxi* [The age of light and shadow: Shadow play at Lufeng]. Guangzhou: Guangdong jiaoyu chubanshe.

Gao, Cheng. [1080?]. *Shiwu jiyuan*. Vol. 9. Collected in *Wenyuange Sikuquanshu*, Vol. 920. Accessed February 18, 2016. http://ctext.org/wiki.pl?if=gb&res=558770&remap=gb.

Gu, Jiegang. 1983. Zhongguo yingxi lueshi jiqi xianzhuang [A brief history of shadow play and its contemporary situation]. *Wenshi* 19:109–36.

Idema, Wilt, ed. 2009. *The white snake and her son*. Indianapolis: Hackett Publishing.

Jiang, Yuxiang. 1992. *Zhongguo yingxi* [Chinese shadow play]. Chengdu: Sichuan renmin chubanshe.

———. 1999. *Zhongguo yingxi yu minsu* [Chinese shadow play and folk customs]. Taipei: Shuxin chubanshe.

Kang, Baocheng. 2003. Fojiao yu zhongguo piyingxi de fazhan [Buddhism and the development of shadow play]. *Wenyi yanjiu* 5:87–92.

Kong, Meiyan. 2002. Shanxi yingxi shi lue [A discussion on the history of Shanxi's shadow play]. *Xiqu yanjiu* 60:165–66.

Laufer, Berthold. 1923. *Oriental theatricals*. Chicago: Field Museum of Natural History.

Li, Yuezhong. 2013. *Zhongguo piying* [Leather shadow play in China]. Jinan: Shangdong youyi chubanshe.

Liao, Ben. 1996. *Zhongguo xiju tushi* [An illustrated history of China's theater]. Zhengzhou: Henan jiaoyu chubanshe.

Liu, Jilin. 2004. *Yingxi shuo—Beijing piying zhi lishi, minsu, yu meishu* [Shadow play: The history, folk customs, and art of Beijing's leather shadow play]. Tokyo: Kōbun Shuppan.

Meng, Yuanlao [et al.?]. [1127?] 1956. *Dongjing menghua lu* [The eastern capital: A dream of splendor]. Shanghai: Shanghai gudian wenxue chubanshe.

Polikoff, Barbara. 1954. Ancient shadow shows of China becoming a lost art. *Chicago Natural History Museum Bulletin* 25 (5) (May): 3–4.

Sun, Kaidi. 1953. *Kuileixi kaoyuan* [The origin of puppet show]. Shanghai: Shangza chubanshe.

Tong, Jingxin. 1934. Zhongguo yingxi kao [A study on the shadow play in China]. *Juxue yuekan* 3 (11): 6.

Tylor, Edward Burnett. [1871] 2010. *Primitive culture: Researches into the development of mythology, philosophy, religion, art, and custom*. Cambridge: Cambridge University Press.

Wimsatt, Genevieve B. 1936. *Chinese shadow shows*. Cambridge, MA: Harvard University Press.

Zhang, Dongcai. 2010. *Zhongguo yingxi de yanchu xingtai* [The performance form of shadow play in China]. Zhengzhou: Daxiang chubanshe.

Chapter 10

An, Jiayao. 1990. Tang Chang'an Ximingsi yizhi fajue jianbao 唐长安西明寺遗址发掘简报 [Excavation report of Xinmingsi of the Tang Dynasty at Chang'an]. *Kaogu* 1:45–55.

———. 2000. Tang Ximingsi Yizhi De Kaogu Faxian 唐西明寺遗址的考古发现 [Archaeological discoveries at Ximing Si of Tang Dynasty]. In *Tang Yanjiu* 唐研究, edited by Xinjiang Rong, 337–52. Beijing: Peking daxue chubanshe.

Bartol'd, Vasiliĭ Vladimirovich, and Clifford Edmund Bosworth. 1988. *Turkestan down to the Mongol invasion*. Oxford: E. J. W. Gibb Memorial Trust.

Brown, Roxanna M. 2009. *The Ming gap and shipwreck ceramics in Southeast Asia: Towards a chronology of Thai trade ware*. Bangkok: Siam Society.

Carswell, John, Siran Deraniyagala, and Alan Graham. 2013. *Mantai: City by the sea*. Aichwald, Germany: Linden Soft.

Chaudhuri, Kirti N. 1985. *Trade and civilization in the Indian Ocean: An economic history from the rise of Islam to 1750*. Cambridge: Cambridge University Press.

Chen, Zunxiang. 1984. Xi'an Hejia Cun Tangdai Jiaocang Qianbi De Yanjiu 西安何家村唐代窖藏钱币的研究 [A study on the coin hoard of Tang Dynasty at Hejiacun, Xi'an]. *Zhongguo Qianbi* 中国钱币 3:30–32.

Chittick, Neville. 1984. *Manda: Excavations at an island port on the Kenya coast*. Nairobi: British Institute in Eastern Africa.

DeBlasi, Anthony. 2001. Striving for completeness: Quan Deyu and the evolution of the Tang intellectual mainstream. *Harvard Journal of Asiatic Studies* 61:5–36.

Fan, Xueyong. 1999. "Ba Leng Bei" Kao Lue <八棱碑>考略 [A study on the *Baleng stela*]. *Xi Bei Shi Di* 西北史地 4:16–20.

Flecker, Michael. 2001. A ninth-century AD Arab or Indian shipwreck in Indonesia: First evidence for direct trade with China. *World Archaeology* 32:335–54.

Franke, Herbert, and Denis Twitchett. 1994. *The Cambridge history of China: Alien regimes and border states, 907–1368*. Cambridge: Cambridge University Press.

Fu, Xinian. 2001. *Zhongguo Gudai Jianzhushi: Sanguo, Liangjin, Nanbeichao, Suitang, Wudai Jianzhu* 中国古代建筑史：三国、两晋、南北朝、隋唐、五代建筑 [History of ancient Chinese architecture: Architectures from the Three Kingdoms, Western and Eastern Jin, the Northern and Southern Dynasties, Sui and Tang Dynasties, and the Five Dynasties]. Beijing: Zhongguo jianzhu gongye chubanshe.

Gabain, Annemarie von. 1980. Gaochang Huihu Wangguo (AD 850–1250) 高昌回鹘王国 [公元850年—1250年] [Uighur Kingdom at Gaochang: AD 850–1250]. Translated by Shimin Geng. *Xinjiang Daxue Xuebao* 新疆大学学报 2:48–64.

Ge, Chengyong. 2009. *Jingjiao Yizhen—Luoyang xinchutu Tangdai Jingjiao jingchuang Yanjiu* 景教遗珍——洛阳新出唐代景教经幢研究 [Remaining treasure of Christianity: A study on the newly excavated Christian column at Luoyang]. Beijing: Wenwu chubanshe.

Ge, Tieying. 2003. Alabo guji zhong de Zhongguo 7 阿拉伯古籍中的中国 [七] [China in ancient Arabian texts, Vol. 7]. *Alabo shijie* 阿拉伯世界 5:50–55.

Gharib, Badrozzamān. 2004. *Sogdian dictionary: Sogdian-Persian-English*. Tehran: Farhangan Publications.

Guo, Moruo. 1972. Chutu wenwu er san shi 出土文物二三事 [A few notes about excavated artifacts]. *Wenwu* 3:2–10.

Guy, John. 2005. Early ninth-century Chinese export ceramics and the Persian Gulf connection: The Belitung shipwreck evidence. *Chine-Méditerranée, Routes et échanges de la céramique avant le XVIe siècle. Taoci, (Editions SFECO-Findalkly, Suilly-la-Tour, France)* 4:145–52.

Hai, Hongtao. 1997. *Lin Tan Xian Zhi* 临潭县志 [The history of Lintan County]. Lanzhou: Gansu minzu chubanshe.

Han, Wei, Zhankui Wang, Xianyong Jin, Wei Cao, Zhoufang Ren, Jianbang Huai, and Shengqi Fu. 1988. Fufeng Famensi ta Tangdai digong fajue jianbao 扶风法门寺塔唐代地宫发掘简报 [Excavation report of the underground palace of Tang Dynasty at Famen Temple pagoda, Fufeng]. *Wenwu* 10:1–28.

Harkantiningsih, N. 1994. Yue and Longquan green glazed wares from archaeological sites in Java and east Indonesia. In *New light on Chinese Yue and Longquan wares: Archaeological ceramics found in eastern and southern Asia, A.D. 800–1400*, edited by Chuimei Ho, 273–83. Hong Kong: Centre of Asian Studies, University of Hong Kong.

Henning, Walter B. 1948. The date of the Sogdian ancient letters. *Bulletin of the School of Oriental and African Studies* 12:601–15.

Ho, Chuimei. 1994. Problems in the study of Zhejiang green glazed wares with special reference to Ko Kho Khao and Laem Pho Payang, southern Thailand. In *New light on Chinese Yue and Longquan wares: Archaeological ceramics found in eastern and southern Asia, A.D. 800–1400*, edited by Chuimei Ho, 187–212. Hong Kong: Centre of Asian Studies, University of Hong Kong.

Ho, Chuimei, Pisit Charoenwongsa, Bennet Bronson, Amara Srisuchat, and Tharapong Srisuchat. 1990. Newly identified Chinese ceramic wares from ninth-century trading ports in southern Thailand. *SPAFA Journal* 11:12–17.

Hourani, George Fadlou. 1995. *Arab seafaring in the Indian Ocean in ancient and early medieval times.* Princeton: Princeton University Press.

Jiang, Boqin. 1994. *Dunhuang Tulufan wenshu yu sichou zhi lu* 敦煌吐鲁番文书与丝绸之路 [Turfan texts at Dunhuang and the Silk Road]. Beijing: Wenwu chubanshe.

Krahl, Regina, John Guy, J. Keith Wilson, and Julian Raby, eds. 2010. *Shipwrecked: Tang treasures and monsoon winds.* Washington, D.C.: Arthur M. Sackler Gallery, Smithsonian Institution; Singapore: National Heritage Board; Singapore: Singapore Tourism Board.

Kuhn, Dieter. 2009. *The age of Confucian rule: The Song transformation in China.* Cambridge, MA: Belknap Press of Harvard University Press.

Lewis, Mark Edward. 2009. *China's cosmopolitan empire: The Tang Dynasty.* Cambridge, MA: Harvard University Press.

Li, Jinming. 1996. Tangdai Zhongguo yu Alabo de haishang maoyi 唐代中国与阿拉伯的海上贸易 [Maritime trade between China and Arab world during the Tang Dynasty]. *Nanyang wenti yanjiu* 南洋问题研究 1:1–7.

Li, Jinxiu. 2005. "Tongdian-Bianfang dian" Tuhuoluo tiao shiliao laiyuan yu"Xiyu Tuji" <通典·边防典>吐火罗条史料来源与<西域图记> [The origin of the Tochari texts in *Tongdian-Border section* and *Charter history of the Western Region*]. *Xiyu Yanjiu* 西域研究 4:25–34.

Li, Zongjun. 2010. Tang chishi Wang Xuance shi Yindu shiji xintan 唐敕使王玄策使印度事迹新探 [A new study on Tang Dynasty's ambassador Wang Xuance's mission to India]. *Xiyu Yanjiu* 西域研究 4:11–22.

Lin, Meicun. 1995. Tang Chang'an suochu hanwen-poluobowen shuangyu muzhi ba 唐长安所出汉文－婆罗钵文双语墓志跋 [Pahlavi-Chinese bilingual tomb inscription from the Tang Dynasty at Xi'an]. In *Xiyun Wenming* 西域文明, edited by Meicun Lin, 251–58. Beijing: Dongfang chubanshe.

———. 2000. "Datang Tianzhu shichu ming" jiaoshi <大唐天竺使出铭>校释 [Interpretation of *The inscription of Tang's ambassador's mission to India*]. In *Zhongya Xuekan* 中亚学刊, edited by Gaohua Chen and Taishan Yu. Urumqi: Xinjiang renmin chubanshe.

———. 2006. *Sichou zhilu kaogu shiwu jiang* 丝绸之路考古十五讲 [Fifteen lectures on the Silk Road archaeology]. Beijing: Peking daxue chubanshe.

———. 2008. Sichou zhilu shang de Tubo zhijin 丝绸之路上的吐蕃织锦 [Tubo brocade on the Silk Road]. In *Sichou zhilu: Sheji yu wenhua lunwen ji* 丝绸之路：设计与文化论文集, edited by Mingxin Bao, 23–31. Shanghai: Donghua daxue chubanshe.

———. 2011. *Menggu Shanshui Ditu* 蒙古山水地图 [Mongolian landscape map]. Beijing: Wenwu chubanshe.

———. 2012. Bosi wenming de xili-2012 nian Yilang kaochaji zhi si 波斯文明的洗礼——2012 年伊朗考察记之四 [Persian civilization—a research trip to Iran in 2012 (4)]. *Zijincheng* 紫禁城, 16–27.

———. 2013. *Dachao chunqiu: Mengyuan kaogu yu yishu* 大朝春秋：蒙元考古与艺术 [Time in a great dynasty: Archaeology and art of Mongolian and Yuan Dynasty]. Beijing: Gugong chubanshe.

———. 2015. Junzi wangcheng guji kao 龟兹王城古迹考 [Investigating ancient remains of Kucha's capital]. *Xiyu yanjiu* 西域研究 1:48–58.

Lin, Meicun, and Ran Zhang. 2015. Zheng He's voyages to Hormuz Island: The archaeological evidence. *Antiquity* 89:417–32.

Liu, Man. 2011. Tang Taozhou zhisuo weizhi kao 唐洮州治所位置考 [Investigating the government's location of Taozhou of the Tang Dynasty]. *Dunhuang Xue Jikan* 敦煌学辑刊 1:17–41.

Liu, Xinru. 2010. *The Silk Road in world history*. Oxford: Oxford University Press.

Lo, Jung-Pang. 2012. *China as a sea power, 1127–1368*. Hong Kong: Hong Kong University Press.

Mao, Yangguang. 2014. Luoyang xinchutu tangdai jingjiao tu Huaxian jiqi qi Anshi muzhi chutan 洛阳新出土唐代景教徒花献及其妻安氏墓志初探 [A study on Tang Christians Hua Xian and his wife Madam An's tomb inscription newly discovered at Luoyang]. *Xiyu yanjiu* 西域研究 2:85–91.

Nanji, Rukshana J. 2011. *Mariners and merchants: A study of the ceramics from Sanjan (Gujarat)*. Oxford: Archaeopress.

Park, Hyunhee. 2012. *Mapping the Chinese and Islamic worlds: Cross-cultural exchange in pre-modern Asia*. Cambridge: Cambridge University Press.

Prickett-Fernando, Martha. 1994. Middlemen and end users: The finds of Yue and Longquan celadons in Sri Lanka. In *New light on Chinese Yue and Longquan wares: Archaeological ceramics found in eastern and southern Asia, A.D. 800–1400*, edited by Chuimei Ho, 299–321. Hong Kong: Centre of Asian Studies, University of Hong Kong.

Qin, Dashu. 2013. Zhongguo gudai taoci waixiao de diyige gaofeng—9–10 shiji taoci waixiao de guimo he tedian 中国古代陶瓷外销的第一个高峰—9~10 世纪陶瓷外销的规模和特点 [China's first ceramic export trade peak—focus on the volume and charactics of ancient Chinese ceramics foreign trade in the ninth to tenth century]. *Gugong bowuyuan yuankan* 故宫博物院院刊 32–49.

Ridho, Abu. 1994. Zhejiang green glazed wares found in Indonesia. In *New light on Chinese Yue and Longquan wares: Archaeological ceramics found in eastern and southern Asia, A.D. 800–1400*, edited by Chuimei Ho, 265–72. Hong Kong: Centre of Asian Studies, University of Hong Kong.

Rong, Xinjiang. 1998. Yige rushi Tangchao de bosi jingjiao jiazu 一个入仕唐朝的波斯景教家族 [A Persian-Christian family in the government of the Tang Dynasty]. In *Yilang Xue Zai Zhongguo lunwenji* 伊朗学在中国论文集, edited by YiliangYe, 82–90. Beijing: Beijing daxue chubanshe.

———. 2012. Tangchao yu Heiyi Dashi guanxishi xinzheng 唐朝与黑衣大食关系史新证 [A new study on the the history of the relationship between the Tang Dynasty and Abbasid Caliphate]. *Wenshi* 文史 3:231–43.

Rougeulle, Axelle. 1996. Medieval trade networks in the western Indian Ocean (8–14th centuries): Some reflections from the distribution pattern of Chinese imports in the Islamic world. In *Tradition and archaeology: Early maritime contacts in the Indian Ocean*, edited by Himanshu Prabha Ray and Jean-François Salles, 159–80. New Delhi: Manohar Publishers and Distributors.

Rudenko, Sergei I. 1971. *Frozen tombs of Siberia*. Berkeley: University of California Press.

Schottenhammer, Angela. 2014. *Yang Liangyaos Reise von 785 n. Chr. zum Kalifen von Bagdad: Eine Mission im Zeichen einer frühen sino-arabischen Mächte-Allianz?* Gossenberg: Ostasien Verlag.

Sima, Guang. [1084?] 1956. *Zi zhitong jian* 资治通鉴 [Comprehensive mirror in aid of governance]. Beijing: Zhonghua shuju.

Sims-Williams, Nicholas. 1996. The Sogdian merchants in China and India. In *Cina e Iran da Alessandro Magno alla dinastia Tang*, edited by A. Cadonna and L. Lanciotti, 45–67. Florence: Leo S. Olschki.

Stein, Aurel. 1921. *Serindia: Detailed report of explorations in Central Asia and westernmost China*. 5 vols. Oxford: Clarendon Press.

———. 1928. *Innermost Asia: Detailed report of explorations in Central Asia, Kan-Su and eastern Iran*. 5 vols. Oxford: Clarendon Press.

Sun, Ji. 1996. Jinnian Neimenggu chutu de Tujue yu Tujue shi jinyinqi 近年内蒙古出土的突厥与突厥式金银器 [Turkish and Turkish-style gold and silver wares from Inner Mongolia in recent years]. In *Zhongguo shenghuo* 中国圣火, edited by Ji Sun, 260–64. Shenyang: Liaoning jiaoyu chubanshe.

Tampoe, M. 1989. *Maritime trade between China and the West*. Oxford: BAR.

T'ien, Ju-kang. 1981. Chêng Ho's voyages and the distribution of pepper in China. *Journal of the Royal Asiatic Society of Great Britain and Ireland* 2:186–97.

Wang, Bangwei. 1988. *Datang xiyu qiufa gaoseng zhuan jiaozhu* 大唐西域求法高僧传校注 [Annotation on biographies of Tang Dynasty monks who traveled to the Western Region for sutras]. Beijing: Zhonghua shuju.

Wang, Pu. 1955. *Tang Huiyao* 唐会要 [Institutional history of Tang]. Beijing: Zhonghua shuju.

Waugh, Daniel C. 2007. Richthofen's "Silk Roads": Toward the archaeology of a concept. *Silk Road* 5:1–10.

Wei, Mingkong. 1999. Sui Tang shougongye yu woguo jingji zhongxin de nanbei yiwei 隋唐手工业与我国经济重心的南北易位 [Handicraft industries in the Sui and Tang Dynasties and the north-south translocation of China's economic center]. *Zhongguo jingjishi yanjiu* 中国经济史研究 2:49–58.

Whitehouse, David. 1979. Islamic glazed pottery in Iraq and the Persian Gulf: The ninth and tenth centuries. *Annali, Istituto Orientale di Napoli Roma* 39:45–61.

Whitehouse, David, and Andrew Williamson. 1973. Sasanian maritime trade. *Iran* 11:29–49.

Wood, Frances. 2004. *The Silk Road: Two thousand years in the heart of Asia*. Berkeley: University of California Press.

Xiang, Da. 1979. *Tangdai Chang'an yu Xiyu wenming* 唐代长安与西域文明 [Tang's Chang'an and the civilizations of the Western Region]. Beijing: Sanlian shudian.

Yelu, Chucai. 1997. *Xi You Lu* 西游录 [Records of the trip to the west]. In *Xiyu Kaogu Lu juan 10* 西域考古录·卷十, edited by Yu Hao. Beijing: Beijing chubanshe.

Yuba, Tadanori. 2014. Chinese porcelain from Fustat based on research from 1988–2001. *Transactions of the Oriental Ceramic Society* 76:1–17.

Zhang, Ran. 2013. Tangmo Yinduyang daguimo taoci maoyi de xingsheng—jianlun Xingyao yu Yueyao zai taoci maoyi zhong de diwei 唐末印度洋大规模陶瓷贸易的兴盛——兼论邢窑与越窑在陶瓷贸易中的地位 [A sudden rise of Chinese ceramic trade in the late Tang period—the position of Xing kiln and Yue kiln in the ceramic trade]. In *Zhongguo gu taoci yanjiu—Yueyao qingci yu Xingyao baici yanjiu* 中国古陶瓷研究——越窑青瓷与邢窑白瓷研究, edited by Zhongguo gutaoci yanjiuhui, 409–22. Beijing: Gugong chubanshe.

Chapter 11

Burton, William, and R. L. Hobson. 1909. *Handbook of marks on pottery & porcelain*. London: Macmillan & Co.

Dreyer, Edward L. 2007. *Zheng He: China and the oceans in the early Ming Dynasty, 1405–1433*. New York: Pearson Education.

Dupoizat, Marie-France. 1995. The ceramic cargo of a Song Dynasty junk found in the Philippines and its significance in the China–South East Asia trade. In *South East Asia and China: Art, interaction and commerce*, edited by Rosemary Scott and John Guy, 205–24. London: Percival David Foundation of Chinese Art.

Flecker, Michael. 1997. Interpreting the ship. In *Archaeological recovery of the Java Sea Wreck*, edited by William M. Mathers and Michael Flecker, 67–77. Annapolis, MD: Pacific Sea Resources.

———. 2002. *The archaeological excavation of the 10th century* Intan Shipwreck. Oxford: Archaeopress.

———. 2003. The thirteenth-century *Java Sea Wreck*: A Chinese cargo in an Indonesian ship. *Mariner's Mirror* 89 (4): 388–404.

Green, Jeremy. 1983. The Song Dynasty shipwreck at Quanzhou, Fujian Province, Peoples Republic of China. *International Journal of Nautical Archaeology and Underwater Exploration* 12 (3): 253–61.

Green, Jeremy, Nick Burningham, and Museum of Overseas Communication History. 1998. The ship from Quanzhou, Fujian Province, People's Republic of China. *International Journal of Nautical Archaeology* 27 (4): 277–301.

Kimura, Jun, Laure Dussubieux, and Tsutomu Saito. 2015. Elementary analysis and provenance study on metal artefacts from the 12–13th century's *Java Sea Wreck*. Paper presented at the 15th International Conference of the European Association of Southeast Asian Archaeologists, July 6–10, at Université Paris Ouest Nanterre la Défense, Paris, France.

Kimura, Jun, Randall Sasaki, and Vu The Long. 2011. Historical development of Asian anchors, as evidenced by two wooden anchors found in northern Vietnam. *International Journal of Nautical Archaeology* 40 (2): 361–73. doi: 10.1111/j.1095-9270.2010.00296.x.

Krahl, Regina, John Guy, J. Keith Wilson, and Julian Raby, eds. 2010. *Shipwrecked: Tang treasures and monsoon winds*. Washington, D.C.: Arthur M. Sackler Gallery, Smithsonian Institution; Singapore: National Heritage Board; Singapore Tourism Board.

Levy, Allison, Joseph B. Lambert, Lisa C. Niziolek, and Gary M. Feinman. 2015. NMR characterization of resin blocks from the 13th-century *Java Sea Wreck*. Paper presented at the 249th American Chemical Society National Meeting and Exposition, March 22–26, Denver.

Liebner, Horst Hubertus. 2014. The siren of Cirebon: A tenth-century trading vessel lost in the Java Sea. Ph.D. diss., University of Leeds.

Mathers, William M., and Michael Flecker, eds. 1997. *Archaeological recovery of the Java Sea Wreck*. Annapolis, MD: Pacific Sea Resources.

Miksic, John. 1997. Historical background. In *Archaeological recovery of the Java Sea Wreck*, edited by William M. Mathers and Michael Flecker, 5–33. Annapolis, MD: Pacific Sea Resources.

———. 2011. Recent research in the southeast Sumatran region. *The MUA Collection*. Accessed February 16, 2016. http://www.themua.org/collections/items/show/1256.

Niziolek, Lisa C. 2015. A compositional study of a selection of Song Dynasty Chinese ceramics from the *Java Sea Shipwreck*: Results from LA-ICP-MS analysis. *Journal of Indo-Pacific Archaeology* 35:48–66.

Niziolek, Lisa C., and Amanda Respess. 2017. Globalization in Southeast Asia's Early Age of Commerce: Evidence from the thirteenth century *Java Sea Shipwreck*. In *The Routledge handbook of archaeology and globalization*, edited by Tamar Hodos, 789–807. Abingdon: Routledge.

Peterson, Barbara Bennett. 1994. The Ming voyages of Cheng Ho (Zheng He), 1371–1433. *Great Circle* 16 (1): 43–51.

Pollard, A.M., and H. Hatcher. 1994. The chemical analysis of Oriental ceramic body compositions: Part 1: Wares from North China. *Archaeometry* 36 (1): 41–62.

Respess, Amanda, and Lisa C. Niziolek. 2016. Exchanges and transformations in gendered medicine on the Maritime Silk Road: Evidence from the thirteenth-century *Java Sea Wreck*. In *Histories of medicine in the Indian Ocean World: The medieval and early modern period*, edited by Anna Winterbottom and Facil Tesfaye, 81–113. Hampshire: Palgrave Macmillan.

Sen, Tansen. 2014. Maritime Southeast Asia between South Asia and China to the sixteenth century. *TRaNS: Trans-Regional and -National Studies of Southeast Asia* 2:31–59. doi:10.1017/trn.2013.15.

Stargardt, Janice. 2001. Behind the shadows: Archaeological data on two-way sea-trade between Quanzhou and Satingpra, South Thailand, 10th–14th century. In *The emporium of the world: Maritime Quanzhou, 1000–1400*, edited by Angela Schottenhammer, 309–94. Leiden: Koninklijke Brill NV.

Wade, Geoff. 2005. The Zheng He voyages: A reassessment. *Journal of the Malaysian Branch of the Royal Asiatic Society* 78 (1) (288): 37–58.

Worrall, Simon. 2014. *The lost dhow: A discovery from the Maritime Silk Route*. Toronto: Aga Khan Museum.

Highlight 7

Brown, Roxanna. 1997. Ceramics inventory. In *Archaeological recovery of the Java Sea Wreck*, edited by William M. Mathers and Michael Flecker, 116–81. Annapolis, MD: Pacific Sea Resources.

Kaptchuk, Ted J. 2000. *The web that has no weaver: Understanding Chinese medicine*. New York: McGraw-Hill.

Laufer, Berthold. 1925. *Ivory in China*. Anthropology, Leaflet 21. Chicago: Field Museum of Natural History.

Miksic, John. 1997. Historical background. In *Archaeological recovery of the Java Sea Wreck*, edited by William M. Mathers and Michael Flecker, 5–33. Annapolis, MD: Pacific Sea Resources.

Respess, Amanda, and Lisa C. Niziolek. 2016. Exchanges and transformations in gendered medicine on the Maritime Silk Road: Evidence from the thirteenth-century *Java Sea Wreck*. In *Histories of medicine in the Indian Ocean World: The medieval and early modern period*, edited by Anna Winterbottom and Facil Tesfaye, 81–113. Hampshire: Palgrave Macmillan.

Wang, Huaiyin. [978?] 1982. *Taiping shenghuifang* [Taiping prescriptions for universal relief]. Beijing: Renmin weisheng chubanshe.

Wiseman, Nigel, and Ye Feng. 1998. *A practical dictionary of Chinese medicine*. Brookline, MA: Paradigm.

Zhao, Rugua. [1225?] 2012. *Chau Jukua: His work on the Chinese and Arab trade in the twelfth, and thirteenth centuries, entitled Chu-Fan-Chï*. Translated by W. W. Rockhill. St. Petersburg, Russia: Imperial Academy of Sciences, 1911. Reprint, Hong Kong: Forgotten Books (page references are to reprint edition).

Conclusion

Anderson, E. N. 1989. The first green revolution: Chinese agriculture in the Han Dynasty. In *Food and farm: Current debates and policies*, edited by Christine Gladwin and Kathleen Truman, 135–51. Lanham, MD: University Press of America.

Bagley, Robert. 1999. Shang archaeology. In *The Cambridge history of ancient China: From the origins of civilization to 221 B.C.*, edited by Michael Loewe and Edward L. Shaughnessy, 124–231. Cambridge: Cambridge University Press.

Barfield, Thomas J. 1989. *The perilous frontier: Nomadic empires and China*. Oxford: Blackwell.

Bettinger, Robert L., Loukas Barton, and Christopher Morgan. 2010. The origins of food production in North China: A different kind of agricultural revolution. *Evolutionary Anthropology* 19:9–21.

Blanton, Richard E., and Lane Fargher. 2008. *Collective action in the formation of pre-modern states*. New York: Springer.

Bodde, Derk. 1986. The state and empire of Ch'in. In *The Cambridge history of China*, Vol. 1, *The Ch'in and Han empires, 221 B.C.–A.D. 220*, edited by Denis Twitchett and Michael Loewe, 20–102. Cambridge: Cambridge University Press.

Bray, Francesca. 1979–80. Agricultural technology and agrarian change in Han China. *Early China* 5:3–13.

Carballo, David M., Paul Roscoe, and Gary M. Feinman. 2014. Cooperation and collective action in the cultural evolution of complex societies. *Journal of Archaeological Method and Theory* 21:98–133.

Cohen, David J. 2011. The beginnings of agriculture in China: A multiregional view. *Current Anthropology* 52: S273–S293.

Deng, Kent G. 2012. The continuation and efficiency of the Chinese fiscal state, 700 BC–AD 1911. In *The rise of fiscal states: A global history, 1500–1914*, edited by Bartolomé Yun-Casalilla and Patrick K. O'Brien, 335–52. Cambridge: Cambridge University Press.

Duan, Chang-Qun, Xue-Chun Gan, Jeanny Wang, and Paul K. Chien. 1998. Relocation of civilization centers in ancient China: Environmental factors. *Ambio* 27:572–75.

Eisenstadt, Shmuel N., and Bernhard Giesen. 1995. The construction of collective identity. *European Journal of Sociology* 36:72–102.

Emberling, Geoff. 1997. Ethnicity in complex societies: Archaeological perspectives. *Journal of Archaeological Research* 5:295–344.

Ertman, Thomas. 1997. *Birth of the Leviathan: Building states and regimes in medieval and early modern Europe*. Cambridge: Cambridge University Press.

Falkenhausen, Lothar von. 1999. The waning of the Bronze Age: Material culture and social developments. In *The Cambridge history of ancient China: From the origins of civilization to 221 B.C.*, edited by Michael Loewe and Edward L. Shaughnessy, 450–544. Cambridge: Cambridge University Press.

———. 2006. *Chinese society in the age of Confucius (1000–250 BC): The archaeological evidence*. Los Angeles: Cotsen Institute.

———. 2007. Review of *The Chinese Neolithic: Trajectories to early states*, by Li Liu. *Harvard Journal of Asian Studies* 67:178–93.

Fang, Hui. 2013. The eastern territories of the Shang and Western Zhou: Military expansion and cultural assimilation. In *A companion to Chinese archaeology*, edited by Anne P. Underhill, 473–92. Chichester: Blackwell.

Fang, Hui, Gary M. Feinman, and Linda M. Nicholas. 2015. Imperial expansion, public investment, and the long path of China's initial political unification and its aftermath. *Proceedings of the National Academy of Sciences* 112:9224–29.

Fang, Hui, Gary M. Feinman, Anne Underhill, and Linda M. Nicholas. 2004. Settlement pattern survey in the Rizhao area: A preliminary effort to consider Han and pre-Han demography. *Indo-Pacific Prehistory Association Bulletin* 24 (2):79–82.

Fang, Hui, Anne P. Underhill, Gary M. Feinman, Linda M. Nicholas, Fengshi Luan, Haiguang Yu, and Fengshu Cai. 2012. *Archaeological report of regional systematic survey in the southeast Shandong* [in Chinese]. Beijing: Science Press.

Feinman, Gary M., Linda M. Nicholas, and Hui Fang. 2010. The imprint of China's First Emperor on the distant realm of eastern Shandong. *Proceedings of the National Academy of Sciences* 107:4851–56.

Fiskesjö, Magnus. 2015. Terra-cotta conquest: The First Emperor's clay army's blockbuster tour of the world. *Studies in Global Asias* 1:162–83.

Hsu, Cho-Yun. 1999. The Spring and Autumn period. In *The Cambridge history of ancient China: From the origins of civilization to 221 B.C.*, edited by Michael Loewe and Edward L. Shaughnessy, 545–86. Cambridge: Cambridge University Press.

Kennedy, Donald, and Colin Norman. 2005. What don't we know? *Science* 309:75.

Kern, Martin. 2007. Imperial tours and mountain inscriptions. In *The First Emperor: China's terracotta army*, edited by Jane Portal, 105–13. London: British Museum Press.

Kiser, Edgar, and Yong Cai. 2003. War and bureaucratization in Qin China: Exploring an anomalous case. *American Sociology Review* 68:511–39.

Ko, Chiu Yu, Mark Koyama, and Tuan-Hwee Sng. 2014. Unified China and divided Europe. Accessed September 20, 2014. SSRN, http://ssrn.com/abstract=2382346.

Ko, Chiu Yu, and Tuan-Hwee Sng. 2013. Regional dependence and political centralization in imperial China. *Eurasian Geography and Economics* 54:470–83.

Kowalewski, Stephen A. 2008. Regional settlement pattern studies. *Journal of Archaeological Research* 16:225–85.

Lattimore, Owen. 1962. *Studies in frontier history: Collected papers, 1928–1958*. Paris: Mouton.

Lewis, Mark E. 1999. Warring States: The political history. In *The Cambridge history of ancient China: From the origins of civilization to 221 B.C.*, edited by Michael Loewe and Edward L. Shaughnessy, 587–650. Cambridge: Cambridge University Press.

———. 2006. *The construction of space in early China*. Albany: State University of New York Press.

———. 2007. *The early Chinese empires: Qin and Han*. Cambridge, MA: Harvard University Press.

———. 2015. Early imperial China from the Qin and Han through Tang. In *Fiscal regimes and the political economy in premodern states*, edited by Andrew Monson and Walter Scheidel, 282–307. Cambridge: Cambridge University Press.

Li, Feng. 2006. *Landscape and power in early China: The crisis and fall of the Western Zhou, 1045–771 BC*. Cambridge: Cambridge University Press.

Li, Xinwei. 2013. The later Neolithic period in the central Yellow River valley area. In *A companion to Chinese archaeology*, edited by Anne P. Underhill, 213–35. Chichester: Blackwell.

Liu, Li. 2004. *The Chinese Neolithic: Trajectories to early states*. Cambridge: Cambridge University Press.

———. 2009. State emergence in early China. *Annual Review of Anthropology* 38:217–32.

Loewe, Michael. 1994. China's sense of unity as seen in the early empires. *T'oung Pao* 80:6–26.

Luan, Fengshi.1997. On phases and regional types of the Haidai Longshan culture. In *Collected works on the archaeology of the Haidai Area* [in Chinese], edited by Fengshi Luan, 229–82. Jinan: Shandong University Press.

Nagel, Joane. 1994. Constructing ethnicity: Creating and recreating ethnic identity and culture. *Social Problems* 41:152–76.

Pines, Yuri. 2005–6. Bodies, lineages, citizens, and regions: A review of Mark Edward Lewis' *The Construction of Space in Early China*. *Early China* 30:155–88.

Pines, Yuri, Lothar von Falkenhausen, Gideon Shelach, and Robin D. Yates. 2014. General introduction: Qin history revisited. In *Birth of an empire: The state of Qin revisited*, edited by Yuri Pines, Lothar von Falkenhausen, Gideon Shelach, and Robin D. Yates, 1–34. Berkeley: University of California Press.

Qin, Ling. 2013. The Liangzhu culture. In *A companion to Chinese archaeology*, edited by Anne P. Underhill, 574–96. Chichester: Blackwell.

Scheidel, Walter. 2009. From the "great convergence" to the "first great divergence." In *Rome and China: Comparative perspectives on ancient world empires*, edited by Walter Scheidel, 11–23. New York: Oxford University Press.

———. 2015. The early Roman monarchy. In *Fiscal regimes and the political economy in premodern states*, edited by Andrew Monson and Walter Scheidel, 229–57. Cambridge: Cambridge University Press.

Shelach, Gideon. 2000. The earliest Neolithic cultures of northeast China: Recent discoveries and new perspectives on the beginning of agriculture. *Journal of World Prehistory* 14:363–413.

———. 2015. *The archaeology of early China*. Cambridge: Cambridge University Press.

Shelach, Gideon, and Yuri Pines. 2006. Secondary state formation and the development of local identity: Change and continuity in the State of Qi (770–221 BC). In *Archaeology of Asia*, edited by Miriam T. Stark, 202–30. Malden, MA: Blackwell.

Sima, Qian. 1993a. *Records of the grand historian*. Vol. 1, *Qin Dynasty*. Rev. ed. Translated by B. Watson. New York: Columbia University Press.

———. 1993b. *Records of the grand historian*. Vol. 2, *Han Dynasty*. Rev. ed. Translated by B. Watson. New York: Columbia University Press.

Sinopoli, Carla. 2001. Empires. In *Archaeology at the millennium: A sourcebook*, edited by Gary M. Feinman and T. Douglas Price, 439–71. New York: Springer.

Skinner, G. William. 1977. Introduction: Urban development in imperial China. In *The city in late imperial China*, edited by G. William Skinner, 3–31. Stanford: Stanford University Press.

———. 1985. Presidential address: The structure of Chinese history. *Journal of Asian Studies* 44:271–92.

Turchin, Peter. 2006. *War and peace and war: Life cycles of imperial nations*. New York: Pi Press.

———. 2009. A theory for the formation of large empires. *Journal of Global History* 4:191–217.

Underhill, Anne P., Gary M. Feinman, Linda M. Nicholas, Gwen Bennett, Fengshu Cai, Haiguang Yu, Fengshi Luan, and Hui Fang. 1998. Systematic regional survey in SE Shanong Province, China. *Journal of Field Archaeology* 25:453–74.

Underhill, Anne P., Gary M. Feinman, Linda M. Nicholas, Hui Fang, Fengshi Luan, Haiguang Yu, and Fengshu Cai. 2008. Changes in regional settlement patterns and the development of complex societies in southeastern Shandong, China. *Journal of Anthropological Archaeology* 27:1–29.

Yao, Alice. 2010. Recent developments in the archaeology of southwestern China. *Journal of Archaeological Research* 18:203–39.

Yates, Robin D. 2001. Cosmos, central authority, and communities in the early Chinese empire. In *Empires: Perspectives from archaeology and history*, edited by Susan E. Alcock, Terence N. D'Altroy, Kathleen D. Morrison, and Carla M. Sinopoli, 351–68. Cambridge: Cambridge University Press.

Yoffee, Norman. 1988. The collapse of ancient Mesopotamian states and civilization. In *The collapse of ancient states and civilizations*, edited by Norman Yoffee and George L. Cowgill, 44–68. Tucson: University of Arizona Press.

Zhao, Zhijun. 2011. New archaeobotanic data for the study of the origins of agriculture in China. *Current Anthropology* 52:S295–S306.

INDEX

Page numbers in italics indicate figures.

archaeology: and the Bronze Age in China, 92, 94; modern, in China, 118, 135, 140

Bagley, Robert W., 105
baguwen (eight-legged essays), 182
bamboo manuscripts, 134–35, *136*, 137
Barber, A. W., 240
Basra, 271, 293
Battle of Talas River, 263, *263*, 270–71
Belitung Shipwreck, 271–73, 293
Bianliang (modern-day Kaifeng), 145, 164
Bixia Yuanjun, *213*
Black, Davidson, 65
Blackstone, Mrs. Timothy B. (Isabella F.), 24
bodhisattvas, 25, 216–17, 219
bogu tu, 184
Bokenkamp, Stephen, 211
bottle gourd, 50
Breaker Shoal Wreck, 294–96
Bronson, Bennet, 1, 35–37, *35*, 281
Bronze Age. *See* China, Bronze Age
bronze production (industry), 94–97, 102, 105–6; workshops, 96, 102–6. *See also* section-mold technology
bronzes, 11, 92, 94–97, *95*, *97*, 105–6, *127*, *128*, *175*, *176*, *273*; animal motifs and decoration, 98, *100*, 101–2, *104*; bells, *106*; inscriptions, 122–26, *123*, *125*, 134. *See also* vessels
Brown, Roxanna M., 271
Buddha, 211, 217–19, 223, 226, 228, 248–51
buddhas, 216–19, *218*, *220–21*
Buddhism, 12, 184, 205, 211, 214–28, 231–32, 261; Chan (Zen), 226–27; Chinese schools, 226; Indic history, 225–26
burials, 74–77, 79–81
Burningham, Nicholas, 283

calligraphy, 129, 134, 191–92, 196, *197*, 201, 233
cargoes, of natural products, 296
cave-shrines. *See* shrines
Celestial Masters, 206, 209–11
ceramics, 284, 287–95, *290*, *291*, *295*, 301, *302*, 311; compositional analysis, 289–90; inscriptions, 288–89, *288*. *See also* pottery
Chan (Zen) Buddhism. *See* Buddhism
Chang, K. C., 83
Chang'an City (present-day Xi'an City), 260–61, 265, 275

Chen Fan Pen, 240, 244
Cheng, Yongxing (prince), 201
Chengguan, 226
Chicago Columbian Museum, 20
chickens, domesticated, in ancient China, 50
China: belief systems, 12; Bronze Age, 89–90, 92–94, 314, 319; collective identities, 305, 307, 309, 319; historical continuity and diversity, 71, 83–84; history, 303–6; imperial court and scholar-officials, 12; the Neolithic period, 11, 69–84, 95, 305–6; Early Neolithic, 72–75; Middle Neolithic, 75–79; Late Neolithic, *48*, 79–83; population, 75, 79, 83, 310; as producer of goods, 280–81, 293; unification, 9, 13, 97, 303–5, 309–10, 319–20; urbanization, 161–63, 306
Chinese Exclusion Act of 1882, 20
Chinese Joss-House, 2, 21
Christianity, 205
Cirebon Wreck, 283, 293–94
cityscapes, 145, 147, 158, 161
civil service examination system, in imperial China, 174–75, 179–82, *181*
cliff inscription, *267*
climate, and the development of agriculture in ancient China, 60–63
coins, *128*, *129*, 293–94, 309
collecting, ethics of, 37
colophons, on handscroll paintings, 150–52
Confucianism, 184, 196, 261
Confucius, 69, 134, 182, *183*, 308
conservation, 164, 166–71
Convention on the Means of Prohibiting and Preventing the Illicit Import, Export, and Transfer of Ownership of Cultural Property (1970 Convention), 37
craft production, 96; state-sponsored, 107
Cyrus Chung Ying Tang Foundation, 14
Cyrus Tang Hall of China, 10, 28, 34, 65, 84, 117, 126, 299, 320; exhibits, 131, 151, 164, *164*, 201, 235, 243; galleries, 7–9, 46, *48*, 131, 138, 146–47, 173, 226, 283; planning and development, 1, 30; staff and scholars, 9

Dai Xi, *193*, 194
Daoism, 12, 173, 194, 205–15, 227–28, 243, 261
Darwin, Charles, 60, 65
Dawenkou, 77

human ecology, 46, 62

I-Ching (monk), 271
incantations, and incantation pillars, 223,
 224, 225
ink, and ink cakes, 191–92, *191*
ink squeezes. *See* rubbings, Chinese
Intan Wreck, 283, 293
iron: and iron technology, in ancient China,
 107; as a trade good, 284
iron concretions, in shipwrecks, 283–84, *283*
iron objects, *127*, 286, *287*
Islam, 205
ivory, 285, *301*, 302

jades, 4, 32, 74, 79–83, *82*, 95, 187, 292
Java Sea Shipwreck, 9, 13, 35–37, 281–87, *281*,
 282, 301–2
Jia Dan, *258*
Jiang Leping, 52
Jiang Yuxiang, 236–37, 248
Jiangnan, 150, 158, 175. *See also* Yangtze River
Jiaqing (emperor), 192
jiehua (rule-lined-style painting), 151
Jimi system, 262
Jin, Zhu Gang (prince), 201
Jin Dynasty, 151–52
Jingdezhen, 290–92
jinshi degree, 182, 194
jinshixue / *jinshi xue* (antiquarianism), 92, 175

Kangxi (emperor), 192–94
Katz, Paul, 214
Ke (Steward), 124
Ke xu, 124, *125*, 126
kendis and *kundikas* (ritual vessels), 284–85,
 302
Kleeman, Terry, 206, 210
Kuahuqiao, 51–53, 56, 62
Kumārajīva, 225

lacquer, 79–80, 83, 107
Lanting Xu, 12, 131, 192, 197–201; You Si's
 Fifty-Second Rubbing of the Lanting
 Xu, 32–35, *33*
Laolangshen, 239
Laozi, 206, 207, 211–13, *212*, *213*, 228
lashed-lug construction. *See* shipbuilding
Late Glacial Maximum (LGM), 57

Laufer, Berthold, 2–5, 10, 23–28, *24*, 32, 235,
 237, 239–40, 267, 302
leaf fossils, 113–14
Li Bai, 194, 211
Li Shouli, 260
Li Si, 34
Li Tieguai, 194
Li Yuezhong, 243
Li Zongtong, 32–34
Liangzhu, 78, 81, 83
Liao Dynasty, 294
Liaoning Provincial Museum, 153, 161
Liebner, Horst, 294
Linji, 227
literati (scholarly elite), in imperial China,
 175–76, 184–86, 190–96
Liu Jilin, 241
Liu Jun, 194
Lizong (emperor), 198
Longshan, 11, 47–48, 59, 80–81, 311–14, *312*, *313*
lost-wax method, 101
Lü Dalin, 92
Lü Dongbin, 214, 244, 246
Lu Xiujing, 211
Lui Hai, 194
Luoyang (present-day Luoyang City), 261,
 263, 275

Magaoku / Mogao Caves (Dunhuang), 12, 134,
 216, 217, 229
Mahāvairocana, *220*
Majiayao, 74, *77*
Manchu regime, 185–86, 190–92
Mandate of Heaven, 92
Manichaeism, 205
maps: ancient, *258*; of archaeological sites,
 46; of China, *11*, *46*, *70*, *73*, *76*, *80*, *307–8*,
 312–13, *315–16*, *318*; of shipwrecks, *281*,
 292; of trade routes, *259*, *278*, *292*
maritime trade, in China, 13, 36–37, 270–75,
 277–81, 293–94
Marquis Yi, tomb, 50, 105–6, *106*
Mathers, William, 282
Mazu, 227
medicine, Chinese, 13, 298, 299–302
Mei Lanfang, 251
Meng Yuanlao, 236
metallurgy (metal production), 83, 94, 97,
 105, 107, 306. *See also* bronze production

scholar-officials, 12, 21, 23, 152, 175–83, 191, 194; court hat, 26, 27

Schreck, Johannes, 131, 135

Schuster, Carl, 39–40

seal script, 129

seals, 208–9, 209

section-mold technology, 95, 101–6, 102

Senna nomame, 49

settlement studies, 45, 305, 311, 312–13, 314, 315–17

settlements, in Neolithic China, 72–82, 74, 78

shadow theater (shadow puppetry; *yingxi* or *piyingxi*), 13, 235–53, 238; for children, 237; as communal theater for the non-elite, 242–51; construction of puppets and stage, 237–39; history, 235–37; lore, 239–40; mysticism and the super-natural, 240–41, 251; as religious and ritualistic space, 239–42

shadows, associated with spirit or soul, 241–42

Shakyamuni, 217–19, 218, 220, 221

Shang Dynasty, 92, 94, 96, 118–21, 134–35, 306–7, 319

Shang Xi, 194

Shangshan, 52–54, 53, 62

sheep, domesticated, in ancient China, 50

Shen Yuan, 156

Shenzong (emperor), 151–52

Shibao (Shipu), battle of, 267, 268–69

shipbuilding, 283, 293–94, 296

shipwrecks, 281, 296–97. *See also* Belitung Shipwreck; Breaker Shoal Wreck; Cirebon Wreck; Intan Wreck; Java Sea Shipwreck

Shiqu baoji (*Precious Collection of the Stone Moat [Pavilion]*), 192

shrines, 216–19

silk, 114, 270, 270, 275; manuscripts, 134–35, 136, 137; for painting, 168

Silk Road (Silk Routes), 13, 114–15, 216, 257–75, 277. *See also individual routes and* mari-time trade, in China

Sima Qian, 92, 239

Sino-Tibetan Road, 266–70

Siraf, 274–75

Smith, Mrs. George T., 32

social order, in imperial China, 180, 182

social structures, in Neolithic China, 75,

77–78, 81–82

Sogdian states, 264, 270

Song Dynasty, 198, 236, 296, 300–302; Northern, 92, 134, 145, 150–52, 158, 164; religion, 211, 214, 223

Song Renzong, 236

soybeans, 48, 56, 58–59, 60

spells (incantations, mantras), 223

spices, 296, 300–301

Starr, M. Kenneth, 32–34, 32

Stein, Aurel, 134–35

steles, 129, 133, 262; Buddhist, 218, 220; Daoist, 22, 22, 173–75, 174; Laozi, 207, 212; Mount Yi, 131, 132

Steppe Road, 262–64

stewardship, versus ownership, 37

stone inscriptions, 129, 131. *See also* steles

street theater, 236

subsistence ecology, human, 45, 47, 50, 57, 61. *See also* resource management, by ancient peoples

subsistence regimes, in Neolithic China, 72–73, 78–79, 83, 306

Sui Dynasty, 179, 226, 260–61

Sun Bu'er, 214

Sun Kaidi, 240

Taizong (emperor), 134, 192, 267

talismans, 208, 208

Tan Degui, 237

Tang Dynasty, 13, 134, 173, 293, 300; capitals and trade routes, 259–61, 264, 275; development of shadow theater, 235–36; religion, 206, 211–14, 226–27, 231–32

Tao Hongjing, 210–11

technology, after the Late Glacial Maximum, 57

textiles and embroideries, 39–40, 39, 83, 178, 179

Thomsen, Christian Jürgensen, 89

Three Dynasties, 92–93, 118. *See also* Shang Dynasty; Xia Dynasty; Zhou Dynasty

Tibetan Empire, 266–70

tomb contracts, 208–9, 208

tombs, 11, 13, 79, 93, 105–6, 137–38, 140–41, 311

Tomb-Sweeping festival, 151, 152

tool use, in ancient China, 46, 57

tools, stone, 66–68, 67

trade: between China and Central Asia,

257–60; in medicinal plant and animal products, 299–300, *300*. *See also* maritime trade, in China

treasure ships, 279, *280*

Tsuen-Hsuin Tsien, 34

turtle shell, used for inscriptions, 118–19, 139–41

Tylor, Edward Burnett, 242

Underhill, Anne P., 1, *35*, 41

United Nations Educational, Scientific, and Cultural Organization (UNESCO), 37

urban ethnography, 150, 158–62

valuation, of artifact donations, 30

vessels (*ding, you, jue, he, gui, yi*), 91, *91*, 94–95, *95*, 97, 98–101, *99*, *100*, *104*. *See also* bronzes

villages, in Neolithic China. *See* settlements, in Neolithic China

Waley, Arthur, 223

Wang Hui, 194

Wang Jian, 152, 194

Wang Shimin, 194

Wang Xizhi (poet and calligrapher), 12, 134, 192, 197

Wang Yuanlu, 134

Wang Yuanqi, 194

Wang Zhe, 214

Warring States, 97, 107, 109, 111, 129, 208, 308–9, *308*, 314–17

water buffalo, 45, 55, *56*

water chestnut, 50

Wei Huacun (goddess), 210

Wencheng (princess), 267

wenfang sibao (Four Treasures of the Scholar's Studio), 191

Weng Fanggang, 201

Weng Ouhong, 240

wheat, 49, *49*, 311

White Snake (*The Legend of the White Snake*), 238, 245, 248–51, *249–50*

Wilbur, C. Martin, 28–32, *29*, *31*

Wimsatt, Genevieve, 239, 242

World's Columbian Exposition (1893 World's Fair), 1, 20–23; Chinese pavilion, *20*

writing, Chinese: development, 126, 233; early, 11, *31*, 83, 95–96, 117–21, 306, 309;

importance in culture, *31*, 134; pronunciation, 122

Wu (emperor), 239

Wu Ding (king), 139–41

Wu XinZhi, 68

Wu Yun, 211

Wuliang shouzong yaojing. See *Aparimitayus Sutra*

Xia Dynasty, 92–93, 95

Xiang (empress), 152

Xiang Zonghui, 152

Xiongnu, 210

Xuan (king), 124, 126

Xuanzang, 225–26

Xuanzong (emperor), 264–65

Yang Liangyao, 271, *272*

Yang Xi, 210

Yangshao, 47, 74–78, *74*

Yangtze River, 46, 62–63, 74–75, 78–79, 96, 137, 210, 306. *See also* Jiangnan

Yellow River, 306; floodplain, 109–15

Yellow Turbans, 206

Yijing, 226

yin and yang, *298*, 299

yingxi, 235–36. *See also* shadow theater

Yixing clay teapot, 27

Yongzheng (emperor), 153

You Si, 198–201, *199*

Yuan Dynasty, 227, 279, 300

Yuanshi tianzhu (deity), 173

Zen (Chan) Buddhism. *See* Buddhism

Zhang Daoling, 206

Zhang Guolao, 194, 244, *246*

Zhang Limo, 231

Zhang Limozang, 231

Zhang Luemozang, *31*, 231

Zhang Qian, 257

Zhang Yimou, 253

Zhang Zeduan (painter), 11, 145–46, *146–47*, 150, 152, *159*, *160*

Zhang Zhu, 151

Zhanghuai (prince), 261

Zhanran, 226

Zhao Buliu, 198

Zhao Zhe, 153

Zheng He, 279–80